Aesthetics and the Philosophy of Art

Elements of Philosophy

The Elements of Philosophy series aims to produce core introductory texts and readers in the major areas of philosophy, among them metaphysics, epistemology, ethics and moral theory, philosophy of religion, philosophy of mind, aesthetics and the philosophy of art, feminist philosophy, and social and political philosophy. Books in the series are written for an undergraduate audience of second- through fourth-year students and serve as the perfect cornerstone for understanding the various elements of philosophy.

Moral Theory: An Introduction by Mark Timmons

Epistemology: Classic Problems and Contemporary Responses by Laurence BonJour

Aesthetics and the Philosophy of Art: An Introduction by Robert Stecker

Aesthetics and the Philosophy of Art

An Introduction

ROBERT STECKER

ROWMAN & LITTLEFIELD PUBLISHERS, INC.
Lanham • Boulder • New York • Toronto • Oxford

ROWMAN & LITTLEFIELD PUBLISHERS, INC.

Published in the United States of America
by Rowman & Littlefield Publishers, Inc.
A wholly owned subsidary of The Rowman & Littlefield Publishing Group, Inc.
4501 Forbes Boulevard, Suite 200, Lanham, Maryland 20706
www.rowmanlittlefield.com

PO Box 317
Oxford
OX2 9RU, UK

British Library Cataloguing in Publication Information Available

Library of Congress Cataloging-in-Publication Data

Stecker, Robert, 1947–
 Aesthetics and the philosophy of art : an introduction / Robert Stecker.
 p. cm. — (Elements of philosophy)
 Includes bibliographical references and index.
 ISBN 0-7425-1460-9 (cloth : alk. paper) — ISBN 0-7425-1461-7 (pbk. : alk. paper)
 1. Art—Philosophy. 2. Aesthetics. I. Title. II. Series.
 BH39.S74 2005
 111'.85—dc22 2004019119

Printed in the United States of America

∞™ The paper used in this publication meets the minimum requirements of American
National Standard for Information Sciences—Permanence of Paper for Printed Library
Materials, ANSI/NISO Z.39.48-1992.

Contents

Preface

One of the major themes of this book is that aesthetics and the philosophy of art are two distinct though overlapping fields. The former was launched in the eighteenth century as the study of beauty and sublimity, art and nature. As the categories of beauty and sublimity proved too constricting, a more wide-ranging and variously defined category of the aesthetic emerged. Aesthetics is the study of a certain kind of value based on a distinctive experience or distinctive properties in objects. The value is identified in judgments about the capability of the object to deliver the experience or possess the properties. The philosophy of art for the most part developed from aesthetics but is distinct from it in two important ways. First, the philosophy of art deals with a much wider array of questions—not just those about value but also issues in metaphysics, epistemology, the philosophy of mind and cognitive science, and the philosophy of language and of symbols in general. Second, art is too complex and diverse to be explicable in terms of a single category such as the aesthetic. "Artistic value" is constituted by a set of different kinds of value. The modes of appreciating art, the means to understanding art, the kinds of objects that are artworks are also all plural.

For this reason, the present work has two parts, each devoted to one of these fields. Part I is about the aesthetic. Part II attempts to give a sense of the range of issues addressed in the philosophy of art.

The aim of this book is to give an overview of the current state of the debate on numerous issues within these two broad main topics. In addition, it takes a stand on each issue it addresses, arguing for certain resolutions and against others. In doing this, my goal is not just to present a controversy in its current state of play but also to help advance it toward a solution. I hope the reader will enter into the debates set out in each chapter, taking his or her own stand that may well be different from the author's.

There is one more aim that should be mentioned. Many individual issues are addressed in the following pages, and it is easy to ignore or become

confused about how they fit together. This work sets out several ways they *might* fit together and once again argues that some offer a better approach than the others. Regarding part I, there are two main messages—first, that the aesthetic should first and foremost be understood in terms of a certain type of experience, and, second, that there are no privileged providers of the experience, such as art. The aesthetic is something that can pervade our experience because virtually every compartment of life contains objects that have aesthetic value. Regarding part II, there are also two main messages. One is the pluralism about value, understanding, and appreciation mentioned previously. The other is that one approach to the philosophy of art—contextualism—works better than its rivals in resolving issue after issue.

Material from several chapters appeared previously in the form of journal articles or book chapters. Chapter 2 greatly expands material found in "The Correct and the Appropriate in the Appreciation of Nature," *British Journal of Aesthetics* 37, no. 4 (1997): 393–402. Chapter 12 includes material from "Reflections on Architecture: Buildings as Environments, as Aesthetic Objects and as Artworks," in *Architecture and Civilization*, edited by Michael Mitias (Amsterdam: Editions Rodopi, 1999), 81–93. Chapter 5 is a revised and expanded version of "Definition of Art," in the *Oxford Handbook of Aesthetics*, edited by Jerrold Levinson (Oxford: Oxford University Press, 2003), 136–54, 307–24. Chapter 6 is based on "The Ontology of Art Interpretation," in *Art and Essence*, edited by Stephen Davies and Ananta Sukla (Westport, Conn.: Greenwood Press, 2003), 177–91. Chapter 7 is a revised version of "Interpretation and the Problem of the Relevant Intention," in *Contemporary Debates in Aesthetics*, edited by Matthew Kieran (in press). Finally, chapter 9 includes material from "Expressiveness and Expression in Music and Poetry," *Journal of Aesthetics and Art Criticism* 59, no. 1 (2001): 85–96. I am grateful to the publishers of these pieces for permission to reprint material from them.

I am also grateful to several people who read parts of the book. Berys Gaut offered valuable comments on chapters 3 and 4. Paul Guyer gave helpful advice on the material on Kant in chapter 2. Allen Carlson provided very useful feedback on chapter 2, as did Matthew Kieran for chapters 10 and 11. Parts of chapter 7 were read at conferences in Manchester, England (2003), and Pasadena, California (2004). I thank the audience at the conferences for their questions and am especially grateful to Kent Bach, my commentator at Pasadena. Last, but not least, I am grateful to an anonymous referee for many good suggestions for improving this book.

1

Introduction

Aesthetics versus the Philosophy of Art

The discipline of philosophical aesthetics was born in the eighteenth century as the study of the beautiful and the sublime in nature, art, and other human artifacts. It focused not only on the features of objects that make them beautiful (sublime) but also on our reaction to these features and the properties of the human mind that make these reactions possible. It attempted to characterize the judgment made when it is asserted that an object is beautiful and the kind of value being ascribed to objects by such judgments.

From this common source, several alternative conceptions of the subject matter of aesthetics have emerged.

One approach is to stick as closely as possible to the original eighteenth-century project as just described. However, the conceptual shifts that have occurred in the past 300 years make it impossible to pursue exactly the same project. For one thing, to confine it to the study of the beautiful and sublime would now be regarded by most of us as too constricting. There are many artworks that are not well characterized by either predicate. There is the art of the grotesque, the horrifying, the morbid, and the shocking. There are ordinary objects in which, it could be argued, we take an aesthetic interest but that do not deserve to be characterized as either beautiful or sublime. These include all kinds of artifacts, ranging from hair clips and T-shirts to household appliances. Perhaps there are even aspects of nature of which the same is true. Consider a smooth, gray stone one might find at a beach. It is attractive to look at and touch but not necessarily a beautiful object like the delicate and colorful scallop shell one discovers soon after. For this reason (as well as others), the focus on beauty and sublimity has given way to an attempt to formulate a broader notion of *the aesthetic*, which then becomes the central focus of this approach. Underlying it is an assumption that

there is a special sort of experience, or a special set of properties, about which we make a distinctive kind of judgment ascribing a unique sort of value, all of which fall under the concept of the aesthetic. Those who accept this assumption are in position to explore the nature of the aesthetic (aesthetic experience, aesthetic properties, aesthetic judgments, aesthetic value) wherever it occurs—in nature, art, artifacts, and so on.

Beginning in the nineteenth century, "aesthetics" gradually acquired a new meaning, namely, *the philosophy of art*. Two further ways of thinking about the subject matter of aesthetics derive from this long-standing tendency. One approach is guided by the thought that art is the most significant or the primary bearer of aesthetic value; it is the one kind of thing that is made chiefly with the intention to create aesthetic value, and, hence, the concept of the aesthetic is the key to understanding the nature and value of art. One might say that this approach adapts the eighteenth-century project into a philosophy of art.

The final approach claims that the adaptation just mentioned is a distorting lens through which to look at art. Art is too complex and is valuable in too many ways to be grasped exclusively through the concept of the aesthetic. Hence, "aesthetics," *understood as the philosophy of art*, has to be freed from an exclusive concern with art as a bearer of aesthetic value! Rather than being an adaptation of the eighteenth-century project, this approach thinks of the philosophy of art and "aesthetics," *understood as the study of aesthetic value*, as distinct and, at best, overlapping disciplines or subject matters.

This book examines all three conceptions of the discipline of aesthetics, but let me say up front that it is aligned with and will argue for the last approach. To avoid confusion, we will use "aesthetics" *only* to refer to the study of aesthetic value and related notions like aesthetic experience, aesthetic properties, and aesthetic judgments. Given this usage, aesthetics is one thing, the philosophy of art is another, though this is not to deny that some conception of aesthetic value will play an important but not defining role in the philosophy of art.

This book offers an introduction to both aesthetics as just defined in part I and the philosophy of art in part II. Interestingly, once we distinguish between aesthetics and the philosophy of art, the first approach mentioned previously, considered as a conception of aesthetics, is perfectly consistent with the third approach. What is at odds with the latter is the second approach.

Aesthetics

The Concept of the Aesthetic

It is plausible that there are countless things that possess aesthetic value in some degree. Among these are artworks and natural objects but also

many everyday things, such as our clothes and other adornments, the decoration of our living spaces, everyday artifacts from toasters to automobiles, packaging, the appearance of our own faces and bodies, the artificial environments we create, the food we eat, and so on indefinitely. Is it really true that all these things share this value in common, and, if so, how should it be characterized?

To illustrate the diversity of views about the nature of the aesthetic, consider a meal at a restaurant. Such an occasion will appeal to us, particularly to our senses, in a variety of ways. First, the restaurant will create a setting, an ambience in which the meal occurs, by such things as the way it is decorated, the amount of light it provides the diners, the seating arrangements, and so on. An order (someone's meal) will provide a variety of looks, tastes, smells, and textures, to some extent presented sequentially (the different courses), to some extent presented simultaneously (the different parts of a single course). Does such a meal possess aesthetic value? Does it provide an aesthetic experience, and does that experience potentially take in everything mentioned so far? Which properties of the occasion and of the food are aesthetic properties? Are the tastes and textures of the dishes aesthetic properties of the meal? Are any of the judgments we make about it aesthetic judgments: that it is good, that the dishes complement each other, that this is spicy, that this tastes of ginger (or is gingery)?

Does a meal have aesthetic value? The fact is that some would say, of course, while others would say, of course not. J. O. Urmson (1957) should belong to the former camp since he thinks that aesthetic value results from pleasure caused by the way things appear to the senses. Hence, a judgment that the food is good based on the way it appears to the senses should be an aesthetic judgment. All the senses are potentially involved in the judgment. Taste and smell are obviously so involved, but the visual appearance of food is important, as is texture, which is discerned by the sense of touch activated in chewing. Even the sense of hearing can come in when dealing with crisp or crunchy food, as advertising agencies well know. Imagine what it would be like to eat a raw carrot and hear nothing. On the other hand, Immanuel Kant (1952), one of the most influential philosophers on the aesthetic, while he might admit that a restaurant's decor could be an object of aesthetic judgment, would deny that the tastes, textures, and smells of the food could be such an object. They are merely agreeable or disagreeable. Kant would say that the pleasure of food is pleasurable sensation (which may be consistent with Urmson's idea that it is pleasure derived from the way food appears to the senses, the way it tastes, smells, looks, and so on). But this is not aesthetic pleasure, which should be distinguished from the agreeable for Kant, and the judgment that the food is good is not an aesthetic judgment. Kant insists that aesthetic judgments are disinterested because he thought that we are indifferent to the existence of what is being contemplated, caring only for the contemplation itself. The judgments

of agreeableness are interested because we care whether the objects of such judgments exist.

Kant and Urmson disagree about the characterization of aesthetic experience but agree that aesthetic judgment has its basis in such experience, which, when the judgment is positive, is some sort of pleasurable experience. Others locate the basis of aesthetic judgments more in the properties of objects than the experience they cause. If food is an aesthetic object, it is because of the tastes and textures we discern or the relations among them rather than the experiences the properties might cause.

Aesthetic Value

There are several further questions about aesthetic value. It is often said that when we think something is aesthetically good, we value it for its own sake or as an end rather than for something else it brings about or as a means. It is true that, when we listen to music, we are likely to focus on the music, whereas as when we go shopping, we are more likely to focus on what we can do with potential purchases. Of course, to say this is to oversimplify. We may well focus on the design of an article of clothing, examining it on its own "merits," and, on the other hand, we may wonder whether the music would be good to dance to or suitable for a certain occasion.

There is a more serious challenge to the idea that we value the music for its own sake. Should we really say this of the music or the experience of listening to it (if either)? If what is crucial to aesthetic value is an experience, perhaps we should say it of the latter, in which case the music itself would seem to have a kind of instrumental value in bringing about the experience.

We might call this question one about *the way* we value objects of aesthetic judgments. There is another, equally important question about the objectivity of this value. In the eighteenth century, aesthetic judgments were called judgments of taste, and we seem to be torn about taste. We feel *both* that there is such a thing as good and bad taste *and* that there is no disputing judgments of taste, and so, to each their own. This mild form of schizophrenia is reflected in the views of two of the most important eighteenth-century writers. Kant, who we have already mentioned, took aesthetic judgments to be subjective ones that did not make truth claims, but he nevertheless did think that they claim universal assent. David Hume (1993), who wrote a little earlier in the century, also thought that judgments of taste have an essentially subjective aspect, being "derived" from sentiment or reactions of pleasure and displeasure, yet he argued for an (intersubjective) standard vindicating good taste over bad. Can one really have it both ways, as Hume and Kant at least appear to want, or does one have to plump for one side of the divide?

This question applies to even the most standard example of the subjectivity of taste as it does to the most plausible exception: art. Consider taste in food. We allow to each their own preferences. You may not like lobster at all, and that is just fine. If you do like it but insist that it should be boiled to a rubbery consistency, we are tolerant of your idiosyncrasy but look on it as just that. Yours will never be the standard of taste among lobster eaters. In this case, if we can talk of a standard, it is a contingent, intersubjective, probably culturally relative one.

When we evaluate works of art, is there a similar standard, and is it more or less contingent, more or less relative to the taste of a group?

In the chapters on the aesthetic that follow, we will lay out and attempt to evaluate various conceptions of the aesthetic. Questions about the way we value aesthetic objects and the objectivity or subjectivity of that value will also be discussed. We will initiate this examination in chapter 2 by taking a detailed look at aesthetic appreciation in a particular domain: nature. This will supply many concrete examples of such appreciation and a variety of views about what ought to be appreciated in nature: views about which experiences and which properties of natural environments are crucial to this appreciation. This will lay the groundwork for and motivate a more theoretical evaluation of conceptions of aesthetic experience, aesthetic properties, and aesthetic value in chapters 3 and 4. At the end of this book, in chapter 12, we will return to the topic of environmental aesthetics by examining the way we appreciate certain artificial environments: buildings and their surrounding sites. We reserve this discussion until the end because many, though by no means all, of these buildings are artworks and to understand our appreciation of them, it will be useful to have the resources provided by the chapters on the philosophy of art.

The Philosophy of Art

The topic of part II of this book is the philosophy of art. Here we have to move beyond issues of the aesthetic and of value but without leaving those issues behind. We have to move beyond the aesthetic because artistic value is not confined to aesthetic value. We have to explore what other properties of works contribute to their value as art and what conception of artistic value this leads us to. We also have to investigate a whole new set of issues.

Central Issues

Aesthetics, at least as set out in this chapter, is primarily a topic within value theory. In contrast, the philosophy of art deals with issues from a wide spectrum of philosophical topics: metaphysics, the theory of knowledge, value theory, and the philosophies of mind and language.

As I conceive of the philosophy of art, there are five central issues. One issue that is already somewhat familiar to us concerns the value of art as art. Not every valuable property of a work is part of its artistic value or its value as art. For example, most people don't think that a work's monetary value is part of its artistic value. Similarly, the fact that a work has sentimental value for me because it was present at a significant moment in my life does not enhance its artistic value. So how do we distinguish artistically valuable properties from other valuable properties? Do the artistically valuable properties justify the great cultural importance given to art? Are the artistically valuable properties among the defining properties of art? Are there properties that a work must have to be artistically valuable?

We have already mentioned that one way people have hoped to answer these questions is via an aesthetic conception of art. This approach identifies the artistic value of art with its aesthetic value. If we can settle on a singular conception of the latter kind of value, we have a simple and neat way of distinguishing artistic from nonartistic value in art. Aesthetically valuable properties would be properties a work must have to be artistically valuable.

However, we have also noted that the aesthetic conception of art has come under strong challenge, and this applies to its theory of artistic value. Some doubt that appeal to aesthetic value is sufficient to explain the cultural significance of art. In recent years, philosophers of art have explored the cognitive value of art: the role of art in the acquisition of knowledge and understanding. They have inquired into the ethical evaluation of art and its bearing on aesthetic evaluation. There has also been a great deal of work on art and the emotions. We ascribe value to art that moves us in various ways. What sort of value is this? The nature and kinds of artistic value are explored in the final chapters of the book: 10 through 12. Chapter 10 presents two contrasting theories of artistic value and argues in favor of one that makes such value more contingent, more plural, and less unique than the rival approach. Chapter 11 focuses on the ethical value of artworks and ways this can interact with a work's aesthetic value. Chapter 12, as mentioned previously, returns to a theme with which we began this book, environmental aesthetics, by examining the value of architecture and the artificial environments it creates. Both chapters 11 and 12 offer further support for the conception of artistic value defended in chapter 10.

A second issue is raised by the question: what is art? One attempts to resolve it by giving a definition or nondefinitional conception of art. A definition attempts to identify the nature of art if art has an essential nature or at least principles of classification for distinguishing art from nonart. Again, the aesthetic conception of art has a neat answer: something is art if it is made to create significant aesthetic value (or a significant aesthetic experience). However, this is an answer that has carried less and less conviction as art has developed through the twentieth century and into the twenty-first. From ready-mades such as *Fountain* (a urinal) selected for its very lack of

aesthetic interest to a crucifix immersed in urine; from pop art replicas of soup cans, hamburgers, and Brillo boxes to all sorts of varieties of conceptual art (postcard series recording life's mundanities, specifications of geographical locations); and from objects scattered across a gallery floor to bisected cows or persons hanging from hooks naked over a city street, we have countless examples of items put forward as art that either aim for something other than aesthetic satisfaction or whose aesthetic payoff requires so much contextualization that those looking for straightforward aesthetic pleasure would do better to ogle a new-car lot.

The seemingly strange turns art has taken over the recent past is only one of several reasons why some way of reconceptualizing all this seems urgent. The mere variety of art forms and the vagueness of the boundaries between such things as art and craft and art and entertainment are other equally compelling reasons. Among those who reject traditional approaches to defining art (such as the aesthetic definition), consensus has wavered between those who claim that art cannot be defined and those who think it can if we look in less obvious places. This debate is surveyed in chapter 5.

The third issue concerns the ontology of art. What type of object is an artwork? This question should not be confused with the one just raised: what is art? At least one way of answering this latter question is to identify a set of properties shared by all artworks and by no nonartworks. However, if all artworks belong to a *type* of object, it hardly follows that no nonartworks belong to that type. Consider a candidate answer. Artworks belong to the type: physical object. Obviously, if this answer were correct, there would be many nonartworks that belong to this type of object too. It also shouldn't be assumed that the sample question just asked to characterize this issue—what type of object is an artwork?—is the right question to ask with regard to this issue. This is because the question presupposes that there is one type of object that all artworks fall under, and this is far from obvious. Paintings may be one type of object, novels a different type. The issue is to identify the relevant type *or types*.

But why? If it is fairly easy to see why one might want a definition of art, it is not so obvious what makes the ontological issue compelling. There are two reasons why we should care about answers to such questions. First, it's just puzzling what art is or, more precisely, what various sorts of artworks are. Consider a piece of music such as Mozart's clarinet concerto or the Beatles' "Yesterday." It is *not* a physical object since there is no object one can uniquely point to and say, "That is the concerto." Nor is it a specific event such as a performance that occurs over an identifiable stretch of time for the same reason. Yet it is not something that exists simply in someone's mind since no mind, not even the composer's, has privileged possession of it. So what is it? Second, the way we answer this question has profound consequences for most other issues in the philosophy of art: questions about the

value as well as the meaning of artworks. So we can't ignore this issue, which is the topic of chapter 6.

A fourth issue derives from the fact that artworks typically mean something in a very broad sense of that term. For example, many works of art are representational; that is, they use the medium of an art form to represent aspects of the actual world or of fictional worlds or of both at once. Yet this is clearly done in quite different ways in different art forms. In two-dimensional visual art, the chief though not the only means of representation is *depiction*. This is something very different from the linguistic representation found in literature or even the three-dimensional mode of representation found in sculpture. Is there a useful general theory of representation available for understanding these different modes of representation, or does each need its own account? In addition to being representational, many works of art are expressive of moods, emotions, attitudes, and other mental states. Is this another way that artworks are meaningful? There are several competing accounts of expression in art that anyone interested in this topic needs to sort out. Representation is the topic of chapter 8, and expression is discussed in chapter 9.

Meaning and understanding are correlative notions. If artworks are meaningful, they are the kind of thing in need of understanding. So it is not surprising that a fifth issue concerns what it is to understand artworks. A good chunk of this issue involves giving a theory of interpretation. Artworks are among the things commonly in need of interpretation, and we come to better understand and appreciate such works by interpreting them. However, I would argue that not all understanding of art is interpretive. Whether interpretive or not, there are a number of important questions about artistic understanding. Are there right and wrong understandings (interpretations)? Is there one right interpretation, or is there a plurality of acceptable interpretations of a work? What role does the artist's intention play in answering these questions? These and other questions will be discussed in chapters 6 and 7.

Central Approaches

So far we have been talking about the issues central to the philosophy of art. Before concluding this chapter, we should say something about different approaches to dealing with these issues.

One approach is *essentialism*. An example of this was mentioned at the beginning of this chapter as the aesthetic conception of art. According to this view, art is essentially something made to provide significant aesthetic experience, and the fact that art has this essence is internal to the concept of art. This approach also sometimes provides an essentialist conception of the value of art. The value of an artwork as art is a function of the aesthetically valuable experience it provides to those who understand it.

The aesthetic conception of art is not the only essentialist conception. What all these conceptions of art have in common is that they claim that the sort of properties that make something an artwork and give it value as art are unchanging ones that can be read off from the concept of art itself. Hence, these features of art are independent of the varying contexts in which works are created.

One alternative to this sort of essentialism is *contextualism*. Contextualism is the view that the central issues of aesthetics can be satisfactorily resolved only by appealing to the context in which a work comes into existence: the context of origin or creation. What makes something art depends not on a static essence but on a relation a given work bears to others. Hence, contextualists believe that a satisfactory definition of art, or nondefinitional conception, must be historical. Contextualists also claim that the very identity of a work—what distinguishes it from other works and from all other objects—depends, in part, on the context in which it is created. So two distinct works might look or sound exactly alike but be distinguished by facts about the context in which it originates. Further, reference to this context is equally crucial for fixing the meaning of works and to their understanding. It is essential for a proper assessment of their artistic value. Hence, all the central issues of aesthetics are resolved by appeal to the context of origin of the work.

Constructivists also deny that art has a fixed essence but in addition believe that context of origin does *not* pin down the artwork once and for all. Hence, constructivism is always incompatible with at least some of the theses held by contextualism as well as with essentialism. For constructivists, what occurs after an artist makes an artifact is at least as important for the creation and meaning of an artwork as the context of origin. For many constructivists, the evolving culture shapes the work at least as much as the artist does. Art is the product of culture for these theorists, as much or more than it is the product of creative individuals, and insofar as it is the product of such individuals, they include critics and interpreters as well as artists.

Constructivism comes in different versions. I distinguish two such versions here. Moderate constructivists claim that artworks undergo changes as they receive new interpretations, as they enter new cultural contexts, or conceptual environments. Furthermore, these changes are not peripheral ones that occur around a stable core fixed by the work's origin. The distinction between core meanings and peripheral ones is rejected. Hence, works are things that are much more in flux than they are thought to be under contextualism, and there is a consequent difference in views about the understanding and value of art. Some moderate constructivists claim that the boundary between properties that belong to artworks and properties that do not is indeterminate. Interpretive properties are imputed to works rather than discovered in them.

Radical constructivists believe that works are created, not merely altered, in the process of interpretation. Of course, this raises the question: the interpretation of what? The answer cannot simply be the interpretation of the created object since an interpretation must begin with some object it is directed at, and the created object is an end product, not in existence until the interpretive activity is complete or at least well under way. There must be an object that initially prompts and guides the interpretation, and this must be different from the created object. Hence, for radical constructivists, there are always three objects involved in art interpretation: the initial object, the interpretation, and the created or subsequent object.

There is a fourth approach to the philosophy of art that is gradually emerging, though at this point it does not offer as clear a program for resolving its central issues as the three approaches just mentioned. This last approach is based on an appeal to the multifaceted discipline known as cognitive science, which includes the area of computer science known as artificial intelligence, cognitive and evolutionary psychology, the philosophy of mind, linguistics, and neuroscience, among other things. The basic thought underlying this approach is that there are certain features of the human mind—its evolution, its cognitive or perceptual structure—that shed light on art, our concept of it, its value for us, and its ability to represent or express that is independent of context of origin of particular artworks or the changing cultural context in which they are received. However, since cognitive science is young, there is little in the way of firmly established theory one can appeal to. Instead, there are still mainly competing hypotheses, and anyone who appeals to cognitive science is making bets on which of these will turn out to be the winners.

As we explore the issues mentioned here, the debate among these different approaches will emerge more sharply.

Part I

AESTHETICS

2

Environmental Aesthetics: Natural Beauty

In chapter 1, we said that aesthetics studies art *and* beauty and that these are overlapping but different subject matters. When we think about the appreciation of art, we find that beauty is one, but only one, among the several things that we value. When we think about the appreciation of nature, it is tempting to suppose that beauty is the main thing. It is also tempting to suppose that beauty in nature is a simpler thing than beauty in art because it can be recognized without much understanding of structure or context. It stares one in the face. Go to a beach and look down the strand where water meets sand. Most everyone can see the beauty in that. However, if you encounter a dead, discolored fish in a state of decay as you walk along the beach, you probably won't think, "That is a thing of beauty." When you encounter beauty in nature, it stares you in the face, and when you don't, it stares you in the face—or so it might seem.

This chapter is concerned with the aesthetic appreciation of nature. Environmental aesthetics, as this topic is also called, is a subject that is attracting increasing attention, perhaps in part because of the potential connection with environmental ethics, a connection that is explored later in this chapter in the section titled "Are There Norms of Nature Appreciation?" Examining a variety of concrete cases of aesthetic appreciation of this type will prepare the way for the more theoretical examination of conceptions of the aesthetic in chapters 3 and 4.

If we take it as literally as we should, the expression "environmental aesthetics" is a broader and more complex topic than one concerned only with natural environments. It should also cover the environments that human beings construct and their interface with nature in the very common situation where they meet. We will return to this topic in chapter 12, where we will discuss the aesthetic value of architecture.

Objects and Models

When it comes to art, it is obvious what objects are appreciated. They are the artworks. Where works are performed, we also appreciate the performances. People disagree about the characterization of these objects and in what proper appreciation of them consists but not about these being the appropriate objects of art appreciation.[1]

While the way we conceptualize nature divides it up into various parts and objects—into flowers and stones, fields and forests, mountain ranges and ridgelines, ecosystems and solar systems—it doesn't tell us which units are appropriate objects of appreciation. Are there appropriate units, or objects, that would imply that others are inappropriate or incorrect?

There are a number of different views on this topic. Let us begin with a survey, bearing in mind that it is not intended to cover all actual, much less possible, proposals.

Some think that what we should appreciate in nature is not so much objects as properties or appearances that nature presents to us. For example, a mountain range presents a constantly changing visual field. It changes with the light it reflects, with the point of view of the spectator, with the seasons. Proper appreciation, on this view, consists in getting a precise take on the visual appearance of the moment. This view can be extended to the other senses as long as one is careful to focus on the impression of the moment. Call this the impressionist model of nature appreciation, obviously named after the mode of perceiving that is embodied in the landscape painting of the impressionists, whose foremost exponent was Monet. (Another painter, Cezanne, painted a particular mountain,—Mount St. Victoire,—over and over again. Each time it has a different look, though one can recognize it as Mount St. Victoire.)

A second view tells us to focus on particular objects. Thus, we may encounter a stone with lovely colors or an unusual shape or smoothness and appreciate the stone for these pleasing qualities. We could do the same with a pretty flower or with an animal, say, a monarch butterfly or a rainbow trout. Notice that, on this view, we can appreciate natural objects in or out of their natural setting because we are focussing exclusively on the object. It's fine if we encounter such objects "in nature," but it is also fine if we bring them home and appreciate them there. We can pin the butterfly and put it behind glass, we can plant the flower in our backyard, and we can put the stone on the mantelpiece. Call this the object model.

This view resembles the previous one in some respects but not in others. When we focus on a particular object, we are likely to pick out for appreciation surface properties, something also emphasized by the impressionist model. But they may not be quite the same surface properties. We appreciate the flower for its "true" color and shape rather than a momentary appearance it happens to present. We are also conceiving of the objects

in terms of categories, such as flower, fish, and stone. We are required to notice properties as properties *of* objects on the object model, while this is more optional on the impressionist model. In fact, some proponents of the latter model advise us to try to ignore the fact that we are seeing a certain object, so we can see what is "really" before our eyes rather than "see" according to a preconception of what such an object should look like.

A third position treats nature as a landscape. It claims that we should focus on a view rather than a single discrete object. A view or vista is an object that can be seen from a relatively fixed point of view. Sometimes the kind of vistas emphasized by the landscape model is the sort that prompts the creation of "scenic turnouts" on highways: scenes of great, even breathtaking beauty. But there is nothing about the view that the object of appreciation of nature is a landscape that requires that we exclusively focus on such spectacular scenes. Just as the history of landscape painting is a history of shifting emphases that range from the representation of dramatic storms to quiet, ordinary agricultural scenes, our interest may vary in the views we encounter in nature. Human beings have a natural tendency to find beauty in what is available. If what is available are ridgelines with sweeping views of lakes and mountains, one might have trouble finding much beauty in a cornfield. However, if cornfields are what one has to look at, one will start discriminating among them and find more to appreciate in some rather than others, finding some, but not all, quite beautiful. (Availability is just one determinant of our ability to discriminate beauty. Another would be the aspects of nature celebrated, revered, or in other ways made salient by a culture.)

Just as the impressionist and object models are not entirely disjoint, so the landscape model partially overlaps with both of these alternatives. This is because there are not only an enormous variety of views to which one can attend but also different ways of looking at views. One way, of course, is the way recommended by the impressionist model. A different way bears a kinship with the object model since it involves the scrutinizing of specific objects contained in the view. However, the landscape model is not committed to one such way of seeing, and that, along with its fixation on views, differentiates it from the other models.

All three of the models mentioned so far are sometimes associated with a doctrine known as "formalism." This doctrine is more commonly directed at art appreciation and claims that, to properly appreciate an artwork, one should attend to its form rather than content, where form is conceived as something immediately available to the senses. (See chapter 5 for more on formalism in the philosophy of art.) Similarly, formalism in nature appreciation claims that the proper appreciation of nature should be confined to properties or appearances immediately available to the senses, without reliance on background knowledge such as that provided by science. Though the three models mentioned so far tend to emphasize

this kind of appreciation, it is not so clear that any of them make the formalist's claim that nature appreciation should be *confined to* the appreciation of such properties. This issue is discussed further in this chapter in the section titled "A Modest Objection."

Before stepping back to take stock of the models mentioned so far, with their favored objects of appreciation, I will introduce just one more for now. Call it the artwork model. Its main idea is that we should appreciate nature as an artwork. There are two versions of this view: the literal version and the "as if" version. The literal version says that nature literally is an artwork. One source of this version is religion: nature is God's, or the gods', artwork, which, given traditional theological beliefs, would require it being seen not only as an artwork but also as the best artwork. Another possible source of this version is a mistaken idea that I have occasionally encountered that something is art if it is a beautiful thing.[2]

The "as if" version does not say that nature really is an artwork. In fact, it denies this but nevertheless says that we should appreciate nature as if it were an artwork. A rationale for this view claims that art appreciation is our only real model of aesthetic appreciation, so if we desire to aesthetically appreciate nature, we have to treat it as if it were art.

This view bears some similarities with the landscape model, from which it might draw inspiration. It is easy to drift from the idea that what we appreciate in nature is a (natural) landscape to the idea that we appreciate nature by treating a view as if it were a landscape painting. However, it is important to recall that this is not what the landscape model actually says, nor is the artwork model committed to treating landscape painting as the only art form relevant to the enjoyment of nature.

The Distortion Objection

All these models have come in for a variety of criticisms. I will focus on two: one severe, one modest. The severe criticism is that all these models distort or misrepresent the proper appreciation of nature and that, because they do this, they should be rejected.[3] Let us explore this criticism first, before turning to the more modest objection.

Perhaps it is easiest to see the force of the distortion claim by examining how it applies to the last model that we discussed: the "as if" version of the artwork model. Here we are explicitly being asked to appreciate nature by pretending it is something it is not. We imagine that a rock face is carved with the intention of producing the shape on view when in fact it was produced by natural forces such as erosion, forces that operate independently of human intentions. This is actually a double distortion. First, we are being asked to distort the object of appreciation by imagining (though not actually believing) it is an artifact when it is no such thing. In addition, this model distorts what actually happens, typically, when nature is an object of

aesthetic appreciation. When you enjoy the sight of a beautiful sunset, is there a pretense that you are looking at a painting? Would such a pretense enhance your appreciation? This version of the artwork model is based on a faulty understanding of "aesthetic appreciation" as a synonym for the appreciation of art. Almost any object presented to the senses or the imagination can be aesthetically appreciated. As noted at the beginning of this book, the concept of the aesthetic developed historically as something that applied equally to art and nature. Hence, the pretense is neither needed nor desirable and may justly be described as a distortion if it is presented as our characteristic mode of aesthetic appreciation of nature.

Does the distortion objection apply to the other models we have mentioned so far? If it does, it must do so on somewhat different grounds since these other models require no pretense on our part. When we examine a stone, we are not pretending that it is smooth, gray, and solid, that it has a graceful shape and is unaccountably pleasant to touch. Nevertheless, the distortion objection has been put forward against this model as well. What it claims is that when we attend to an object in isolation from its natural environment, some of its properties become invisible, while others take on a false appearance. Because a stone is such a hard and solid thing, looked at in isolation, it may give us a sense of permanence. However, if we see it in relation to and as part of its natural setting, we would be more likely to realize that its current properties are molded by natural forces that were previously invisible to us, and we might be more impressed with its malleability and regard the sense of permanence as a false impression. So the purported distortion that results from adhering to the object model is due to its tendency to hide some aesthetically relevant properties from view while falsely suggesting the existence of others. Or, to put the matter another way, objects, both living and nonliving, possess an "organic unity" with their environments that is the source of much of the object's aesthetic value, and this unity is destroyed when the object is viewed in isolation.

One can also criticize the landscape model and the impressionist model on somewhat similar grounds. The former asks us to appreciate something that is "arbitrarily" framed, that is, "static" and "two dimensional." It reduces nature to something that is purely visual, cutting off the engagement of the other senses. It requires a fixed point of view, whereas nature is in fact something in which we can move around, in which we are immersed. The impressionist model can be criticized for treating objects as mere patterns of light and sound (a rushing river) or shape and color (a mountain in autumn).

Digression: Is Nature an Artwork?

Before evaluating the distortion objection and turning to the not-yet-formulated more modest objection to the models so far laid out, we will

briefly digress to discuss the literal version of the artwork model, which typically derives from a religious conception of nature appreciation. In order to properly evaluate this view, it is important to distinguish two claims that it makes, the first purportedly lending support to the second. It is especially important to distinguish these claims because it is easy to wrongly suppose that they come to the same thing. The first claim is that nature is the creation of an intelligent being or beings. The second claim, for which the first is purportedly a reason, is that nature is like an artwork created by human beings, except that it is a far superior one since it is created by a far superior being or beings.

This view can appeal only to those who are willing to take seriously the initial conception of nature as the result of intelligent design or an intentional, voluntary act of creation. As such it has a more limited appeal than the other models, which can be employed (even if improperly so, if the distortion objection is correct) by anyone with or without religious cast of mind. Nevertheless, many people do accept the religious conception of nature (as created by an intelligent being or beings), and the interesting philosophical question is whether it *follows* from this conception that nature is as artwork. I will argue that the answer is no.

There are three reasons why this does not follow. First, not everything that is created is a work of art, as is made obvious by inspecting the variety of human artifacts. Hence, "x is created" does not imply "x is an artwork" any more than does "x is an artifact" imply this. Second, there is good reason to believe that the manner in which nature is created, if it is, is so very different from the way artworks are created that it becomes positively implausible to think of the former creation as the creation of art. Artists typically craft, or at least select, the individual item that is the artwork, being guided in either case by intentions toward that item. There is a very good reason to believe that nature operates according to general laws. If we wanted to explain the existence of beech trees along a ridge in a forest, we would refer to various features of the forest environment, properties of beech trees, and laws of biology. We would not mention the intentions of an intelligent creator. Such intentions would come in at a very general level—in the intention that nature operate according to the laws that in fact hold and perhaps to very distant initiating events. Finally, if we somehow became convinced that each item that comes into existence is intended to do so by the intelligent creator(s), the content of these intentions is hidden from us. Are objects in nature intended to provide aesthetic relish? We may feel that they must be, but we really don't know.

Given these reasons blocking the inference from the createdness of nature to nature being an artwork, the difference between the "as-if" version of the artwork model and the literal version is less than it seemed on first appearance. There is still a difference since the literal version of this model does not involve pretense. What it does involve are large assumptions. I am

not thinking of the assumption that nature is created but rather assumptions about the intentions involved in the creation. Further, if these assumptions were to lead one to ignore the more immediate causes of the natural world—natural events, forces, and laws—then this model's literal version might be as open to the distortion objection as the other models considered so far. However, we have yet to determine the force of this objection. It is to this we now turn.

Evaluating the Distortion Objection

Do we distort the object of aesthetic appreciation by looking at it in isolation from its surrounding environment, by focusing on a view for the visual pleasures it provides, or by attempting to "capture" the impression of the moment? In other words, will employing the object, landscape, or impressionist model of nature appreciation necessarily lead to such distortion?

Begin with the object model. To appreciate some but not other properties of an object is not to distort it but to appreciate it selectively. Suppose I am admiring a wildflower, a pink trillium, which appears fairly early in the spring in woodlands along riverbanks and other moist places. To admire the pale pink color; the three-petal, three-leaf pattern of the plant; and the shape of petal and leaf is so far to distort nothing. The plants with pink flowers are those near the end of their bloom, and people with this knowledge might appreciate them differently than trillium whose flowers are still white. I also might appreciate the flower more if I realized that I am lucky to catch sight of it in its relatively brief early spring blooming period. I don't know what role the trillium plays in the ecology of its environment, but perhaps such knowledge would also enhance my appreciation. To focus just on this one flower may hide, make invisible, some of the appreciation-enhancing properties just mentioned, but it does not lead me to ascribe to it properties it does not have. The same is true of the smooth gray stone discussed earlier. I may arrive at an impression of permanence by scrutinizing it, but that would just be a possibly faulty inference and faulty only if, by permanence, I meant, implausibly, unchangeability. The other properties I appreciate in the stone are uncontroversially possessed by it.

The real issue raised by the object model and its criticism is not whether it distorts the object of appreciation but whether there is something improper or inappropriate about the sort of selective appreciation this model promotes.

It might seem more plausible that the landscape model really does distort. The critics of this model claim that it requires us to treat nature as a static two-dimensional representation—as a landscape painting. If this is correct, it is certainly distorting since nature is none of the above. The landscape model becomes a version of the artwork model. But is the criticism correct? Is it

fair? Not really. The landscape model directs us to appreciate views or vistas. In doing so, it is also promoting a selective appreciation of a limited set of properties. First, these are strictly visual properties. Second, the object of attention is framed by a more or less fixed point of view. But the model does not claim either that what we actually see is a two-dimensional object or that we pretend it is a representation. Further, this model allows us to engage with a great variety of views of nature from grand vistas to mundane agricultural scenes, from relatively permanent natural features to the most fleeting effects of light. What we see may be influenced by a particular style of landscape painting but is not to be confused with it. One can go further. There is an extremely fruitful interaction between landscape painting and seeing natural landscapes. This is because there are many ways of seeing, many different features of the visible world one may actively seek to focus on, and the interaction just mentioned is what enables us to explore these ways.

The impressionist model also may seem vulnerable to the distortion objection. On the most austere versions of this model, one ignores the fact that one is perceiving a certain kind of object, and one is encouraged to merely take note of colors, shapes, sounds, and so on conceptualized only in terms of such sensory qualities. Pinks, golds, and grays stretch out before me. This is what I see, ignoring that what is responsible for these colors is a winter field covered with snow reflecting the sunset.

Again the temptation to call this distortion should be resisted. These colors are really on view, accurately pinned down like a carefully displayed moth. This way of pursuing the impressionist model raises a different question: does the aesthetic appreciation of nature require perceiving natural objects as those very objects—the perception of a field rather than a mere array of colors in the case at hand?

What is certainly true is that a less austere version of the impressionist model is available and quite possibly preferable. The snowfield at sunset is a more complex object of perception imbued with more aspects than a snowfield considered as a mere array of colors. The former is likely to create a richer impression. For example, when one sees the pinks and golds as snow reflecting light in the winter at sunset, these normally warm colors actually give the scene a colder feel. But some would claim more, namely, that one is not engaged in the appreciation of nature at all when following the austere version because one is not appreciating objects of nature.

So the distortion objection, while inapplicable to the three models of nature appreciation discussed in this section, gives way to two others: that these models promote an incomplete or too selective kind of appreciation and that, to appreciate nature properly, one has to appreciate natural objects as the natural objects they are (rather than mere arrays of sensuous properties). We will discuss these new objections later in this chapter in the section titled "Knowledge and Nature Appreciation."[4]

A Modest Objection

First, however, we should articulate the more modest objection to the models mentioned but not stated previously. We will see that this objection is obviously correct, at least if each individual model is presented in a certain way. Suppose each model claimed to provide the exclusively correct way to appreciate nature. Then they would be open to the objection that there are at least equally good alternatives provided by the other models. This objection to the models should be accepted since these models focus our attention on different, if overlapping, aspects of nature, and there is no good reason to exclude one at the expense of another. It is not, however, obvious that the models were ever intended to tell the whole story about nature appreciation, to identify the uniquely correct way to appreciate the natural world. The fact that they so obviously don't makes it implausible that they are so intended.

This, however, raises a question, if not an objection. The models are most plausibly interpreted as providing several ways to partially appreciate nature. Even if we set aside the issue of whether such partial appreciations are too incomplete to be legitimate, there is still the question of whether there is a model that provides a more complete picture of nature appreciation. We will now look at the most ambitious and thorough attempt to provide such a model.

The Environmental Model

The environmental model, unlike the models considered so far, claims to be a comprehensive aesthetics of nature, identifying the proper object of appreciation of the natural world and the categories or concepts we need to bring to this context to fully appreciate these objects.[5] The model makes two central claims. First, it is claimed that the object of appreciation is not confined to discrete objects, views, or impressions but is an object-in-an-environment or a collection of objects that form part of an environment. Second, the properties of these objects that are to be appreciated should be picked out by scientific or at least commonsense knowledge of the environment. If this second requirement is not met, the appreciation is malfounded or inappropriate.

Is this model superior to the others that we have considered so far? It might appear superior in comprehensiveness in claiming that environments (and what they contain) are the appropriate objects of appreciation. For environments contain the objects and views and provide the opportunity for the impressions that we have so far discussed. But they also provide opportunities for many additional forms of appreciation. So the environmental model appears to free us from any one narrow conception of

the way nature should be enjoyed. So interpreted, it provides a way of collecting together and extending in important ways the models mentioned so far.

However, just how comprehensive this view is and whether it gives us the freedom just mentioned depends on its positive account of the way environments are to be appreciated. Sometimes the proponents of this view favor certain ways of appreciating an environment, which are taken to exclude some of the ways endorsed by the models mentioned previously. Here are three approaches favored on different occasions by such proponents. The *immersion approach* tells us that nature is to be appreciated by immersing oneself in it: wondering through it with all one's senses alive to what is on offer. Not one but a constantly shifting point of view is what is needed. The idea is to take in as much of a given environment as possible with as many senses as possible on a given occasion.[6] The *ecological approach* recommends that one perceive in nature the relations of dependence, sustenance, or conflict that constitute an environment's ecosystem, finding aesthetic satisfaction in the perceived relations and the balance or harmony they create. Finally, there is what is sometimes called *order appreciation*, where one focuses on the order imposed on selected natural objects by the causes that produce and sustain them (see Carlson 1993). The smooth gray stone perceived as the product of forces of erosion would be an example of order appreciation. Perhaps the ecological approach can be subsumed within order appreciation, simplifying matters a little.

If we combine the immersion approach with order appreciation by saying that nature is to be appreciated through one *or* the other, we have a fairly wide array of possible appreciations. Notice, however, that we achieve this degree of comprehensiveness by agreeing to a disjunction, two alternative approaches, as equally legitimate. If we can have two, we can have more, supplied by the models discussed in the earlier sections. Whether we need more depends on how leniently we apply the immersion approach and the order appreciation approach. Does the former permit "minimal" immersions in the environment consisting of perusing a clump of flowers or admiring a view that can but need not be parts of more extensive immersions? Or does it require more extensive and more strenuous immersions with multiple perspectives that cover a stretch of countryside? If so, we want to make room for other alternatives. Finally, notice no matter how comprehensive we make the environmental model by being lenient about what falls within it, it may never cover all appreciations of nature. Imagine looking back at the earth from a spaceship and seeing the Americas spread out before one's eyes. This would no doubt be a beautiful sight, and if continents aren't part of nature, what are? Appreciating this sight does not fit any version of the environmental model. The same goes for looking at the myriad heavenly bodies that fill the sky on a clear night in the country far away from city lights.

The most controversial part of the environmental model is its invocation of knowledge as the arbiter of appropriate appreciation. "To aesthetically appreciate nature we must have knowledge of the different environments of nature and of the systems and elements within those environments" (Carlson 1979, 273). This passage tells us that some knowledge is required to properly appreciate nature. It also seems to tell us something about the knowledge needed. It is knowledge of *different* environments, of *systems* and *elements* within them. That looks like a fair sum of rather intimidating technical knowledge.

But if the environmental model is not to be ruled out of court from the start, the knowledge demanded needn't be large or technical. This is acknowledged by the proponents of this model who admit that common-sense knowledge of the environment is an acceptable substitute for scientific knowledge (Carlson 1995). If I know this is a woodland clump of flowers whose surface features are carefully observed and the environment (woodland), system (clump), and elements (observed features) have all been duly noted and all else being equal, this could lead to a presumably satisfactory appreciative experience about which there is nothing improper or in need of correction.

The environmental model might be seen as adding some important options (immersion, order appreciation) for appreciative experience that were not made available by the models we considered earlier rather than finding a way of unifying all of them under a single idea or as revealing the inappropriateness of those alternatives.

However, because of the ambitious claims that it makes, the environmental model also does something else that is of great interest: it raises a number of important questions. When and how does knowledge enhance the appreciation of nature? Is there some minimum of required knowledge for such appreciation to be proper or appropriate? Are there norms of nature appreciation, so that we can say that some attempts at appreciation are malfounded, improper, or inappropriate? Is the appreciation of nature that we have been talking about throughout this chapter really aesthetic appreciation?

Knowledge and Nature Appreciation

There is no question that the acquisition of knowledge can both enhance and, on some occasions, irrevocably alter our appreciative experience of nature. Some knowledge enables us to perceive nature in more complex ways. Someone who understands how tidal pools work sees a little interconnected world in such an environment, whereas someone lacking this knowledge may merely see a collection of objects. Naturalists or, for that matter, people who fish or hunt see bodies of water or woodlands as habitats for different species of animals and in doing so look at these areas in more fine-grained

ways than someone who merely looks at them for a view. One can enjoy a flower simply for its surface properties, but one can "thicken" this enjoyment by knowing that it indicates a certain stage of spring, when other items one savors also appear, or that it indicates things to come, as blossoms indicate fruit. Knowing that a pink trillium flower is a later stage in the blooming of a previously white one makes one more appreciative of its sighting, though I doubt knowing the chemical basis of this change enhances appreciation. As one becomes familiar with a species of plant or animal, one's perception of what is normal and what is unusual (including what is unusually fine and what is deformed or diseased) will irrevocably alter. Notice that some of this knowledge that has a bearing on appreciation clearly changes one's very perception of nature (knowledge of a species). Some claim that this is *the* unique requirement on knowledge that is relevant to appreciating nature (Matthews 2002). However, this is not obvious because there is some knowledge that enhances appreciation but does not so obviously enhance or alter perception (for example, knowledge that the blooming of trillium foreshadows the appearance of morels). This latter sort of knowledge enhances appreciation by enhancing one's immersion in a complex natural environment. Still other knowledge seems to have no bearing on appreciation, such as knowledge of the chemical basis of color variation in trillium, yet I doubt that we can conclusively predict that it will never have such a bearing.

That knowledge can both enhance and alter the appreciation of nature for individuals does not imply that it must do so uniformly across all individuals. It is an interesting question whether the acquisition of pieces of information has a uniform effect on the appreciative experience of similarly knowledgeable individuals. The answer to this question is uncertain, but I am inclined to give it a negative answer because people are differently disposed to be responsive to the countless aspects of nature capable of aesthetic appreciation.

Another question, one that we raised at the end of the previous section, is whether there is some minimum of knowledge that one *must* bring to the appreciation of nature for it to be proper or appropriate. When evaluating the distortion objection, we discovered an intuition that some such minimum is required. However, our subsequent discussion of the environmental model raises doubts about what this minimum knowledge could be. We found nothing inappropriate in the appreciation of the surface features of individual natural objects, such as a clump of wildflowers. So the thought that such appreciation might be too selective should be rejected. The same should be said of the appreciation of a snowfield as an array of colors. While it is true that we are not appreciating the snowfield as a snowfield, we are appreciating it as something truly contained in nature: shape and color. These are indeed features of nature that are abstracted from particular objects, but who is to say that appreciating nature for its most elemental properties is an inappropriate mode of appreciation?

Such properties as shape and color and such things as edges, fields (as in color fields, not cornfields), and patterns occur both in nature and in artifacts. In fact, a natural object and an artifact might share identical colors, shapes, or patterns. So it might be argued that when we appreciate what we just called elemental aspects of nature, we are not appreciating nature per se because they are aspects of the world that are shared by nature and artifacts alike. One can respond to this claim in a number of different ways. Certain patterns of color or shape originate in the natural world (though they can be transferred to artifacts). The pattern of crystals is an example, but so is a pattern of colored light on a snowfield. So one might say that as long as one is appreciating a natural pattern that one encounters in nature as a natural pattern, one is still appreciating nature. Or one might say that appreciation of patterns of elemental properties is aesthetic appreciation, but it is not nature appreciation because it occurs at too abstract a level. Which of these responses do you think is better?

Instead of trying to identify a minimal sort of knowledge that we must bring to nature, a good way to approach the question of whether we need some knowledge to appreciate nature is to ask whether appreciation based on false belief should be regarded as essentially flawed. If such appreciation is flawed, then *some* knowledge is required for proper appreciation. Certain sorts of false belief should be regarded as permitting genuine appreciation of nature if one is faultless in holding them or, in other words, does so with good reason. Imagine being transported to a planet that contains a substance that looks and behaves just like water but in fact has a very different chemical composition. At first, at least, one has no reason to doubt one is seeing water, and as one looks down the beach, one can be enjoying its beauty while falsely believing that one is seeing water breaking over sand. Similarly, there may have been a time when people were faultless in believing whales and dolphins were fish. Should we say they were unable to see the beauty of these creatures? We shouldn't say so, any more than we should think that people of an earlier age could not see the beauty of the human body because they radically misunderstood the nature of this body.

The art of the past shows us that people could appreciate human beauty, even though we know that their understanding of the nature and workings of the human body was deeply flawed, in fact riddled with false beliefs. If they could appreciate this sort of beauty, with equally flawed beliefs, they could appreciate beauty in nature (the rest of nature, for surely we and our bodies are part of nature). Of course, our ancestors had many true beliefs as well about both the body and nature. So none of this shows that some knowledge, or true belief, is unnecessary for proper appreciation. It shows only that some amount of false belief does not disqualify the appreciative experience.

Does the situation change when error is easily avoidable? Someone today who cannot distinguish sea mammals from fish might be thought to

bring an inadequate set of distinctions or categories to the appreciation of this part of nature. Once one has the knowledge made possible by these distinctions, it might be thought that one's perception of the phenomena is bound to change and that only this more refined perception now counts as proper. I am not sure that these claims are true, but they strike me as plausible if the standard of avoidable error or necessary knowledge is kept low. It is common knowledge in our culture that whales are not fish, and so, to the extent that this alters our perception of whales, it can be required of those who wish to properly appreciate them. However, once we get to less widely available scientific knowledge, we enter the arena where it becomes optional whether we bring such knowledge to our appreciative experience. Such knowledge can enhance our experience or change it, but it does not follow that the experience of nature not informed by this knowledge is bogus. As long as it pays careful attention to the appearance of the part of nature under observation or to its perceptible properties, appreciating them as properties of the part of nature in question, the most important bases will be covered.

Are There Norms of Nature Appreciation?

Norms tell us what we *should* do. The norms that you are probably most familiar with are norms of morality, such as those embodied in such codes as the Ten Commandments. You are also familiar with norms of prudence: norms that tell you what to do if you want to pursue your own self-interest or get the things you want. The most abstract or general of these prudential norms tells us that once you decide to do something or to achieve some goal, you ought to adopt the means necessary to achieve your end. Aesthetic appreciation or enjoyment is one of our ends, one of the things almost all of us want in our lives, and so the general norm of prudence just mentioned applies to its pursuit.

A way of putting the final conclusion of the previous section is that with regard to the knowledge we must bring to our subject, the norms of nature appreciation are weak though not nonexistent. Some knowledge of nature is needed for proper appreciation, but this is mostly observational rather than theoretical scientific knowledge, with the exception of scientific concepts that have become part of common knowledge. Additional knowledge can enhance or alter our appreciative experience, but it is usually optional whether we employ such knowledge.

The following examples might be used to challenge such a claim. First, consider the plant purple loosestrife. It is not native to the U.S. Midwest but has been introduced as a garden plant because of its tall, spiky, purple flower. Unfortunately, it has come to thrive in the wild, including in wetlands, where it has the ability to take over and dry up this valuable envi-

ronment. If you were to look at an area full of purple loosestrife in bloom without this knowledge of its effect on the environment, one would find it very beautiful. But what about after one has this knowledge? Will one cease to find the scene beautiful? Some people report that when they look at this plant after learning what purple loosestrife does to the environment, their aesthetic experience changes. Has this knowledge corrected their judgment of the scene's beauty by changing their experience?[7]

Consider next sunsets, something that seems a paradigm of harmless but considerable beauty. Apparently, however, the sunsets we would find most beautiful are caused by the refraction of light due to the higher-than-normal occurrence of certain kinds of particles in the atmosphere. A typical cause of the increase in particles is air pollution. So the sunsets we typically appreciate most are caused by air pollution. With this knowledge in hand, does our experience of sunsets change, and would this change justify altering our judgment of their beauty?

In the cases we are looking at, there are two distinct but noteworthy reactions among observers with the newly acquired knowledge of the effects of purple loosestrife and the causes of sunsets. One reaction is to cease to find these beautiful. Another reaction is to continue to find beauty in these things but to deplore them on ethical grounds. There just is not a uniform change in experience across observers sensitive to environmental issues. Given these different reactions, it is just not clear what, beyond the reactions themselves, should guide us in making a judgment of beauty about loosestrife and sunsets.

Earlier we discussed two different bases for knowledge being relevant to the aesthetic appreciation of nature. One basis was that the knowledge changes the way we perceive. Since the change varies from person to person in the case at hand, it is an unreliable basis here (unless one could argue for the superiority of one way of perceiving over the other). The other basis was immersion in nature. If knowledge enhances the degree of immersion, it is relevant to appreciation and to judgments of natural beauty. We usually think of "enhancement" as something positive, but perhaps it has a negative correlate. As we immerse ourselves in the natural world, we might experience the loosestrife flowers and the sunsets with a more negative attitude in recognition of the effects of the former and the causes of the latter.

However, is this negative attitude aesthetic? The information about these items that we have been pondering has its natural home in environmental ethics. Loosestrife is purportedly bad for the environment, and those who care about the preservation of wetlands possibly ought to be in favor of their eradication. (See note 7 to understand the reason for the qualifications "purportedly" and "possibly" in this sentence.) Air pollution is bad for the environment, and those who believe that it is important that we have cleaner air ought to be willing to sacrifice colorful sunsets. However, there

is nothing inconsistent in believing that such steps are necessary while also believing that something is really being sacrificed, namely, beautiful sights. This claim may seem paradoxical because we have a tendency to believe that it is ugly things, not beautiful ones, that harm the environment and that pollution makes the world uglier, not more beautiful. Unfortunately, this tendency may not uniformly guide us to the truth.

In this section, we have considered an objection to the claim that there is enormous leeway in the knowledge we must bring to nature in order to properly appreciate its beauty. We have tentatively rejected the objection, concluding that the considerations it brings forward are relevant more to environmental ethics and policy than to judgments of natural beauty. Those who would defend the objection would have to argue for a tighter connection between ethics and aesthetics than we have been able to establish in this context.[8]

When Is Nature Appreciation Aesthetic?

In the previous section, an issue that was under the surface for much of this chapter began to emerge more explicitly: when is the appreciation of nature aesthetic appreciation? Let us conclude this chapter by addressing this issue.

As we noted in chapter 1, the concept of aesthetic appreciation is complicated by at least two different factors. First, it is intimately related to a number of other "aesthetic" concepts: those of aesthetic experience, aesthetic property, and aesthetic value. What one takes aesthetic appreciation to be depends on one's understanding of these other concepts and on which of these concepts one most emphasizes. Second, there are multiple conceptions of the aesthetic, and, among these, there is no uniquely correct one.

One theory of aesthetic appreciation has it that its proper objects are aesthetic properties. These include such things as general-value properties such as beauty and ugliness; formal features such as balance or diversity; expressive properties such as sadness; evocative features such as power or being awe inspiring; behavioral features such as stillness, fragility, or grace; and second-order perceptual features such as being vivid or gaudy. Some of these, such as being graceful and being gaudy, are also value properties but are of a more specific variety because they contain more descriptive content than general-value properties such as beauty. Others, such as being sad, seem to be purely descriptive. Further, the theory claims that the recognition of the most general-value properties (such as beauty) is based on perceiving the other properties (formal, expressive, evocative, behavioral, and second-order perceptual) on our list. These properties, in turn, are taken in by perceiving nonaesthetic perceptual properties, such as color and shape (Goldman 1995, 17).

What is of immediate importance here is that, while we readily talk of beauty in nature, so much of our experience of nature that we regard as aesthetic appreciation does not seem to involve the less general aesthetic properties but rather judgments of beauty either based directly on first-order perceptual properties or on second-order properties of a nonaesthetic character. For example, my appreciation of trillium is bound up mainly in the delight in their color and shape closely observed. Even when an aesthetic property may appear to be the source of appreciation, this may not really be so. Imagine looking, on a windless morning, at a lake the surface of which is perfectly still and as a result reflects sky and shoreline with a mirror-like quality. Part of what we appreciate here is the lake's stillness, but it is not clear that we are referring to an aesthetic property of stillness but to a first-order perception of complete lack of movement or lack of surface disturbance that is there for anyone to see. No "taste" or sensitivity is required.[9] Next consider the "order appreciation" endorsed by the environmental model. If I see a stone as molded by forces of erosion, my appreciation consists, in part, in noting what is at best a second-order perceptual property, the stone's malleability. This is a second-order perceptual property because seeing it requires seeing something else—the stone's smoothness—in terms of information about natural forces one brings to the viewing. But malleability is not an aesthetic property.

This is not to deny that sometimes our appreciation of nature involves aesthetic properties. We enjoy the *vivid* colors of a New England hillside in autumn, the *graceful* movements of deer, and the *grotesque* appearance of bare apple trees. It is just that recognition of such aesthetic properties seems optional in the sense that other experiences of nature engage our aesthetic appreciation without the noting of the descriptively "thicker" aesthetic properties. This leaves the boundaries of such appreciation uncertain at least until an alternative conception, not limited to engagement with aesthetic properties, is proposed.

A more useful model of aesthetic appreciation of nature might be found in a conception of aesthetic experience. One conception that we will examine in chapter 3 proposes that aesthetic experience is experience resulting from attention to formal, sensuous, and meaning properties of an object valued for its own sake. "Object" is used very broadly, so it is not confined to the items emphasized by the object model of nature appreciation discussed previously. It would include whatever any of the acceptable models select as what should be appreciated: from views to environments. Some items have formal properties (in some sense of the term: individual flowers have arrangements of parts, repetitions of shapes that can be looked on as formal properties.) Some items have natural meanings in the sense of causal connections of human significance (as in blossoms indicating fruit). They also may have cultural meanings or significance as cherry blossoms and autumnal maples have in Japanese culture.[10] In addition to the three

sorts of properties mentioned so far, we can add structural or etiological properties emphasized by order appreciation. This conception of aesthetic experience accounts for the various features of the aesthetic appreciation of nature noted previously: the importance of close observation and knowledge of observable properties, the possibility of appreciation being enhanced by additional knowledge, and the optionality or variable importance of aesthetic properties.

An alternative conception of nature appreciation is modeled not so much on aesthetic experience as on art appreciation. The claim is not that we should appreciate nature as or as if it were an artwork (as the artwork model considered earlier claims) but that there is a useful analogy between the two kinds of appreciation. Many people think we have to bring certain categories to art,[11] those of intention, convention, style, period, genre, or context, to properly identify even many aesthetic features of artworks. Further, artistic value is not confined to aesthetic value. That is, the value proper to good art includes aesthetic value but also includes such things as cognitive value, art-historical value, and so on. (We will elaborate on this in chapter 10.) If the model of the appreciation of art is brought to the appreciation of nature, then we have to find analogues of these features of the former for the latter. This will require a more complex set of criteria of proper appreciation for nature. The result might be a more constrained conception of appropriate aesthetic experience for nature. However, we have found no good justification for such constraints in the body of this chapter if we focus strictly on aesthetic appreciation. Alternatively, the model of art appreciation might suggest that the appreciation of nature is a more complex practice than simply deriving aesthetic value from observing and interacting with nature. Like art, ethical, cognitive, and other considerations have to be thrown into the mix to get a proper conception of the appreciation of nature. This way of looking at the appreciation of nature might provide a rationale for some of the points of view we considered earlier: the environmental model as *the* correct model of nature appreciation or the importance of ethical consideration in such appreciation. However, what the proponent of such a view would have to argue at this point is that to properly appreciate nature, we *have to* bring this specific mix of considerations to it, and I am skeptical that this could be done successfully. A weaker claim, more in keeping with the main message of this chapter, is that this hybrid form of appreciation based on several factors is yet one more option we have in appreciatively taking in the natural world.

Summary

In this chapter, we have examined a number of models of the aesthetic appreciation of nature that pick out different objects of appreciation. We have

concluded that most of these models identify legitimate ways of appreciating nature aesthetically and that the best way to approach them is to regard them all as providing *a* way but not *the* way to bring about such appreciation. The hope to find the one correct model is doomed to fail because the objects that can be appreciated in nature are so many and various, and unlike the case of art, there are no guiding intentions or conventions to narrow our focus. The legitimate models include but are not necessarily confined to the impressionist model, the object model, the landscape model, and the environmental model. If there is one approach that is suspect, it is the artwork model, just because it requires us to either imagine patent falsehoods about natural objects or make highly speculative assumptions about them.

In the latter parts of this chapter, we confronted some additional issues concerning the role of knowledge in nature appreciation, the norms of such appreciation, and the features that make such appreciation aesthetic. We attempted not to definitively resolve these issues but rather to come to some partial, tentative conclusions. We recognized that knowledge of nature, both of the scientific and of the commonsense varieties, could enhance or change our appreciative experience for the better. However, we are not required to bring a great deal of scientific knowledge to nature to properly appreciate it, and even a good deal of false (though faultless) scientific belief is consistent with proper appreciation. Some knowledge of nature is required for such appreciation, but this is confined to that part of scientific theory that has become common knowledge and to observational knowledge. Close or careful observation of first-order perceptual features of natural things as features of those things is of special importance even if it is not completely independent of one's theoretical beliefs. This sums up the norms of appreciation with regard to the knowledge we must bring to nature. We also tentatively concluded that the aesthetic appreciation of nature seems to be more bound up with the observation of first-order perceptual properties than with the apprehension of so-called aesthetic properties, though they have a role too. Finally, we distinguished between aesthetic appreciation on the one hand and attitudes based on the conclusions of environmental ethics on the other. We tentatively concluded that items that are pernicious to an environment and hence that are condemned from the point of view of environmental ethics could still be beautiful or have beautiful effects.

We now turn to a more theoretical examination of the notions of aesthetic experience, aesthetic properties, and aesthetic value.

Further Reading

Berleant, Arnold. 1992. *Aesthetics of the Environment*. Philadelphia: Temple University Press. Defends the immersion model.

Budd, Malcom. 2002. *The Aesthetic Appreciation of Nature.* Oxford: Oxford University Press. Collects all of Budd's writing on the aesthetics of nature.

Carlson, Allen. 2000. *Aesthetics and the Environment.* New York: Routledge. A collection of essays by the most influential figure to defend the environmental model.

Hepburn, Ronald. 1996. "Landscape and the Metaphysical Imagination." *Environmental Values* 5: 191–204. Defends a pluralistic approach to the appreciation of nature.

Matthews, Patricia. 2002. "Scientific Knowledge and the Aesthetic Appreciation of Nature," *Journal of Aesthetics and Art Criticism* 60: 37–48. Attempts to identify the scientific knowledge needed to fully appreciate nature.

Notes

1. Like many plausible claims, this one is for the most part true but probably has exceptions. Consider ballads like "Sir Patrick Spens," folk songs like "John Henry," or popular songs like "Yesterday" or "I Shot the Sheriff." The same ballad or song has a number of variations or versions. Is the work the ballad or song or the individual variation? Whichever answer one gives, there is an object of appreciation that is not a work but something else related to the work but different from it or a performance of it. Literary cases are interestingly set out in Howell (2002a) Similar issues regarding rock music are discussed by Gracyk (1996). Lydia Goehr (1992) makes a more radical but less plausible claim that one does not find true musical works until the beginning of the nineteenth century. For a critique of Goehr and further discussion of this issue for music, see Stephen Davies (2001).

2. Why is this idea mistaken? There are many reasons. First, the relation between art and beauty is rather tenuous because there is plenty of nonbeautiful art, either because its aim requires that it be other than beautiful or because it is just bad art. Second, even among human artifacts, there are beautiful ones that are not art—beautiful cars, utensils, mathematical proofs. Beautiful nature lacks one essential feature of all art, that it is made or at least put forward by someone or some group, unless one has a theological conception of nature. However, even if one thinks of nature as the creation of an intelligent being and as beautiful, it doesn't follow that it is art. See the section later in this chapter titled "Is Nature an Artwork?"

3. The most forceful proponent of the distortion objection is Allen Carlson. He presents this objection to the object and landscape models in Carlson (1979).

4. Malcom Budd (1996) argues that to properly appreciate nature one has to appreciate it "as nature," and to do this one has to conceive of the object of appreciation as some natural thing (such as a snowfield). Allen Carlson's post-1979 discussions of the distortion objection emphasize the two ways of developing the objection proposed here. See Carlson (1981, 1993), both reprinted in Carlson (2000).

5. Carlson is the chief proponent of the environmental model. His numerous essays setting out and defending this model are collected in Carlson (2000).

6. The immersion model, though not foreign to views like Carlson's, is most closely associated with Arnold Berleant's (1992) "aesthetics of engagement."

7. Actually, it is not so clear that purple loosestrife does damage wetlands in the way just described. Apparently, it makes them somewhat drier, but I have heard different opinions about whether any wetland has been destroyed by this plant. It also crowds out native species, but whether that in itself constitutes a harm to the environment is debatable.

8. It seems plausible to me that policies that preserve the natural environment and reduce threats to it like the ones we have been talking about will also make the environment more beautiful in the long run. This claim, however, should not be confused with and does not resolve the issue discussed in the main body of this section, namely, whether the causes or effects of environmental deterioration can themselves be beautiful things.

9. Frank Sibley (1959) suggested that aesthetic properties are marked by the fact that taste or sensitivity is needed for their recognition.

10. Carlson (2001, 431–32) mentions the significance of the cultural meaning of natural phenomena.

11. The locus classicus of the view that we have to bring such categories to artworks in order to properly appreciate them is Walton (1970). The idea that we need to find analogous categories to understand in what proper aesthetic appreciation of nature consists is due to Carlson (1979), and it is this thought that motivates the development of the environmental model.

3

Conceptions of the Aesthetic:
Aesthetic Experience

It is autumn in Vermont. You are sitting on a hilltop across from a moun-
tain range covered in fall foliage. At first you see the endless shades of reds,
oranges, purples, browns, and yellows covering the slopes. As the sun sets, this
array gradually changes to one uniform purplish color. You sit there en-
tranced until there is nothing, not even a visible ridgeline. This is one ex-
ample of an aesthetic experience. Another, different aesthetic experience oc-
curs when you read the poem "Aura" by Hayden Carruth about just such
an encounter with autumn colors. Here are some lines from the poem:

> All day the mountain
> flared in Blue
> September Air. . . .
> Now twilight comes;
> . . . brute
> wonder drains
> from my eyes. . . .
> That light, far
> lavender, restores
> distance
> and measure. . . .

One of these experiences is of nature, the other of an artwork. One is sen-
suous, pleasurable, possibly meditative. The other vividly conceives or imag-
ines the first experience and interprets it. Both experiences may be highly
valued but not for exactly the same reasons. What then makes them both
aesthetic experiences? Is there an account of this type of experience that
explains why both should be so classified?

We will identify a number of different conceptions of aesthetic experi-
ence, and we will see that while some are open to serious criticism and so
should be abandoned, others have to be seen as alternative accounts that

carve out the realm of the aesthetic in different but acceptable ways. We begin with an extended discussion of two accounts that can be derived from the writings of Kant. The first has wielded enormous influence and has often set the terms for theorizing about the aesthetic. The second is a more historically accurate rendering of Kant's thought on this topic. This will be followed by the examination of a number of plausible conceptions of aesthetic experience that have been in play in the debate on this topic over the past fifty years.

Aesthetic Experience and Pleasure: A Kantian Conception

On some conceptions of aesthetic experience, pleasure is a defining feature of it. Aesthetic experience is a special type of pleasurable experience. Alternatively, positive aesthetic experience is pleasurable, while negative aesthetic experience, if one recognizes such a category, is positively unpleasant. (Which alternative one chooses here seems to be a semantic issue. Everyone should agree that some things are aesthetically good, others are bad, and still others are indifferent. We have experiences of the bad and the indifferent just as we have experiences of the aesthetically good. So the only issue seems to be whether we call the experiences of the bad and of the indifferent, through which we judge these items bad or indifferent, aesthetic experiences.)

What are the characteristics of (positive) aesthetic experience? Although Kant did not talk about aesthetic experience in so many words, one interesting, complex, and very influential characterization of it derives from his views about aesthetic judgments.[1]

Kant thought that four features are essential to such judgments and distinguish them from others with which they might be confused. First, such judgments are subjective; that is, they are based on a felt response of pleasure rather than the application of a rule or a concept. Second, aesthetic judgments claim "universality"; that is, implicit in them is the claim that others ought to judge or respond similarly. Third, such judgments are disinterested. This means that our response is independent of any advantage I or someone else could gain from the object of the judgment, whether that advantage is material, cognitive, or moral. The pleasure is even independent of the very existence of the object. What is important is the experience it delivers in the contemplation of it. Finally, the response (or judgment) is one that engages not only my senses but also my imagination and intellect. Kant characterized this last feature in terms of the free play of the imagination and understanding in responding to an object.

The aesthetic judgments are thus distinguished from a number of others. They are distinguished from judgments of agreeableness, which, like aesthetic judgments, are subjective but, unlike them, do not claim univer-

sality, nor are they disinterested, nor need they rise above the pleasure of the senses. Aesthetic judgments are distinguished from cognitive judgments, which, like aesthetic judgments, claim universal assent but not on the basis of a subjective response to an object.

Kantian (positive) aesthetic experience inherits these features. To bring this down to earth, consider the experience listening to a piece of music. We listen, desiring nothing beyond the experience itself. But this experience is one that is focused on an object, the music, rather than one that launches from the music to whatever thoughts or images it brings to mind. It is an experience in which not only the sense of hearing but also the imagination and intellect are engaged. As we take in the sounds, we hear them in connection to what went before and form expectations about what will come. We look for coherence in these connections but not coherence based on some further purpose they might serve, such as delivering a message of some sort, but coherence simply as a structure of sound. Dwelling on the music and finding a coherence of structure brings pleasure.

This notion of aesthetic experience has various implications that further illuminate it but also open it up to criticism.

One feature of this experience/judgment that both puzzles and attracts is the claim to *subjective* universality. It attracts because Kant is not alone in believing that aesthetic experience has *something like* the two disparate features captured in the phrase "subjective universality." On the one hand, the experience is intimately connected to an aesthetic value judgement, and as such it is not a mere expression of liking: it attributes value to something. On the other hand, it is often claimed that the judgment can be legitimately based only on direct experience of the object; the testimony of others purportedly pulls no weight in the aesthetic arena. But how can we believe that not merely those who share our sensibility but all others ought to feel a similar pleasure in just those objects we appreciate aesthetically? What could justify such a claim that the experience (judgment) of beauty carries with it a universal normative judgment? Kant says some things to suggest that the justification is that others *would* feel pleasure under the right conditions. On Kant's view, it is a condition of our having cognitive powers at all that some (potentially all?) objects can stimulate our imagination and understanding in a way that creates the pleasure of free play when one considers their "form" and seeks in it the possible coherences mentioned previously in connection with music. However, if this is what justifies an aesthetic judgment, why isn't the claim that the object has this capacity what such judgments assert? If it were, such judgments would not be subjective but would be just as objective and fact based as any conceptual judgment. On the other hand, it might be claimed that since the judgment that others *ought* to feel a similar pleasure is a normative one, it can't be reduced to the claim that others would feel such pleasure in the right circumstances or that the object has the capacity to produce it. However, if this is right, we are no further along

in justifying a claim to subjective universality. The resolution to the puzzle of subjective universality remains elusive.

There is another implication of the subjective character of aesthetic experience that is troubling. A subjective judgment is one that consists in or is based on a felt response (of pleasure, in the present instance), and it stands in contrast with a cognitive judgment that applies a concept F or a rule about Fness to an object a so that, in the simplest case, one judges that a is F. Kant often suggests that subjective and cognitive are mutually exclusive types of judgment or, rather, that a pure judgment of beauty excludes cognitive judgment.[2] However, our appreciation of beauty and more generally our aesthetic experience seem to be shot through with cognition, and at a minimum the greater part of it would be impossible without a large array of cognitive judgments. These judgments, furthermore, are not merely preliminary to but also embedded in the aesthetic judgment. For example, we judge something a beautiful bird, thereby judging it to be a bird. We appreciate a tidal basin in terms of the cycle of tides that dictates that it is sometimes above and sometimes below water, thereby cognizing it in terms of a complex of relevant concepts. We appreciate even the formal features of artworks within the frameworks of stylistic categories so that two similar arrangements of lines and color will provide very different experiences when seen as the product of different styles, thereby cognizing each work in terms of these style concepts.

The concept-guided nature of much aesthetic experience lends support to the claim that it involves the understanding and imagination but undermines the idea that this is illuminatingly characterized in terms of the free play between them. Consider an appreciative experience of Mondrian's well-known abstract painting *Broadway Boogie Woogie*. The painting contains the painter's usual grid of geometrical figures painted in primary colors, but in this instance they atypically suggest movement, pulsing with energy. "The understanding" categorizes the painting as an example of Mondrian's mature personal style, but with the help of the imagination, we perceive it as unusually lively and joyful. While it is not entirely clear where free play ends and concept-guided appreciation begins, the present case is more aptly characterized as concept guided.

These cognitive features of aesthetic judgment and experience raise additional difficulties for another aspect of the Kantian conception of this experience. If disinterest requires indifference to or a lack of concern with the real existence of its objects, it's hard to see how much aesthetic experience can be correctly characterized as disinterested. When I enjoy the sight of a beautiful bird, an important part of my appreciation of it is as a living thing of a certain kind. An imaginary bird seen in a virtual reality show or a birdlike artifact, no matter how perfectly resembling the real thing, would not deliver the same experience or, rather, possibly could only if I misjudge these to be living (hence existing) creatures.

Finally, I wonder whether all aesthetic experience engages our cognitive and imaginative powers to the degree that this Kantian conception suggests. Consider the enjoyment of a sunset. This would pretheoretically be taken as the experience of beauty in nature and, for that reason, aesthetic experience. The experience is not free of cognition because typically one experiences the array of colors in the evening sky caused by the setting sun *as* a sunset. But there is nothing intellectually demanding in this, and it does not give cognition a role in the free play that constitutes the aesthetic response itself. Something similar could be said about the imagination. It is certainly present in the experience since, for Kant, it is present in every determinate perceptual experience where it unifies a "sensuous manifold" (to use Kantian jargon). What is hard is to find a role for the imagination in a response of free play because in enjoying the illuminated evening sky, there is not sufficient challenge to either the understanding or the imagination to generate very much free play of those faculties. (Contrast this experience with the experience of music described previously.) A Kantian might say that this is really the experience of the agreeable rather than genuine aesthetic experience. However, I am at least as inclined to speak of beauty here (as opposed to mere liking) as in the case of the Mondrian, so there is a real question whether the reply is justified.

An Alternative Kantian Account

An alternative conception of aesthetic experience that avoids some of the problems just discussed can be derived from Kant himself. That is because what I have so far been calling the Kantian conception is based on Kant's account of judgment of *free* beauty or of pure judgments of taste. This is the main subject of the part of *The Critique of Judgment* called "The Analytic of the Beautiful," and it is Kant's account of these so-called pure judgments that has had, by far, the greatest influence in shaping subsequent conceptions of the aesthetic. But there is a lot more to Kant's views about aesthetic judgment and experience, and it is here that some resources can found to face up to the problems created by taking the pure judgment of taste as the model for a conception of aesthetic experience.

The resources I shall appeal to are to be found in Kant's discussion of "dependent" beauty, of art, and (less orthodoxly) of the agreeable. Several of the previously raised problems derive from the fact that much aesthetic experience involves conceptualization and cognition of the objects of the experiences in a way forbidden for the experience of free beauty. However, these strictures are lifted in the case of dependent beauty, which does "presuppose a concept" and an "answering perfection in the object" (Kant 1952, 72). Exactly what dependent beauty is and what the experience of it consists in is a highly contested part of Kant interpretation.[3] What seems

fairly clear, however, is that in enjoying the dependent beauty of a cathedral, we can appreciate it *as* a cathedral, even perhaps a cathedral of a certain period and style.

Fine art, according to Kant (1952), is "a mode of representation that is intrinsically final . . . and has the effect of advancing the culture of the mental power in the interest of social communication" (166). A work of fine art is a representation of something that makes characteristically Kantian demands on our mental powers and that aims at a kind of communication. For this reason, one cannot properly appreciate an artwork without bringing to it "a concept of what the thing is intended to be" (173). Art, in "presupposing a concept," is a species of dependent beauty, and hence the aesthetic experience derived from the appreciation of works of art is not to be understood in terms of the strictures on conceptualization and cognition placed on free beauty.

Finally, on Kant's official account, there is not only more than one kind of judgment of taste (judgments of free and of dependent beauty as well as judgments of sublimity that have been ignored here). There are also different kinds of aesthetic judgments. This is so because Kant includes judgments of the agreeable as well as judgments of taste under the broad heading of aesthetic judgments ("First Introduction," 1902, 20:224; Kant also speaks of agreeable art as well as fine art [1952, 165]). For Kant (1952), the agreeable is that which "the senses find pleasing in sensation" (44). An example that Kant offers is pleasure found in the green color of a meadow. The usual modern understanding of this classification is that Kant's notion of *taste* corresponds to (indeed helped create) our current concept of the aesthetic, whereas Kant's notion of the *aesthetic* contains two disparate elements, one of which—the notion of the agreeable—should be ignored in a true account of aesthetic experience and judgment. (I followed this understanding in the previous section.) However, I would like to suggest now that we reevaluate this understanding. We noticed at the end of the previous section, in thinking about sunsets, that their appreciation seems like a typical example of the aesthetic experience of nature, but they don't fit the mold of a Kantian judgment of taste. To this we may add the enjoyment of a newly green meadow in spring. Both cases in fact correspond more closely to Kantian judgments of the agreeable. To some, this might suggest that we don't aesthetically appreciate sunsets and the color of meadows, but this conclusion is perverse. It's better to say that at least some experiences of the agreeable are truly aesthetic experiences.

We have broadened the original Kantian conception of aesthetic experience at both ends, as it were. On the one hand, we have included experiences involving far more cognition of the object of the experience than judgments of free beauty permit. On the other, we have included experiences that bring pleasure primarily because they please one or more of the

senses but place few demands on other mental powers. Do we now have an adequate conception of the experience?

Yes and no. This new conception comes considerably closer to extensional adequacy. That is, it succeeds better in covering what most people would regard as positive aesthetic experiences. Unfortunately, what the conception does not do is provide a clear and coherent account of the experience. This is so for two reasons. First, what we now have is more a patchwork conception of aesthetic experience than a unified one. What exactly does the enjoyment of the sunset have in common with the enjoyment of the cathedral on the present conception? What makes them both aesthetic experiences? It's not clear that the broadened Kantian conception provides an illuminating answer. Second, the broadened account does not dispense with (but also does not clarify) the more obscure parts of the original Kantian conception. The claim that aesthetic experience is disinterested, that it involves the free play of the understanding and imagination, and that it is characterized by subjective universality is just as obscure but now even more questionable than before.

Selfless Absorption

Kant arrived at his conception of the aesthetic at the end of a century of very hard thinking about this concept, and his views at least have the virtue of capturing many of the complex strands of thought that emerged throughout this period.

Many subsequent conceptions simplified matters by focusing on and, one might think, exaggerating the significance of one or a few of these strands. For example, Kant distinguishes aesthetic judgments from both ordinary cognitive judgments and practical judgments made in pursuit of the good. However, Kant also suggests that the experience of beauty is not cut off from the rest of life because connections exist between cognition and cognitive free play and between beauty and morality. In Schopenhauer, aesthetic experience is a state of mind completely severed from the rest of life, and that is its chief source of value. One is temporarily freed from willing and striving—the source of endless human misery according to him—as one contemplates the essential forms of reality.

The influential art critic and theorist Clive Bell echoes this idea. Bell (1914) famously claims that "to appreciate a work of art we need bring with us nothing from life, no knowledge of its ideas . . ., no familiarity with its emotions. Art transports us from a world of man's activity to a world of aesthetic exaltation. . . . We are lifted above the stream of life" (27). For Bell, aesthetic experience, or emotion as he prefers to call it, occurs when we discover and contemplate "significant form," that is, formal features of artworks that are somehow uniquely capable of inducing the special experi-

Goldman's version of the view could attempt to meet this objection by appealing to a special object of attention (absorption): a virtual world distinct from the real one. He tries to make a case that various art forms—literature, painting, and music—present such a world. He could claim that this is what distinguishes aesthetic absorption from nonaesthetic attention. However, though we can be just as absorbed in music as in the world of a novel, it is a stretch to claim that it presents to us an imaginary world as a fictional representation does. When we turn to architectural or ceramic works, it becomes more than a stretch.

Hence, at best, selfless absorption gives us a conception of a type of aesthetic experience, even when we confine our attention just to art. It seems unable to account for the experience of beauty or, more generally, pleasing sights and sounds outside art. Perhaps this omission could be partially remedied "in-house," as it were, by claiming the existence of selfless absorption in nature, something that plausibly occurs. But a new explanation would be needed to distinguish this from close attention of a nonaesthetic character. Just as important is that not all experience of either nature or art attains the level of nearly mystical absorption and loss of practically oriented self-consciousness. This is so for two quite different reasons. One reason is simply that some experience of art and nature is of a lesser intensity and totality. The other, more interesting reason is that some experiences of art and nature are not disinterested, and yet they have a good intuitive claim to be aesthetic experience. Consider a morel-hunting expedition. Morels are highly distinctive and especially delicious mushrooms that pop up briefly at the height of spring. They are found in woodlands where one can also see spring wildflowers and new foliage. The experience of searching for and finding these mushrooms is one in which one is immersed in a world of new growth, where one enjoys the sights, sounds, smells, and anticipated tastes of what one encounters. The beauty one enjoys is not sharply partitioned from the fact that one is foraging for one's dinner, indeed, seems to be enhanced by this interested pursuit. Hence, the practically oriented self can be very much on hand on this occasion, and this is because the object of the experience is valued *both* for itself and for other things to which it is a means. This harmony between pure delight and practical pursuits creates an appreciation of beauty in nature that can be valued as intensely as selfless absorption, but the two experiences are not to be conflated.

A final reason to reject selfless absorption as *the* correct account of the aesthetic experience is simply the existence of others that emphasize other strands of thought about the aesthetic. It is to these that I now turn.

Object-Directed Sensuous Pleasure

There is a common experience of noticing the look or sound of an object and finding it appealing or unappealing. This might happen in the contexts

ence just mentioned. (The tightly circular interdefinition of aesthetic experience and significant form comes straight from Bell.)

In a not-so-different vein, Alan Goldman (1995) has proposed that "when we are so fully, and satisfyingly involved in appreciating an artwork, we can be said to lose our ordinary, practically oriented selves in the work" (151). Goldman speaks of appreciating an artwork in this passage, but it is important to bear in mind that he is concerned with the aesthetic value of art understood as a paradigm of aesthetic value per se. Goldman has a much wider conception of engagement than either Schopenhauer or Bell. Such engagement does not exclude attention to a work's representational properties, historical context, and referential or symbolic content along with sensuous, formal, and expressive properties. Indeed, what Goldman emphasizes is that we will lose ourselves most thoroughly in a work's virtual world when we perceive in it all these elements and their interaction. Imagine watching a play and being so involved in the evolving fate of the characters, the words they utter, and what all this might symbolize that everything else is forgotten. The very same thing might happen when listening to music and one becomes wholly focused on the evolving structure of sound, its dynamic and dramatic qualities, and so on.

The common elements in these three approaches to aesthetic experience are 1) the loss of self, will, or practical concerns and the separation from the everyday world for absorption in a complex of elements provided by a work of art. 2) As such, this conception of aesthetic experience is completely art oriented. Its emphasis on what we leave behind or lose could be said to carry on the idea that 3) aesthetic experience is disinterested (though not quite in Kant's sense).

Particular versions of this view face serious criticism. One can question whether the essential forms that Schopenhauer appeals to exist or, if they do, could be offered up by artworks. Bell has often been criticized for failing to provide a nonvacuous conception of significant form and for confining aesthetic experience to the apprehension of form. However, Goldman's version of the view demonstrates that these problems are avoidable and that the view can be put forward without appeal to metaphysically dubious entities or an overly narrow view of the object of the aesthetic experience of art. Nor is this view committed to obscure notions such as Kantian free play of the understanding and imagination.

However, it faces a more general problem that equally applies to the other versions of this view as well. The problem is that selfless absorption is simply attention to an object to the exclusion of everything else from one's consciousness. This can occur in many nonaesthetic endeavors, from meditation to furniture making and from fishing to philosophical exploration to geographical exploration. All that is needed is total attention to what is immediately at hand (for an elaboration of this point, see Dickie 1974).

in which one is engaged in a practical pursuit (shopping for a new toaster) or one in which one is taking in sights and sounds for their own sake. When we fasten on the look of the toaster rather than the fact that it has four slots to enable more simultaneous toasting, it is common parlance to say that we are focusing on the artifact's "aesthetics." When we look at a row of trees making a border for a field and attend to the phenomenal appearance presented by field and trees—the impression created at that moment by those objects in that light, time of day, and season—we don't say we are focusing on the aesthetics of the trees and so on, but nevertheless it is unlikely that we would be contradicted if we count this an aesthetic experience.

For some (Lind 1992; Urmson 1957), this enjoyment of looks, appearances, impressions, or views is a paradigm of aesthetic experience. This view is not entirely disjoint from the Kantian tradition. For Kant, too, the material for aesthetic experience is delivered by the senses. Further, this view does not ignore the fact that aesthetic experience can be cognitively demanding (see the following discussion), but nevertheless it emphasizes something that seems completely absent from Kant: the sensuous pleasure of the experience. Because of the emphasis on the sensuous, the line between the agreeable and the aesthetic is far less clear, if it can maintained at all. This suggests that the view has different or additional roots. Whatever the historical sources, the idea that in aesthetic experience not just our cognitive faculties but also our senses are stimulated and brought to life is an important one that is emphasized better by this view than by the others we have so far examined.

In contrast to the art-oriented character of selfless absorption, this conception of the aesthetic easily fits appreciative experiences of nature, of ordinary, everyday artifacts, and of the human body and other animals. The conception can also be extended to other senses, such as the sense of taste and of smell. It is on this view that a meal, centering on the enjoyment of food, of wine, even of an after-dinner cigar, can be an aesthetic experience.

On the present conception, is there any distinction between agreeable, sensual pleasure and aesthetic experience as Kant insisted? There is, but it lies in a different place here than in a Kantian conception. The line here is drawn by distinguishing between mere pleasant sensation and pleasure derived from discrimination of the sensuous or perceptible properties of the object of the experience. Thus, if the pleasure of a meal consists simply in sensation of one's hunger being dissipated or the sheer pleasure of undiscriminated tastes in one's mouth, this is not aesthetic pleasure. But if the experience is focused on the object of the experience—the food and its various qualities of texture and tastes in relation to one another—then we have aesthetic experience, which is also a source of sensuous, indeed, for the nonce, sensual pleasure. This is why the conception is called "object-directed sensuous pleasure."

It is generally thought by the proponents of this view that it easily extends to the appreciation of the visual arts and music, though it obviously faces problems identifying what aesthetic experience could be in the case of narrative, especially literary, arts. However, even the extension to the most straightforward cases in the visual arts, such as painting, reveals an implicit complexity but also important limitations of the present proposal. To bring out the complexity and the limitations, it is helpful to first distinguish among several kinds of appearances.

The sort of interest taken in the field and trees as described previously might be called an interest in its appearance-of-the-moment or phenomenal appearance. This is an appearance that is impermanent because it is the consequence of the joint operation of the properties of the object, the condition of the perceiver, and the properties of the medium (such as the condition of the light) through which the object is viewed, which can easily change within a short time period. There is a cognitive challenge in noticing phenomenal appearance, which requires two complementary abilities: to finely discriminate among properties in one's perceptual field and to overcome the habit of seeing according to broad classificatory categories (for example, to suppose that a mountainside covered by trees looks green because trees are green).

On might take a similar interest in a toaster perused as a prospective purchase, but one is more likely to be interested in its true appearance. That is, one is typically concerned with what its visible properties *really* are because that is what one needs to know to decide whether it will fit in one's kitchen (an aesthetic question) and whether it might maintain its (no doubt limited) charm over years of use. So one might ask whether it is pure white or cream colored and whether it really has the gentle curves one perceives it as having at the moment.

There is a third sort of appearance one might find in the trees if they look lonely or sad, in the toaster if it looks purely functional, or in a car if it looks fast. This sort of appearance suggests an overall character an object presents—sometimes described metaphorically, sometimes not. Call this characteristic appearance to distinguish it from phenomenal and true appearance.

If we turn now to paintings, we should ask two questions in connection with this conception of aesthetic experience: 1) what sort of appearances interest us in the case of paintings, and 2) is the aesthetic experience of painting well captured by the enjoyment of such appearances? To the first question, the answer is that we typically have little interest in the phenomenal appearances of paintings themselves (though we may be interested in the phenomenal appearances some paintings represent—a very different matter). Our interest is more commonly in the true appearance of the painting—the colors, shapes, and so on that mark its surface—and in characteristic appearances it presents. Since there are an enormous variety of paintings, it is hard to answer the second question with complete generality.

There may be some abstract, nonrepresentational paintings in which the satisfaction of these interests provides the chief aesthetic experience to be gained from the works. However, far more typical of aesthetic enjoyment of painting is the experience of noticing the interaction of the low-level perceptual features with representational features and matters of large-scale formal design. Furthermore, it is often only after we have experienced this interaction that those low-level features take on a characteristic appearance. It is often only after we see a complex shape as an arm that ends in a fist striking a blow that it takes on its characteristic dynamic quality. Our interest in a painting's represented world is hardly limited to the way it arises from lower-level features, and this takes the aesthetic experience of painting well beyond the enjoyable noticing of appearances.

There are two assessments of aesthetic experience as object-directed sensuous pleasure that seem to me reasonable. One, alluded to earlier, is that it confuses agreeable perceptual experience with aesthetic experience and for this reason should be rejected. It is a sensual siren song that should be resisted (to put the matter more colorfully). Those who wish to adhere to the first Kantian conception of the aesthetic would accept this assessment. Alternatively, it could be said that, like selfless absorption, it offers a coherent conception that captures some of the things we label "aesthetic experiences." It not only captures this partial extension but also captures a reason we think of these items in terms of the aesthetic, that is, a conception of aesthetic experience actually in use. For this reason, it should be not rejected but rather accepted after the fashion we accepted selfless absorption: as *a* but not *the* concept of aesthetic experience. Though both assessments are reasonable, this second assessment is the more reasonable.

The Two-Level Conception and the Minimal View

We have now looked at four conceptions of aesthetic experience. Three (the first Kantian conception, selfless absorption, and object-directed sensuous pleasure) have been fairly widely accepted among different groups of thinkers, but none of these seems to cover the whole extension of the aesthetic. The fourth (the second Kantian conception) comes closer to covering the extension but has not enjoyed the same acceptance, and deservedly so since it does not offer a coherent account of a unified conception of the aesthetic. We have also noticed that some conceptions work better with regard to art (selfless absorption), while others work better for nonart objects, such as nature and everyday artifacts (object-directed sensuous pleasure). There are still other conceptions that have achieved some importance but suffer from similar limitations.[4]

Instead of itemizing these, let us ask, Is there a conception that both succeeds better in covering the range of aesthetic experiences and explains

what unifies them under this concept? There are several recent proposals
that do indeed come closer to accomplishing this feat. However, being sev-
eral, there is the problem of choosing between them.

Here is one recent proposal.

"To appreciate something aesthetically is to attend to its forms, qualities,
and meanings for their own sakes, and to their interrelations, but also to at-
tend to the way all such things emerge from [a] particular set of low level
perceptual features" (Levinson 1996, 6). Forms (emphasized by Bell's ver-
sion of selfless absorption), qualities (emphasized by object-directed sensu-
ous pleasure), and meanings (emphasized in our recent discussion of the
aesthetic experience of painting and in Schopenhauer's and Goldman's ver-
sion of selfless absorption) are all objects of aesthetic experience on this
view. To appreciate these things for their own sake as they emerge in the
experience of an object is to have aesthetic experience. Further, by ab-
stracting from various features important in the accounts previously con-
sidered, this proposal succeeds in casting a wider net without succumbing
to the apparent disunity of the second Kantian conception. Levinson's pro-
posal appears to be especially designed to cover those cases of the aesthetic
experience of art, such as those of painting just mentioned, that the object-
directed sensuous pleasure view is too thin to account for. Nevertheless, it
is also capable of covering simpler cases of enjoyment of nature, of ordinary
artifacts, of food, and so on. It is also free of those features that limited the
scope of selfless absorption. It does not require loss of self or of practical,
worldly concerns and complete absorption in the aesthetic object yet can
include such experiences within its scope.

This—call it the two-level conception—is an extremely attractive char-
acterization of aesthetic experience, broadly characterized. It is a complex
account requiring attention to or apprehension of several distinct elements,
their interrelations to each other, and lower-level perceptual features, or a
"structural base," as Levinson also puts it. However, it is this very complex-
ity that raises some doubt about the conception. To confine the discussion
to just one of these doubts, does one always have to apprehend how the
quality of one's experience arises from a structural base? What does such a
base consist in when one aesthetically experiences a sunset? There just do
not seem to be lower-level perceptual features from which the experience
arises in this case, distinct from those directly enjoyed—qualities of color and
luminescence. Levinson (1996) suggests that the structural base is "shades
and brightness of yellow . . . appropriate to the heavenly body to which life
depends" (8). But the shades and brightness of colors make up the original
object of the experience, while the "appropriateness" condition invoked
here appears to be a matter of conceptualizing the object of perception as a
sunset rather than being itself a lower-level perception. Thus, either the con-
ception contains an equivocation or it is open to counterexample.

It looks like there may be a more minimal aesthetic experience than the
two-level conception recognizes—the experience derived from attending

in a discriminating manner to forms, qualities, or meaningful features of things, attending to these for their own sake or the sake of a payoff intrinsic to this very experience. Call this the minimal conception. Anything that includes this minimal characterization, such as Levinson's more complex experience, and the more specialized experiences characterized by selfless absorption and object-directed sensuous pleasure also makes up aesthetic experiences.

Is the minimal conception, once recognized, the right conception of aesthetic experience? One is not forced to this view. Some would feel it is too minimal. Others might believe it is not inclusive enough. Consider the experience one has when shopping for a new toaster of coming across the model ideal for one's kitchen. No doubt some purely utilitarian features that one notices have nothing to do with the aesthetic, such as the number and dimensions of its toasting slots. But other features in the mix are aesthetic ones or commonly regarded as such in this context—color, design, and the relational property of coordination with one's kitchen's decor. One might even say that the toaster's design is a pleasing one, without thereby committing oneself to the claim that the experience of the toaster at this moment is intrinsically pleasurable or is in any other way enjoyed for its own sake. Since we are not attending to the qualities of the toaster for their own sake or for the sake of a payoff intrinsic to the experience (such as pleasure), this is not an aesthetic experience according to the minimal view. Yet this is an experience where one engages with the aesthetic properties of the artifact in question. So why not consider it an aesthetic experience?

Some may dismiss these reflections because of the humble and utilitarian object on which they centered—a toaster. However, they raise two important questions. We have been assuming that aesthetic experience requires a special kind of engagement with an object in which the object, some of its properties, or the experience of these is valued for its own sake.[5] This is what is implied when we say we attend to these things for their own sake or the sake of a payoff intrinsic to the experience (such as pleasure). The first question is whether this assumption is correct. Could something be an aesthetic experience without its being valued for its own sake? Second, this reflection suggests a new conception of aesthetic experience consistent with a positive answer to the previous question. Something is an aesthetic experience if it attends to aesthetic properties of an object even if this is not done for its own sake. Is this an adequate conception of such experience? Investigating these two questions will conclude this chapter and launch us into the next.

What Kind of Valuing Makes an Experience Aesthetic?

In this section, we focus on the first question raised previously: could something be an aesthetic experience without its being valued (or valuable) for

its own sake? In particular, we will look at some recent arguments for a positive answer to this question.

Before turning to these arguments, though, we should make sure we understand the distinction underlying the arguments. Being valued for its own sake (or for itself) can be defined negatively. If we value something for its own sake, we continue to value it even when we believe it brings to us nothing *further* that we value. On the other hand, if we value something *simply* for the sake of something further that it brings us, then we cease to value it on the occasion in question once we believe that it does not bring us this or any other further value. Similar distinctions apply to what is *valuable* for its own sake and what is valuable simply for the sake of something else. The most straightforward way in which something is valued (valuable) for the sake of something else derives from its being a means to this further thing. Medicine, especially unpleasant medicine, is a good example of something we value in this way. No one takes unpleasant medicine unless they believe it is a means to something else they desire, such as a cure, and if they come to believe it is not such a means, they cease to have any use for it. However, there is another way to be valued (valuable) for the sake of something else. This is to be valued (valuable) simply as a constituent of something of value rather than a means to it. An example of this might be the *taste* of certain ingredients involved in creating the overall taste of a dish or drink. For example, there are certain artificial sweeteners that have an unpleasant, bitter taste on their own but that when added to coffee or tea add a sweet taste to the drink. The sweetener is valuable as a means to a sweet-tasting drink, but the *taste* of the sweetener is a constituent of the taste that some people value. I will say that an item has instrumental value when it is valuable either as a means or as a mere constituent.

Two other points are worth adding to avoid confusion. First, there is no reason why some things cannot be valued (valuable) both for themselves and for further things they bring about; they are valued in both ways. Health might be a good example of something that fits this description. Second, being valued for its own sake is not the same as being valued disinterestedly. Being valued in the latter way probably implies being valued in the former but not vice versa. On a Kantian conception of disinterestedness, what we value in this fashion is at the same time not valued for its beneficial consequences and so is not valued for something further it brings us. However, as we have just seen, this is not implied by valuing something for its own sake.

There are many things we do (or at least seem to) value for themselves: pleasure, knowledge, freedom, happiness, intimacy, certain achievements, and various experiences and activities. Is aesthetic experience necessarily among these? Traditionally, it is considered to be, but now we are ready to turn to arguments to the contrary.[6]

One argument against the traditional view is this: if aesthetic experience is valuable for itself, it must be something of positive value, something that is good. But there is both positive and negative aesthetic experience: positively valued experiences of aesthetically good things, negatively valued experiences of aesthetically bad things. Hence, aesthetic experience needn't be valued for itself.

This argument can be quickly refuted by adverting to a point already broached at the beginning of this chapter. Is aesthetic experience always something positively valued? The answer is that this is a semantic matter, but we can certainly recognize negatively valued aesthetic experiences, consistent with the idea that such experiences are valued for themselves. All that is needed is that the negative evaluation is of the experience itself rather than further things it brings to us.

A more subtle issue is whether there are some aesthetic experiences that are like the constituent items discussed previously: items of no value in themselves but valuable only as constituents of something larger. Would noticing the meter of a poem or the "repetition of rectilinear forms in a cubist painting" (Carroll 2002a, 149) count as aesthetic experiences of this type? As far as I can see, these items are simply perception-based cognitions of works of art, which traditionally would not be considered aesthetic experiences per se. There is no conception of aesthetic experience that is committed to the idea that every perceptual experience of an artwork that may ultimately contribute to our valuing that work aesthetically is itself an aesthetic experience.

A quite different argument, with a seemingly stronger conclusion, is that there is something scientifically anomalous about the idea that aesthetic experiences are valuable for themselves rather than their consequences. The attitude behind this argument is expressed by the thought, "how can the objective intrinsic value of aesthetic experience be made comprehensible in a world where evolution reigns?" (Carroll 2002a, 157).

But what exactly is the argument behind the attitude? One premise is that humans from all cultures going back in time indefinitely have made surprisingly large efforts to secure aesthetic experience. The second premise is that such efforts that persist in a species are usually accompanied by evolutionary advantages—advantages the efforts are a means to. The conclusion is that aesthetic experience is valuable for its consequences. The premises of the argument could be questioned. However, even if they are accepted, this argument just doesn't do its job. All that it implies is that aesthetic experience is valuable for the sake of further things it brings to us (or, more accurately, to the survival of the species). That is perfectly compatible with the idea that aesthetic experience is, by definition, valued (valuable) for its own sake. Indeed, as a general rule, activities and experiences that have value from the evolutionary point of view are valued by individuals and are valuable to those individuals not for that reason but for some other. Consider

the value we find in sexual intercourse. From the evolutionary point of view, it is valuable for the usual reason: it is necessary for the survival of the species. But few, if any, people value it for this reason, nor is this the only reason it is valuable in the human world. Those who value sexual intercourse as procreation value it as a means, perhaps, but not as the means to our species' survival. Rather, they value it because a human being is (or rather may be) brought into this world, whether or not this is good for the species as a whole. On the other hand, in valuing sexual intercourse for being an intensely pleasurable activity or as a form of intimacy, we value it for its own sake. There is nothing unscientific or mysterious in this. It simply reflects the fact that, from different viewpoints, things can be of value in different ways.

Similarly, being aesthetically engaged with an object—an artwork, a natural environment, or whatever—is being in a state of mind valued (valuable) for itself. Typically, it is a pleasurable state of mind, and this provides a transparent explanation of why it is valuable for itself. However, in the case of some artworks, the state of mind is not aptly characterized as pleasurable. Some artworks shock, unsettle, disturb, or disgust us, but if we are inclined to say that they still offer a positive aesthetic experience, this is because we value this experience of engaging with them. On the other hand, suppose that after attending an exhibit of a bisected cow, we say this: "It was just like visiting the dentist; I hated being there, but I'm better off for it. I can deal better with things that disgust me." Here we find positive instrumental (even perhaps survival) value in the experience, but we would not count it as aesthetically positive, if we count it an aesthetic experience at all.

Let's summarize the state of the argument so far. We have looked at and rejected a number of arguments that claim that aesthetic experiences need not be valued for their own sake but merely instrumentally for goods they are a means to. First, the fact that there might be negative aesthetic experiences does not imply that the disvalue is not attached to the experience itself rather than a consequence of it. Second, the fact that we have perception-based knowledge of some features of artworks—such as the meter of poem—does not imply that these are aesthetic experiences; rather, they are ones we do not value for themselves because it is not implied that these are aesthetic experiences at all. Third, the fact that we have a strong, innate desire for aesthetic experience may or may not imply that the occurrence of such experiences delivers an evolutionary advantage. However, even if there is such an advantage, it doesn't follow that these experiences are not valued for themselves by individual human beings. In fact, it provides some indirect evidence that they are so valued because nature seems to arrange that we take pleasure in evolutionarily valuable activities and we value pleasurable experiences for their own sake. Finally, we have pointed out that it is easy to think of cases where an experience of an artwork is found to have negative value in itself but positive instrumental value. Here we are inclined

to say the aesthetic experience is negative or nonexistent (depending on our semantics), but the encounter did us some good. We wouldn't say this if aesthetic experience could have merely instrumental value.

There is one final argument that we should consider. The argument is set up by positing two experiences. The content of these experiences is purportedly the same. However, in one case the experience is valued for its own sake, in the other it is not. The argument claims that this difference is insufficient to show that one experience is aesthetic and the other is not. Hence, aesthetic experience need not be valued for its own sake.

In order to evaluate this argument, consider Jerome and Charles, who are both engaged in the experience of viewing a painting by Picasso. Jerome values the experience for its own sake (which does not preclude him also valuing it for additional benefits that come in its wake). What this specifically does require is that if the benefits could be delivered in some other way, then Jerome would feel he was still missing out on something he values in missing the experience of the Picasso painting. Charles believes he values the experience of the Picasso simply for various benefits he receives. He revels in the thought of his enhanced powers of discrimination, pattern recognition, and so on. But both are taking in the same properties of the painting and thereby noticing the same formal structures and expressive properties. So aren't they both having the same experience of the painting? If Jerome's is aesthetic experience, it is claimed, so is Charles's.

To test out this conclusion, let's extend the thought experiment. Suppose Jerome and Charles receive an enticing offer. A psychologist claims he can provide the very same benefits to a significantly greater degree through subliminal processes. Both take up the offer. They go to the psychologist's lab and experience nothing scintillating but over a couple of weeks notice the exponential growth of their powers of pattern recognition and perceptual discrimination. Jerome, if he has not deceived himself, will not consider this a complete substitute for his experience with paintings such as the Picasso. He will miss the experience of them, though this does necessarily not mean he will return to museums. The instrumental value of his time in the lab *might* outweigh for him the combined intrinsic and instrumental value of his experience of the paintings. But he still clearly valued the experience of the Picasso for its own sake. On that basis, we can say that he aesthetically appreciated the painting and that his experience of the painting was aesthetic.

What about Charles? He too might miss the experience of viewing paintings, and this might reveal to him that there was something he valued in that experience that was not purely instrumental. Then it would be right to claim that that Charles aesthetically experienced the paintings but not that he values them only instrumentally (though right in saying he believed he did). But suppose Charles says, "There is no point in looking at paintings any more. I get the same sort of benefits I sought from them in the lab and to a much greater degree."

If the latter reaction is Charles's, then only Jerome was aesthetically ap-
preciating the Picasso on the occasion mentioned previously. If only Jerome
was aesthetically appreciating the Picasso, only he was experiencing the
painting aesthetically. But how could this be if both were having the same
experience as was claimed previously? In the present context, "the same"
means qualitatively similar. Both may be perceptually processing the same
properties of the Picasso painting. But this doesn't mean that their experi-
ences are the same in every respect. In particular, *they are reacting to this per-
ceptual processing differently*. Jerome is enjoying the experience itself. Charles,
evidently, is not enjoying the experience itself since he loses nothing when
he receives similar benefits subliminally. So there is clearly a difference be-
tween Jerome's and Charles's experiences. It is the difference between the
mere perceptual cognition of an artwork and the aesthetic experience of it.
In virtually all traditional attempts to identify aesthetic experience, percep-
tual cognition has never been regarded as sufficient for such experience.
Some such reaction—of pleasure, enjoyment, or other form of satisfaction—
is also required.[7]

Aesthetic Experience as Attention to Aesthetic Properties

The second question raised previously asks whether aesthetic experience
might simply consist in attention to the aesthetic properties of objects.[8] On
the view discussed and rejected previously, this could consist in the mere
perceptual cognition of such properties independently of the interest we
take, the appreciation we feel, or the value we find in them. The experience
of the previously mentioned toaster is as much an aesthetic experience as
Jerome's experience of the Picasso.

In the previous section, we argued that we are not forced to accept this
conception of aesthetic experience because there is nothing problematic in
the more traditional idea that nothing is an aesthetic experience that is not
valued for its own sake. More than this, there seemed something counter-
intuitive in the thought that Charles's experience of the Picasso qualifies as
aesthetic experience in the same sense that Jerome's does.

And yet we also hold that there is no uniquely correct notion of aesthetic
experience. So perhaps we should allow this one too into the family of pos-
sible conceptions of this experience. We can call this the purely content-
oriented conception. Its advantage lies in its inclusiveness and in its seemingly
straightforward mapping of aesthetic experience onto attention to aesthetic
properties. It avoids whatever oddness might be found (if any) in denying
that noticing the toaster's aesthetic features prior to purchasing it is aesthet-
ically experiencing it. Its disadvantage lies in extending the range of such ex-
perience beyond anything traditional conceptions envisioned. However, if
we can include among the coherent conceptions of the aesthetic ones that

exclude items that are often counted as aesthetic experiences—as do selfless absorption and object-directed sensuous pleasure—then we can also include a conception that extends the experience somewhat beyond its usual range for the sake of simplicity and tidiness.

However, there is a complication. Many, if not all, aesthetic properties are among those known as response-dependent properties. This means that their existence depends not just on the state of the object to which they belong but also on the way human beings respond to the object. Color properties are sometimes considered examples of response-dependent properties. An object is the color blue, on this view, if normal human beings in daylight respond to the object in a certain way—with visual sensations of blueness.

In the case of color properties, the relevant response is a sensation had in the appropriate circumstances. If aesthetic properties are response dependent, what is the appropriate response characteristic of them? While this question will be explored in more detail in the next chapter, for now let us consider the question in a preliminary way via the following example. Suppose Charles is studying for an exam in his Shakespeare class. He will have to analyze one of the sonnets and explain how it "works." He will have to identify properties of the poem. Let us suppose that the only thing of value Charles derives from this encounter with the poem is that it prepares him to get a good grade on the exam. Knowledge that he is prepared may please him, but he gets no other pleasure or satisfaction from the encounter with the poem. Charles could certainly notice that certain passages are metaphorical representations of a subject matter or that the poem contains series of interrelated images, that it is in sonnet form, even that the meaning of the final couplet "reverses" the message of the main body of the poem. This might suffice for the exam. But no aesthetic property has yet been noticed. If he goes on to recognize that the metaphors are witty or the images poignant, he is now noticing aesthetic properties. Could wit be noticed without feeling at least a bit amused? Could the poignancy be noticed without feeling a trace of sadness? If one has these reactions, won't they involve experiences one values for themselves?[9]

Something similar may be said about other aesthetic properties. Consider a property such as gracefulness. Some claim that one does not perceive an object as graceful unless one responds *favorably* to it. If this is right, a valuation is built into the very perception of some aesthetic properties. And if that is right, there is no such thing as a neutral perceptual cognition of properties such as being graceful, witty, poignant, vivid, gaudy, or dull. The content-oriented view would then appear to collapse back into the minimal view, or, to put it another way, the minimal view could be expressed as the content-oriented view without loss.

However, this result depends on the correctness of the idea the aesthetic properties are response dependent in a way that includes a favorable or

unfavorable reaction to an object. This needs investigation, as does the very idea of an aesthetic property. It is to the investigation of this idea that we turn in the next chapter.

Summary

In this chapter we have examined a variety of conceptions of aesthetic experience: the two Kantian conceptions, selfless absorption, object-directed sensuous pleasure, the two-level conception, the minimal view, and finally the content-oriented conception. We have argued that no conception is uniquely correct. Several conceptions are coherent and lucid, and they capture what is sometimes meant, or might be meant, when people speak of this experience. We have argued, however, that only two of these views can reasonably claim to more or less cover the whole range of experiences we are inclined to classify as aesthetic: the minimal view and the content-oriented view. In comparing these two conceptions, we have argued that the minimal view is superior because it, unlike the content-oriented approach, captures the idea that aesthetic experiences are valued for their own sake. Since all the conceptions of the experience with the exception of the latter contain this idea, leaving it out is highly revisionary. The superiority of the minimal view lies in providing a nonrevisionary but equally adequate alternative.

Further Reading

Allison, Henry. 2001. *Kant's Theory of Taste*. Cambridge: Cambridge University Press. An important commentary on Kant's *Critique of Judgment*.

Beardsley, Monroe. 1982. *The Aesthetic Point of View*. Ithaca, N.Y.: Cornell University Press. A collection of essays, many of which present Beardsley's various efforts to define aesthetic experience.

Bell, Clive. 1914. *Art*. London: Chatto and Windus. An influential version of aesthetic experience as selfless absorption.

Carroll, Noël. 2000. "Art and the Domain of the Aesthetic." *British Journal of Aesthetics* 40: 191–208.

———. 2002. "Aesthetic Experience Revisited." *British Journal of Aesthetics* 42: 145–68. This article and the previous one argue for the content-oriented conception of aesthetic experience.

Dickie, George. 1974. *Art and the Aesthetic: An Institutional Analysis*. Ithaca, N.Y.: Cornell University Press. Contains an influential critique of various attempts to define aesthetic concepts.

Guyer, Paul. 1997. *Kant and the Claims of Taste*. 2nd ed. Cambridge: Cambridge University Press. Another excellent commentary on Kant's *Critique of Judgment*.

Kant, Immanuel. 1952. *The Critique of Judgment*, translated by J. C. Meredith. Oxford: Oxford University Press.

Levinson, Jerrold. 1996. *The Pleasures of Aesthetics*. Ithaca, N.Y.: Cornell University Press, 3–24. The first two essays in this collection set out the two-level conception of aesthetic experience.

Schopenhauer, Arthur. 1966. *World as Will and Representation*. 2 vols. Translated by E. F. Payne. New York: Dover. The original source of selfless absorption.

Urmson, J. 1957. "What Makes a Situation Aesthetic?" *Proceedings of the Aristotelian Society* 31 (suppl.): 75–92. Presents a version of the object-directed sensuous pleasure conception of aesthetic experience.

Notes

1. Kant discusses such judgments in *The Critique of Aesthetic Judgment*, which is the first part of a larger work, *The Critique of Judgment*. The account of aesthetic judgments given here is based on Kant's discussion of "judgments of taste" in a part of *The Critique of Aesthetic Judgment* called the "Analytic of the Beautiful." The next section of this chapter, "An Alternative Kantian Account," presents some of the complications in Kant's actual views. Two thorough but distinctly different accounts of Kant's views are Allison (2001) and Guyer (1997).

2. For an exposition of Kant's distinction between free and dependent beauty, see the section later in this chapter titled "An Alternative Kantian Account." Dependent beauty involves conceptualization in some way, at least in individuating an object prior to aesthetically responding to it. Free beauty is the object of pure judgments of taste, and what role, if any, Kant allows for concepts here is particularly problematic.

3. For various accounts of dependent beauty, see Allison (2001), Crawford (1974), Guyer (1997), Stecker (1987b).

4. The most prominent among these is an often revised series of conceptions proposed by Monroe Beardsley between 1958 and 1983. I believe the following was Beardsley's (1969) best shot: "an experience is aesthetic over a particular stretch of time if and only if the greater part of [one's] mental activity during that time is united and made pleasurable by being tied to the form and qualities of a sensuously presented or imaginatively intended object on which primary attention is concentrated" (5).

5. There is a distinction between valuing something and its being valuable. If one values something, at a minimum one believes it to be valuable (though one's belief might turn out to be false). Here, however, I mean something less minimal by "value." I mean that one takes some sort of satisfaction in the experience. This is sometimes appropriately described as pleasure, but not always. (See the following discussion for exceptions.) Since one values the experience *for itself*, one values the experience per se regardless of further benefits it brings. Finally, since taking satisfaction in something is itself a valuable state of affairs, when an experience is valued in this way, it is valuable, indeed, valuable for itself.

6. The source of these criticisms is Carroll (2002a). Also see Carroll (2000c) and the exchange between Carroll and Stecker (Carroll 2001b; Stecker 2001).

7. Carroll (2001a) has offered three replies to the previously mentioned argument. First, he claims that Charles may have enjoyed the experience of the Picasso because of the instrumental value received. But this is not in dispute. What is in

dispute is whether this sort of enjoyment is sufficient for an experience to be aesthetic, and the previous example shows it is not. Second, Carroll suggests that Charles may return to viewing paintings because he distrusts the subliminal process of the psychologist. No doubt this might happen (though it is to change the example). However, this just shows that Charles is uncertain whether he is getting the same (or superior) benefits from the laboratory. It is indisputable that he might get such benefits there and that, if he believed that he was, he would have no reason to return to looking at paintings. Finally, Carroll replies that enjoyment per se is not required for (positively valued) aesthetic experience. Again this is true. We aesthetically appreciate grotesque works such as those of Grunewald, and some might be able to similarly appreciate Damien Hirst's bisected cows. Enjoyment might not be quite the right word here, but whatever is the right word, what is in question is an experience that we value for itself and not simply for some heightening of our abilities that it brings about. Otherwise, we have the case, described previously, where an experience has positive instrumental value and negative or nonexistent aesthetic value.

8. Carroll (2002a, 164) offers a more elaborate, disjunctive version of the content-oriented view: an experience is aesthetic if it is directed to the form of an object and/or its aesthetic/expressive properties and/or to the interaction thereof and/or to the way the aforesaid factors modulate our response to the object.

9. The exam situation is used to present another argument for the content-oriented conception (Carroll 1999). The argument claims first that in studying for an exam, one may encounter the same aesthetic properties as one does in an experience valued for its own sake but for the nonce valued simply as preparation, as is the case with Charles in the previous example. The second claim is that if one takes in the same aesthetic properties, one is having an aesthetic experience. The conclusion is that one can have such an experience without valuing it for its own sake. One can reply to this argument in a number of ways. The simplest is to point out that the second premise begs the question: it assumes the correctness of the content-oriented conception. One can also question whether such preparation, if it is really devoid of intrinsically valued experience, constitutes a genuine encounter with aesthetic properties rather than nonaesthetic ones, such as the possession of images or metaphors. This is the criticism that depends on the claim the aesthetic properties are response dependent and the response is such as to involve the right type of intrinsically valued experience. Alternatively, it may in fact be that one can simply infer the presence of an aesthetic property without having such an experience, even if aesthetic properties are response dependent, by inferring that they would produce the appropriate response in a receptive individual. However, I see no reason to speak of an experience, much less an aesthetic experience, when one makes such an inference. Hence, the ability to cognize aesthetic properties in this way would not help the content-oriented approach to aesthetic experience.

4

Conceptions of the Aesthetic: Aesthetic Properties

Chapter 3 examined various conceptions of aesthetic experience. These lead us to inquire whether there are certain properties that are aptly called "aesthetic properties" and, if so, how they are to be characterized. We are led in this direction for several reasons. First, the content-oriented conception of aesthetic experience claims that aesthetic experience should be understood independently of attitudes we bring to it or the way it is valued. Yet many people believe that aesthetic properties are response dependent in a way that essentially involves the attitudes or evaluations of responders. So we need to examine whether this belief is true. A second issue also related to the claims of the content-oriented view is whether aesthetic properties are identifiable independently of aesthetic experience or, alternatively, whether our notions of the experience and the properties are interdependent. A third issue that came out in the previous chapter is whether there might be an asymmetry in our concepts of aesthetic experience and aesthetic properties. That is, is there aesthetic experience of "nonaesthetic" properties or appreciation of aesthetic properties that does not involve aesthetic experience? Is it nonsensical to attempt to conceive such possibilities?

Before turning to these issues, we need to get a sense of the sort of items commonly classified as aesthetic properties and what principle of classification might underlie this. We also need to get a sense of the role these properties might be assigned in the economy of aesthetic life and its value.

The Range of Aesthetic Properties

Consider Shakespeare's Sonnet 73:

> That time of year thou mayest in me behold
> When yellow leaves, or none, or few, do hang

Upon the boughs which shake against the cold,
Bare ruin'd choirs, where late the sweet birds sang.
In me thou see'st the twilight of such day
As after sunset fadeth in the west;
Which by and by black night doth take away,
Death's second self, that seals up all the rest.
In me thou see'st the glowing of such fire,
That on the ashes of his youth doth lie,
As the death-bed whereon it must expire,
Consumed with that which it was nourish'd by.
This thou perceivest, which makes thy love more strong,
To love that well which thou must leave ere long.

The subject of the poem's main body (before the rhymed couplet at the end) is the waning of life, beauty, and perhaps passion in growing old. The metaphors for these things that the work employs, considered in the abstract, are very familiar, even trite, and would have been so in Shakespeare's day too: a season (autumn), times of day (twilight, night), a fire dying out, ruins. What makes this a great poem is the way the metaphors are realized in concrete or evocative images. The autumnal time of year is represented by tree branches with "yellow leaves or none or few" (in which I find just a hint of humor if one thinks of this as a reference to an aging head) shivering in ("shake against") the cold. The next line, the most famous in the poem, is a metaphor for the metaphor of leafless trees, "bare ruin'd choirs where late the sweet birds sang." Not only is this a metaphor for a metaphor, but it is more evocative than precise in the image it presents—are the singers literally birds or a further metaphor for the more usual singers in choirs; and is the singing before or after the choir becomes ruined? The effect of this line is to transform a somewhat wry tone into one that is very poignant. The last four lines of the main body present the most complex metaphor of all. Simply summarized, it is an image of a dying but still-glowing fire. The dead ashes are the speaker's youth. The speaker's present life is the glowing of embers kept alive by what combustible substance remains. The ashes are a "death-bed' and a sign of what the glow will become, when it "is consumed with that which it was nourish'd by." The complexity of metaphor (as well as its syntax and use of pronouns) recalls the wit of the poem's opening image, but the vision of a hot glowing thing gradually dying out and becoming cold is as moving as the "bare ruin'd choirs." This effect is heightened further by the final couplet. While the body of the poem emphasizes the dwindling of everything in old age, the final couplet emphasizes the intensifying of a love that will soon lose its object. The poem is witty in the way it uses language to complicate and pile on metaphors, sometimes turning them on their heads. These metaphors present images that are sometimes vivid and crystal clear, sometimes evocative. The poem's beginning is wryly amusing but turns that emotional tone into something very moving.

In describing this poem, I used a number of terms that seem both to describe the experience of reading it and capture properties we find valuable in it. "Wry," "witty," "amusing," "poignant," "moving," "evocative," "vivid," "clear," "intensifying," and "great" are among these, and they are good examples of terms thought to stand for aesthetic properties. I will for now take for granted that where there is a term, there is also a property. Later we will examine grounds for questioning this.

So we now have *two* broad types of reasons for investigating whether there are aesthetic properties and, if there are, how they should be characterized. We have all the theoretical reasons mentioned in first paragraph of this chapter. We also have just seen that we seem to inevitably refer to such properties when we try to describe what there is to appreciate in artworks.

Alan Goldman has provided us with possibly the most differentiated classification of terms most commonly regarded as picking out aesthetic properties. There are *broad or general evaluative* properties, such as beauty and ugliness. *Great* would also belong here. There are *more specific evaluative* properties, such as being graceful, elegant, or witty. There are *formal* properties, such as balanced, unified, or harmonious. There are *expressive* properties, such as sad, joyful, angry, or serene. There are *evocative* properties, such as powerful, stirring, amusing, or boring. There are *behavioral or dynamic* properties, such as sluggish, bouncy, or buoyant. There are *second-order perceptual* properties, such as vivid, dull, muted, mellow, or steely. Possibly there are *representational* properties, such as being true to life, distorted, or realistic.

This classification is useful in revealing at least a large part of the range of purported aesthetic properties and in giving different names to different sets of them and some sense of the diversity of such properties.

However, the classification is also confusing in a number of ways. First, there is a terminological issue. "Evaluative property" sounds like it refers to a property that evaluates something. But properties don't evaluate; in fact, they don't do anything. People evaluate using words (terms) and sentences that refer to *valuable* properties, such as being beautiful or elegant. Being beautiful is a property of general value because it indicates the overall aesthetic value of an object. Further knowing merely that an object is beautiful tells one little or nothing about the specific features that make it such. On the other hand, knowing that an object is elegant gives one more information about its features. So we can say that being elegant is a property of specific value. *Saying* that something is elegant evaluates but also describes an object. To keep the distinction between terms and properties clear, I will speak of general-value properties and specific-value properties rather than evaluative properties. I will also speak of descriptive properties, by which I mean a property that could be mentioned to describe an object. As just noted, specific-value properties are also descriptive.

Second, it shouldn't be supposed that putting an item in one group excludes it from belonging to another. Being vivid might be a second-order

perceptual property—that is, something we perceive in perceiving something else, as when we perceive the color of a maple tree in fall and perceive the vividness of the color at the same time—but it is also a specific-value property. Things are typically aesthetically better for being vivid.[1] Do all the properties mentioned previously give value to objects? Most think not. Expressive, behavioral, and most of the remaining second-order perceptual and the representational properties don't seem to be inherently polarized toward positive or negative value. Some think that none is so polarized. It is commonly held that where a property has value polarity, this is reversible in specific cases as a result of interaction with other properties. For example, though grace is usually a property that gives the object that possesses it positive value, on some occasions it may detract from the overall value of the object of appreciation. An artwork intent on exhibiting the brutality of war would not help itself by rendering its dying figures gracefully.

What principle of classification should be used in deciding whether something is an aesthetic property? One suggestion is that these are properties that critics refer to when evaluating artworks. So any property that adds value to an artwork or possibly contributes to or provides the basis for this added value is an aesthetic property.[2]

Unfortunately, this proposal begs too many questions to be satisfactory. One question it begs is whether all artistic evaluations are aesthetic evaluations. At one time perhaps, such an identification seemed unproblematic, but this is no longer true. Part II of this book will argue that it is not only problematic but also incorrect. The second question that is begged is whether the totality of aesthetic properties are exhausted by those mentioned by critics in evaluating artworks. Nonartworks have aesthetic properties too. Now it may turn out that any aesthetic property possessed by nonartworks will also crop up in the critical evaluations of artworks. But do we know for sure this is so? The present proposal, because of its thoroughly art-oriented nature, doesn't explain why it must be so, thereby leaving it open that it might not be.

A proposal that bears some kinship with the one just considered claims that aesthetic properties are ones that require taste to detect.[3] The kinship lies in the thought that critics, or good critics at least, are likely to have taste. However, the exercise of taste extends beyond artworks, so it is unlike the first proposal in not being thoroughly art oriented. Further, if the appeal to taste is legitimate, perhaps we can use it to distinguish aesthetically valuable artistic features from other valuable artistic features. The detection of the former requires the exercise of taste, while the detection of the latter doesn't. In this way, we avoid the other problem with the first proposal.

But is the appeal to taste legitimate? Sometimes taste means subjective preference, as when we say "it's a matter of taste" or "in matters of taste, to each his own." There is certainly such a thing as subjective preference, but

this is not what taste is supposed to be in the present proposal. Rather, it is ability to discern genuine aesthetic properties or a faculty that allows us to do this, and this is supposed to be something over and above ordinary perceptual abilities. However, many of the items on the original list require no more than ordinary abilities—such as the second-order perceptual properties. Discerning others, such as the expressive properties, sometimes requires in addition no more than certain kinds of background knowledge. Even some of the best candidates for taste-requiring properties, such as formal properties or specifically evaluative properties, turn out to be questionable candidates. Is it really true that a different faculty comes into play in discerning visual grace or elegance than those used to distinguish fine shades of red? If there is a difference, it does not so much involve an additional faculty kicking in as the presence or absence of an accompanying evaluation.

When we split the difference over what is problematic in the first two proposals, we get the thought that aesthetic properties are those we appeal to in *aesthetic evaluations*.[4] I think this proposal points in the right direction, but if it's workable at all, it needs to overcome two problems: a problem about circularity and a problem of specificity.

First, there is the threat of vicious circularity in attempting to identify *aesthetic* properties by reference to *aesthetic* evaluation. Which evaluations of artworks, for example, are aesthetic? If it is not true that all evaluations that pertain to a work's artistic value are aesthetic evaluations, how do we pick out the ones that are? If we appeal to aesthetic properties, the vicious circle is completed. If we don't, either we implausibly take the idea of aesthetic evaluation as primitive or we need to appeal to something further—something, it is hoped, we can reference without mentioning anything aesthetic.

I think the most promising suggestion is to use one or another of the conceptions of aesthetic experience mentioned in chapter 3 to provide conceptions of aesthetic properties and evaluations. The claim is not exactly that we should define aesthetic properties and evaluations in terms of aesthetic experience per se. That would be no better than defining aesthetic properties in terms of aesthetic evaluation. Rather, we use one of the conceptions of said experience—which does not itself mention anything aesthetic—to define not just the relevant experience but the relevant evaluations and properties as well. Thus, if we rely on the minimal view, we can say that aesthetic experience is experience we value for its own sake in virtue of being directed at the form, qualities (perceivable properties), or meaning properties of an object; aesthetic properties are the properties of objects appropriately related to the experience we value for its own sake; and aesthetic evaluation is an evaluation of an object's ability to deliver such experiences when veridically perceived and correctly understood. Aesthetic evaluation often mentions aesthetic properties in identifying and accounting for this ability.

If we adopt this suggestion, we don't have to do so in terms of the minimal conception. We could do it in terms of selfless absorption, object-directed sensuous pleasure, or the two-level conception. The one conception of aesthetic experience that is ruled out is the content-oriented approach since it defines aesthetic experience in terms of aesthetic properties. If the suggestion is the one we need to follow to provide a viable conception of aesthetic properties, this would require us to reject the content-oriented conception of aesthetic experience. This suggestion, if correct, also tells us how to answer one of the questions raised at the beginning of this chapter: can aesthetic properties be identified independently of aesthetic experience? It tells us the answer is no.

So much for the problem of circularity. The second problem is the problem of specificity. If aesthetic properties are the properties of an object that are *appropriately related* to certain experiences of an object, we need to *specify* what this relation is if we are to identify aesthetic properties in this way.

One approach that won't do is to simply say that they are the properties of the object that cause the experience. One reason this won't do is that there are too many such properties. For example, among the properties of an object that cause my experience of it are its microstructural properties. These properties play a causal role in my perceiving the colors and shapes of objects, and my perceiving the color and shapes of objects is causally implicated in my perceiving the elegance and gracefulness of an object. However, not all the properties in this causal chain are aesthetic properties. Most think that only elegance and gracefulness are. Some think that color and shapes might be, but no one thinks that microstructural properties are aesthetic ones.

A more subtle approach involving a reference to causes might work better. Beauty, perhaps, is simply a property that we mention to indicate the value of the experiences that the object is capable of providing to (that is, causing in) those who perceive it veridically and understand it correctly. This captures the fact that "beauty" is a term of almost pure evaluation, with little descriptive content.[5] This, however, is not generally the case with aesthetic terms, some even seeming to make no evaluation when used. So is there a story about the relation of aesthetic properties to evaluations that covers these various cases?

Here is a simple story. To judge a work beautiful is simply to say that it has a high degree of aesthetic excellence, which can be further cashed out in terms of the value of the experience the object offers. (See note 5 for a qualification of this claim.) To judge that a work has any of the other aesthetic properties (those other than the general-value ones) is to say how and why a work has the general-value property correctly ascribed to it (Zangwill 2001, 36–37).

This story may not be false, but it is too simple because on the one hand it slurs over too many differences among aesthetic properties and on the

other it is too reticent about saying how and why a work has a general-value property. It avoids the specificity problem rather than solves it. As Goldman (1995) notes,

> An artwork may be beautiful because of its grace or balance or power or vivid colors. It may in turn be graceful because of its delicate lines, balanced by virtue of its symmetrical composition, powerful because of its piercing poignancy, vivid because of its highly saturated colors. Finally, its lines may be delicate because of their thin smooth curves, and its poignancy may derive from its subtle expression of deep sadness. (23)

Notice that this passage suggests that, in saying how and why something is beautiful, we appeal to several layers (levels) of explanation. This typically starts with a reference to one or more specific-value properties that have more descriptive content than beauty. The explanation moves on, at the next level, to another set of properties that may or may not also be specific-value ones (which will be even more descriptive?), but if they are value properties, they invite yet another level of explanation. Does the explanation end only when we reach a nonevaluative level? At least where disagreements in evaluation occur, our explanations need to reach that level (Zangwill 2001, 38). For example, when there is disagreement whether a musical work is powerful, that disagreement will probably not be settled by pointing to its "piercing poignancy" or even its "subtle expression of deep sadness" because these are all still evaluative claims that are likely to be disputed if power is not heard in the first place. To say of the music simply that it is sad (as opposed to a *subtle expression* of *deep* sadness) carries much less, if any, evaluative force. Yet sadness is commonly regarded as an aesthetic property, so the fact that we have reached a nonevaluative level does not imply that we reach a level free of aesthetic terms or properties. On the other hand, most people do not regard reference to "thin smooth curves" as an appeal to an aesthetic property.

Goldman gives a more complicated story that is more helpful than the simple story with which we began. We can say that aesthetic properties are those general-value properties that are mentioned in our overall aesthetic evaluations, those specific-value properties that are mentioned in saying "how and why" something deserves the general evaluation it receives, and even some of those purely descriptive properties that appear at lower levels of the "how and why" explanation. However, here the story, as we have so far given it, becomes vague because it doesn't tell us what makes one purely descriptive property aesthetic and another, also appearing at the same level of explanation, nonaesthetic.

It is best at this point to live with this vagueness in the distinction between aesthetic and nonaesthetic properties. The reason it is best is that further progress in identifying the range of aesthetic properties, if it is possible

at all, is possible only after we have investigated some further issues. There
are two issues that need examination. First, we have to look at the long-
postponed issue of response dependency. Second, we have to look at chal-
lenges to the reality of aesthetic properties.

Response Dependency

Recall that a property is response dependent if its instantiation in an object
consists in the object having a steady disposition to bring about a certain
reaction in human beings. The property of being red is response dependent
in case an object is red if humans with normal vision experience it as red
(have red visual sensations) in daylight.

There is an amazing variety of opinions regarding the response-dependent
character of aesthetic properties. At one end of the spectrum is outright de-
nial: aesthetic properties are intrinsic properties of objects, hence nonrela-
tional properties, hence non–response dependent (Eaton 2001).[6] In the mid-
dle range of the spectrum are those who accept response dependency, but this
range contains several different accounts of what it consists in (Goldman
1995; Levinson 1994, 2001; Zangwill 2001). Finally, there are those who deny
response dependency not because they have an alternative account of such
properties but because they deny there are such properties (Bender 1996). A
common reason for this view is that aesthetic responses to objects vary too
much to sustain the claim that such properties exist.

In this section, we examine the response-dependency view. In the next
section, we examine the last view: antirealism about aesthetic properties.
For a discussion of the claim that aesthetic properties are intrinsic proper-
ties of objects, see note 6.

One version of the response-dependency view is based on the reaction
of ideal observers who are the replacements for normal observers in the re-
sponse-dependency analysis of color properties. The appeals to a normal
observer in the one case and an ideal observer in the other have similar ra-
tionales. We assume that certain conditions will impede the ability to react
in such a way as to indicate the presence of the relevant property. For ex-
ample, if one is anemic, objects appear to have a yellow tinge whatever their
true color. If one is wearing red-tinged sunglasses, one imposes an inter-
vening medium that affects the light waves that reach one's eyes. If one is
color blind, one has a defect of vision. All these are ways of being nonnor-
mal observers of color, which seem to obviously stand in the way of hav-
ing reactions indicative of true color. On the other hand, it takes no skill to
be an accurate observer of color; one just needs to be free of impediments.
(This is not to deny that some skill is required to accurately discriminate
fine shades of color.) In the case of the appreciator of aesthetic value, skill
is required. That is why the view under discussion is an ideal rather than

normal observer view. Being normal does not suffice. One needs an ability to discriminate finely, one needs background knowledge, one needs familiarity with the type of object under appreciation so one is familiar with a comparison class, one needs to be able to see connections and draw inferences, one needs to be free from bias, and so on.[7] An ideal observer is simply a normal observer with these additional skills: a suitably skilled normal observer.

Our discussion in the preceding section implicitly classified aesthetic properties into three types (after beginning with a far more complex classification): general-value properties, specific-value properties, and purely descriptive properties. A thoroughgoing proponent of response dependency will claim that each type of property is response dependent, but each is so in a different way. An object is aesthetically fine (excellent, beautiful) if an ideal observer of the object would experience it with a high degree of satisfaction (will have an experience highly valued for its own sake) based on the relevant type of apprehension (perception, imaginative awareness) of more basic properties of the object (such as its form, qualities, or meanings).[8] An object has a specific-value property if an ideal observer will react with satisfaction (dissatisfaction) in virtue of apprehending features $f_1 - f_n$, where the features apprehended identify the descriptive content of the specific-value property. So in the case of vivid color, perhaps the features apprehended will be high saturation, brightness, and so on. Finally, regarding the purely descriptive aesthetic properties, if they are to receive response-dependent analysis, it won't involve a reference to a positive or a negative reaction but to a value neutral reaction. Thus, a work's being sad may in part consist in ideal listeners hearing sadness in it, and a painting's being distorted may in part consist in ideal observers seeing something in it.

How plausible is this proposal? I find it very plausible for general-value properties and more problematic for the remaining properties. As argued previously, aesthetic value is plausibly understood in terms of a kind of valuable experience, and this is captured in the proposal's treatment of general-value properties. In addition, the proposal actually offers a coherent way to cash out Kant's proposal that (general) aesthetic judgments are both subjective and universal. The subjective aspect of the judgment lies in its reference to experience valued for its own sake. The value is tied to how we (ideally) react to objects. The universality lies in the (purported) uniformity of reactions by ideal observers. Of course, we can't ignore a possibility, which we will explore in the next section, that even among ideal observers, reactions are not uniform. But if this turns out to be true, it plausibly undermines unqualified ascription of general aesthetic merit.[9]

The proposal for the specific-value properties is far more problematic. What is said to distinguish the specific from the general-value properties is the possession by the former of a descriptive content. However, it is not even clear how we should individuate these properties. Is there a single

property, *being vivid*, that is possessed by foliage in the autumn, paintings, musical passages, and character portrayals in plays or novels? Or is being a vivid color a different property than being a vivid portrayal? It is very plausible that it is, if being vivid in color is a second-order perceptual property, since being a vivid character portrayal is not a perceptual property of any sort. Even if we decide this matter by opting for the latter view, let us ask whether there really is an $f_1 - f_n$ that gives us the descriptive content of vivid portrayals in general. It is not really plausible that there is a set of features uniform across all objects that give us the descriptive content we are looking for, at least if these are objective features of the objects in question (Sibley 1959). One portrayal may be vivid because of the great quantity of visualizable descriptions it provides. Another is vivid because of a single, salient, powerful image it offers. If there is not a constant set of features underlying vivid portrayals, how can we talk about a property of being vivid that is specified by a descriptive content and an evaluative reaction?

A possible solution to this problem is to say that the common descriptive element for these properties is misspecified by objective features $f_1 - f_n$. Rather, the common descriptive content consists in an "emergent holistic impression" in the observer (Levinson 1994). The aesthetic property is a disposition of an object to produce such an impression in ideal observers (call this the impression view of aesthetic properties). There will, of course, always be objective features of an object that produce this impression, but these are not uniform across objects. A vivid portrayal in one work might be the result of descriptions of characters that allow one to see them in one's imagination acting and suffering in their fictional world; in another, it might be a consequence of dialogue written with a perfect ear; in a third, it is produced by the powerful emotions the characters express; in a fourth, it is produced by the intimate voice of a first-person narrator. In all these cases one has the impression of the characters "coming to life," which is another way of referring to the vividness of the portrayal.

The proposal has the advantage of bringing the account of specific-value properties in line with that of the purely descriptive ones. As suggested previously, what makes music sad is that it creates a certain impression in ideal listeners—they hear sadness in the music. Hence, other than the most general aesthetic terms, which simply express an overall evaluation of an object, terms for aesthetic properties always refer to an impression in ideal observers. Some also refer to an evaluative reaction to this impression, while others don't.[10]

Does reference to an emergent holistic impression solve the problem of specifying the descriptive content of aesthetic properties? Again, there are problems: the problem of vacuity and the problem of diversity. The first problem is that it is not clear that we have said much by mentioning this impression. Of course, if something is graceful, it will make a graceful im-

pression on people receptive to this feature. Is this really supposed to suffice in identifying the descriptive content of "graceful"? As it stands, it does not.

To respond to this problem, the proponent of this view has to say more about the impressions. Given the diversity of aesthetic properties, I suspect that there is not a uniform line to take but, rather, various approaches to nontrivially identifying them. Some are capable of more informative description: for example, a gaudy arrangement of colors creates an impression of being a "bright, nonharmonious, eye catching color combination" (Levinson 1994, 352). What it is for us to see or hear sadness in something (for it to have a sad look or sound) might be established by pointing to a variety of items—weeping willows, certain dog faces, foghorn sounds, musical passages, and so on—allowing us to find a common impression in these different manifestations. Some are just unproblematic: most agree that being amusing is a disposition to affect people in a certain way that we can all recognize.

These brief remarks don't show that there are informative procedures across the board for identifying the impressions associated with each aesthetic property or even that the proposals discussed here are really satisfactory. Nevertheless, let us turn to the other difficulty for the impression view: the diversity problem.

The diversity problem begins with the widely accepted fact that different people, as well as the same person on different occasions, get different impressions from the same work. This in itself is no objection to the view we have been considering. That view might even predict there are these differences because actual observers fall short of being ideal observers. The claim that makes the impression view problematic is that even ideal observers can have different impressions based on recognizing the same objective properties $f_1 - f_n$. If this claim is true across the board, then there are no unique dispositions in objects to cause any aesthetic impressions in ideal observers, and so the impression view itself would imply that there are no aesthetic properties. It would imply antirealism about aesthetic properties.

A defender of the impression view can argue that two different reactions have been confused in the previously mentioned claim. There are evaluative reactions, and there are "impressions," where the latter purportedly capture the descriptive content of an aesthetic property. The suggestion is that it really is possible to secure general agreement over the descriptive content even where different evaluative reactions persist, as a result of distinct, freestanding sensibilities of (even ideal) observers. So, for example, some might hear Schubert's "Death of the Maiden" quartet as one of the most powerful expressions of grief-stricken sadness among musical works, while someone else might think it overly dramatic or insufficiently subtle, features that lessen its emotional impact. All, however, will agree that, virtually from beginning to end, it has a dark, sad quality.

The opponent of the impression view, or of aesthetic properties per se, may reply that sometimes the evaluative reaction and the impression are inseparable. For example, someone has the impression that a painting is gaudy in its use of color, while another finds that same array is attractively vivid; this may be due to the first having the impression of disharmony among the colors and the second not having this impression. Disharmony was previously put forward as part of the descriptive content of gaudiness, but it usually has a negative polarity. Hence, just which aesthetic term is applied to an object may not always be independent of evaluative reaction. It follows that, if ideal observers may have blamelessly different sensibilities, then they may just not agree on their aesthetic descriptions either. Further, even among those properties that are purely descriptive, difference in impression may be possible. Many descriptions of music in terms of expressed emotion are good candidates, especially when the description gets more complex—despair mixed with resignation—or involves a highly concept-bound emotion such as hope (or, for that matter, despair and resignation.) Poetry is just as likely to create such differing impressions of emotional quality, usually resulting from different interpretations of the poem. Whether such differences are equally possible for simple, basic emotional qualities such as joy or sadness is more debatable.

The various response-dependent conceptions of aesthetic properties we have considered are sufficiently problematic (though not clearly false) to make antirealism about these properties a plausible option. So let us now consider in what this view consists and what might be said in its favor.

Antirealism

We have already indicated the negative claim that antirealists make about aesthetic properties: there really aren't any. However, this denial leaves the antirealist with the task of saying what we do when we make judgments that seem to mention aesthetic properties. When we say that the fall foliage is vivid, the painting is sad, the opening measures of the symphony are perfectly elegant and graceful, or the sculpture is beautiful, what are we doing if not asserting that the object mentioned has a property true of it?

There are three sorts of things the antirealist can say about these judgments. First, some could claim that we are still making assertions, some true, some false, but they are about the aesthetic experience rather than aesthetic objects. Call this subjectivism. Second, one might claim that one is not asserting anything about one's experience or its objects but rather giving expression to the former or expressing an attitude toward the experience or the object. Call this expressivism. The third option, unlike the first two, does not deny that we are talking about the *objects* of experience, and it may even agree that we are saying things true or false about it, but it claims, further,

that what we are saying, if true, is true relative to something further that varies among different groups of persons. Suppose, for instance, that we can group people according to distinct tastes or sensibilities (for example, those who like bold departures and sharp breaks with tradition and are willing to tolerate what others find unacceptably shocking or discordant and those who have less tolerance for these things and who favor more conservative or well-established artworks). A proponent of the third option might say that things aren't disharmonious per se or elegant per se or beautiful per se but only so relative to these sensibilities. Call this relativism. We need to explore these views in more detail.

Subjectivism

The simplest version of subjectivism asserts that people use aesthetic terms to report their own experience of objects. When they say, "These ruins are positively elegant," they are reporting an impression of elegance but not a (steady) disposition in the ruins to produce that impression. This does not mean that appreciators cannot give reasons for reacting as they do. They can point to objective features $f_1 - f_n$. For example, they might say, "Look how the pieces of the ruins arranged themselves as if someone intentionally laid them out that way," "Look how the different parts complement and balance each other's shapes," and so on. A listener who didn't see the elegance before may be brought around. But she may not be, and if not, barring further remarks, that is the end of the matter.

People's experience can change as in the case of the person brought around by the remarks about the ruins. Furthermore, an initial impression can be rejected on further consideration. The simplest version of subjectivism can only mark these events as changes of experience and successive judgments as reports of different experiences. This way of characterizing the judgments seems to leave something out—the idea that a previous reaction was wanting in some way.

A more complicated version of subjectivism can accommodate what has been left out. Perhaps some reactions can be seen as defective or less valid than others because of features of them that common sense tells us are failings. If I am extremely biased in favor of an item, because I am in love with its creator, that would color my experience in the kind of way that makes it less valid. Similarly, if I previously haven't noticed some feature that makes an important difference to my experience, my later experience that includes recognition of the feature is more valid. Even if objects lack a steady disposition to cause common aesthetic experiences in everyone, we can maximize common ground among different people by doing things such as flagging bias as a defect and agreeing that appreciation that takes in more features is more adequate than one that notices fewer. So the more complex subjectivism asserts that aesthetic judgments are claims to *valid* experience, which

can be impugned or rendered less valid by mentioning a defect in the experiencer or the circumstances in which the experience occurs.

This more complex version of subjectivism has some clear advantages over the simpler version. It gives aesthetic judgments a way of being incorrect other than being a mere misreporting of the experience. So when one revises one's judgment, the complex view can capture the idea that the new judgment is a correction of the old. It also allows for genuine disagreements, whereas simple subjectivism does not. That I experience something one way is consistent with your experiencing it differently. When we report our different experiences, we are not disagreeing with each other. The more complex view allows for different valid experiences, but if I say that your experience is not valid and you say that it is, we are disagreeing, and one of us may be wrong.

However, there is something else common to many aesthetic judgments still missing from the subjectivist account. This is their evaluative aspect. That is, the subjectivist account as it has been developed so far simply reports that the speaker receives an impression from a work or, in its more complex version, receives a valid or nondefective impression. In saying the impression is valid (nondefective), I evaluate the impression, but I don't evaluate the object of the impression. Yet many aesthetic judgments give specific or general evaluations of their objects. Can the subjectivist account for this feature?

At first glance, the solution might seem to lie in claiming that there is another part to what we report when we make many aesthetic judgments. When I say that the ruins are elegantly laid out, I'm claiming to have a valid impression, but it might be said that I am also reporting that I approve of the layout of the ruins or receive satisfaction from it or value it. This is how "elegant" differs from a nonevaluative aesthetic term such as "sad." When I say that the painting is sad, I am reporting an impression, claiming it to be valid, but not reporting approval or disapproval.

Unfortunately, this proposal doesn't quite do the trick. Reporting that I approve of something is not evaluating it; it is saying something about my own psychological state. To get an evaluation of an object, we have to do something further or different from such reporting.

The most natural move for the subjectivist to make here is to extend the account of valid or nondefective judgment to evaluations. When I say that the ruins are elegant, I am saying that they produce an impression on me, that it is a valid impression, that it is one in virtue of which I approve, that I receive satisfaction from or value the ruins, and finally that this approval is itself valid in virtue of the impression being valid. It is the last clause, which asserts that the approval is valid in virtue of the impression being valid, that purports to be the evaluative element in the judgment.

Two objections might be made to this claim. The more minor objection asserts that, just because the impression is valid, it doesn't follow that the ap-

proval is too. Perhaps there are additional ways approval can be defective. The second, more serious objection is that the claim still does not provide an evaluation of the object of experience. It is evaluating the wrong item, in this case, the approval, satisfaction, or valuing of the appreciator.

Regarding the first objection, the subjectivist can resist it or concede it without much effect on the overall subjectivist view. It is worth resisting until the objector indicates in what ways an approval can be defective that is not transmitted by a defect in the impression. I find it hard to identify such ways. But if they can be discovered, this can be built into the subjectivist account by requiring that the approval not be defective in the further ways.

If the second objection is correct, that would scotch the subjectivist's attempt to account for the evaluative aspect of many aesthetic judgments. However, the subjectivist does have a good reply to the objection. First, she needs to remind the objector that she is offering a subjectivist account of aesthetic judgment, so one shouldn't expect the evaluation of objects to be independent of reactions of appreciators. If someone aesthetically values an object and this valuation is blameless or, in other words, cannot be impugned by pointing to some defect in the enabling impressions, then the object can be credited with the positive or negative evaluation on offer. The object, veridically perceived, properly understood, and considered as a whole, combined with the appreciator's sensibility, is responsible for the evaluation and so deserves credit. This leaves room for other people, having different blameless reactions leading to different evaluations. Evaluations are subjective but not unchallengeable.

Is this subjectivism a version of an ideal observer theory akin to the one discussed in the previous section? It could be thought of that way, in which case its assertions would make reference to ideal observers capable of different reactions to the same objective features and the same background knowledge. However, it is more in keeping with the idea that this is a version of subjectivism that, when I say, "That's elegant," my judgment makes reference to myself, not an ideal observer. I'm saying that I'm having certain impressions and evaluative reactions and that in having them I'm meeting a certain expected standard that renders them nondefective or valid. An ideal observer can be conjured up to embody said standard, but the judgment itself doesn't refer to that abstraction.

Expressivism

Expressivists find it counterintuitive that we are making *claims* about ourselves when we appear to be talking about objects and their aesthetic properties but agree we are not, despite appearances, making true or false assertions on these occasions about the objects of experience. They bolster this intuition by pointing to certain features of our talk about these objects.

This talk often appears to be metaphorical. Not only do we say that music is sad (when, it's claimed, only sentient beings can literally be sad), but we talk about musical movement, tension and release, and so on when none of these purportedly, literally apply to the music. They also point out that much aesthetic experience involves aspect perception: seeing or hearing something *as* F or seeing or hearing F in an object (hearing joy in the music, seeing roads leading nowhere in a painting). This should not be confused with perceiving that an object has a property (perceiving that a large blue area occupies the upper-left portion of the painting). Perceiving the latter implies that the object has the blue area. Perceiving roads in a painting does imply the painting actually has roads.

If we are not making assertions, true or false, about either the objects of experience or the experiences we are having, what are we doing? Expressivists derive their name from the idea that we are expressing rather than reporting a psychological state, such as a feeling or an attitude, that we are undergoing as a result of commerce with an object. Some things we utter show forth or give vent to our feelings or express rather than describe an attitude. If I say, "I love you," I'm typically expressing my love, not offering a description of how I feel.

When it comes to the evaluative element in an aesthetic judgment, expressivists will say that we are expressing our approval or satisfaction or valuing of the object of experience. The harder task is to give an expressivist account of the "descriptive" aspect of aesthetic judgments. What the expressivist would like to say is that we are expressing this too. When we say, "The music is sad," I am purportedly expressing the aspect perception I am undergoing (Scruton 1974). Unfortunately, this just does not seem right. It's not clear that experiences, unlike feelings and attitudes, are things we express rather than describe. Furthermore, when I say the music is sad, I am committing myself to something more than my undergoing a certain experience because, whatever the experience is, it can be true that I am having it without its being true or appropriate to say the music is sad.

To accommodate the latter point, the expressivist needs the sophisticated subjectivist's idea of valid or nondefective experience of an object. If my hearing sadness in the music is nondefective or valid, then I'm entitled to the judgment that the music is sad; otherwise, I am not. Further, if experiences are features of a mental life that we can describe but not express, as just claimed, it seems that the expressivist about aesthetic judgments would have to settle for a hybrid subjectivist/expressivist theory: subjectivist about the descriptive aspect of aesthetic judgments and expressivist about the evaluative aspect. Whether there is any advantage to such a theory over a purely subjectivist one we discuss later in this chapter.

Contemporary expressivists want to claim that there are better and worse, if not strictly true or false, aesthetic judgments. How can they do this

if they think that one is just expressing a feeling, attitude, or other psychological state when making the judgment? Once again, they would have to follow the trail blazed by the sophisticated subjectivist. Attitudes, for example, can be more or less justified by the objective properties of the item being judged and the ability of the person making the judgment to take in the relevant facts, ignore irrelevant ones, and process them in an appropriate fashion. The ability is not enough, of course; it has to be used in the case under evaluation. An evaluative aesthetic judgment about an object can be criticized by pointing out that it fails to take into account important properties of an object; that the appreciator displayed certain defects such as bias, inattention, or lack of background knowledge; or that the circumstances of appreciation were less than ideal. An attitude can be justified by arguing that no such defects were present.

Relativism

The relativist is happy to say that when we judge that the ruins are elegant, we are stating something "directly" about the ruins, namely, that they are elegant. But they say this with a qualification. The qualification is that the truth of such claims varies across different groups. Something is elegant relative to one group, not elegant relative to another. Relativists assert that it is this variation across groups that explains the blameless differences in aesthetic judgments about the same object. Relativists don't agree among themselves about what is the variable feature that is responsible for these differences in judgment. Some suggest it is a matter of different sensibilities or tastes. Others think the crucial difference consists in the critical school or community to which one belongs. The important point is that these differences don't just explain differences in aesthetic judgments about the same objects, but they make these different judgments true or false, appropriate or inappropriate, relative to a standard derived from the respective group.

This view might seem quite different from the subjectivism and expressivism considered previously because it seems to focus on objects rather than experiences. However, it really is not so different because the judgments it makes about objects are mediated by an experience-shaping characteristic of individuals, ideal or actual, belonging to a group: a sensibility or an attitude shaped by membership in a critical community. One version of this relativism is well expressed by the "subjectivist" version of the ideal observer theory briefly mentioned earlier. Something is elegant s_1 if an ideal observer with sensibility s_1 reacts in the appropriate way to it: with the appropriate impression and evaluation. An actual appreciator with sensibility s_1 who judges an item elegant may or may not judge truly or appropriately depending on whether it matches the judgment of the ideal observer.

Evaluation of the Proposals

We now have a bunch of proposals before us about aesthetic judgments that appear to assert that an object (an artwork, a natural object or environment, an artifact) has an aesthetic property. Some of these proposals imply that the judgments assert precisely what they appear to and include an account of the nature of aesthetic properties (the ideal observer account of aesthetic properties supplemented by the impression view). Some imply that there really are no aesthetic properties, only experiences (which include impressions and evaluative reactions) caused by nonaesthetic properties of objects (subjectivism and expressivism). Finally, relativism is, in a sense, an intermediate view. It could be taken to acknowledge aesthetic properties after a fashion: properties relativized to different groups of appreciators. It could be said to deny the existence of such properties: properties that are available to everyone. I don't claim that these proposals exhaust the plausible options. However, they give us plenty to consider.

Is one of these proposals the right one? How does one go about deciding?

We have already looked at some objections to the realist, ideal observer view, so let's begin now by looking at the antirealist views. Are there decisive objections to antirealism or to specific versions of it? If not, is there some way of choosing among the three main options (subjectivism, expressivism, relativism)? Finally, we can ask whether realism can overcome objections to it and whether we should prefer it to any sort of antirealism.

One objection to all versions of antirealism is that it does not sufficiently capture the normative character of aesthetic judgments (Zangwill 2001). Normative judgments are judgments about value. They tell us that something is good or ought to be done. It is the former sort of judgments that are more relevant in aesthetics.

As we have seen, antirealist theories do attempt to account for the evaluative, hence normative, character of aesthetic judgments by appealing to the "valid" or nondefective approval of real appreciators or the approval of ideal observers. If an object is capable of eliciting such approval (satisfaction, valuing), it is aesthetically good. Why does this not suffice to account for the normative character of such judgments?

For the critic of antirealism, this approach doesn't go far enough. It allows for blameless differences of judgment that leave no one wrong. To put it in Kantian terms, it does not distinguish judgments of agreeableness from judgments of beauty. Consider taste in food (a matter of agreeableness). We can certainly rule some people more "valid" judges of cuisines than others. Someone with much experience eating sushi, who has traveled extensively in Japan trying out the many varieties of that dish, and who has become familiar with the standards of those in the know (for there are such standards or criteria) is a better judge of good sushi than someone trying it for the

first time. If the thought of eating raw fish and/or seaweed turns your stomach, you are too biased to be a good judge. If your taste buds or sense of smell are damaged, your discriminatory disability disqualifies you. Yet if you don't like even the best sushi, you don't exhibit an insensitivity to the presence of value. You are blameless, as are those who are equally good judges of that type of food, who equally enjoy it, but whose preferences differ to some degree.

The critic of antirealism claims that unlike the inability to appreciate sushi, the inability to appreciate beauty, when one encounters it, *is* insensitivity to the presence of value. She claims that allowing for blameless differences, for a take-it-or-leave-it attitude, to objects of high aesthetic merit, hasn't adequately accounted for the normativity of aesthetic judgments.

The critic may be right, but so far she has just begged the question. Who is right here is the main issue. One side cannot argue for their view by presupposing they are right. One of the points underlying antirealism is that while some differences in judgment are disputable, others just aren't. There is an element of nonrational preference or sensibility in these judgments just as there is in taste in food. The barren hills or mountainsides one finds in some parts of California hold no beauty for me, but I can readily imagine others reacting very differently. And it might be claimed that food, despite the existence in people of nonrational preferences for some items over others, can also provide aesthetic experience.

Turning from criticism of antirealism in general to the specific versions of it, is there one that should be preferred? We should look at sophisticated subjectivism and relativism as near variants of each other. We have already noted that, when subjectivism is expressed in terms of ideal observers, it becomes relativism. Relativism, however, makes a commitment to the existence of several distinct, identifiable groups that need not be made by subjectivism. For relativism, blameless differences in aesthetic judgments lie in differences in group character. This relativist assumption is open to question. There are many variables that enter into overall reactions to aesthetic objects, including some that might vary with the kind of objects in question. Our reactions to art may differ in this respect from our reactions to nature in virtue of the fact that one approaches art critically, ready to interpret and evaluate, whereas one does not approach nature in this way. Subjectivism is preferable as an account of aesthetic judgment, as long as we don't know whether there are sufficiently robust groupings of sensibilities, but if there are such groupings, we may prefer a relativism that captures them.

Contrary to majority opinion in philosophical circles, I believe that subjectivism is also preferable to expressivism. Expressivism is clearly preferable to simple subjectivism because the latter view appears unable to account for the evaluative or normative aspect of aesthetic judgments. The general criticism of antirealism just considered really does apply to simple subjectivism.

This is precisely what prompted the revisions in the subjectivist view that led to the more sophisticated variety. However, the sophisticated view explains normativity just as well, and in a not very different way, than does expressivism. It does so while preserving the idea that aesthetic judgments are assertions or statements. Expressivism must deny this, and it is forced into all sorts of convolutions to explain how we do things that are very like making assertions without actually doing so. The fact that it enables us to avoid the convolutions is enough reason to prefer subjectivism.

Someone might object to the reason just given for preferring subjectivism to expressivism. The choice should depend on what we are really doing when we make aesthetic judgments: whether we are expressing something or reporting something. It shouldn't turn on considerations of tidiness. The only response I have to the objection is this: if you can figure out what we are really doing without appealing to methodological considerations, go ahead. But I can't.

Finally and, it would seem, most important, should we opt for realism or antirealism (in whatever version we suppose to be best)? My initial suggestion is that there may not be a uniform answer to this question. There may be some aesthetic properties the awareness of which either occurs below the level of differing sensibilities or else there is a right culturally determined sensibility to bring to bear. The presence of visual grace may be an example of the former possibility. The presence of simple expressive properties, such as joy or sadness, in Western tonal music seems to me a good candidate for the latter possibility (always allowing for exceptions or borderline cases). For other properties, a more antirealist (subjectivist or relativist) view may be the right one. Beyond this, when examined in the highly abstract terms of this chapter, it is too hard to know where the truth lies, to find decisive grounds for either position.[11] This is a good question for the reader to attempt to take further. We will return to it in chapter 12, where we are concerned with the more concrete issue of the appreciation of architecture.

Loose Ends

At the beginning of this chapter, we raised several questions. We raised the question whether the notion of an aesthetic property can be understood independently of aesthetic experience. We now know that the answer is that it cannot (see this chapter's summary). We raised the question whether aesthetic properties (if there are such) are response-dependent properties that essentially involve the attitudes and evaluations of appreciators. We now know that the answer is that, if there are aesthetic properties, many would essentially involve these things. We were led to raise these questions because of the problems they posed for the content-oriented conception of aes-

thetic experience. The answers we have reached pose serious objections to this conception of aesthetic experience. That conception is workable only if aesthetic properties can be understood without appeal to aesthetic experience and in a way that does not imply that we value this experience for its own sake. Our conclusions imply that these conditions for the workability of the conception are not met.

We also raised another pair of questions we have not yet answered. They are about a possible asymmetry between appreciation from the perspective of aesthetic experience and from the perspective of aesthetic properties. Are there aesthetic experiences of nonaesthetic properties? Is there appreciative awareness of aesthetic properties that occur outside aesthetic experience? Given that the notion of aesthetic property cannot be understood independently of aesthetic experience, one might think that there could not be such an asymmetry. But matters are not quite so simple.

Regarding the former question, the problem lies in the boundaries of aesthetic properties (or terms, if we are antirealists). Most, though not all, would say color and shape are not aesthetic properties, but we seem to have appreciative experiences of them, much like aesthetic experiences, in nature, as we discovered in chapter 2.

Regarding the latter question, I think there is a kind of appreciation for an object's experiencible features that falls short of aesthetic experience of these features. We are shopping for a toaster, and we spot one that will go perfectly in our kitchen. Here we may have no aesthetic experience of the toaster on this occasion, but we do project or predict that we will have one when the toaster is placed in the kitchen. We appreciate the toaster now for an experience we have every reason to believe it will produce in the future.

Summary

In this chapter, we turned from a focus on the aesthetic experience of appreciators to the (purported) aesthetic properties of objects. We asked three main, interrelated questions: What is the range of the (purported) properties? What makes them aesthetic properties (if there are such)? And are there, in fact, aesthetic properties? To the first question, we answered that aesthetic properties (if there are such) range over general-value properties, specific-value properties, and purely descriptive properties. But, of course, not all such properties are aesthetic. Being beautiful is a general-value aesthetic property, being morally good isn't. Being graceful is a specific-value aesthetic property, being honest isn't. Being a sad musical passage is a descriptive aesthetic property, being a sad person isn't. So what makes a given property in each category aesthetic? Initially, we answered this question in terms of the role these (purported) properties play in aesthetic evaluation, but ultimately we did so in terms of its being a property related in the right way to aes-

thetic experience. The reason why this turned out to be an attractive way to categorize aesthetic properties (if there are such) is that chapter 3 provided several conceptions of aesthetic experience couched entirely in nonaesthetic terms. By employing one of these conceptions, we could finally say something informative about aesthetic properties.

However, we don't say something sufficiently informative until we say what the appropriate relation to aesthetic experience is. This is to be done by conceiving aesthetic properties as response dependent. Aesthetic properties would be constituted by steady dispositions in objects to cause certain reactions in ideal observers: purely evaluative reactions (valuing the experience of the object for its own sake in virtue of lower-level reactions), evaluative reactions combined with a specific phenomenal impression, and reactions that simply involve such an impression.

This analysis leads to a very precise way of raising the question whether there really are aesthetic properties: do objects have or not have a steady disposition to produce the relevant reactions in ideally situated observers? If the answer is yes, there are such properties. If no, there are not, and then we would have to accept one of the three antirealist views mentioned previously: subjectivism, expressivism, or relativism.

Further Reading

Bender, John. 2001. "Sensibility, Sensitivity and Aesthetic Realism." *Journal of Aesthetics and Art Criticism* 59: 73–83. A critique of realism.
Goldman, Alan. 1995. *Aesthetic Value*. Boulder, Colo.: Westview Press. An influential treatment of aesthetic properties in a sophisticated subjectivist vein.
Hume, David. 1993. "Of the Standard of Taste." In *Hume: Selected Essays*, edited by L. A. Selby-Bigge. Oxford: Oxford University Press, 133–54. The classic eighteenth-century source of subjectivism about the aesthetic.
Levinson, Jerrold. 2001. "Aesthetic Properties, Evaluative Forces, and Differences in Sensibility." In *Aesthetic Concepts: Essays after Sibley*, edited by Emily Brady and Jerrold Levinson. Oxford: Oxford University Press, 61–80. A defense of realism.
Sibley, Frank. 1959. "Aesthetic Concepts." *Philosophical Review* 68: 421–50. A classic paper on aesthetic properties.
Zangwill, Nick. 2001. *The Metaphysics of Beauty*. Ithaca, N.Y.: Cornell University Press. A realist account of aesthetic properties.

Notes

1. Goldman (1995) seems to disagree, claiming the vividness is not "directly evaluative" (19). Yet he also says that "an artwork may be beautiful because of its grace, or balance or power or vivid colors" (23). Grace and power are normally evaluative, suggesting that being balanced or vivid should also be so taken.

2. Gaut (in press) makes this proposal.

3. This is the official view of Sibley (1959).

4. How does this proposal derive from the criticism of the first two? Criticism of the first proposal leads us to substitute *aesthetic* for *artistic*. Criticism of the second proposal leads us to substitute *evaluation* for the exercise of *taste*.

5. At least, there is a use of "beauty" as a general term of praise of which this is true. There is another use where "beauty" has more descriptive content. Beautiful objects, in this latter sense, are pleasing to look at and are not jarring, grotesque, or horrifying, among other things. Levinson (2001, 62) makes a similar point.

6. The main contemporary proponent of this view is Eaton (most recently 2001). Eaton clearly holds that aesthetic properties are intrinsic, and some of her remarks about the nature of intrinsic properties imply that they are nonrelational. However, her primary criterion for being intrinsic is epistemic, that is, how we gain knowledge of the property. Eaton says that the fact that an object has an intrinsic property can be known only by direct inspection (in perceiving it, for example). Her examples suggest that this is an exaggeration of the more plausible claim that there are certain properties the presence of which in objects is typically known by such inspection. She says one must look at a building to know that it is neo-Gothic, but it's plausible that I can also learn this from a guidebook or other reliable third-person source. The more important point is that, if the main criterion of being an intrinsic property is epistemic (however this criterion should be formulated), it doesn't after all rule out that the properties are in general relational or in particular response dependent. Hence, what looked like a stark alternative to response dependency ends up being a characterization of aesthetic properties that is neutral on that issue.

7. These qualities derive from Hume's (1993) characterization of the ideal critic in "Of the Standard of Taste."

8. This is adapted from Goldman's (1995, 21) characterization.

9. One might object to this account of general evaluative aesthetic properties on another ground, namely, that it is too broad. Certain kinds of sexually pleasurable experiences satisfy it. For this case, I agree and include them in aesthetic experiences. However, there are other cases that are more problematic. Consider the experiences involved in doing a difficult crossword puzzle. One may experience repeated satisfactions as one focuses on each clue and finds the right word. One has to apprehend the clue in a more or less imaginative way to find the right word. Yet this is not aesthetic experience, at least as it is usually understood. One might say the experience is too intellectual or insufficiently object oriented. Certain satisfactions are more process oriented, and the one derived from crossword puzzles is a good example of these.

10. Zangwill (2001, 176–200) proposes a response-dependent theory of aesthetic properties that completely excludes the evaluative response.

11. Levinson (2001) reaches a similar conclusion. Before leaving this issue (for now), let me mention one way of arguing for a realist view suggested by Peter Railton without denying the existence of blameless differences in reaction that the antirealists emphasize. Suppose Fred admires the ruins for their elegance and Pam doesn't. She cannot see anything elegant in the ruins. Still, she might believe that Fred's impression is "valid" in the sense discussed previously and thereby acknowledge that he is sensitive to an aesthetic merit she cannot detect. He might do the same when it comes to detecting different degrees of merit in close harmony

singing where Pam is the more sensitive listener. Even if others are not so gener-
ous, they should be. The idea is that there are all sorts of aesthetic value out there
that are not equally available to everyone. As long as there is no defect in the way
the individual arrives at the judgment that the value is present, we should all ac-
knowledge its existence, whether or not our experience leads to a similar judg-
ment. Even if we accept this, as I think we might, there are still some judgments
that might elude a realist treatment, such as judgments of comparative value.

Part II

PHILOSOPHY OF ART

5

What Is Art?

Perhaps you have a handmade piece of furniture passed down from generation to generation. You have always admired it. It is beautiful. Is it an artwork? What about a lovely bowl you recently encountered at a Japanese restaurant or, for that matter, the beautifully presented meal? When you visit museums and art galleries featuring contemporary works, you again might wonder whether some of the items you encounter are artworks, or, if you take that for granted given that you are in an *art* gallery after all, you may still be puzzled why many of these items are art.

The question, What is art? is commonly asked in attempting to find necessary conditions and sufficient conditions for the truth of the statement that an item is an *artwork*. That is, the goal is normally to find a principle for classifying all artworks together while distinguishing them from all nonartworks. Sometimes the goal is set higher. Some look for a "real" definition, that is, one in terms of necessary conditions that are *jointly* sufficient for being an artwork. We will see later in this chapter that several promising approaches to answering this question do not meet this more stringent requirement.

This project is often identified as trying to "define" something: a property (being art, being an artwork), a concept (*art, artwork*), a word ("art," "artwork"). At the end of this chapter, I will explore the relation between the classificatory project and the attempt to define the items just mentioned. In the meantime, I will often speak of proposals to answer "what is art" questions as definitions as a convenient shorthand throughout the chapter.

Who Cares What Art Is?

Why are classificatory principles philosophically interesting? Why should we care what art is? The reason that jumps out at one these days is the

permanently puzzling nature of avant-garde art. From impressionist paintings to piles of dust and unmade beds recently exhibited in galleries, such works, in their time, puzzled and sometimes enraged critics and viewers. Are these items art (if they all are) merely because they are put forward by an artist and placed in a setting such as a gallery, or is there something more to being art that needs to be identified? Can something be put forward in this way but fail to be an artwork?

Avant-garde art of the past one hundred years has made the nature of art increasingly puzzling because it has progressively stripped works of the traditional marks by which we recognize them as art while expanding the category of objects capable of art status. With regard to new categories, examples are legion. Found art has added unworked objects chosen by the artist that are often ordinary artifacts, such as bottle racks and bicycle wheels. Earth, bricks, and scraps of cloth are materials of now famous recent works. With regard to the stripping away of traditional marks, the same is true. In some works that, in addition to found art, include aleatoric art, where the final product is left to chance, the contribution of the artist is minimized. In some works, form seems to disappear as in a lint-strewn gallery floor. Many works attempt to eliminate aesthetic properties. Robert Morris issued a notarized statement withdrawing all aesthetic qualities from a metal construction with the poetic title *Litanies*. Sometimes this stripping away is pursued because artists themselves have taken an interest in the nature of art. Hence, anyone cognizant of the art world can hardly avoid the question, What is art?

These aspects of recent art history reflect underlying issues that have always been with us. Why do all the diverse things that are artworks and forms that are art forms fall under the concept art while other similar items fail to do so? Why do some talismans and ceramic vessels but not others, some buildings but not others, some essays but not others, and paintings in galleries but not most paintings on billboards fall under the concept? Why are wine, food, cigars, and various skillful entertainments excluded?

Finally, there is an issue (one that we will return to at the end of this chapter) concerning choice of concepts. The fact is that there is not just one concept of art. Our current concept or concepts have a number of historical predecessors. One of the earliest is the concept expressed in the ancient Greek word *techne*, which refers to any skilled activity and its products. We still sometimes use "art" in this sense, as when we call cooking and all manner of crafts "arts." We also have today a use of "art" that is much narrower than the one in which we are interested, which refers exclusively to the visual arts. The concept of *fine art* that came fully into use in the eighteenth century comes closer to the concept of art we are interested in here. This concept centrally includes the five major arts of poetry, painting, sculpture, music, and architecture. It is less clear what else it includes and how it stands to the related but different category of decorative art, which emerged

around the same time. Many would say that the philosophy of art is concerned with fine art, but I am inclined to think we are working with a different concept that gradually evolved from it. Our concept countenances the multiplication of art forms, a vast broadening of objects capable of achieving art status, the stripping away of marks of arthood necessary for achieving that status. Further, we no longer think of the artist exclusively as a genius set apart from normal humanity as the eighteenth century did. We now think in more democratic terms. We also distinguish less sharply between fine and popular or folk art. So there is a real challenge to attempt to pin down the relevant current concept of art.

Historical Background

Something should be said about the historical roots of the attempt to define art. It is sometimes supposed that the earliest definitions of art are to be found in the writings of ancient philosophers such as Plato and Aristotle. In fact, one won't find in these writers a definition of art in the sense of an item belonging to the fine arts or of art in its current sense if that departs from the concept of the fine arts. It is now widely accepted that the former concept was not fully in place until sometime in the eighteenth century, and hence it seems implausible that the ancients would think in terms of or try to define fine art. What is true is that they wrote about such things as poetry, painting, music, and architecture, which came to be classified as fine arts, and saw some common threads among them. Plato was very interested in the fact that poetry, like painting, was a representation or imitation (*mimesis*) of various objects and features of the world, including human beings and their actions, and that it had a powerful effect on the emotions. Aristotle also emphasized the idea of poetry as imitation and characterized other arts, such as music, in those terms.

This way of thinking of the arts wielded enormous influence in the Renaissance and Enlightenment, so when the concept of the fine arts solidified, the first definitions of art were cast in terms of representation by such important figures as Hutcheson, Bateaux, and Kant. It is not necessary to set out the exact content of all these definitions here since in the later period in which we are interested, they were superseded by other approaches. Of these earlier definitions, Kant's definition is the one that has had truly lasting influence. Fine art, according to Kant, is one of two "aesthetic arts," arts of representation where "the feeling of pleasure is what is immediately in view." The end of agreeable art is pleasurable sensation. The pleasure afforded by the representations of fine art, in contrast, is "one of reflection," which is to say that it arises from the exercise of our imaginative and cognitive powers. Fine art is "a mode of representation which is intrinsically final . . . and has the effect of advancing the culture of the mental powers in

the interest of social communication" (Kant, 1952, 165–66). There are elements in this conception that survive even after the idea that the essence of art is representation is abandoned. One is a series of contrasts between (fine) art, properly understood, and entertainment (agreeable art). Art makes more demands on the intellect but offers deeper satisfactions. Art is "intrinsically final," that is, appreciated for its own sake. Art has some essential connection with communication.

The struggle to replace the idea that art is representation takes place in the nineteenth century. This occurs on many fronts, just as did the formation of the concept of the fine arts a century earlier. Artistic movements such as romanticism, impressionism, and art-for-art's-sake challenge ideals associated with exclusive concern with representation and direct attention to other aspects of art, such as the expression of the artist and the experience of the audience. Debates among critics in response to these movements raise questions about the boundaries of art. The invention of photography challenges the representational ideal in painting, at least if that is regarded as the increasingly accurate, lifelike depiction of what we see. The increasing prestige of purely instrumental music provides at least one clear example of nonrepresentational art. For some, such music provides a new paradigm captured by Walter Pater's claim that all the arts aspire to the condition of music. In response to all this, new definitions of art appear, especially expression theories, formalist theories, and aesthetic theories.

What all these theories have in common with each other, as with representationalism, is that they identify a single valuable property or function of art and assert that it is this property that qualifies something as art. Such theories dominate the attempt to define art right through the middle of the twentieth century. Although they now no longer dominate, they are still regularly put forward. Those cited at the end of the previous paragraph have been the most important and influential examples of this type of theory. Each deserves attention in some detail.

Art as Expression

The ostensible difference between expression and representation is that while the latter looks outward and attempts to re-present nature, society, and human form and action, the former looks inward in an attempt to convey moods, emotions, or attitudes. We seem to find instances of expressive art where representation is deemphasized or absent. It is very common to think of instrumental music, or at least many pieces of music, in these terms. As the visual arts moved toward greater abstraction, they too often seemed to deemphasize or abandon representation for the sake of expression. One can even extend this to literature, which pursued expressivist goals from the advent of romantic poetry through the invention of "stream

of consciousness" and other techniques to express interiority. So it might seem that one could find art without representation but not without expression. This might encourage the further thought, independently encouraged by various romantic and expressivist movements in the nineteenth and twentieth centuries, that even when expression and representation co-occur, the real business of art is expression.

Space permits the examination of only one specific proposal to define art in terms of expression. The definition comes from Collingwood's *Principles of Art* (1938). Collingwood defines art primarily as an activity: that of clarifying an emotion, by which he means identifying the emotion one is feeling not merely as a general type such as anger or remorse but with as much particularity as possible. Collingwood does not deny that one can rephrase this definition in terms of a work of art rather than an activity, but he believes the work exists primarily in the minds of artist and audience rather than in one of the more usual artistic media. He seems to think of the job of the medium as enabling the communication of the emotion to the audience who then have the same clarified emotion in their minds, which is to say, for Collingwood, the work of art itself.

The definition has well-known problems. First, even if expressiveness, in some sense, is a widespread phenomenon in the arts, it is far too narrowly circumscribed by Collingwood. He prescribes a certain process by which a work of art must come about, whereas it is in fact a contingent matter whether works are created in the way he recognizes. Not unexpectedly, the definition rules out many items normally accepted as artworks, including some of the greatest in the Western tradition, such as the plays of Shakespeare, which by Collingwood's lights are entertainment rather than art. The definition assumes that the emotion expressed in a work is always the artist's emotion, but it is not at all clear why a work cannot express or be expressive of an emotion not felt by the artist when creating the work. In recent years, the idea that art expresses an actual person's emotion has given way to the idea that art is expressive of emotion in virtue of possessing expressive properties, such as the property of being sad, joyful, or anxious, however such properties are analyzed. Such properties can be perceived in the work, and their presence in a work does not require any specific process of creation.

Formalism

Developing alongside expression theories of art were formalist theories. If one stops thinking that art is all about representation, a natural further thought is that what art is all about is form rather than representational content. This thought gained support from various developments in the arts during the period of high modernism, a long, exciting period roughly between

1880 and 1960. Though many art forms contain modernist masterpieces, the works of painters were the paradigm and inspiration for many of the most influential formalist theories. Cezanne in particular was the darling of the early formalists Clive Bell (1914) and Roger Fry (1956). Cezanne's paintings contain perfectly traditional representational subjects—landscape, portraiture, still life—but his innovations *could* be seen as formal with virtually no concern, furthermore, to express anything inner other than Cezanne's eye making features of visual reality salient. These innovations involved the use of a wide-ranging palette, a handling of line, and an interest in the three-dimensional geometry of his subjects that give his figures a "solidity" not found in his impressionist predecessors while at the same time "flattening" the planes of the pictorial surface. Taking such formal features as the raison d'être for these paintings became the typical formalist strategy for understanding the increasingly abstract works of twentieth-century modernism as well as for reconceiving the history of art. Like the other simple functionalist theories under discussion here, formalism is not just an attempt to define art. It is a philosophical theory of art in the sense that it also attempts to identify the value of art and what needs to be understood in order to appreciate an artwork.

A formalist attempt to define art faces several initial tasks. They all have to do with figuring out how to deploy the notion of form in a definition. One can't just say that art is form or that art is what has form because everything has form in some sense. The first task is thus to identify a relevant sense of "form" or, in other words, to identify which properties give a work *form* in the chosen sense. Second, if objects other than artworks can have form in this same sense, one has to find something special about the way artworks possess such form.

The best-known and most explicit formalist definition of art is Clive Bell's. According to Bell, art is what has significant form. Significant form is form that imbues what possesses it with a special sort of value that consists in the effect produced in those who perceive it. Bell calls the effect "the aesthetic emotion," though, as Carol Gould (1994) has pointed out, this is probably a misnomer since what he has in mind is more likely a positive, pleasurable reaction to a perceptual experience. So Bell performs the second task mentioned previously by claiming that what is special about form in art is that it is valuable in a special way.

However, until Bell dispatches the first of the previously mentioned tasks, that is, until we know what he means by form, his claims about significant form are unilluminating. Unfortunately, regarding this task, Bell is remarkably cavalier. Being concerned primarily with the visual arts, he sometimes suggests that the building blocks of form are line and color combined in a certain way. But this is not adequate to his examples, which include Sta. Sophia (a building), the windows at Chartres, Mexican sculpture, a Persian bowl, Chinese carpets, and the masterpieces of Poussin. Perhaps even three-dimensional works such as buildings, bowls, and sculptures

in some abstract sense are "built" out of line and color. A more straightforward way to itemize the formal properties of a bowl would be color, three-dimensional shape, and the patterns, if any, that mark its surfaces. Notice that every three-dimensional object has formal properties so characterized, and those that have significant form are a subclass of those that have form. Essentially the same is true in the cases of buildings and sculptures, though these are typically far more complex in having many parts or subforms that interact with each other and with a wider environment. But a similar complexity can be found in many three-dimensional objects, both manufactured and natural.

In the case of pictures in general and paintings in particular, which is the sort of visual art in which Bell was most interested, speaking of form as arising from line and color is, if anything, more unilluminating because all sorts of its properties, including the representational properties, so arise. Further, it gives no indication of the complexity of the concept as it applies to a two-dimensional medium capable of depicting three dimensions. The fact is that the form of a painting includes but is hardly confined to the two-dimensional array of lines and color patches that mark its surface. As Malcom Budd (1995) has pointed out in one of the most sensitive treatments of the topic, it also includes the way objects, abstractly conceived, are laid out in the represented three-dimensional space of the work and the interaction of these two- and three-dimensional aspects. For example, formalists, when discussing particular paintings, often refer to the *volume* a group of figures fill in the represented three-dimensional space of the picture. They regard this as a formal feature of a painting even though it is part of the representational content and stands in some relation to the two-dimensional design of the picture.

If we can pin down the sense of form as it applies across the various art media, can we then go on to assert that something is an artwork just in case it has significant form? Bell's definition hinges on his ability to identify not only form but also significant form, and many have questioned whether he is able to do this in a noncircular fashion. His most explicit attempts on this score are plainly circular or empty involving the interdefinition of two technical terms, significant form being what and only what produces the aesthetic emotion and the aesthetic emotion being what is produced by and only by significant form. Others (Gould 1994), however, have claimed that a substantive understanding of when form is significant can be recovered from formalist descriptions of artworks purportedly in possession of it.

Even if Bell can successfully identify significant form, his definition is not satisfactory. It misfires in a number of respects that are typical of the simple functionalist approach. First, it rules out the possibility of bad art since significant form is always something to be valued highly. Perhaps there can be degrees of it, but it is not something that can occur to a very small degree unless one can say that a work has negligible significant form. Second, it displays the common vice of picking out one important property for which

we value art while ignoring others at the cost of excluding not just bad works but many great works. Thus, someone who defines art as significant form has little use for artists such as Breughel, whose paintings, many of which teem with vast numbers of tiny human figures, give a rich sense of many aspects of human life but lack art's defining feature as Bell would understand it.

Perhaps there is a better way to deploy the notion of form or formal value in a definition of art. This is a possibility that, whatever its merits, has gone largely unexplored. Instead, those who remained attached to the simple functionalist model turned to an alternative approach using a more flexible concept, that of the aesthetic. So rather than exploring hypothetical formalisms, we turn to this new approach.

Aesthetic Definitions

The concept of the aesthetic is both ambiguous and contested, as was made plain in chapters 3 (on aesthetic experience) and 4 (on aesthetic properties). For our purposes, we can stipulate that the aesthetic refers in the first instance to experience valued (valuable) for its own sake that results from close attention to the sensuous features of an object or to an imaginary world it projects. Aesthetic properties of objects are those that have inherent value in virtue of the aesthetic experience they afford. Aesthetic interest is an interest in such experiences and properties. Aesthetic definitions—attempts to define art in terms of such experiences, properties, or interest—have been, with only a few exceptions, the definitions of choice among those pursuing the simple functionalist project during the past thirty years. The brief exposition given previously of definitions of art in terms of representational, expressive, and formal value suggests why this is the case. Each of the previous attempts to define art attempts to do so by picking out a valuable feature of art and claiming that all and only things that have that feature are artworks. One of the objections to each of the definitions was that they excluded works of art and ones possessing considerable value, but not in virtue of the feature preferred by the definition. Hence, such definitions are not extensionally adequate.

By contrast, aesthetic definitions seem, at first glance, to be free of this problem. Form and representation can both afford intrinsically valuable experience, and, typically, such experience does not exclude one aspect in favor of the other. The same is true for the experience afforded by the expressive properties of works. All such experience can be regarded under the umbrella of aesthetic experience.

Aesthetic definitions of art are numerous, and new ones are constantly on offer. I mention here a few of the better-known or better-constructed definitions:

An artwork is something produced with the intention of giving it the capacity to satisfy the aesthetic interest (Beardsley 1983).

A work of art is an artifact, which under standard conditions provides its percipient with aesthetic experience (Schlesinger 1979).

An "artwork" is any creative arrangement of one or more media whose principal function is to communicate a significant aesthetic object (Lind 1992).

Despite the fact that the notion of the aesthetic better serves the simple functionalist than the notions of representation, expression, or form, such definitions are still are far from satisfactory. To bring this out, consider two basic requirements on the definition of any kind (class, property, concept) K: that it provide necessary conditions for belonging to (being, falling under) K and that it provide sufficient conditions for belonging to (being, falling under) K. To be an artwork, is it necessary that it either provide aesthetic experience or even be made with the intention that it satisfy an interest in such experience? Many have thought not. Those who deny it are impressed with art movements such as Dadaism, conceptual art, and performance art. These movements are concerned, in one way or another, with conveying ideas seemingly stripped of aesthetic interest. Dadaist works, such as Duchamp's ready-mades, appear to be precisely aimed at questioning the necessary connection between art and the aesthetic by selecting objects with little or no aesthetic interest, such as urinals, snow shovels, and bottle racks. Some instances of performance art appear to be based on the premise that political ideas can be conveyed more effectively without the veneer of aesthetic interest. Some conceptual works seem to forgo or sideline sensory embodiment entirely.

Defenders of aesthetic definitions take two approaches to replying to this objection. Some (Beardsley 1983) attempt to deny that the apparent counterexamples are artworks, but this seems to be a losing battle, as the number of ostensible counterexamples increase and gain critical and popular acceptance as artworks. What has recently come to be the more common tack in replying to the objection is to claim that the apparent counterexamples do have aesthetic properties. (Lind 1992). The ready-mades, for example, have such properties on more than one level. Simply regarded as objects, they have features that to a greater or lesser degree reward contemplation. As artworks, they powerfully express Duchamp's ironic posture toward art.

Can we deploy the notion of the aesthetic to provide a sufficient condition for being an artwork? As the previous paragraph already begins to suggest, any object has the potential to be of aesthetic interest, and so providing aesthetic experience is hardly unique to art. Beardsley's definition rules out natural objects since they are not made with the requisite intention, but it seems to rule in many artifacts that are not artworks but are made with aesthetically pleasing features.

There are three ways a defender of aesthetic definitions of art might try to cope with the pervasiveness of the aesthetic outside of art per se. One way is to redefine what counts as art as any artifact with aesthetic interest. (Zangwill [2000] suggests this approach.) The problem with this move is that it just changes the subject from an attempt to figure out why we classify objects as art to a mere stipulation that something is art if it is an aesthetic object. A definition that includes doughnut boxes, ceiling fans, and toasters, even when not put forward as ready-mades, is simply not a definition of art in a sense others have attempted to capture. Second, one can attempt to rule out nonart artifacts by claiming that artworks have a "significant" aesthetic interest that distinguishes them from the "mere" aesthetic interest possessed by other artifacts (see Lind 1992). But this line is equally unlikely to succeed. The more one requires such "significance," the less likely it is that all artworks will possess it, for we have seen that many recent works are not concerned primarily with creating a rich aesthetic experience. The last strategy is to claim that, despite intuitions to the contrary, aesthetic experience is something that is either uniquely or primarily provided by art. This strategy faces the daunting task of specifying an experience common to all artworks and that art uniquely or primarily provides, but without making essential reference to the concept of art. Though some, such as Beardsley (1969), have attempted such a specification, the consensus is that no proposal has been successful.

Antiessentialism

Although aesthetic definitions of art continue to have adherents, the dominant trend within this topic since the 1950s has been to reject simple functionalism—as we can call any view that claims that art can be defined in terms of a single function. This rejection began with the more sweeping thought that the attempt to define art is misguided because necessary and sufficient conditions do not exist capable of supporting a real definition of art. The most influential proponents of this antiessentialism were Morris Weitz (1956) and Paul Ziff (1953). Guided by Wittgenstein's philosophy of language, they claimed that it was atypical for ordinary language empirical concepts to operate on the basis of such conditions. Rather, as Weitz put it, most such concepts were "open textured," meaning that the criteria by which we apply the concept do not determine its application in every possible situation. While the concept of art is by no means unique in being open textured for Weitz and Ziff, the concept still stands apart from many other empirical concepts in one respect. For many empirical concepts, open texture merely creates a theoretical possibility that situations may arise in which criteria no longer guide us, and a new decision is needed whether the concept applies. Weitz and Ziff conceived of art as requiring such de-

cisions on a regular basis as new art movements continually create novel works. This novelty provides a constant source of counterexamples to simple functionalist definitions.

Instead of being classified by necessary and sufficient conditions, claimed Weitz and Ziff, works are classified as art in virtue of "family resemblances," or sets of similarities based on multiple paradigms. So one work is art in virtue of one set of similarities to other works, while another is art in virtue of a different set of similarities. An alternative approach, also Wittgensteinian in spirit, is that art is a cluster concept (see Gaut 2000). This means that we can discern several different sets of properties the possession of any of which suffices for an object to achieve art status but no one of which is by itself necessary for such status.

Each of these suggestions, while proposing that the concept of art is best captured by something other than a definition, in fact lays the ground for new approaches to defining art. The family resemblance view claims that the concept of art is formed by a network of similarities. But which ones accomplish this? If none are specified, then the view is empty since everything bears a similarity to everything else. In fact, Ziff suggested that the relevant domain of similarities is social or functional in nature, though in the case of the latter not in the way simple functionalists had hoped for. As for the cluster concept view, if the set of conditions sufficient for being an artwork are finite and enumerable, it is already equivalent to a definition of art, namely, a disjunctive definition.

While attempting to demonstrate that art cannot be defined, antiessentialism actually resulted in a whole new crop of definitions, most of which look completely different from their simple functionalist predecessors and rivals.

Danto and Dickie

In a highly influential article, Maurice Mandelbaum (1965) was among the first to point out that the appeal to family resemblance does not preclude but rather invites definition. It may be true that when we look at the resembling features within a literal family, we may find no one *exhibited* likeness that they all have in common. However, Mandelbaum observes, family resemblance is no more satisfactorily explicated in terms of an open-ended set of similarities differentially shared among the family's members, for people outside the family may also possess the exhibited features without thereby bearing a *family* resemblance to the original set of people. What is rather needed to capture the idea of family resemblance is a *nonexhibited* relation, namely, that of resemblance among those *with a common ancestry*. Without proposing a specific definition, Mandelbaum suggested that in attempting to define art, we may fill in the gap left to us by the family resemblance view by appealing to

some nonexhibited relational property—perhaps one involving intention, use, or origin.

Among the first to explore the possibility of defining art in these terms and certainly the most influential proponents of this approach were Arthur Danto and George Dickie. In part because both cast their thought about art in terms of "the art world," in part because Danto was not explicit about his proposed definition, for some time it was thought that they were advancing similar definitions of art. However, it is now understood that each was developing quite different theories, Danto's being historical and functional, Dickie's being radically afunctional and institutional.

In some early papers, Danto (1964, 1973) outlines desiderata to which a definition of art must conform without yet setting forth a definition that satisfactorily meets the desiderata. The first point, illustrated by the ready-mades as well as such works as Warhol's Brillo boxes, is that art and nonart can be perceptually indistinguishable and so cannot be marked off from each other by "exhibited" properties. (A corollary to this is that one artwork cannot always be distinguished from another by appeal to exhibited properties.) Second, an artwork always exists in an art-historical context, and this is a crucial condition for it to be art. Art-historical context relates a given work to the history of art. It also provides an "an atmosphere of artistic theory," art being "the kind of thing that depends for its existence on theories" (Danto 1981, 135). Third, "Nothing is an artwork without an interpretation which constitutes it as such" (135). Every work of art is about something but equally invariably expresses an attitude of the artist toward the work's subject or a "way of seeing" the same. An interpretation, then, tells us what the work is about and how it is seen by its maker and further expresses the artist's intention on this score.

Danto's most important work in the philosophy of art and his most sustained attempt to discern the essence of art is the book *The Transfiguration of the Commonplace* (1981), where he elaborates on the considerations stated previously and adds others. However, it was left to commentators to fashion an explicitly stated definition of art from this material. The best statement, and one endorsed by Danto, is provided by Noël Carroll (1993, 80) as follows: X is a work of art if and only if (a) X has a subject (b) about which X projects an attitude or point of view (c) by means of rhetorical (usually metaphorical) ellipsis, (d) which ellipsis requires audience participation to fill in what is missing (interpretation), (e) where both the work and the interpretation require an art-historical context.

To a considerable extent, this definition follows the pattern of traditional simple functionalist definitions of art. Basically, conditions (a) and (b) give to art the function of projecting a point of view or attitude of the artist about a subject, and this puts it in the broad class of attempts to define art in terms of expression. That this function is accomplished in a special way (c) and requires a certain response from the audience (d) is not an uncom-

mon feature of expression theories. If anything sets Danto's definition apart from other simple functionalist proposals, it is the last condition (e) that requires that a work and its interpretation stand in a historical relation to other artworks.

It is this last feature that has made Danto's definition influential, but it is not clear that it helps very much to save it from the fate of other simple functionalist definitions. Many believe that there are works of art that fail to meet all of the first four conditions. Aren't many works of music, architecture, or ceramics and even some abstract or decorative painting examples of works of art that are yet about nothing?

George Dickie's art world is different from Danto's. Rather than consisting in historically related works, styles, and theories, it is an institution. In attempting to define art in terms of an institution, Dickie abandons the attempt to offer a definition not only in terms of exhibited features but in terms of functions of any sort. Dickie originally conceived of this institution as one that exists to confer an official status, even if it does so through informal procedures. Increasingly, however, he came to view it differently, as one geared to the production of a class of artifacts and to their presentation to a public.

As might be guessed from his changing understanding of the institution of art, Dickie (1974) has proposed two distinct institutional definitions of art, the second being based on his own rejection of the first. Both, however, have received a great deal of attention and exercised considerable influence, so each deserves some discussion here. The first definition goes as follows: something is a work of art if and only if 1) it is an artifact and 2) it has a set of aspects that has had conferred on it the status of candidate for appreciation by some person or persons acting on behalf of the art world.

Notice that the status conferred that makes some artifact an artwork is not the status of being art (at least not straightforwardly that) but of being a candidate for appreciation, and this status is conferred on a set of aspects of the item rather than on the item itself. Dickie's definition itself does not tell us who in the art world typically confers status. One might think it would be people such as critics, art gallery owners, or museum directors because they are the ones who select and make salient to a broader public aspects of a work for appreciation. However, Dickie's commentary on the definition makes clear that he thinks artists are the exclusive agents of status conferral. Since conferring would seem to be an action, one might wonder what an artist does to bring it about. It can't just be making something with properties capable of being considered for appreciation. Stephen Davies (1991, 85) has suggested that conferral consists in someone *with the appropriate authority* making or putting forward such an object.

For many, the crucial idea that makes this definition of art institutional is that being an artwork consists of possessing a status conferred on it by someone with the authority to do so. However, this is precisely the idea

that Dickie eventually rejected. Rightly or wrongly, he came to view status conferral as implying a formal process, but no such process need occur, nor, typically, does it occur in bringing artworks into existence.

Dickie's second definition of art is part of a set of five definitions that present the "leanest possible description of the essential framework of art":

1. An artist is a person who participates with understanding in making a work of art.

2. A work of art is an artifact of a kind created to be presented to an art world public.

3. A public is a set of persons whose members are prepared in some degree to understand an object that is presented to them.

4. The art world is the totality of all art world systems.

5. An art world system is a framework for the presentation of a work of art by an artist to an art world public. (1984, 80–81)

The basic idea here is that the status of being art is not something that is conferred by some agent's authority but instead derives from a work being properly situated in a system of relations. Preeminent in this system is the relation of the work to the artist and to an art world public. It is the work's being created by the artist against the "background of the art world" (1984, 12) that establishes it as an artifact of a kind created to be presented to an art world public, that is, an artwork.

If we abstract from the particulars of Dickie's two definitions, one can discern a common strategy that gives rise to a set of common problems for his approach. In both definitions, Dickie set out a structure that is shared with other institutions or practices beyond the "art world." Conferral of status occurs in many settings, and even the conferral of the status of candidate of appreciation frequently occurs outside the art world (whether or not it occurs within it). For example, an "official" tourist brochure issued by a tourism board confers the status of candidate for appreciation on some particular place. So does official recognition that a building is "historical." (Remember that Dickie self-consciously refuses to say what kind of appreciation is conferred by agents of the art world.) Even advertising might be thought to confer such status, as is certainly its aim. How does Dickie's first definition distinguish these conferrals of candidacy for appreciation from art-making conferrals? Only by referring to the art world, that is, gesturing toward art forms and their making, distribution, and presentation without explaining what marks these off from other status-conferring practices. Similarly, regarding the second definition, there are many artifact production and presentation systems outside the art world. Wherever a product is produced for consumers, there is such a system. How does Dickie distin-

guish art world systems from other artifact presentation systems? He does so only by naming the art world systems "art world systems," that is, gesturing toward the relevant systems without explaining what marks them off.

This strategy gives rise to the problems of circularity and incompleteness (see Davies 1991; Levinson 1987; Stecker 1986, 1997; Walton 1977). Dickie acknowledges that his definitions are circular but denies this is a problem. It is clearly a problem, however, when a definition is insufficiently informative to mark off the extension of what it is attempting to define. Because Dickie's definitions simply gesture toward the art world without marking it off from similar systems, it is incomplete for lack of informativeness. Dickie (1989) replies that it is ultimately arbitrary whether a system is part of the art world, but such a claim seems to be an admission that the definition cannot be completed.

Historical Approaches

Others have proposed that the situation is not as hopeless as Dickie (inadvertently) suggests. Kendall Walton (1977) was among the first to suggest that the art world systems that Dickie gestures toward might be defined historically. Walton's suggestion is that the art world consists of a limited number of proto-systems plus other systems that develop historically from these in a certain manner (1977, 98). Dickie (1984, 76) has pointed out that this leaves unsettled the issue of why the proto-systems belong to the art world in the first place and has expressed the belief that no real explanation is possible. This assessment may be overhasty. One possible place to look for the set of original proto-systems would be the formation of the system of the fine arts in the eighteenth century with poetry, painting, sculpture, architecture, and music (possibly confined to vocal music) being the paradigmatic proto–art forms. Surely, there is an explanation of why these forms composed an important category at this time. This explanation might refer to a common functional property, or it may itself be historical. A residual problem with this approach is whether it accounts for all items classified as artworks. The view appears to imply that to be art it is necessary and sufficient that it belong to an art form or art system, and not everyone would accept both parts of that claim (Levinson 1979; Stecker 1997). The view, even rehabilitated along quasi-historical lines, may also fail to account for artworks and art forms from non–Western and earlier Western cultures that are conceptually but not historically linked in the right way to the eighteenth-century prototypes.

Stephen Davies is the most important defender of the institutional approach since Dickie. Davies does not actually offer a definition of art but sketches lines along which it should develop. First, it should reinstate the idea that the art world is structured according to roles defined by the authority

they give to those who occupy them. Art status is conferred on works by artists in virtue of the authority of the role they occupy. Second, art world institutions should be understood historically. Davies's discussions of the historical roots of art have come to focus more on individual artworks than on art world systems. Consider very early artworks. Did such works exist in an institutional setting? If so, what gave rise to these institutions? Surely, it was even earlier works around which the institutions grew. Davies initially attempted to give an institutional analysis to cases such as this as well as cases of isolated artists whose work is disconnected from art institutions as we know them (Davies 1991). His current view, however, is that the earliest art, the prototypes from which art and its institutions arose, are to be understood functionally. Such items are art because their aesthetic value is essential to their function. However, once art institutions become established, art can develop in ways that no longer require an aesthetic or any other function (Davies 1997b, 2000).

In addition to attempts to historicize the institutional approach to defining art, a number of philosophers have explored other forms of historical definition. Jerrold Levinson (1979, 1989, 1993) has proposed that it is a historical relation that holds among the intentions of artists and prior artworks that is definitive of art, James Carney (1991, 1994) claims that the relation is one holding among historically evolving styles, while Noël Carroll (1994), though not offering a definition, has put forward the suggestion that art is identified by historical narratives that link later works to earlier ones. I have proposed that art is defined in terms of historically evolving functions (Stecker 1997).

Levinson's (1989) proposal is one of the best worked out and most carefully defended. It is that "an artwork is a thing that has been seriously intended for regard-as-a-work-of-art, i.e., regard in any way pre-existing artworks are or were correctly regarded" (21).

One wants to know more about what it is to intend a thing for regard-as-a-work-of-art and why this core aspect of Levinson's definition does not make it as tightly circular as Dickie's. It turns out there can be two relevant types of intentions. On the "intrinsic" type, one intends a work for a complex of regards for features found in earlier artworks without having any specific artwork, genre, movement, or tradition in mind. One might intend it for regard for its form, expressiveness, verisimilitude, and so on. Alternatively, there is the "relational" type of intention, in which one intends an object for regard as some particular artwork, genre, and so on is or was correctly regarded. When one fills in these possible regards, in theory one eliminates the expression "as-a-work-of-art," which is the basis of Levinson's defense against the charge of circularity.

As with some other historical accounts (such as Carney's and Carroll's), Levinson's main idea is that something is a work of art because of a relation it bears to earlier artworks, which are in turn art because of a relation

they bear to still earlier works and so on. Once this is clear, it becomes obvious that as one moves back along the relational chain, one will come across artworks for which there are none earlier. These earliest artworks have come to be called "first art." We need a separate account of what makes first artworks art and a reason for thinking that this separate account won't serve to explain why all artworks are art, obviating the need for a historical approach. Davies (1997b, 2000) now gives an essentially functional account of first art in his historicized institutional approach and would claim this won't explain why all artworks are art because, within an art institution, objects can acquire art status while lacking the original function of art.

Levinson (1993) prefers to avoid this straightforwardly functionalist approach to first art. For him, what makes something first art is that it is "the ultimate causal source and intentional reference of later activities we take as paradigmatically art." Furthermore, first art aims at "many of the same effects and values, that later, paradigmatic art has enshrined" (421). These remarks come close to a functional approach similar to Davies but substitute causal and intentional relations to functions for direct reference to the functions themselves.

There are a number of objections to Levinson's definition. Against taking it as a sufficient condition for being art, various examples have been offered where the requisite intention is purportedly present, but the item in question is arguably not an artwork. In 1915, Duchamp attempted to transform the Woolworth Building into a ready-made. He was not successful, but not for lack of an appropriate intention (Carney 1994). A forger of a Rembrandt self-portrait may intend that his work be regarded in many ways the original is correctly regarded without thereby creating another artwork (Sartwell 1990, 157). There are also objections to the claim that the definition provides a necessary condition for being art of. There can be objects that achieve functional success as art in that they reward a complex set of intrinsic regards but lack the required intention. They may spring from an artistic intention based on a misunderstanding of earlier works or a utilitarian intention that adventitiously results in an object with artistically valuable properties. For example, one might set out just to make a vessel that holds water and end up with a remarkably beautiful pot.

Levinson has replied to all these criticisms (see Levinson 1990, 1993). Duchamp failed because he lacked the relevant "proprietary right" to the building. The forger does not create an artwork because, though he intends the forgery for many regards correctly applied to the Rembrandt, they are not correctly applied to his own painting. Levinson seems to admit that there can be art that lacks the intentions he ordinarily requires for arthood but holds that this points to further, less central senses of art. However, it is not clear that these replies are completely satisfactory. The "proprietary right" condition looks rather ad hoc, especially since it does not hold in

general. Art made from stolen materials may put in question an artist's "ownership" of a work but not its art status (as Noël Carroll has previously pointed out). The forger may not be able to make all the regards that are applicable to a Rembrandt applicable to his own painting (such as being an example of seventeenth-century painting) but can make many others applicable (such as expertly exhibiting the chiaroscuro technique). So it's plausible that the forger can muster a sufficiently robust set of regards that correctly apply to his own work. This would imply that the forgery is an artwork, according to historical intentionalism.

Even if the replies work, they, along with the previous remarks on first art, add new conditions to and hence considerably complicate Levinson's original definition. Sometimes, too, many qualifications can kill a proposal by, as it were, suffocation. (There are a number of other objections to the intentional-historical definition. For a summary of and response to these, see Levinson 2002; for a critical discussion of historical definitions in general, see Stecker 1997, 87–109).

Historical Functionalism

At a number of junctures it appears that Levinson might have achieved a simpler definition by appealing directly to functions or regards rather than intentions. Historical functionalism formulates a definition of art that appeals more directly to a historically evolving set of functions, without completely dispensing with a reference to artistic intentions (Stecker 1997; for a similar view, see Graves 1998). This approach does not define art explicitly in terms of a historical relation linking the art of one time with the art of an earlier time. Rather, the definition proceeds by reference to art forms and functions that exist at a given time. Historical functionalism assumes that these forms and functions evolve over time. At any given time, art has a finite set of functions that range from genre specific values to those widespread representational, expressive, formal, and aesthetic values enshrined in the simple functional definitions considered earlier. The functions of art at a given time are to be identified through an understanding of the art forms central to that time. However, that does not mean that items that don't belong to a central art form are never art. According to this view, almost anything can be art, but artifacts outside the central art forms have to meet a higher standard. This motivates a disjunctive definition of art: an item is an artwork at time t, where t is not earlier than the time at which the item is made if and only if 1) it is in one of the central art forms at t and is made with the intention of fulfilling a function art has at t or 2) it is an artifact that achieves excellence in achieving such a function.

With this definition too there are various problems. The appearance of circularity is handled in much the same way as with Levinson's definition:

eliminating reference to art by enumerating central forms and functions. However, this requires that some account of these items be provided. What makes something a central art form? How are genuine functions of art distinguished from accidental functions (such as using sculptures as doorstops or paintings for insulation) and extrinsic functions (such as using art as an investment)? Finally, there are things that appear to fulfill functions of art to a high degree, but no one would call them artworks. Suppose there was a pill that induced a fine aesthetic experience. The pill is not a work of art even though it appears to fulfill a function of art with excellence.

The last problem is most easily handled. Aesthetic experience isn't just any pleasurable sensuous experience. It requires attention to an actual object and its properties. A pill that mimicked an aesthetic experience, say, by inducing a hallucinatory experience that felt like one that is aesthetic would not actually create the real thing. Alternatively, it might make us particularly receptive to such experiences, but then it is an aid to, not an object of, those experiences.

What makes something a genuine art function? Let me suggest three routes to identifying genuine art functions. First, art functions are normally tied to the experience of the work. The value of insulation, a doorstop, or an investment can all be completely grasped without even encountering the object that possesses these properties. Typically, if not invariably, an art function can be appreciated only by experiencing a work. A work's capacity to provide aesthetic experience, to move an audience, even to enlighten it, requires experiencing the work. Even works that have minimal aesthetic payoffs, such as the previously mentioned ready-mades, have to be encountered at least in photographs to be fully appreciated because part of their power as a source of questions about the nature of art derives from the full realization of their aesthetically trivial nature.

Second, common knowledge provides a great deal of information about art functions. We know that much art is concerned with such things as representation, expression, and the discovery of forms suitable to the artistic project being carried out. In fact, we have much more detailed knowledge than that. We bring this knowledge to attempts to define art. As long as it is nontendentious, it is available for the identification of artistic functions.

Finally, when it does become controversial whether something is an artistic function, we appeal to historical connections between the purported artistic function and recognized ones. Thus, it is easy to see how the project Proust pursues in his great novel *In Search of Lost Time* of giving "literal and metaphorical expression to the nuances of self-consciousness and memory" (Stock 2000, 437) arises from a more general function of the novel to provide psychological insight or to explore the first-person point of view.

The last issue that needs to be addressed is what makes something a central art form at a given time. The answer to this question might be different

in different eras. However, whatever the details, the answer is, at its core, institutional. Items within central art forms are standardly subject to certain sorts of treatment. The specific treatment depends on the art institutions of the day and the culture. Currently, this would involve being subject to specific modes of presentation to a public, to certain sorts of critical appraisal and audience appreciation, and to a historical connectedness to earlier items. In chapter 12, we will discuss the institutional basis for taking architecture to be an art form: its classification as one of the fine arts in the eighteenth century, the current nature of architectural criticism and history, and so on.

Unfortunately, this proposal for identifying central art forms invites an objection to historical functionalism. Return one last time to Duchamp's ready-mades. They were artworks when they first appeared, but did they belong to a central art form? One might well be inclined to say no in that ready-mades were a new art form that had no time to become "central." In the twentieth century, such new forms were constantly coming into existence, though usually standing in some relation to a recognized art form: papier collé derives from painting, ready-mades from sculpture, happenings from drama. So perhaps we can get away with an emendation. Instead of talking exclusively about *central* art forms in the first disjunct of the definition, we need to also include others recognizable as art forms through their derivation from the central ones.

Consensus and Skepticism

The historicist views discussed in the previous two sections suggest that a consensus is developing about how art should be defined (see Matravers 2000; Stecker 2000). Though each at first appears to represent a different approach (institutional, intentional, functional), the similarities among these views are more striking than the differences. All accept Danto's view that art must be defined historically, and all, in the end, are committed to a definition that consists of a disjunction of sufficient conditions rather than a set of necessary conditions that are jointly sufficient (so-called real definitions). Further, unlike simple functionalist definitions, these definitions do not form the kernel of a larger, normatively aimed theory of art but are compatible with many different theories. In particular, these definitions, like Dickie's definitions, distinguish an understanding of what art is from a conception of the value of art. In fact, the disjunctive character of recent definitions suggests not only that there is no one value or function essential to art but that there is no essence of art at all.

Whatever the extent of this consensus, it excludes two parties to the debate. One is those who are still interested in pursuing a simple functionalist definition, typically in terms of aesthetic experience or properties (see Anderson 2000; Zangwill 2000). The other comprises those who

are skeptical of the possibility of any definition of art (Novitz 1996; Tilghman, 1984).

Enough has been said about aesthetic definitions, but before concluding this chapter, more should be said about contemporary skepticism and its sources. I have just said that the current institutional and historical approaches to this issue can be viewed as denying that art has an essence. What this means at a minimum is that there is not a set of essential properties that are individually necessary and jointly sufficient for an item to be an artwork. Nothing like the following is the case (pace simple functionalism): artworks are artifacts (genus) intended to provide a significant aesthetic experience (species).

However, the skeptic takes this a step further, claiming that if there is no essence, there is no definition at all—not even one containing a disjunction of sufficient conditions. Let me suggest three different motives underlying this skepticism. One is the thought that all the disagreement about what art is indicates that no answer—no definition—will ever receive total acceptance. This thought is probably correct but is indecisive regarding the main issue. A view doesn't have to receive unanimous support to be true. Further, if what was said at the beginning of this section is correct, a degree of agreement, imperfect and partial though it be, has been achieved. Facts to be mentioned in the following provide an alternative explanation for the lack of complete agreement. For now, we can just point out that lack of agreement in philosophy is hardly peculiar to attempts at definition. It is the norm regarding any philosophical project. If one despairs because of a lack of agreement, one ought to despair about philosophy and much else besides.

A second motive to skepticism about a definition of art turns on a revisionist view about concepts. The assumption here is that what we are trying to define is the concept of art, but this is based on a misunderstanding about the nature of concepts. According to prototype theory, currently popular in cognitive science, concepts are picked out not by definitions but by prototypes. A prototype is a set of statistically significant features of instances of a given kind. Prototypes are derived from exemplars: items that are typical examples of a kind, perhaps ones that might be pointed out in learning situations where the concept is acquired. Actually, this can be only part of the story about concepts. Prototypes at best pick out prototypical members of the kind in question. (Let's shelve a possible worry about how typical members of a kind are identified as members of that kind in the first place.) Part of having a concept is to be able to extend it to nonprototypical members, which are extremely numerous given the way prototypes are formed. So really a concept is a prototype and a method of extension (prototypes +, for short; for skepticism about defining art based on prototype theory, see Dean 2003).

This view raises two questions: Are concepts really prototypes +? If they are, does this really rule out definitions? I doubt that concepts are prototypes

while admitting we might have prototypes. If concepts were prototypes, there would be far more fragmentation of concepts than there is. Consider the concept *bird*, a common example used by prototype theorists. Suburbanites would have a prototype perhaps based on the features of robins, sparrows, and finches, whereas people who live near the ocean would have one based on features of gulls, terns, and cormorants. Chickens and ostriches would be birds by extension, except for people living on farms raising one or the other species. People living in Southeast Asian cities would have a different concept based on the mynah. But none of this seems to be the case. Even small children have no problem classifying chickens and even ostriches and emus as birds. People do *not* think that birdhood comes in degrees so that sparrows are *really* birds but herons are only sort of birds. Prototype theory gets our bird-classificatory practice completely wrong (for another critique, see Fodor 1998, 88–108).

However, suppose that these objections are misplaced and that concepts (or some of them) are based on prototypes. Suppose further that *art* is such a concept. Does that mean that a definition of *art* is ruled out? No. It is true that a prototype is not a definition, nor can a definition be derived from it. This is because it does not pick out the whole class of items falling under the relevant concept. The features collected in the suburbanite prototype for *bird* entail that ostriches neither are nor are not birds. However, we saw previously that concepts should not be identified with prototypes even if they are based on prototypes. Concepts would at least have to be prototypes +. Once we add the "+" (that is, the method for extending the prototype), it's not clear that we don't have the materials needed for a definition. To put the matter another way, recall the family resemblance view of the mid-twentieth-century skeptics. The problem with this view is that, if the type of resemblance used in classification is left unspecified, nothing is excluded from the classification, while if the resemblance is narrowed to specific respects, we have the material for a definition of art. Exactly the same situation occurs with prototype theory, which is also based on relevant resemblance, though this time it is to the prototype.

The last cause for skepticism is also based on the idea that what we are trying to define is the concept of art. The claim this time is not that concepts have a particular structure that rules out definitions but rather that the concept of art has become fragmented. There just isn't one thing to define anymore. There is no one concept to capture. People have different conceptions of art because art is not one thing. There can, perhaps, be mistaken conceptions, but there is not one concept that all correct conceptions have to conform to.

This thought is intriguing because it raises important questions about what would have to obtain for there to be a single concept of art. One proponent of the "no single concept" view is Alan Goldman. He appears to base his view on the purported fact that the art world is fragmented into

various different circles of artists, of critics, of ordinary art appreciators, and as one goes from circle to circle at all levels one finds no common core of agreement about what is art. So his argument is that there is no agreement among experts (artists and critics), and there is no agreement in ordinary use, so there is no common concept. Rather, we would have a concept of art relative to a circle.

The premises of this argument are very far from obvious. First, such claims tend to be based on rough-and-ready impressions rather than painstaking efforts to sort out where agreement exists and where it doesn't. Second, much of the data on which impressions are based concern judgments about particular works, and differences in such judgments have many causes, only one of which is a difference in one's art concept. They can also be based on the way works are perceived or understood, personal biases, lack of familiarity or overfamiliarity, boredom with a particular art movement, and so on. Third, the judgments that are relevant to the conclusion of this argument are classificatory judgments about candidate artworks. But it is well known that judgments that an item is or is not art are often issued to praise or disparage a given artwork, not to classify it.

Let an individual's conception of art be the totality of his or her beliefs relevant to classifying something as art or not art. A grain of truth contained in the premises of this argument is that it is false that conceptions of art are uniform across individuals. However, this in itself is not a very interesting truth. For one thing, it is probably true of individual conceptions of most objects of thought. For another, many individual conceptions of art are prereflective, insufficiently informed, and biased, and lack of uniformity among conceptions is, at least in part, due to such factors. Individual conceptions, like other beliefs, can be evaluated against various desiderata and ought to be revised to the extent that they fail to meet these. An adequate conception is one that satisfies all the desiderata. An adequate conception ought to be well informed (about the history of art forms, for example), unbiased, and reflective (in the sense of taking into account implications of one's view and recognizing other well-known views). It ought to be consistent and not viciously circular. It ought to be able to cover the generally agreed-on extension of "art" and handle hard cases in plausible ways. It ought to make the judgment that something is art corrigible. One can argue about what exactly a list of desiderata should or should not contain, but it should be initially easier to reach agreement here than on individual conceptions of art.

The important issue, in deciding whether the concept of art is fragmented, is whether there is more than one *adequate* conception of art. The more adequate conceptions there are and the more diverse these conceptions are, the more fragmented (relativized) the concept.

For reasons already given, if there are different adequate conceptions of art, they will be expressed using a common core of ideas so that all of them

will be roughly in the same ballpark. The conclusion I think we should draw from these reflections is that there is a degree of vagueness about the concept of art but not that there is serious fragmentation of the concept. Perhaps it is possible that there is more than one adequate conception of art because of this vagueness. However, far from being special to art, this is true of many of our concepts.

All this suggests that, for the project of defining art, both extreme pessimism (skepticism fed on despair of making progress in this arena) and overly buoyant optimism (supposing there is a definition that reveals the essence of art) are misplaced. What we can reasonably hope to do is suggest ways of making sense of a practice which is not so uniform as to yield an essence of art and not so shot through with inconsistency as to resist any attempt at sense making of it. By doing so, we become clearer about our individual conceptions of art, can examine them against various desiderata for an adequately defining art, and perhaps extend the common ground in our various individual conceptions.

Summary

In this chapter we have examined many proposals for classifying individual pieces as artworks and distinguishing them from nonartworks. There are three groups of proposals. First, simple functionalist proposals identify one valuable property that many artworks share and claim that this is the defining feature, the essence, of art. Whether representation, expression, form, or the aesthetic is put forward as the relevant property, simple functionalism is never able to cover the whole extension of art, struggles to accommodate bad art and struggles to exclude all instances of nonart. Hence, there are always fairly straightforward counterexamples to any simple functionalist definition. Second, there are proposals derived from the view that our classificatory practice is best captured by something other than a definition: by similarity to various paradigms (family resemblance), by clusters of properties forming several sufficient conditions, by prototypes. This view is more plausible than simple functionalism. However, it struggles between two difficulties. On the one hand, it has a tendency to underspecify our practice. For example, family resemblance views often leave undetermined the specific resemblance relevant to art classification, and prototype theories often leave out the extension principles needed to cover atypical members of a class. On the other hand, when this deficiency is remedied, these views begin to look like or at least suggest definitions. Third, there are relational definitions making up the institutional and historical views that dominated the past thirty years of the twentieth century. The view recommended here—historical functionalism—comes from this class, as does the partial consensus about how art should be defined on the basis of features com-

mon to various relational definitions. However, one point that emerges from reflections on our concept of art at the end of this chapter is that it is a vague concept, and this means that any proposed definition has to either capture this vagueness or be considered to some extent an idealization of the actual concept. In reality, both of these features are probably true of the relational views we considered—they have some of the vagueness yet are idealizations of the concept of art in play in the early twenty-first century.

Further Reading

Anderson, John. 2000. "Aesthetic Concepts of Art." In *Theories of Art Today*, edited by Noël Carroll. Madison: University of Wisconsin Press, 65–92. A defense of an aesthetic definition of art.

Beardsley, Monroe. 1983. "An Aesthetic Definition of Art." In *What Is Art?* edited by Hugh Curtler. New York: Haven Publications, 15–29. A famous attempt to define art in terms of the aesthetic.

Bell, Clive. 1914. *Art*. London: Chatto and Windus. A classic defense of formalism.

Carney, James. 1991. "The Style Theory of Art." *Pacific Philosophical Quarterly* 72: 273–89.

———. 1994. "Defining Art Externally." *British Journal of Aesthetics* 34: 114–23. Two statements of the style-historical definition of art.

Carroll, Noël. 1993. "Essence, Expression, and History: Arthur Danto's Philosophy of Art." In *Danto and His Critics*, edited by Mark Rollins. Oxford: Basil Blackwell, 79–106. The best attempt to construct a definition of art from Danto's writings.

———. 1994. "Identifying Art." In *Institutions of Art: Reconsiderations of George Dickie's Philosophy*, edited by Robert Yanal. University Park: Pennsylvania State University Press, 3–38. A historical procedure for identifying art.

———, ed. 2000. *Theories of Art Today*. Madison: University of Wisconsin Press. An excellent collection of essays on contemporary attempts to define art.

Collingwood, R. G. 1938. *Principles of Art*. Oxford: Oxford University Press. A classic statement of expression theory of art.

Danto, Arthur. 1964. "The Artworld." *Journal of Philosophy* 61: 571–84. An early attempt to conceive art historically.

———. 1981. *The Transfiguration of the Commonplace*. Cambridge, Mass.: Harvard University Press. Danto's most developed work on the nature of art.

Davies, Stephen. 1991. *Definitions of Art*. Ithaca, N.Y.: Cornell University Press. An important overview of the debate on the definition of art that defends an institutional view.

Dickie, George. 1974. *Art and the Aesthetic: an Institutional Analysis*. Ithaca, N.Y.: Cornell University Press. The best source of Dickie's early institutional definition of art.

———. 1984. *The Art Circle*. New York: Haven Publications. The best source for the later institutional definition.

Gaut, Berys. 2000. "'Art' as a Cluster Concept." In *Theories of Art Today*, edited by Noël Carroll. Madison: University of Wisconsin Press, 25–44. Just what the title says.

Levinson, Jerrold. 1979. "Defining Art Historically." *British Journal of Aesthetics*, 19: 232–50. Defends the best-known version of the historical definition of art.

Mandelbaum, Maurice. 1965. "Family Resemblances and Generalization concerning the Arts." *American Philosophical Quarterly* 2: 219–28. Raised important doubts about antiessentialism.

Stecker, Robert. 1986. "The End of an Institutional Definition of Art." *British Journal of Aesthetics* 26: 124–32. A critique of Dickie's later institutional definition.

———. 1997. *Artworks: Definition, Meaning, Value*. University Park: Pennsylvania State University Press. Defends historical functionalism and provides a wide ranging critique of alternatives.

Walton, Kendall. 1977. "Review of *Art and the Aesthetic, An institutional Analysis*." *Philosophical Review* 86: 97–101 A criticism of Dickie's earlier institutional view.

Weitz, Morris. 1956. "The Role of Theory in Aesthetics." *Journal of Aesthetics and Art Criticism* 15: 27–35. The classic source of antiessentialism.

6

What Kind of Object Is a Work of Art?

Recently, the DVDs of many of Charlie Chaplin's films have been created. In accomplishing this task, technician and producers had to look at many prints of the films containing different versions. Chaplin produced some of these versions, but sometimes he altered his own originals. For example, his famous film *The Gold Rush* was originally a silent movie, but after the advent of sound, Chaplin produced a version with voice-over narrative. Does this mean that there are two similar but distinct films with the same title and director (Chaplin), or can one film literally have different versions? There are other versions that add scenes that Chaplin edited out and others that leave out scenes contained in Chaplin's versions. It might seem that we can dismiss these in virtue of departing from the work Chaplin intended. In some cases we can clearly do this, as in pirated copies where scenes are cut because that part of the print had deteriorated. Some, however, might argue that such a dismissal could in some circumstances be overhasty. What if Chaplin (contrary to fact) preferred one of these versions and had expressed this preference publicly? If we agree with this preference, should we say that this is a better but different film than the one Chaplin made or a better version of the same film? Alternatively, suppose that a print "enriched" with previously cut scenes happened to be the one audiences favor and that some of these scenes crucially shaped critical reception and common perception of the film over the years. Would these facts help shape the work, perhaps by altering its properties?

However we answer these questions about versions and the role of original intention and subsequent reception in constituting a privileged version of a film, there are still more basic questions about the kind of entity films are. No print, reel, electronic copy, or screening is the film. Even the only print of the film is not the film because it can go out of existence without the film doing so if it is copied just before its demise. So what exactly is the film? Similar questions apply to works of music and literature. Neither a

score nor a performance is the musical work, though the latter enables us to hear it. No copy of a novel or poem is the novel or poem, though it allows us to read it.

This chapter is concerned with the objects of critical interpretation and appreciation: artworks. The questions it raises are the following: What kind of objects are these? Do they belong to a common kind, or are these objects too diverse for such a common characterization to be possible? Are the objects of art interpretation the sorts of things capable of having an essence or essential properties? As we will see, the way one answers these questions has a bearing not only on one's conception of these objects but on how we should conceive interpretation as well. Hence, this chapter is both about artworks and their interpretations.

How is the question we are asking now related to the one asked in chapter 5: what is art? Here are some differences between the questions. Suppose we find out an answer to the question we are asking now. We will argue here that many artworks belong to one of two kinds: physical objects and structural types. (Chaplin's films belong to the latter category.) This has implications for the kind of properties these works possess and how we can access them. It also has implications for what makes a given work the individual work it is. However, it won't help us with the classificatory project of the previous chapter. Being a physical object or a structural type does not distinguish artworks from many other objects, which are also physical things or structural types but are not artworks. However, making this distinction is precisely the task of classification. So while the two questions—what is art, and what kind of objects are artworks?—look and sound similar, answers to them give us quite different pieces of information.

The Contextualist Paradigm and the Constructivist Paradigm

Suppose Peter gives a critical interpretation of *Macbeth*. Peter is doing something. He is doing it with respect to some object. What is he doing? What is the object his doing addresses?

These seemingly simple and straightforward questions call forth a bewildering variety of answers. Let us begin with what I take (perhaps unwisely) as common ground. If Peter is giving a *critical* interpretation, he is either thinking or saying something about *Macbeth*. He is doing this to better understand or better appreciate the play. If that is common ground, this is where it ends. Some people think that what Peter is doing is best characterized as attempting to grasp or discover certain truths about the play (Beardsley 1970; Carroll 2001a; Davies 1991; Hirsch 1967; Levinson 1996; Stecker 1997, 2003; Wollheim 1980). Other people believe that interpretation is never concerned with truths—truth and interpretation exclude each other. However, the people who take this view don't agree among them-

selves on the positive account of what Peter is doing. There are those who believe that when something is a matter of interpretation, we are concerned with a way of taking an object (such as *Macbeth*), which is not straightforwardly true or false of the object but claims to be a plausible, apt, or reasonable way of making sense of the object (Margolis 1980, 1995; McFee 1992; Shusterman 1988). Those who think this sometimes go on to claim that meaning is being created or constructed by this process. That is, prior to interpretation, the play is indeterminate or incomplete with respect to certain questions, and it is interpretations that make it more determinate or more complete. A more radical view is that interpretations don't merely make something more complete but also create something new—a new object from the one initially encountered (Fish 1980; Thom 2000).

With these different conceptions of what Peter is doing go different conceptions of the object of interpretation, the referent of "*Macbeth*" for the case at hand.

Those who believe that giving an interpretation of *Macbeth* involves attempting to discover truths about the play very commonly also believe that the play exists and that the properties of it that interpreters hope to identify are in place before interpretation begins. Indeed, it is very common among those who hold this view to believe that the play possessed those properties since it first came into existence—roughly the moment when Shakespeare completed the writing/revising of the play. The idea that the chief properties interpreters hope to identify are fixed at the origin of a work is frequently tied to a view about the nature of the object of interpretation, namely, that features of the context in which the work was created are essential to the work—we don't have that work absent those features.

I say these views are often held together. One can say something stronger: that these claims taken together explain what people are doing when they interpret artworks in virtue of how core meaning properties are fixed, which in turn is explained by the nature of the works themselves. The latter views are one possible underpinning of the former and an underpinning that a number of philosophers have found attractive (Carroll 2001a; Davies 1991; Levinson 1996; Stecker 1997; Wollheim 1980). This set of claims forms the contextualist paradigm that we mentioned toward the end of chapter 1. It can be summarized as follows: when we interpret a work of art,

1. we are attempting to discover certain truths about it,

2. which are fixed when the work is created,

3. in virtue of features of the context in which the work is created,

4. which features are essential to the very existence of the work.

We also find a paradigmatic set of connected beliefs when we turn to the alternative conceptions of what we are doing when we interpret works. Those who believe that we are constructing the objects we interpret, either because our interpretations alter those objects by imputing properties to them or because they actually create new objects, believe there is some degree of dependence by the object of interpretation on the interpretation of the object. Those who hold the views mentioned so far also frequently claim that the object of interpretation lacks an essence or fixed nature. Perhaps this is also a consequence of the idea of the dependency of objects of interpretation on their interpretations. If one believes, for example, that this object is constantly changing in virtue of being constantly reinterpreted, this might influence one in believing the interpreted object lacks a fixed nature that would "resist" such change. Call this set of views the constructivist paradigm. It can be summarized as follows: when we interpret a work of art,

1. we are imputing properties to something which either alters that very thing or creates something new.

2. Hence the objects of interpretation have a degree of dependence on the interpretations people give of these objects.

3. Such objects are identified in terms of the properties they are conceived as having (intentional objects).

4. Such objects lack an essence or fixed nature.

We have, then, two paradigmatic views about interpretation and its objects: the contextualist paradigm and the constructivist paradigm. In the debate over interpretation and its objects, people have tended to gravitate around these sets of beliefs. They don't exhaust the whole field of views about interpretation, but they hold a prominent place in the theoretical landscape. Because of this, we should give careful consideration to each paradigm. I begin by examining some of the claims made within the constructivist one.

Objects of Interpretation as Intentional Objects

It is sometimes claimed that the object of interpretation is an intentional object. This can mean different things, but one thing it is sometimes taken to mean is that the object of interpretation in the case of *Macbeth* is the play *as it is conceived in the thought of an interpreter*. "The intentional object of interpretation is that toward which the act of interpretation is directed. It is identified via a set of features *believed by* the interpreter to apply to it" (Thom 2000, 20, emphasis added).[1] This view, call it the intentional view, confuses

the object being interpreted with the interpretation. It is the latter—the interpretation—that tells us how an interpreter conceives of an object, but then it is always open to us to ask, Is the conception true or false, plausible or implausible, adequate or inadequate, useful or not useful, and so on? If the object of interpretation is simply an object as conceived in an interpretation, it is not clear how we could sensibly ask these questions. The conception is automatically true of and adequate to the intentional object since it is defined as having just those properties it is conceived to have. Given this, it makes little sense to go on to ask whether it is either useful or plausible to conceive the intentional object as it is defined to be.

To this it might be replied that there are some conceptions of objects that are prior to particular interpretations of the objects. This is certainly a possibility, and where one identifies a prior conception with the object of interpretation, one could not say that this object is being confused with the interpretation. It would remain a mistake, however, to make this identification. For we can still ask, of the preinterpretive conception, the set of questions mentioned in the previous paragraph. With respect to the work, is this conception true or false, adequate or inadequate, useful or not useful? If we can sensibly answer these questions, the work is the real object of thought, the conception being some beliefs about this object prior to and quite possibly facilitating an interpretation of it. It is only if we cannot sensibly answer these questions that it would be plausible to say the conception itself is the object of thought and interpretation, but the idea that the questions make no sense is one few would want to accept. When we form a conception of something, that is, when we come to think of an object as having certain properties, this conception is not the object of thought but the vehicle or content of thought. What we think about an object shouldn't be confused with the object being thought about.

Proponents of the intentional view sometimes claim that the interpretation relation is not a two-place relation (A is the interpretation of B) as it appears to be but is one that has three terms. The idea is that interpretation always involves two objects (in addition to the interpretation itself). There is an initial object that prompts us to interpret and a subsequent object that is the product of our interpretation. The subsequent object is constructed from the initial object by the interpretation. This conception of interpretation is sometimes used to attempt to fend off objections such as those just raised to the intentional view. How this is to be done depends on the way that we think of the initial object. (The subsequent object is always understood as intentional.)

One line of thought is that the subsequent object is constructed by selecting "material" found in the initial object (Krausz 1993, 66–67). This suggests that the initial object is a nonintentional object such as a work or text. We can now sensibly ask of the subsequent object whether the properties it purportedly selects from the initial object are really possessed by it,

whether it is plausible that the initial object has those properties, whether it is a useful selection, and so on. The problem with this approach is that it is completely unnecessary to hypothesize the subsequent object to understand what is going on when we engage in interpretation. Suppose that the initial object is the work, which is the most plausible assumption. The interpretation itself already selects features from the work in order to make various claims about it. It is the work, after all, that is the object we are interested in understanding and appreciating. It is the feature-selecting interpretation that accomplishes this understanding. Not only is there no need to postulate another subsequent object, but doing so does not help us see how interpretations illuminate *artworks*. Supposing that interpretations construct subsequent objects is a prime example of confusing or conflating the interpretation and the object of interpretation.

A second line of thought supposes that both the initial object and the subsequent object are intentional objects. The initial object is the intentional object defined by the sort of preinterpretive conception that we mentioned previously. The subsequent object constructs a richer, more significant intentional object (Thom 2000, 184). So, for example, suppose we have two interpretations of Macbeth's "life's but a walking shadow" speech. One claims that it represents only Macbeth's frame of mind at this point in the drama. Another claims that it represents not merely how Macbeth sees human existence but also the play's vision of life. On the present view, the initial object is our conception of this speech prior to either interpretation. There are two subsequent objects, each supplementing the initial object with one of the two interpretations. There are two main problems with this line of thought. First, we seem to have completely lost the play *Macbeth* as an object of interpretation since the play is identical neither with the initial nor with either subsequent object. The play exists independently of any individual interpreter's conception, while the initial and subsequent objects just mentioned do not. This result is unfortunate because we want interpretations to illuminate artworks, not merely supplement our conceptions of artworks. Second, it is very obscure how we are to evaluate competing interpretations on the present view. We cannot turn to the prior objects since they are completely silent on interpretive matters. They simply lack the properties predicated to the subsequent objects. My initial conception of Macbeth's speech is silent on whether it just reflects Macbeth's state of mind or presents a vision of life endorsed by the play. To evaluate these interpretations, one has to consult what is so far missing—the play. However, if we have to do this anyway, there is a much simpler conception of interpretation at hand, namely, that the object of interpretation is neither an intentional initial object nor an intentional subsequent object but rather the artwork (or other nonintentional object) about which the interpretation makes claims as to its meaning and significance.

I conclude that the object of interpretation is not an intentional object in the sense of an object-under-a-conception.

There is another sense of intentional object that is more plausible. Something is an intentional object in this sense if it is a being that possesses intentional properties either inherently or in virtue of being produced by individuals or groups with intentional properties whose states they express or represent. People are intentional objects in this sense because they have intentional states (beliefs, desires, intentions, and so on), and artworks and other objects of interpretation are intentional objects in virtue of expressing or representing intentional states. The claim that objects of interpretation are intentional objects in this sense is unobjectionable, but it is no longer a view peculiar to the constructivist paradigm. It is held just as firmly within the contextualist paradigm.

Do Artworks Lack Essences?

A second important belief about the object of interpretation that is a part of the constructivist paradigm is that artworks and other objects of interpretations lack a "fixed nature" (Margolis 1995, 80), or essences. Clearly, one *motivation* for making this claim is to consistently allow a work's meaning to be open to alteration by interpretation, without being committed to the idea that such interpretations (literally) change the subject by addressing a new and different work. "If a text or artwork has no fixed nature, then its ongoing interpretation . . . may change its 'nature' without producing incoherence or self-contradiction and without jeopardizing . . . its identity" (Margolis 1995, 80).

Of course, the mere fact that one statement conveniently bolsters another that one happens to believe is no *reason* to accept the former, even if it is a motive for doing so. For one thing, the latter statement may be better supported by something else (for example, works can undergo changes in meaning because meaning properties are not among a work's essential properties). Do those who embrace the constructivist paradigm give us reason to believe that artworks and the like lack essences? One important philosopher, Joseph Margolis, offers up the following: 1) no one has ever proved that to deny essences commits one to a contradiction; 2) no one has ever been able to identify a set of general attributes by which each individual can be distinguished from every other in the universe; 3) evolutionary theory suggests that biological entities change in traits by which one species is distinguished from another, which, it is claimed, rules out essences in their case (Margolis 1995, 72–73).

It would take us too far afield and many more pages than are available to consider any of claims 1 to 3. To facilitate discussion under these constraints, I propose we consider a couple of more manageable questions: Do

artworks, among the objects of interpretation, have *essential properties*, that is, properties without which they cease to exist? Can Margolis consistently deny that artworks lack such properties? Regarding the first question, I believe there are strong intuitions that artworks do have essential properties. For example, suppose we blew up Michelangelo's *David*. Surely it would cease to exist even if we were able to collect all the matter that previously composed it and place it in a pile. Doesn't this mean that the pile lacks properties essential to being *David*? Doesn't this strongly suggest that it is not a contingent fact that *David* is not a pile of variously shaped pieces of marble along with some vials of gasses? Now suppose that a contemporary Italian artist made a work that looked just like the un-blown-up *David*. Doesn't this sculpture also lack something essential to being *David*? Just what this is might be debated, though a very plausible view would be that one of the relevant properties is that of being created by Michelangelo. None of this proves that *David* does have essential properties since someone might agree that both the pile of rubble and the early twenty-first-century replica are not *David* but insist this is a contingent fact (contingent, perhaps, on our identificatory practices). On the face of it, however, that view is far less plausible than the view that the sculpture couldn't be a pile of rubble. On the face of it, it is very hard to believe the statement that it *could* be true that the pile of rubble is *David*.

Turning to Margolis's own views about the ontology of art, it also appears to be committed to the existence of essential properties. Margolis's views here consist in a number of different claims of which I will mention three. First, artworks are culturally emergent, physically embodied entities. Second, artworks are tokens-of-types. Third, we reidentify artworks by appealing to sameness in structure and history. Each of these claims strongly suggests that artworks have certain essential properties. To say that something is culturally emergent implies, for Margolis, that it has intentional properties. To say that it is physically embodied implies that it has certain physical properties—properties of the sort possessed by physical objects. Surely this means that artworks are essentially things having both intentional and physical properties, and anything that lacked this combination of properties—such as the rubble I spoke of earlier—would lack something essential to being an artwork. Now consider the claim that artworks are tokens-of-types. To see how this implicates the existence of essential properties, consider a nonart example of a token-of-a-type—the American flag. Notice that nothing could be such a token that didn't have certain structural properties that it shares with the type, such as having stars and stripes and being red, white, and blue. Such properties are essential for being a token of that type. Notice further that there being essential properties does not rule out certain historically grounded changes in structure over time as is evident in the variety of different designs possessed by American flags. Given Margolis's idea that artworks are tokens-of-types, we can see why we reidentify them by appealing

to structural and historical properties, but at the same time this reinforces the claim that some such properties are essential to the works being reidentified.

Finally, notice that Margolis believes that artworks are all one kind of entity: tokens-of-types that are culturally emergent and physically embodied. As we have already seen, if this were so, it would imply that artworks do have essential properties since it would imply that nothing could be an artwork that was not this kind of object.

However, the converse of this claim is certainly false. Just because artworks have essential properties, it does not follow that they all belong to the same ontological kind. A more plausible view, as we shall now see, is that they belong to a variety of kinds, but it remains true that the identity of an artwork depends on certain historical and structural properties.

Contextualism

I now turn to the way the object of interpretation is conceived within the contextualist paradigm. Although there is not a single such conception, contextualists share in common the following ideas (Davies 2001; Levinson 1990; Wollheim 1980): 1) Artworks are ontologically diverse. There is no single sort of thing that all artworks are. 2) All share at least one thing in common: that the identity of a given work in part depends on the historical context in which it is created. 3) Musical and literary works are "context-sensitive" structural types.[2] 4) Some artworks, such as paintings and some sculptures, are physical objects. Note that it is not being claimed that context-sensitive structures and physical objects are the only types of thing that artworks can be. Call this position "heteronymous contextualism" because it claims that the class of artworks consists of different types of entities, the identity of all of which is tied to their context of origin.

The main advantages of this contextualist position are two. First, it captures a strong intuition that there is a significant difference between paintings and uncast sculptures on the one hand and literary and musical works, films, and cast sculptures on the other. (This is not meant to imply either that there are no ontologically significant differences within these categories or that there are not other significant categories of artworks.) Second, the way the position attempts to capture the difference seems to be roughly right, namely, that the former category contains concrete things, while the latter contains things that are abstract and therefore not physical. This is so because a given work in this category has many instances, and in virtue of this, there is no physical or concrete thing one can point to and say without qualification, "That is the work."

However, despite this rough rightness, there are important problems for the idea that both some works are context-sensitive structures and others are physical objects.

An abstract structure is an object that is capable of many instances. The square is a two-dimensional geometrical structure—an arrangement of lines and angles. One can encounter many instances of such an arrangement, many instances of the square. Musical works have sound structures, and literary works have linguistic structures (texts). These structures are also abstract because one can encounter them over and over again—each time one hears the music or reads the literary work. Some claim that musical and literary works just are these context-independent, abstract structures (Goodman and Elgin 1988, 49–65; Kivy 1993, 35–94). However, there are three objections to this view. One is that such structures cannot be created but only discovered. But works of music and literature are created, so they cannot be mere context-independent structures.[3] Second, different works can share the same abstract structure, so these structures alone cannot be the works.[4] Third, a work has crucial artistic properties that derive not from their structure but from their origin. For example, it is plausible that abstract structures don't have a style since styles are ways human beings do or make things. However, Mozart's mature music, such as his clarinet concerto, is an example of the classical style. This supplies a reason to suppose that their individuation in part depends on the context of creation. So abstract, context-independent structures cannot give the whole story about the identity of works.

If one accepts all or some of these objections but plausibly believes that a structure is essential to a work's identity, then it would be natural to suppose that a work is something like a structure-given-in-a-context. This is because this view promises to capture the three intuitions behind the objections to the claim that some musical and literary works are abstract or context-independent structures, namely, that these works are created, that different works can share the same structure, and that some of their essential properties derive from context. The best-known version of this view is that a work is an indicated structure, that is, a structure indicated by an artist at a time in an art-historical context (Levinson 1996, 146) where the time is the time the work is created (discovered) and the context the artist's cultural world at this time.

This view has problems of its own. First, one might doubt that indicating a structure really is creating anything (Predelli 2001); second, one might find the idea of an indicated structure obscure or doubt that there really are such entities (Currie 1989); and, third, one might find that the view individuates artworks incorrectly (Currie 1989).

To elaborate: the first problem is made vivid when we think of indicating in completely literal terms. Indicating is normally a matter of pointing or some other kind of demonstrating, and demonstrating isn't creating. Imagine that a person is "standing next to" an abstract structure (perhaps embodied in a text or score) and pointing at it. He creates nothing new simply by pointing to a structure. No doubt, Levinson does not mean us to

take indicating so literally, but that raises the question of what is meant. This immediately brings up the second problem, the claim that the idea of an indicated structure is obscure. The third problem is most commonly supported by the claim that if the same structure is put forward by different artists in the same context at roughly the same time, the result will be that each artist produced one and the same artwork, not two different ones. Hence, the identity of the artist isn't essential to the identity of the work.

One response to these objections is to retreat to a more modest version of contextualism. One proposal is to say that a work is a structure made normative in an art-historical setting. A structure is "made normative" where the structure is put forward in such a way as to determine correct and incorrect instances of it.[5] For example, when a composer creates a score, she indicates an abstract musical structure and at the same time indicates when a performance of her work will be a correct one, namely, when it instances the same structure. The first two objections are handled by substituting "made normative" for "indicated," while the third is handled by allowing that two artists might produce the same work in the same setting.

I find this response not completely satisfactory as it stands. The main reason is that the same structure and the same art-historical setting are insufficient to guarantee identity of work. Identical scores might be produced in the same musicohistorical setting, but if one is made with the intention that it be played to parody the other, it is plausibly a different work. More generally, the same art-historical context leaves room for artists to do quite different things with the same structure. That is sufficient for the making of different works.

I endorse a different response, one that claims that literary and musical works are structures-in-use. What do poets actually do when they "indicate" structures? They put words together to make lines and lines together to make a poem. They use words and lines to do something. Writers working in other literary forms and composers do similar things. We can think of an indicated structure—a work—as a *structure-in-use*. It is very common for humans to use abstract structures. For example, that is what we constantly do when we use language. We take abstract structures—sentences—and use them to say something. Each time a student comes to my office, I utter the same sentence—would you like to sit down?—and use it to say something slightly different each time since I refer to a different student. When I do this, we produce something new: an utterance. Utterances say things that the sentences by themselves did not say. The content of what we say is a proposition, but to identify the proposition correctly, it is not sufficient to refer to the sentence, but we also must make reference to the context of utterance.

We should think of literary and musical works on this model. Writers and composers use abstract structures to do something, thereby producing something new: the work, the product of what writers and composers do.

Works come to us when a writer or composer uses a structure at a given time in a historical context. This should be regarded as no more obscure than using language to say something. Talk of using structures, by the way, shouldn't mislead us into thinking that structures are found whole and ready for use like a preassembled trampoline. Writers and composers have to assemble the structures they use. That is also true of most of the sentences we use to make utterances. Like utterances, works have properties that abstract structures considered apart from the context of creation don't and couldn't have. However, musical and literary works are still abstract entities.

In order to flesh out this view further, let us consider how it answers the following questions: If works are structures-in-use, does it follow that they are or are not norm-kinds? Are they tied to a single agent (artist or ensemble of artists)? Are they created?

The view that some artworks are structures-in-use is compatible with the idea that one of the things that the artist does in using the structure is to make certain properties normative, and further, in doing this, the normativity of the property is made an essential feature of the work. If this makes a work a norm-kind, then it is consistent with the structure-in-use view that works are norm-kinds. It does not, however, strike me as obvious that making some property normative is something artists do across the board in using a structure. It is an apt idea in the performing arts where, in making works, artists at the same time create instructions (such as scores) for performing those works. For nonperforming literary works, what are made normative are conditions for creating a good text of a work, which depends on having the *correct* sequence of symbols.

Is a work essentially tied to a single artist (or ensemble), or can different artists working independently be responsible for the same work? Different people can make the same utterance, that is, say the same thing. So there is some plausibility in saying that it is logically possible, if most unlikely, that two artists, in the same art-historical context, working at roughly the same time, might do the same thing with the same structure, thereby "indicating" the same work. On the other hand, the set of properties essential to understanding and appreciating artworks is far richer than the semantic and pragmatic properties essential to understanding conversational utterances. The former set may include, for example, relational properties connecting this work to other works in an artist's oeuvre. Imagine that Haydn wrote a symphony—his lost last symphony—that is note for note identical with Beethoven's First Symphony. It is plausible that these symphonies would have essentially some very different musical and historical properties. So, while I don't claim that the matter is entirely settled, on the structure-in-use view, given the sort of essential, contextual properties works possess, the more plausible view is that many, if not all, work will be essentially tied to a single artist or artists working in collaboration.

Are works not only tied to a single artist (or ensemble) but also literally created by them? I don't find it obvious that abstract entities, abstract structures included, cannot be created. Consider the design for the 1995 Buick Skylark. Since artifacts are certainly things that are created, it is not obvious to me why their designs or structures are not created too rather than discovered. Amie Thomasson (1999), who recognizes a class of created abstract entities that she calls abstract artifacts, endorses this view. Among these are some that are brought into existence by the acts of their creators in a particular historical context, which content is essential to them. Julian Dodd (2000), on the other hand, argues that even context-sensitive structural types are not created since they are still types and that all types are eternal. His test for the existence of a type is the existence of an associated property that supplies conditions that must be satisfied for something to be a token of the type. Consider a type partially defined by the property: being created in 1995. This property is eternal even though only things created in 1995 have the property. So, for Dodd, the type is eternal. However, one needn't accept Dodd's view. First, it is not clear that all properties are eternal (Howell 2002b). Consider the property of being a remake of the Spencer Tracy–Elizabeth Taylor film *Father of the Bride*. Could that property exist before the existence of actors and film? Second, one can require, for a type to exist, not only that there be the associated property but also, among other possibilities, either that there be tokens of the type in existence (Margolis 1980) or at least instructions or designs for creating such tokens. There is some plausibility in saying that the whale does not exist until there are whales (tokens of the type) and that Mozart's Clarinet Quintet doesn't exist until he wrote the score—the instructions for creating tokens.[6] My sympathies lie with Thomasson rather than Dodd. It is counterintuitive to suppose that the 1995 Buick Skylark and the clarinet existed in the age of the dinosaurs. If that is true for types of automobiles and musical instruments, it is true for Mozart's compositions for clarinet. So I conclude that types can be created, and structures-in-use, or at least many of these, would be apt candidates for being created types.

I now turn to the claim that some artworks, such as drawings, paintings, and uncast sculptures, are physical objects. An initial objection to the claim that paintings and the like are physical objects hinges on the idea that they too are really structures or at least structures-in-use. Every drawing or painting has structural features, though, as with literature and music, there are different ways of defining structure. The structure of a drawing might be an arrangement of lines and shadings, or it might also include the way three-dimensional space and objects conceived as volumes are represented. The objection is simply that we should opt for a more uniform ontology of art by conceiving of all works, including paintings and drawings, as structures-in-use potentially with multiple instances, if not always so in practice.

The answer to this "objection" is that it is really a suggestion for revising our conception of the artworks under discussion for the sake of conceptual tidiness, and conceptual tidiness is not a good enough reason to do this. I believe conceptual change along these lines might be justified, but only if there are insuperable problems for our current conception or at least advantages for the new conception more substantial than tidiness. I will concentrate on defending the coherence of the physical object conception of paintings and the like.

An objection of more substance to the view that paintings are physical objects is that such works have properties, "intentional properties," that physical objects cannot have (Margolis 1995). "Intentional" here is being used in the second way discussed previously in connection with intentional objects. At least a partial characterization of *intentional property* is this: Human beings have intentional properties in virtue of having intentional psychological states, that is, contentful states such as thoughts, beliefs, desires, and intentions. Objects have intentional properties in virtue of expressing some of those psychological states. So intentional properties of a painting might include its representing a lion, its symbolizing injustice, its expressing indignation. However, it is not clear why physical objects cannot have both sorts of intentional property. If human beings are just living biological organisms, then they would be physical objects possessing the relevant intentional psychological states. If a stop sign is a physical object and yet expresses a message (stop!), then physical objects can express human intentions. The possibility is clearly a very live option, so this objection is less than decisive.

A third objection concerns the essential properties of artworks and physical objects. A painting is created when a quantity of paint is applied to a canvas and arranged in a certain way. Similarly, a sculpture of a man is created when a piece of clay is molded into a certain shape. Obviously, the piece of clay existed before it was so molded and will survive another change in shape. So the sculpture is not the same physical object as the piece of clay since it has its shape essentially. When the clay is a "shapeless lump," whether this is before or after the sculpture of a man is created, it is not a sculpture of a man. The sculpture is not even the same physical object as the man-shaped piece of clay because being man-shaped is a contingent property of the piece of clay but an essential property of the sculpture. There is no reason to suppose that the man-shaped piece of clay wouldn't survive a change in shape. There is every reason to suppose that the sculpture wouldn't survive a change in shape. So either the sculpture isn't a physical object or, if it is, there are (at least) two physical objects occupying exactly the same place at the same time—the one that wouldn't survive a change in shape and the one that would. Similarly for the painting; there is the object that couldn't survive a rearrangement of paint on canvas and the one that could. The problem is that there cannot be two ob-

jects of the same kind in the same place at the same time. If there are two physical objects where the painting or sculpture is, we appear to violate this principle. If paintings and sculptures are physical objects, we appear to have too many of them at a given time and place.

To solve this problem, it may look appealing to replace the claim that paintings and sculptures are physical objects with the claim that they are culturally emergent, materially embodied objects. We now seem to get a different kind of object occupying the same space as the physical paint on canvas. Further, paintings can exist and acquire identity conditions only in a cultural context. So the suggestion not only seems to solve the problem but also seems apt. However, this appearance is illusory. The reason is found when we inquire further into what these culturally emergent entities are. One condition they must meet is that they possess some properties of the material object that embodies them (Margolis 1980, 21–22). Which properties? Presumably, physical properties such as weight and dimensions. However, it is a principle at least as plausible as the one cited in the previous paragraph that what possesses physical properties is a physical object. So it turns out that culturally emergent, materially embodied objects are physical objects after all. If so, we are back to square one.

Here is an alternative solution. The problem we are discussing applies to artifacts of all kinds, not just certain types of artworks. Consider an iron wheel. Where the iron wheel is, there is also a wheel-shaped lump of iron. A lump of iron is a physical object. If the wheel is a physical object and there cannot be two physical objects in the same place at the same time, then the wheel is the lump of iron. But the wheel and the lump have different essential properties. If the piece of iron were put in a press and made into an iron cube, the lump would survive, but the wheel would not. So an iron wheel is not a physical object. This conclusion is absurd. So the principle that leads us to it is false. A plausible alternative principle says that we can have different physical objects in the same place at the same time as long as they are different kinds of physical objects (Wiggins 1980). There is no reason why the identity parameters of some physical objects, especially functional objects made by human beings, should not be interest relative and culturally conditioned. So both wheels and lumps of iron (even wheel-shaped lumps) are physical objects, but they are different kinds of physical objects with different kinds of identity conditions. The same is true for painting and sculptures on the one hand and paint on canvas and lumps of clay on the other.

Summary

In this chapter, I first distinguished between two paradigmatic sets of beliefs about interpretation and its objects: the contextualist paradigm and the

constructivist paradigm. Under the constructivist paradigm, artworks and other objects of interpretation are conceived to be intentional objects that lack essences but, with questionable consistency, are also all supposed to be objects belonging to a single kind. I argued against this conception and in favor of heteronymous contextualism. Some artworks are context-dependent abstract structures—structures-in-use. Others are physical objects. There no doubt are other types of artworks that belong to other ontological categories.

It should not be concluded that the criticism of the constructivist paradigm shows that the whole constructivist conception of interpretation is implausible. Constructivist views about interpretation itself are not logically tied to the ontology we considered under the constructivist paradigm. Hence, an evaluation of those views would require an independent examination (see Stecker 2003). However, we will not pursue such an examination here. Rather, taking our cue from the contextualist paradigm, we will ask in the next chapter how the various features in the context of the creation of artworks—intentions, conventions, and background features—fix the meaning of those works. There are many possibilities here and many competing theories to occupy our attention.

Further Reading

Davies, Stephen. 2001. *Musical Works and Performances*. Oxford: Oxford University Press. An overview of the debate about the ontology of music and a defense of contextualism.

Dodd, Julian. 2000. "Musical Works as Eternal Types." *British Journal of Aesthetics* 40: 424–40. A defense of the view that musical works are uncreated abstract types.

Goodman, Nelson, and Catherine Elgin. 1988. *Reconceptions in Philosophy and Other Arts and Sciences*. Indianapolis: Hackett, 49–65. A defense of literary works as an abstract sequence of symbols.

Howell, Robert. 2002. "Types, Indicated and Initiated." *British Journal of Aesthetics* 42: 105–27. A defense of the idea that abstract objects such as types can be created.

Kivy, Peter. 1993. *The Fine Art of Repetition*. Cambridge: Cambridge University Press. A defense of music as an eternal type.

Krausz, Michael. 1993. *Rightness and Reasons*. Ithaca, N.Y.: Cornell University Press, 1993. An influential examination of constructivism and the conception of art objects as intentional objects.

Levinson, Jerrold. 1990. *Music, Art, and Metaphysics*. Ithaca, N.Y.: Cornell University Press. A highly influential collection of essays from a contextualist point of view.

Margolis, Joseph. 1980. *Art and Philosophy*. Atlantic Highlands, N.J.: Humanities Press. Margolis's clearest statement of his constructivism.

———. 1999. *What, After All, Is a Work of Art?* University Park: Pennsylvania State University Press. An updated version of Margolis's constructivist views.

Stecker, Robert. 2003. *Interpretation and Construction*. Oxford: Blackwell. A critique of constructivism and a defense of contextualism.

Thom, Paul. 2000. *Making Sense*. Lanham, Md.: Rowman & Littlefield. An easily accessible defense of constructivism.

Wollheim, Richard. 1980. *Art and Its Objects*. 2nd ed. Cambridge: Cambridge University Press. One of the first works to propose that literary and musical works are types, while painting and sculptures are physical objects.

Notes

1. It should be emphasized that "intentional object" is a technical term to indicate an object defined in terms of the way it is conceived or interpreted. Intentional object does *not* mean an object the correct interpretation of which is fixed by the intention of the artist. The role of artist's intention in interpreting artworks is discussed in chapter 7. For further development of the conception of an intentional object discussed in this chapter, see Krausz (1993) and Margolis (1980, 1995).

2. For Levinson, these are *indicated* structures, that is, structures that an artist puts together or identifies in some way in a context at a time. The identity of the artist, time, and context are all essential to the identity of the work (Levinson 1996, 146). For Davies (2001), only context and time are essential. Howell (2002a) has convincingly challenged the claim that all literary works are structures partially defined by a specific word sequence and would issue a similar challenge regarding musical works. In light of this, the thesis should be restricted to some types of literary and musical works.

3. I will argue later in this chapter that some abstract structures are created. The structures referred to in this objection, however, are eternal, hence uncreated, patterns, to use Robert Howell's (2002b) terminology.

4. The idea that one can have different artworks with the same abstract structure derives from arguments offered by Danto (1981) that one can have indiscernible artworks and thought experiments such as that provided by Borges in "Pierre Menard, Author of the *Quixote*." This objection and the next are intimately linked. If different works can share the same structure, then other factors must be responsible for crucial artistic properties, and broadly contextual factors are obvious candidates.

5. Davies (2001). The idea of a "norm-kind" was first advanced in Wolterstorff (1980). Levinson himself appeals to the concept of a norm-kind to help flesh out the notion of an indicated structure (Levinson 1996, 144–46), but this can't be his whole story if indicated structures are essentially tied to specific artists. Norm-kinds need not be so tied.

6. Further arguments for such a view are given in Howell (2002b), who perspicuously writes, "When, through the coming into existence of a community practice, a pattern takes on the property of functioning to carry such semantic, formal, and expressive qualities—or when the pattern simply takes on the property by being singled out, through the existence of the practice, for production and recognition by the community—the pattern becomes the type. The property here is not the property that underlies the pure pattern itself. . . . Rather, it is a property *of* the pattern, roughly the pattern's property of actually being used in the community to carry out those qualities" (119).

However, Dodd (2002) questions whether this picture is correct. Consider two symbols that share a pattern: the Nazi swastika and the hooked cross used by the pre-Columbian Amerindian cultures. Howell and Dodd agree that these are different symbol types because they have different meanings in different communities. For Howell, the types come into existence only when the patterns acquire the property of being used as Amerindian (Nazi) symbols. Hence, the types come into existence at specific times. For Dodd, the types always exist, and their existence consists in being patterns with such and such meanings. Specifying this meaning may even involve reference to a specific historical context. Thus, the Nazi swastika is a symbol of the Nazi Party that existed in Germany in the 1930s and 1940s and perhaps subsequent political parties that are modeled on that German one. However, Dodd believes that this property (being the symbol of the Nazi Party that existed in Germany in the 1930s and 1940s) exists eternally, and this is all that is needed for the type to also exist eternally. The coherence of Dodd's view depends on whether something can be a symbol tied to a certain community before the symbol is used by the community or even before the existence of the community itself.

7

Interpretation and the Problem
of the Relevant Intention

A Brief Introduction to the Philosophy of Art Interpretation

The contextualist paradigm tells us to look to the context of origin to identify crucial features of artworks. In chapter 6, we investigated how this context provides properties essential to the identity of these works. In this chapter, we look at the role context of origin plays in interpreting artworks by focusing on the relevance of the intentions of artists to the interpretation of their works. However, as we investigate this issue, other features of the context of origin—convention and background features—also come to the fore.

The topic of intention is plausibly the one that was at the center of attention when interpretation first became an important issue in the philosophy of art and in literary and art theory. The early debate often had an all-or-nothing character with anti-intentionalists arguing that reference to artists' intentions are simply irrelevant to the interpretation of their works and intentionalists arguing that the meaning of works are to be identified with such intentions. Sixty years later, this issue is still with us, but it is now intertwined with a number of others, and the positions about the relevance of intention are both more subtle and more moderate.

Several distinct issues have emerged in the debate about the nature of art interpretation. Most relevant to the intention debate are the following three:

1. *The proper aim issue.* This concerns what interpretations of artworks are trying to accomplish and whether this can be expressed in terms of one central proper aim or whether there are multiple central proper aims.

2. *The critical monism–critical pluralism issue.* This concerns whether there is a single correct interpretation of an artwork or whether there can be multiple, noncombinable acceptable interpretations. Notice that both

of these first two issues have to do with multiplicity and plurality—of aims in the first instance and of interpretations of individual works in the second.

3. *The work meaning issue.* Is there something that we can identify as the meaning of the work and is identifying this at least one, if not the only, aim of art interpretation?

We will address all three issues in this chapter.

The Place of Intention in the Interpretation Debate: Interpretive Aims

Questions about intention enter the interpretation debate at two chief locations: with regard to the proper aim issue and with regard to the work meaning issue. This section concerns the question whether it is a proper and central aim of art interpretation to identify the intentions of actual artists.

On the face of it, it seems obvious that interpreters of artworks do have available to them the aim of figuring out the intentions of artists in making their works. After all, critics and ordinary art lovers still make such inquiries, and their doing so seems to be in keeping with other interpretive practices. To stick to matters that are completely nontendentious, when we need to interpret conversational utterances, instructions, official statements, policies, or expressions of thought such as those found in philosophical works, we routinely and uncontroversially inquire into the intended meaning of these items.

One thing that adverting to these other practices shows is that one of the most common worries about this interpretive aim, namely, whether we can ever know about the intentions of others, is overblown. In conversation, we believe that we can grasp the intentions of our interlocutors normally without asking for clarification (or else asking for clarification would be pointless). It might be replied that this is because we share a rich context of utterance when involved in conversation, but that this is the main reason we can often infer intention is belied by the fact that we bring the same belief to the interpretation of philosophical works from the past. We may have to know about the context of an utterance to have a good basis for inferring intentions, but that doesn't mean we have to operate from within the same context.

Reference to other interpretive contexts does not ward off a different kind of objection. This is the claim that art interpretation has a special dominant aim not found in these other practices that precludes the aim of identifying artists' actual intention. The claim here is that *the* aim of art interpretation is to achieve a certain sort of payoff: an appreciative experience,

enhanced aesthetic appreciation, making the work the best (object of appreciation) it can be (see Davies 1991, 181–206, Dworkin 1986, 45–86; Lamarque 2002). The basic proposal is that interpretation of artworks is for the purpose of better appreciating them. The subsidiary claim is that focus on the intention of the artist is not the best route to achieving this, or, alternatively, it is to shift our attention from *the* proper aim of interpretation to a different, improper aim.

There is undoubtedly at least one valuable point to be derived from this objection. It is that identifying the actual intention of the creator of an artwork is not the only aim we have when interpreting a work. We do sometimes aim at the sort of enhanced appreciation the objection trumpets. However, beyond this important point, there is little to be said for the objection, and to the extent that its point is to rule out the identification of intention as *a* proper aim of art interpretation, it is ineffective. This is so for at least three different reasons.

The first reason is that intention-oriented criticism can be just as appreciation enhancing as any other. While it is not necessary that the interpretation that captures the artist's intention gives us the "aesthetically best" interpretation, it is as likely to do so as any other. At the very least, it will add to the variety of reasonable interpretations of the work, which itself can add to the work's appreciation, as is recognized even by some who take the view that the purpose of interpretation is appreciative experience (Goldman 1990).

Second, it's not clear that the primary or initial aim of *any* interpretation is to enhance appreciation. Rather, it is to do this by pointing to something in the work that is not obvious or at least by pointing to a nonobvious way the work could be taken. That is, we seek to appreciate a work by forming a deeper understanding of it or by arriving at *an* understanding that delivers a richer appreciative experience. So the aim that the proponents of the objection under consideration should be pushing is better described as appreciative understanding, and one route to this is via the actual intentions of artists.

Finally, it is simply dogmatic to maintain that enhanced appreciation is *the* goal of art interpretation. Someone may simply want a better understanding of a work or, more narrowly still, be curious about what an artist intended to do in it. It's plausible that we interpret with a number of different aims no one of which is the supreme one (for a defense of this thesis, see Stecker 2003).

There is one other objection to taking the identification of actual intentions as an aim of art interpretation. This objection does not deny that we try to figure out this sort of thing, but it does deny that it has anything to do with the interpretation of artworks. Rather, it is claimed, it is concerned with the biography of the artist. The argument behind this objection is simple. Intentions belong to people, not things. Artists are people;

works are things. Therefore, discovering intentions is finding something out about artists, not artworks.

This an admirably straightforward argument. Its premises are straightforwardly true. Unfortunately, it is just as plain that the conclusion does not follow. This is because, although people have intentions and things don't, people's intentions transmit properties to the things those people do and make that are ontologically dependent on those intentions. So one can't understand those properties of things without understanding the intentions constitutive of them. Hence, when we discover art intentions, though we do find out something about the artist, we also find out something about the work. To see this, consider first an example outside the arts. Suppose you visit my house and you see, near the fireplace, a large tree stump. You wonder if it serves as a seat, but I wave you off. It is a wood-splitting platform by virtue of my intention to use it for that purpose. On the table near the fireplace is a manuscript titled "A Chronicle." You say that you did not know I engaged in historical research. I inform you that it is work of fiction. What makes it fiction rather than a real chronicle, in part, is my intention to produce a certain type of work.

The examples given so far are untendentious illustrations that intentions bear on the nature of things though they belong to people, and so an investigation into the identity of certain intentions is not merely biographical. That is, it is widely accepted that we have to appeal to certain "constitutive" intentions to understand or correctly identify certain items (see Levinson 1996, 188–89). What is the subject of greater controversy is whether actual intentions bear not just on the type of thing done or produced but also on what such a thing means or communicates (when it is the sort of thing that means or communicates at all). Settling this controversy brings us to the second way that intention enters the interpretation debate: with regard to the meaning of artworks. To understand artwork meaning, do we need to understand artists' intentions?

Actual Intentionalism as a Theory of Meaning

The most extreme intentionalist view, one that was the object of those early attacks on intentionalist accounts of meaning mentioned at the beginning of this chapter, is the identity thesis: that the meaning of a work is identical to what the artist intends to convey or express in the work. There are decisive objections to this sort of intentionalism. One such objection will suffice here. People, including artists, do not infallibly succeed in realizing everything they intend to do. The meaning of a work could hardly be identical to an *unrealized* intention. Yet this is among the implications of the identity thesis. Hence, the thesis must be false since it has a false implication.

As it turns out, the identity thesis never has had many defenders (perhaps the only unequivocal proponents of it are Knapp and Michaels 1985, 11–30). However, targeting this thesis does help isolate a necessary condition for an intentionalist theory of meaning that has a chance of success. Unrealized intentions must be excluded from the meaning-determining intentions. Unfortunately, there is disagreement over when an intention is unrealized, and this leads to different intentionalist theories. In setting these theories out, it is easiest to begin with cases of linguistic/literary meaning. We can ask later how the most viable theories can be extended across the arts.

One popular view is that intentions select a meaning when linguistic conventions leave an utterance ambiguous or indeterminate. Analogously, the intention of the author is what disambiguates literary works that would otherwise have two or more viable readings (Carroll 2001a, 198; Iseminger 1992). The conception of a realized intention, on this view, is an intention consistent with the framework provided by the operative conventions. An intention would fail to be operative that violates such a convention. Thus, Mrs. Malaprop frequently fails to say what she intends because she constantly violates the conventions of English. When she says, "There's a nice derangement of epitaphs," her utterance just can't mean that there is a nice arrangement of epithets because arrangement is not one of the conventional meanings of "derangement" and similarly for "epitaph" and "epithet." On the other hand, it is open to me to make my words refer to a riverside appointment when I say I will meet you at the bank because a riverside is one of the conventional meanings of "bank." Call this *convention-constrained intentionalism.*

There are two main problems with this suggestion. One is that its account of a realized intention is too narrow or restrictive. There are many uses of language, both in conversational and in literary contexts, where we use words in a way that extends or departs from conventional literal meaning without failing to realize our intentions. One example of such a case is irony. If you say to an acquaintance particularly prone to callous behavior that you have always been impressed with his sensitivity and compassion, the meaning of your words will be clear to most of your audience with the possible exception of the individual being addressed, who may be too conceited to take in the irony. Yet convention-constrained intentionalism implies that you necessarily failed to say what you meant since callousness is not one of the conventional meanings of "compassion" any more than arrangement is one of the conventional meanings of "derangement." Irony is usually regarded as a use of language that provides one of the best cases for actual intentionalism about meaning, and an intentionalist view that cannot accommodate it is clearly inadequate. However, there are many cases where we intend to convey something that goes beyond the conventional meaning of our words. For example, I might say, "The bus is coming," in order to tell the

children to go to the bus stop. In the context of a game of bridge, you might point out that Mary doesn't have a heart to convey that she can't trump her opponent's ace. The conventions of language permit us to convey all these things, but what we convey are not conventional meanings.

While convention-constrained intentionalism is too restrictive in some cases in its account of realized intentions, in other cases it is too broad or permissive. This is the second problem with the account. The reason for this is that it ignores context, which is just as important as convention in fixing meaning. For example, suppose I am your real estate agent, and I say, "We will close on the house [you have bought] at the bank," meaning the river-bank (because I think it would be just lovely to perform the official transfer of ownership at such a pretty spot). I probably have not done enough to convey my intention and override the contextually supported assumption that I am referring to the offices of the institution financing the purchase. Here context supplies a referent to "bank" *independently of* my intention, and in order to realize my intention that my words refer to a riverbank, I need to draw your attention to this fact and away from the contextually supplied referent.

Given the problems with convention-constrained intentionalism, one might be attracted to its polar opposite: *whatever-works intentionalism*, a view that is inspired by (but should not be attributed to) Davidson (1986). According to this view, intentions are realized if one manages to communicate them. Otherwise, they are unrealized. This view has no problem explaining the successful use of irony, figures of speech, or contextually based extensions of meaning such the use of "the bus is coming" to tell children to go to the bus stop. More dubiously, according to this view, if Mrs. Malaprop can convey to us (with an assist from context) that she means a nice arrangement of epithets by "a nice derangement of epitaphs," then her intention is successfully realized and her utterance has that meaning. It is simply of no consequence that her success has no basis in the conventionally fixed referents of the words she happens to use.

One problem with whatever-works intentionalism is that it is unable to make the important distinction between what someone says on the occasion of utterance and what is conveyed by the utterance on that occasion. This is because its whole focus is on what is conveyed. But even in conversational contexts, we are often interested in distinguishing between what a speaker intends (which if grasped is obviously conveyed) with what is actually said. This is almost always true in official conversation (such as one's boss explaining the conditions for promotion), but it is true on many other occasions as well. In making this point, I am not claiming that the meaning of an utterance should simply be identified with what is said rather than conveyed, but I would suggest that not everything conveyed is part of utterance meaning. For example, if one manages to convey something despite rather than because of the conventional meaning of one's

words (as is the case with Mrs. Malaprop), then that is not part of utterance meaning.

What we need is a conception of a realized intention and a related conception of utterance or work meaning that is intermediate between the two views we have discussed so far. Such a view might go as follows: an utterance means X if the utterer intends X, the utterer intends that her audience will grasp this in virtue of the conventional meaning of her words or a contextually supported extension of this meaning permitted by conventions, and the first intention is graspable in virtue of those conventions or permissible extensions of them. If the conditions are met, the intention to convey something with an utterance has been realized. This intention can be realized in other ways (as whatever-works intentionalists understand) but not ways that guarantee that the utterance will mean what it manages to convey.

This view—call it the *intermediate view*—has the advantage of co-opting the plausible intuitions behind convention-constrained and whatever-works intentionalism while avoiding their unattractive consequences. Intentions that determine utterance (work) meaning are tied to operative conventions but not restricted to the literal, conventional meaning of words. The role of context is also recognized. However, certain intentions conveyed (realized) via contextual pointers are ruled out as meaning determiners because they are not permitted extensions of operative conventions.

The intermediate view can be extended to all sorts of art forms beyond literature. To do this, one has to hook intentions up to the routes through which meaning is conveyed in a given art form, which may not always be convention. For example, pictorial representation may operate via natural, innate, species-wide, recognitional abilities alongside the conventions associated with a style, genre, or period. A painting will represent X if the painter intends to represent X; intends to do this via the audience's recognitional abilities, relevant conventions, or permissible contextually supported extensions of the conventions; and if the audience can recognize X through these factors.

Finally, the intermediate view needs to be regarded not as a freestanding account of utterance (work) meaning but as part of a larger account that can also include some nonintentional determinates as well. The real estate agent's proposal to meet at the bank might be an example where the intended referent of "bank" (riverbank) is less salient than, and for that reason overridden by, the contextually supplied referent (financial institution). In a somewhat different vein, a literary work, *in addition to* what it intentionally does, may inadvertently express attitudes toward a race or a gender, for example, that may also be part of the meaning of the work. For example, as Noël Carroll (2001a, 186) has noted, although Jules Verne's novel *Mysterious Island* intentionally and explicitly opposes the institution of slavery, it also, no doubt unintentionally but no less actually, expresses a residual

racism in representing the former slave Neb as a superstitious, docile, naive, childlike individual with a curious affinity with a domesticated monkey.

Criticisms of Actual Intentionalism

We have now given a role to the actual intentions of utterers and artists in fixing the meaning of utterances and artworks. It is a modest role because it is nothing like the claim of the identity theorist, that the meanings of these items are just the intentions of their makers. The intermediate view recognizes that actual intentions are one factor among several that fix meaning and that meanings can sometimes be unintended in virtue of the operation of these other factors.

Even the most moderate intentionalism has its critics who fail to be convinced that intentions have any role in fixing meaning. In this section, we will look at some of the most serious criticisms of actual intentionalism per se.

The *first objection* is the *publicity paradox*. It argues that once we take seriously a certain intention shared by all artists, this rules out the consideration of other intentions as determinative of artwork content. The widely shared intention is to create an object for public consumption, an object available to a public absent the artist. Such an object must, as it were, stand on its own. So one might conclude that the initial intention with which works are made is the intention that one's intentions not be consulted. So intentions are not relevant to work meaning (content).

Unfortunately, the reasoning behind the publicity paradox is fallacious. First, there is no paradox, and so there is no reason to reject intentionalism because it leads to contradictory conclusions (that is, to the paradox that we should both consult and not consult the artist's intentions). Rather, the point that the publicity "paradox" is making is that if we consult one intention that all artists have (to produce an object for a public), that precludes the consultation of other intentions. The first intention is constitutive: it determines the type of object we are dealing with. The intentions that we purportedly should not consider are meaning determining. The claim that the previously mentioned constitutive intention with which artworks are made rules out consulting the meaning-determining intentions of artists is either true or false but not both true and false. Of course, if it is true, that is still devastating for even moderate intentionalism.

The second point, though, is that the claim is not true. A minor problem with the claim is that it falsely assumes that all artists make their works with the "publicity intention." Some artists seem to work primarily for themselves rather than for an autonomous public, while others, especially in recent art history, attach all sorts of explanatory appendages to reveal their intentions in the absence of their person. The main reason, however, that the claim is false is that the fact that works are intended for public

consumption in no way implies that the artist intends that her meaning-determining intentions not be consulted. Just as compatible with the public nature of works is the idea that they reveal the artist's intention without further consultation. This latter idea captures the way many other forms of public communication work. If I post a set of rules for behavior in a given environment (such as a classroom), I assume that people will understand what behavior they are intended to elicit or prohibit and that they will act accordingly without further consultation. If I write a philosophy paper, once again the aim is not that readers won't consult (attempt to identify) my intentions but rather that they won't need to consult me to identify those intentions but only my paper. In short, publicity is perfectly consistent with an interest in intentions. It at most implies that interest is satisfied primarily by means of the work itself.

It might be thought that publicity has one further implication that is still damaging to actual intentionalism. This implication is that the range of evidence of intention compatible with publicity is *limited to* consulting the work. While intentionalism can recognize the work as the primary source of information about intention, it cannot confine admissible evidence to it. After all, there are often disputes about the intention of a work, and if we really want to settle these, any available evidence ought to be relevant. However, once again the claim about what publicity requires is inaccurate. This is clearest after we acquire a historical distance from a work. Then, more collateral information may be needed to access its meaning, even if its meaning-determining intentions were initially transparent. However, it is reasonable to assume that some such information is always needed, as works are not only public objects but contextualized ones connected to a culture, to traditions, as well as to an individual (or group) creator. To think of a work as a public object is at best to have a partial understanding of its nature. Publicity couldn't imply that works are self-contained modules accessible without any collateral information because such a claim is just not true.

A *second objection* to moderate actual intentionalism based on the intermediate view is the *knowledge of intention dilemma* (Trivedi 2001). To understand the objection, recall first that unrealized intentions (indeed, even some realized intentions) do not determine work meaning. The intermediate view selected a class of realized intentions and claimed that they are meaning determining. The current objection falls into place once we ask, How do we know when we have such an intention? The objection claims that there are two possible answers to this question, and neither is palatable to the intentionalist. The first answer is that we have to figure out the intention, figure out the work meaning, and then see if they match. The problem here is that if we can figure out the work meaning independently of figuring the intention, then intentions are not needed to identify work meaning, and work meaning can be defined without mentioning intentions. On the other hand, suppose work meaning cannot be identified independently of identifying

the properly realized intentions. Then we could never find out whether intentions are properly realized, and work meaning would forever be unavailable.

If the identity thesis were true, this dilemma would clearly be fallacious. For then, where we determine meaning, we would also determine properly realized intention and vice versa. To see this, consider an entirely different sort of identity: that of water and H_2O. Notice that we have developed two distinct sets of tests: water tests and H_2O tests. Water tests are based on appearances: looks, tastes, feels, and functions: what we can do with the stuff. H_2O tests involve chemical analysis. One might say that since we can figure out what water is independently of H_2O tests, water and H_2O are logically distinct. But this is not so. In reality, water tests are H_2O tests and vice versa. However, since moderate actual intentionalists recognize that there are nonintentional sources of meaning, there is not a mapping from one concept to the other as there is with water and H_2O.

The complexity of work meaning makes it harder to see that the dilemma is fallacious, but fallacious it is, and the chief problem is the second horn, the claim that if work meaning cannot be identified independently of properly realized intentions, we will never be able to determine either. We can determine both, under the given assumption, through a process of mutual adjustment of hypotheses. To see how this works, first consider a conversational case. We are at the airport check-in, and I say, "This bag is heavy." You can identify a literal meaning of my words without regard to intention: that this suitcase weighs more than the average in the appropriate comparison class. However, you also know that I am not uttering those words simply to make a factual observation regarding the weight of my bag, so your next step is to form a hypothesis about my intention in making the utterance, which may be to request help in moving the bag or to express the fear that I will have to pay an overweight charge and so on. Context (for example, some bag struggling) will help you choose among these hypotheses. All this will result in reading my remark as a request for help, which identifies its utterance meaning as well as successfully realizing my intention.

The process is not very different when we are interpreting artworks. We constantly are forming hypotheses about the point or function of this or that bit in the overall economy of the work. For example, we read in James Joyce's story "The Dead," "He asked himself what is a woman standing on the stairs in the shadow, listening to distant music, a symbol of" (Schwarz 1994, 48). "He" is the protagonist, Gabriel, and the woman is his wife, Gretta. There is no problem knowing the literal meaning of the sentence. We want to know its *point*: why it is put there. Are we to ask the same question as Gabriel, and is the answer more accessible to us than to him? Or are we to realize he is asking the wrong question at this moment, a fact that reveals an alienation on his part from the flesh-and-blood Gretta? The default assumption is that this is a hypothesis about Joyce's point (intention), and

only if we can't make that assumption work do we look for alternative determinants of meaning. In the case of other questions about work meaning, the default assumption may not be that we are identifying an intention. For example, if our question is, What attitude does *Joyce* express toward women in "The Dead," we may not start out with the assumption that the predominant attitude is one that Joyce intended, but we may nevertheless end up with the view that indeed it is (Norris 1994). Notice that we don't reach these conclusions by matching two independent statements: one about Joyce's intention and one about work meaning. Rather, we form hypotheses and attempt to figure out if they are true and how they should be characterized (as pertaining to intentions or not). Hence, we can reject the second horn of the dilemma.

A *third objection* to actual intentionalism claims that *reference to intentions is eliminable* and hence inessential to an account of work meaning. To flesh out this objection, recall that on several occasions in this chapter I have appealed to convention and context to help fix properly realized intended meaning. It is also true, though this was not made explicit, that when there is no properly realized intention to fix meaning, it is plausible that this is accomplished by convention and context directly. Consider a case where I misspeak: I say, "There is a fly in your suit," whereas I intended to say that there is a fly in your soup. Assuming that context provides the appropriate articles of clothing (in virtue of your wearing a suit), I say, on this occasion, that there is a fly in your suit, and this is fixed by the conventional meaning of my words, and the immediate context in which they are uttered, but not by my unrealized (or improperly realized) intention. So in a case where I mean to say that there is a fly in your suit, why shouldn't we say that here, too, convention and context do all the work in fixing utterance meaning? What contribution is left to be made by my intention to say this? On this occasion, at least, the answer appears to be none.

I believe that this example may appear persuasive because in many cases intentions that are properly realized are straightforwardly conveyed by convention and context so that we don't have to *figure out*, at every turn, what is being communicated. Even in these very straightforward cases, there may often be an assumed (as well as actual) communicative intention that an audience appeals to in, for example, disambiguating words before context and convention can do their job. (For example, in case where I say, "Mary doesn't have a heart," while watching her play bridge, my audience has to decide whether I mean to refer to the card suits in her bridge hand, her style of playing, or her general attitude toward other people, among other possibilities.) However, once we leave these most straightforward or literal cases, we generally won't be able to fix what is being said without thinking about the intention or point of saying it. If this is sometimes true in conversational contexts, it will be even more common in artistic ones. We won't be able to recognize irony, allusion, parallelism, imagery, or symbolism without being

directly involved in figuring out communicative intention. Recall the previously quoted passage from "The Dead." The operative question about it is, What is its point? It is always possible that the answer we are forced to is that these words could not convey any plausible intention of the author and so must be understood in other terms. However, when the interpretive question is what is the point, such an answer will be atypical. Hence, we can set aside this last objection.

Hypothetical Intentionalism

Although I have not set out every serious objection to moderate actual intentionalism (others are set out and countered in Stecker 2003), it is more crucial to devote the remaining allotted space to an assessment of a plausible and popular alternative to the view we have been defending. This alternative is hypothetical intentionalism. It is important to consider because it accepts a central intuition employed in replying to the previous objections but claims there is a better way of deploying it.

Hypothetical intentionalism accepts that when we interpret in order to identify utterance or work meaning, we inevitably look for an intention or a point with which something is said or presented. That is the common intuition it shares with actual intentionalism. Hypothetical intentionalism denies, though, that the intention we are looking for is the actual intention of the utterer or artist. It is rather a virtual intention suggested by the utterance or work. Different proponents of hypothetical intentionalism define this intention differently, but what I will consider here are two importantly distinct alternatives. According to the first, a hypothetical intention is an ideal audience's best hypothesis regarding the actual artist's (utterer's) intention, given a certain restriction on available evidence. An ideal audience is one that is historically situated so that it knows the corpus of the artist's work as well as other publicly available features of the context of creation. A best hypothesis is one that is most justified by the evidence and, where there is a tie among such hypotheses, one that makes the work aesthetically better. The restriction on evidence is that direct pronouncements of intention by the artist are off limits (Levinson 1996, 175–213). When all these conditions are met, the hypothetical intention identified is the meaning of the work. It may well coincide with the artist's actual intention, but it needn't.

A second version of hypothetical intentionalism abstracts still further from actual intentions. It claims that the meaning of an utterance or work is fixed by the intention of a hypothetical utterer or artist who is fully aware of context and conventions and uses them flawlessly to say or do what she intends (Nathan 1992).

What is attractive about hypothetical intentionalism, and why would anyone suppose that utterance or work meaning is identified by a hypo-

thetical intention? There are three reasons. First, it is a plausible solution to a semantic problem regarding utterance meaning (and work meaning if it is to be understood on the model of utterance meaning). We have already seen that neither the meaning of utterances nor of works should be *identified with* intended meaning. But we have also seen that they are not to be identified with the conventional or literal meaning of the words or sentences that constitute linguistic utterances and literary works. (The meaning of other artworks couldn't possibly be so identified.) Hypothetical intentionalism offers an alternative to these unacceptable options. Of course, the version of moderate actual intentionalism defended previously is another such alternative. However, when we compare these two views, hypothetical intentionalism is the more elegant proposal. Moderate actual intentionalism says that sometimes a properly realized actual intention determines meaning. Sometimes nonintentional considerations do so. These nonintentional factors include a variety of conventional and contextual considerations that are also in play in conveying properly realized intention. In contrast to the nest of considerations that moderate actual intentionalism appeals to, hypothetical intentionalism offers a single explanation of utterance/work meaning. This superior elegance is the second reason for adopting it. The third reason is that it gives works of art a greater autonomy from the creative artist since, according to hypothetical intentionalism, the actual intentions of artists play no direct role in fixing their meaning. Of these reasons, the last is the most controversial since not everyone agrees that artworks have the degree of autonomy hypothetical intentionalism attributes to them. In fact, since the second version of this view gives works a greater degree of autonomy than the first, even hypothetical intentionalists do not agree among themselves about what degree of autonomy is the right one.

Whatever precisely has motivated its acceptance by some and despite its superior elegance, hypothetical intentionalism faces some counterexamples that disqualify it from being a viable alternative to moderate actual intentionalism. I conclude by briefly setting these out.

Let us begin with the first version, which says that the meaning of a work is the intention an ideal audience would attribute to the actual artist based on the total admissible evidence and, where needed, considerations of aesthetic merit. There are two counterexamples to this. The first counterexample consists in cases where a work W means p, but p is not intended and the audience of W is justified in believing that p is not intended. In such a case, the present version of hypothetical intentionalism implies, ex hypothesi wrongly, that W does not mean p. Here is an example. According to the Sherlock Holmes stories, Dr. Watson received a wound during his service in the British army. Unfortunately, the stories give the wound two different, incompatible locations. We know that Conan Doyle did this unintentionally because it is impossible for one wound

to be in two such different locations, and the realistic style of the stories precludes the fictional assertion of impossibilities. Nevertheless, such an impossibility is fictionally asserted and is part of the meaning of the story. However, an ideal audience would not attribute to Conan Doyle the intention to fictionally assert an impossibility, so hypothetical intentionalism would falsely deny that it is part of the meaning of the story.

The second counterexample is the case where the artist intends W to mean p, it is known that the artist has this intention, but W does not mean p but q. In this case, hypothetical intentionalism implies, falsely, that W means p since an ideal audience would attribute to the artist the intention to mean p. That the two objections are closely related can be seen from the fact that an ideal audience would attribute to Conan Doyle the intention to give Watson's wound a single location, which falsely implies, on the present version of hypothetical intentionalism, that the story does this. Here is another, nonliterary example. Suppose someone says, "You're a very perspicuous fellow." The best hypothesis is that the speaker intends to say that the person addressed is perspicacious (that is, someone with acute judgment), but it doesn't follow that the speaker did say this. In fact, it seems quite certain that he didn't but rather uttered the nonsense that the person in question is expressed very clearly.

Turning to the second version of hypothetical intentionalism, it fares no better with the second example. How can it explain how a hypothetical flawless user of the language can utter nonsense? At least, it appears to escape the first counterexample. The hypothetical artist, being a flawless user of the language, must have meant to give Watson's wound two locations if his words imply as much. The trouble is that this hypothetical author can't be both a flawless user of the language and, at the same time, a flawless purveyor of the realistic style. Hence, it is not so clear that the second version of hypothetical intentionalism can handle this example any better than did the first version. Furthermore, this version of hypothetical intentionalism attributes the right meaning to this bit of the Sherlock Holmes stories for a very odd reason (that is, a cooked-up hypothetical author intended it), whereas moderate actual intentionalism seems to find the right explanation; in this instance, Conan Doyle failed to properly realize his intention and, as a result, says something other than what he intended in virtue of the conventional meaning of his words and the fictional context.

Summary

The question whether artists' actual intention is relevant to the interpretation of their artworks turns out to splinter into a number of subquestions. I have attempted to answer two such subquestions here: 1) Is identifying the

artist's actual intention a proper and central aim of art interpretation? and 2) Is artwork meaning defined, in part, in terms of the artist's actual intentions? This chapter has defended affirmative answers to both questions, although we have also seen that great care is needed to define the role of intentions in fixing work meaning and in not overstating the importance of this role. Finally, we have seen that, while hypothetical intentionalism provides a more elegant account of work meaning, it is vulnerable to serious counterexamples.

Further Reading

Barnes, Annette. 1988. *On Interpretation*. Oxford: Blackwell. A defense of moderate intentionalism and pluralism.

Beardsley, Monroe. 1970. *The Possibility of Criticism*. Detroit: Wayne State University Press. A well-known critique of intentionalism.

Carroll, Noël. 2001. *Beyond Aesthetics: Philosophical Essays*. Cambridge: Cambridge University Press. Contains several essays defending moderate actual intentionalism.

Goldman, Alan. 1990. "Interpreting Art and Literature." *Journal of Aesthetics and Art Criticism* 48: 205–14. Argues that the aim of interpretation is to maximize appreciation.

Hirsch, E. D. 1967. *Validity in Interpretation*. New Haven, Conn.: Yale University Press. A well-known defense of intentionalism.

Iseminger, Gary. 1992. "An Intentional Demonstration?" In *Intention and Interpretation*, edited by G. Iseminger. Philadelphia: Temple University Press, 76–96. An argument defending moderate intentionalism.

———, ed. 1992. *Intention and Interpretation*. Philadelphia: Temple University Press. A valuable collection of essays on the intentionalism debate.

Knapp, S., and W. B. Michaels. 1985. "Against Theory." In *Against Theory*, edited by W. J. T. Mitchell. Chicago: University of Chicago Press, 222–32. Argues for the identity thesis.

Lamarque, Peter. 2002. "Appreciation and Literary Interpretation." In *Is There a Single Right Interpretation?* edited by Michael Krausz. University Park: Pennsylvania State University Press, 285–306. Argues that the aim of interpretation is to enhance appreciation and that the idea that literary works have an identifiable meaning is misguided.

Levinson, Jerrold. 1996. *The Pleasures of Aesthetics*. Ithaca, N.Y.: Cornell University Press. The best-known defense of hypothetical intentionalism.

Livingston, Paisley. 1998. "Intentionalism in Aesthetics." *New Literary History* 50: 615–33. Argues for moderate intentionalism.

Nathan, Daniel. 1992. "Irony, Metaphor and the Problem of Intention." In *Intention and Interpretation*, edited by Gary Iseminger. Philadelphia: Temple University Press, 183–202. A critique of actual intentionalism.

Nehamas, Alexander. 1981. "The Postulated Author: Critical Monism as a Regulative Ideal." *Critical Inquiry* 8: 133–49. One of the first defenses of hypothetical intentionalism.

Stecker, Robert. 1997. *Artworks: Definition, Meaning, Value.* University Park: Penn-
 sylvania State University Press. Argues that actual intentions are an essential
 component of work meaning. Also presents a critique of hypothetical inten-
 tionalism.
Tolhurst, William. 1979. "What a Text Is and How It Means." *British Journal of Aes-
 thetics* 19: 3–14. One of the first pieces to propose hypothetical intentionalism.

8

Representation: Fiction and Depiction

Interpretation is a common means to the understanding and appreciation of artworks because such works contain elements that are meaningful or significant yet not always transparent in their meanings or significance. Two among the ways many such works are meaningful or significant are in being representational and in being expressive. This chapter explores the first of these ways, the next explores the second.

Representation in one of its broader senses is a pervasive though not invariable feature of artworks, but it is just as common outside art. Compare a painting of a man and a man figure on a restroom door. Both are representations in this broad sense. So are sentences or their utterance that, say, ask, command something, or, as happens in many literary works, present something to the imagination. We have a representation in this broad sense when one thing—a symbolic vehicle—stands for something else—an object or state of affairs. A state of affairs is an object or objects being a certain way. Typically, a painting will not just represent a man but also represent the man being a certain way, such as sitting and glaring across a table. It represents a state of affairs. Perhaps the man representation on the restroom door does not do this, or perhaps it does. I'll leave that up for grabs. Furthermore, many representations typically do not just "stand for" something else. They do something with or express some attitude toward what is represented. For example, an utterance of the sentence, "It's hot," may be asserting that it is hot, and a stop sign does not just "stand for" the action of stopping but commands that action for approaching vehicles. The objects and states of affairs represented by a symbol need not be "concrete" things such as an individual man sitting and glaring. We can represent actions and events, kinds (the whale), and abstract objects (injustice). We can represent facts and falsehoods, beliefs, and make-believe.

Representation in this broad sense, just because of its broadness, is *not* of special interest in the philosophy of art, but there are types or modes of

representation that are. Two, in particular, will be discussed in this chapter. One is fictional representation. The other is depiction. We are all familiar with fictional literature, but we are also familiar with much visual art—paintings, cinema, sculpture—that is also fictional. Paintings, photographs, and other (but not all) types of visual art (not sculpture) represent primarily by depicting. As just pointed out, at least many of these depictions are also fictional representations.

As with representation in general, there is lots of fiction and there is lots of depiction outside art. Advertisement, for example, is a rich source of both. However, to understand our engagement with a great deal of art, we must understand what fiction is, and to understand our engagement with much visual art, we must understand what depiction is. Since so much (on some views all) depiction is fictional, we may also wonder whether there is something that unifies the accounts of each. So we will ask three questions here: What is fiction? What is depiction? Is there a conceptual connection linking fiction and depiction? We will be concerned mainly with the first two questions and briefly address the last at the end of this chapter.

What Is Fiction?

Preliminary Issues

There are at least two senses of the word "fiction" that are easy to run together but need to be distinguished for our present purpose. In one sense, a fiction can simply be a type of falsehood, and a claim to fictionality can be a claim to nonexistence. If I say, "Your Ph.D. is a fiction," I am using "fiction" in this sense. I am simply saying that it is false that you have a Ph.D. or that the degree you claimed to have does not exist. On the other hand, if I say that *Middlemarch* is a fiction, I am *not* saying that the novel does not exist. I am saying that it is a certain type of book, story, or representation. The book, story, or representation clearly does exist.

Unlike ambiguous words such as "bank," there is probably *some* connection—for example, an etymological one, among others—between the two senses of "fiction," which explains the ease with which they are run together. Works of fiction typically contain an element of "unreality." In reality, there is no such town as Middlemarch and no such people as the characters Dorothea or Casuabon who in the fiction inhabit the town. In fact, unlike the novel, the town Middlemarch and the people Dorothea and Casuabon are fictions in the *first* sense. On the other hand, it is important to realize that the logical or semantic relationship between the two senses of fiction is loose. Fictions in the first sense can be lies and always involve falsehood or "unreality." Works of fictions—a class of representations—are never lies, can refer to real things such as historical personages (Julius Caesar, Napoleon) and actual places (Rome, Moscow), and can contain truths

about them. In fact, the purpose of a work of fiction, or one of its purposes, can be to convey certain truths. Some people think that there can be works of fiction, which only represent truths, though, if they are really fictions, their sole purpose cannot be to assert these truths. We will return to this issue later.

The sense of "fiction" that interests us is the second one, which refers to a class of works: works of fiction. Having identified it, our job is to figure out what characterizes it and makes it distinct from other representations. But before directly tackling that issue, there is one further, preliminary one. This is to get some sense of the range of works of fiction.

Fiction is sometimes identified with a type of discourse. So understood, it is a linguistic phenomenon, something created by using language in a certain way, with certain intentions. Certainly novels, stories, and dramas are preeminent examples of fictions. Another literary category often treated as fiction is poetry. Some poems tell stories that are obviously fictional. It is a little more puzzling, however, why many poems are so treated. Recall the poem "Aura" about viewing a mountainside in autumn quoted in chapter 3 or the Shakespeare sonnet from chapter 4. Are they fictions or not? If we think that in these poems the poets Carruth and Shakespeare, respectively, are addressing someone—his audience perhaps in Carruth's case or his lover in Shakespeare's—then we would not think of it as fiction. On the other hand, if we think of the utterer of the words of the poem as akin to a character in a novel, as an imaginary speaker of those words, then we immediately switch gears and take it as fiction. Since many poems (some think all poems) should be conceived in this latter way, at least many are as much works of fiction as novels and short stories.

It is obvious that there is lots of nonlinguistic, nonliterary fiction. Media such as cinema and television constantly trade in stories that are fictional. Songs often tell fictional stories. Many paintings also present fictional representations. Consider Vermeer's *A Woman Weighing Gold*. A woman stands before a balance beneath a picture of the Last Judgment. Light from a nearby window divides the picture into two diagonals, the upper one light, the lower one dark. The picture doesn't tell a story; it is not a narrative. But it is also not a portrait of an actual woman. Though Vermeer almost certainly used a model to paint it, the picture is not a portrait of her. The scene is an imaginary one, a fiction.

This suffices as a preliminary survey. As we look at attempts to define fiction, we will see that, according to some, other items get included in this category that have not yet been mentioned. One issue will be whether their inclusion is a good idea, but we will cross that bridge when we come to it.

We are now ready for the main question: what is fiction? There is one large class of answers I will simply ignore: those that define fiction as a type of linguistic discourse. We know in advance that these will be inadequate because of the ample existence of nonlinguistic fiction (for a survey and

critique of these, see Walton 1990, 75–89). There are two broad classes of
answers that remain. One kind defines fiction in terms of pretense or make-
believe. A second defines it in terms of a special type of reference.

Pretense and Make-Believe

One might think that the standard function of a mode of representation
such as language or pictures is to inform us about the actual world, to as-
sert or show us things about it. Fiction could then be thought of as some-
thing derived from this standard use. Instead of actually asserting some-
thing, a fictional story or its author pretends to assert it. Instead of showing
us something about the actual world, a picture such as *A Woman Weighing
Gold* or the painter Vermeer pretends to show us something about it (Searle
1975).

This proposal would need to be refined to even approach adequacy. Con-
sider an epistolary novel—one whose story is told not through a narrative
but through a series of letters written by one or more characters. Here the
author does not pretend to assert something but, if the pretense view is cor-
rect, pretends to present letters that, among other things, make assertions.
Such adjustments, while needed to make the pretense view work, are not
hard to make and hence do not pose a serious problem for the view.

There is another problem with the pretense view that is not fixable. Pre-
tense does not always seem to be the right description of what artists are
doing in their works. Consider a clear case of pretense. I am pretending to
sing by lip-syncing. There is no intent to deceive, just as there usually is not
when an artist produces a fiction, but I am doing one thing in order to pre-
tend to do another. Is Vermeer pretending to show us a real scene by paint-
ing an imaginary one? That is what does not seem right. To adequately de-
scribe what Vermeer is doing, it is enough to say that he is painting an
imaginary scene without adding anything about something he is thereby
pretending to do. In fact, there would be a certain irony if we did say that
because it is very likely that Vermeer painted an imaginary scene by using
a real one as a model.

So what is it to write a fictional story if not to engage in a sort of pre-
tense? What is it to paint an imaginary scene if not to pretend to do some-
thing? One might think that one has represented an imaginary scene if
there is no real scene "corresponding" to the one that is painted or de-
scribed. This won't work. Misdescriptions satisfy this condition without be-
ing imaginary scenes. Further, in the Vermeer case, there might have been
a real scene corresponding to the one represented in the painting. In fact,
there could have been several of them. It is possible (though here we enter
into the realm of fanciful speculation) that Vermeer saw someone in his
household weighing gold beneath a picture of the Last Judgment with the
light entering the room just so and thought, that would be a fine subject

for a painting. He then arranged a room to reduplicate what he saw using the very same person as model. He then painted the picture that presents a fictional, possibly allegorical scene!

The make-believe view offers an alternative answer. In order to understand this view, one has to recognize that "make-believe" is being used in a restricted, somewhat technical sense. There are some ordinary uses of "make-believe" in which it is a synonym for pretense. "Let's make-believe we are pirates." "Let's pretend we are pirates." These say the same thing. So what is the restricted, technical sense of make-believe in question, and how is it employed to present an alternative to the pretense view?

Make-believe in the relevant sense involves two special features. First, it involves props. Props are publicly accessible objects that guide imaginings. Suppose children are playing school with dolls. The dolls are props. Paintings, novels, and poems are also props on the make-believe view. Second, make-believe, unlike some other imaginings, operates according to underlying rules about these props that authorize or mandate certain imaginings. For example, the game of school might operate according to the rule that the number of students in the classroom is equal to the number of dolls arranged in a certain way. If we are reading to the dolls, it is story period in the class. If the dolls are lying down, it is rest period. Similarly, a given art form or genre will have certain rules that guide the audience's imaginings (Walton 1990).

A fiction, on this view, is a work that is intended to be or has the function of being a prop in a game of make-believe. What makes *A Woman Weighing Gold* fictional is that it is, first of all, a work—a painting in this case—and, second of all, it is intended or has the function of being a prop of the kind described previously. It authorizes us to imagine certain things: that we are seeing a woman before a balance in the act of weighing gold, standing beneath a picture of the Last Judgment, and so on.

The make-believe view has become one of the most widely held accounts of the nature of fiction. However, there are some differences among those who accept it. One of these is embodied in the very definition of fiction just given. It concerns whether a work must be intended by its maker to be a prop (Currie 1990; Levinson 1996, 287–303) or whether it is enough that it functions as a prop (Walton 1990). The latter condition is too weak. We can treat almost anything, from a committee report to a scientific paper to a shopping list, *as if* they were fictions, and for the nonce they acquire the function of being props. Furthermore, at least the first two items just mentioned (if not the shopping list) are works. But treating something as if it were a fiction does not create a work of fiction. On the other hand, perhaps regular treatment or conventions can render a work a prop for make-believe without an original intention that it be so treated. We tend to treat the ancient "myths" of other cultures not only as if they were fiction but also as fiction. (Let us assume they were not originally so

intended.) *Perhaps* this use creates a work of fiction. If so, the original intention requirement is too strong. The most plausible view lies somewhere between the two thus far discussed. We can express it this way: F is a fiction only if it is a work with the *proper* function of being a prop in a game of make-believe. To speak of a proper function is to screen out items treated as if they are fictions or that acquire the function of being props on an ad hoc basis. Only things that have the prop function as such, as it were, are fictions. This typically is the result of an original intention that it be so used, but the function can perhaps be acquired in other ways.

We have just claimed that a *necessary condition* for being a fiction is properly functioning as a prop for a game of make-believe. Another disagreement concerns whether this condition also is sufficient on its own to pick out works of fiction or whether a second condition is needed. Here is one type of situation that, according to some, gives rise to the need for a second condition. Suppose, thinking about my own life, I think it contains the stuff of a great narrative. I could present this as my autobiography, but I think it would have greater significance to present it as a fictional story: a novel. The only thing is, every sentence states a fact. The question here is whether I am attempting to do something that is impossible—make a fiction out of fact. There are those who answer this question affirmatively (Currie 1990) and so claim that we need a second condition on the definition stipulating that a narrative that is "nonaccidentally" true throughout is not a work of fiction.[1]

I don't find this case so problematic. The important matter is not whether the sentences express truths but how they are intended to be taken. Suppose they are simply intended to be taken as true in the story because the omniscient narrator asserts them to be such. Further, it is not intended that the reader ask whether they are true in reality because they are to function as props for make-believe and not as autobiography. Then they constitute a fiction. No further condition is needed so far. (By the way, the intentions mentioned so far are perfectly consistent with a further intention that the reader will grasp certain truths about reality by reflecting on the narrative.)

However, there is a problematic set of cases. Further, these cases involve perfectly familiar items. There is no appeal to such unlikely things as a fictional narrative only expressing true propositions. Suppose that I do in fact present my story as autobiography but in such a way that you can vividly imagine the events of my life. Then it appears that my work fulfills two functions. One is to inform you about my life. A second is to enable you to engage in the kind of guided imagining that is constitutive of make-believe in our technical sense. (Since this imagining is about real events, it is hardly make-believe in its ordinary sense.) Something similar happens with certain works of history, journalism, and the "nonfiction" novel, such as Truman Capote's *In Cold Blood*. All these works are props that authorize cer-

tain imaginings and hence meet our first condition. There are some who claim that because of this, these works are fictional even if the primary purpose lies elsewhere (Walton 1990). However, this does not seem right. Historical novels are fictional; history is not, even if it uses techniques that produce guided imaginings. How are we to express the difference? Fiction always presents some things to the imagination that are placed there simply for the purpose of being imagined. Whether they express truths or refer to items in the actual world is irrelevant to their proper functioning in the work. This need not be true in the historical and the other nonfiction works just mentioned. This does not mean that fiction cannot contain some elements that are meant to express truth or pick out actual people, places, or other things. It just means that not everything in the fictional work so functions. Even in a historical novel, where every character picks out a real person from the past, we are to imagine certain doings or conversations without worrying whether they occurred. This also does not mean that a work of history could not contain some fictional elements, such as imagined thoughts of a historical figure or invented dialogue. It just means that the mere fact that the work authorizes certain imaginings is not sufficient by itself to give it a fictional aspect.

So on the present proposal, something is a fiction if it is a work that properly functions as a prop for make-believe and at least some of the imaginings it authorizes are so placed for the sake of being imagined without also being placed for the purpose of expressing a truth or referring to an item in the actual world.[2]

Fictional Reference

Most fictional works have a feature that we have mentioned but so far have not emphasized. They appear to refer to people and other things that don't exist or to be about states of affairs that are not to be found in reality. (This is a point where "fiction" in the sense we are concerned with it—as a type of representation—ties in with "fiction" in the first sense discussed previously.) For some who hold the make-believe view, this is strictly appearance. We are not really referring to anything. We are making believe that such reference to fictional entities occurs, but it really does not.

However, there are others who hold that some sort of reference to fictional things really occurs. These people can be divided into two camps. Some believe that such things as fictional characters actually exist (Howell 1979; Thomasson 1999; Van Inwagen 1977). They posit such things more to explain the things we say about fiction than to explain fiction itself. They claim that fictional characters are akin to theoretical entities that we acknowledge because of their theoretical utility. Further, they are not claiming that there is any such *person* as Sherlock Holmes. Characters are not really people, though fictional works speak of them as if they are. The

plausibility of this view hangs on whether we actually gain something by making this posit that is denied to those who claim that we merely make believe that people are being referred to in fictions or who claim that it is merely true in the fiction but not in reality that such reference occurs. This is an issue we don't have to pursue here because it is irrelevant to our question: what is fiction? Those who believe that there are theoretical entities that we talk about when we talk about fiction presuppose a working understanding of fiction itself.

The other camp claims we refer to fictional people and other fictional things, even though they deny that fictional things exist (Dilworth 2004; Zemach 1997). Sherlock Holmes does not exist, according to them. In this, they agree with some of those who hold the make-believe view. But the people in this camp don't think that that is a reason to deny that we refer to fictional things. In fact, their chief claim is that we can refer to what does not exist, including fictional people and places. If they are right about this, perhaps they have a way of answering the question, What is fiction that provides an alternative to the make-believe view? In fiction, we refer to things that don't exist, while in nonfiction we refer to things that do. Alternatively, in fiction we intend to refer to things that don't exist, and in nonfiction we intend to refer to things that do.

The view under discussion makes two interesting claims. One is that we can define fiction through reference to nonexistent things. The second is simply that such reference is possible and actually occurs. The first claim obviously depends on the second, which is very controversial. What is fair to call the majority view (which obviously doesn't mean it is the true one) is that one can refer only to what exists. When we refer to something, we pick it out, and what doesn't exist can't be picked out because there is nothing to be picked out. If there were something, it would exist. The things we refer to are distinguished from others in virtue of their properties or characteristics, but nothing can have properties unless it exists in the first place. Existence is not just another property but is the condition for having properties. What does not exist is nothing and so cannot have properties.

Those who believe we can refer to nonexistents deny that they lack properties. Compare Hamlet and Macbeth, the characters from the two plays by Shakespeare. Hamlet is a prince of Denmark. Macbeth is a Scottish lord, a usurper, a king. They have different properties, it is claimed, so they must have properties. One property that both Hamlet and Macbeth lack is being real or existing. For those who believe that there is fictional reference to nonexistents, existence *is* just another property and not a condition for having properties.

Those who doubt that there is fictional reference deny these claims. They say that the only truths here are about the plays. It's true in (or according to) the play *Hamlet* that there is a prince of Denmark and so on. This does not imply that a nonexistent person has the property of being a

prince. If we can get along just by talking about plays, we shouldn't buy into dubious claims about the properties of nonexistents.

There are many more moves that can be made in this controversy and many variations on it that we haven't considered. But let us wrap up the discussion of fiction by asking whether appealing to the fictional reference provides a plausible alternative to the make-believe view regarding the question, What is fiction? It does not. If there is reference to nonexistents, it can occur both inside and outside fiction. If I am a habitual liar and lie about where I spent my vacation, claiming it was on the golden mountain, I referred to a nonexistent object and did so intentionally (according to those who believe such reference occurs), but I did not create a fiction in the relevant sense. I merely told a lie. If a write a historical novel, I may refer only to existents (past or present), but I still create a fiction. Hence, fictional reference does not provide a route to answering the question, What is fiction?

What Is Depiction?

Survey of Issues

A natural contrast is one between description and depiction. Descriptions are linguistic representations in the broad sense of representation mentioned at the beginning of this chapter. Depiction is representation by means of picturing: pictorial representation. Descriptions seem (and are) arbitrary or conventional. That "red" rather than "rot" means red in English is simply the result of the conventions currently holding for that language. There is nothing intrinsically more suitable about "red" compared to "rot" that makes it worthy of designating the color red. This can be seen from the fact that "rot" does the same job in German.

In pictures, not only do we see symbols that stand for things, but it seems as if we see things themselves. Look at a picture of a woman such as *A Woman Weighing Gold*. Not only do we know that it is about a woman, but we know this because there is something about our visual experience that is akin to seeing a woman. It is a mark of depiction that it provides such experiences and succeeds in being about things or having a representational content in virtue of providing such experiences.

We should note in passing that pictures can represent in ways that go beyond their depictive content and that are more language-like. This mode of representation is sometimes called symbolization or iconographic representation. A dog in a picture may symbolize the virtue of loyalty, scales commonly symbolize justice, laurel leaves refer to fame, and so on. This sort of pictorial representation usually depends on depiction—the depictions of a dog, scales, and laurel leaves, respectively, in the examples—but is not itself depiction.

Only pictures literally depict. Pictures are found in many different media, for example, painting, drawing, printmaking, still photography, and cinema. It might be surprising, but it is controversial whether all these media produce depictions, that is, representations of the relevant kind, though I think it is agreed that they produce pictures. There is also a controversy whether all pictures in a given medium are depictions. There is a type of painting called "trompe l'oeil," which is characterized by the fact that, when viewed under the right conditions, one cannot tell one is looking at a painting. The actual picture surface is invisible, and it looks like one is seeing what is pictured rather than a picture of it. Some deny that such paintings are depictions.

The central controversy, however, is about the best or the correct way to characterize depiction. There is a lot of disagreement on this score and quite a few distinct theories of depiction. In fact, there are quite a few different types of theories within which there are different variations.

The sharpest distinction among theories of depiction is between those that are symbolic or structural in character and those that are perceptual or experiential in character. The first treats depictions as symbolic systems (a language being a paradigm of a symbolic system) and defines it in terms of special features of the symbols;[3] the second defines depiction as a special type of perception or perceptual experience. In describing depiction in the previous paragraphs, I did it in largely perceptual and experiential terms, thereby expressing a bias in favor of perceptual theories.

Seeing-In

I will be concerned with perceptual/experiential theories and examine whether they are adequate to define depiction and explain its important characteristics.

Many of these theories share a central intuition that I will call the "seeing-in" intuition. The seeing-in intuition is that whenever one sees what a picture depicts, one is engaged in seeing-in, and to bring this about is the central (but not the only) proper function of depictions. Naturally, to understand this intuition, one has to grasp the concept of seeing-in.

Seeing-in stands in contrast with ordinary seeing. Of course, when I look at a painting, I do see it in the ordinary sense. I see a canvas covered by paint that has certain properties: a rectangular shape, a colored surface, and a visible design on that surface. If I truly see all these things, then it follows that there exists a painting that has the various properties mentioned so far, just as if I see a brown cow, there is a brown cow that I see. Call this property of ordinary seeing "existence." However, if the painting is representational, then in some sense I see more. I see "in" the painting a room containing a woman before a balance underneath a painting of the Last Judgment with the light entering to cut the space occupied by these ob-

jects into two diagonals: one dark, one light. However, in seeing these things *in* the painting, it does *not* follow that there is a room containing a woman, a balance, and so on, the space of which room is cut into two diagonals by the entering light. Further, while I am seeing-in the painting these various things, I am typically still aware that I am looking at a painting with certain surface design features.

So two typical features of seeing-in are, first, that one can see something that is F in something else, call it P, without it following that there is something F that I am seeing, and, second, that I am aware of seeing P and some of its features, while I am seeing-in P something that is F. Call the first feature "nonexistence" and the second "twofoldness." Nonexistence does not imply that I can see-in only depictions of fictional beings. Portraits and some other depictions represent real people. In the case of paintings, at least, even when the painting is a portrait (say, of Henry VIII) or represents an actual person (say, Socrates), though it is not a portrait of that person, most people think I am not actually seeing Henry VIII or Socrates in seeing them in the painting. However, nonexistence does not even imply that I am never really seeing something that is F in seeing it in the picture. It just says that there is *no entailment* from seeing something that is F in P to actually seeing something that is F. There is also no entailment from seeing something F in P to there existing something that is F.[4]

One might think, of course I don't see an actual woman when I look at a painting, and in general, of course, I don't see an actual something that is F. I see a representation or a picture of a woman (something that is F). A representation of an F is usually not an F. So when we say we see a woman in a painting, aren't we just saying that we see a representation of a woman, which of course we can do while noticing other features of the painting? If so, isn't the idea of seeing-in vacuous?

When we speak of "seeing-in," we are not just using an unusual word for representation. The phenomenon of seeing-in is not confined to pictures, and it is also not confined to representations. We can look at an old, stained cracked wall and see rivers in it running down through some sort of terrain. We look up at a cloud and notice it looks like a fox. We see an animal in the cloud (or we see the cloud as an animal). The exact locution that we use may vary, but the two conditions characteristic of seeing-in are in place. We continue to see the cloud and some of its surface features while seeing it as a fox (twofoldness), and in seeing the cloud as a fox, we are not actually seeing an animal. There is not an animal to be seen (nonexistence).

The fact that we engage in seeing-in when there are no representations shows that "seeing-in" is not equivalent to seeing a representation. The fact that we have similar visual experiences with all kinds of seeing-in shows that seeing-in might be useful in giving an account of the special kind of representation of interest here: depictions. That sort of visual experience might be what distinguishes them from other representations. However,

seeing-in can't be the whole story about pictorial representation because it occurs when no depiction is present.

Two people can see different things in the same cloud formation, and there is no room for argument about who is seeing it correctly. In the case of representations, there is room for argument. There can still be diverse seeings-in, but some might be incorrect. For example, one might see-in a painting an angel traveling toward earth when it is in fact rising toward heaven. So for a work to depict something that is F, it is not enough that someone can see something that is F in the work. One proposal is that a work depicts something that is F just in case a suitably sensitive and informed spectator can see something that is F in the work and the creator of the work intended something that is F to be seen in it. The second condition that mentions intentions of the creator might be adjusted to take in special circumstances where something else determines what it is correct to see-in the work. We can leave that open.

We now have an account of depiction mainly in terms of seeing-in. There are people who share the seeing-in intuition but don't accept the seeing-in account. They think the account is incomplete in one way or another. These people offer proposals that supplement the seeing-in account or explain the seeing-in phenomenon in other terms.

Seeing-In in Other Terms

One objection to the seeing-in account is that the twofoldness condition does not always hold. Trompe l'oeil is the standard counterexample here since under the right conditions one cannot see the surface or design properties of such paintings. Cinema is another counterexample. People often don't notice anything other than pictorial content while caught up in a movie. It should be noted that both these examples are controversial since there are people who deny that they are examples of pictorial representation or any sort of representation. Photographs of all kinds present interesting issues regarding representation that will be discussed later in this chapter.

I am inclined to allow that the items discussed so far are really counterexamples to the idea that seeing-in requires rather than merely permits and is usually accompanied by twofoldness. They prompt us to realize that even in cases where the twofold aspect of seeing-in is possible, viewers sometimes focus exclusively on one aspect. This, however, is a clarification rather than a denial of the seeing-in account.

If this is right, then seeing-in should be reconceived as follows. It is an experience *as of* seeing an object or state of affairs that is F in something else, that allows for but does not always require being visually aware of the object through which one is having the experience as of seeing something that is F (Levinson 1998b).

The chief objection to the seeing-in account, echoed by almost everyone who is not satisfied with it, is that it is incomplete or not sufficiently informative. If seeing-in is a perceptual experience, what underlies or explains? If it is not (wholly) perceptual, what is its exact character?

There are three main proposals to supplement the seeing-in account. One proposal appeals to the familiar idea of resemblance. It claims that the basis of seeing-in is a resemblance between the visual experience of a representation and the visual experience of an object represented. A second proposal appeals to the idea of a recognitional ability as the underpinning of seeing-in. A third proposal appeals to the technical idea of make-believe that we discussed in the section on fiction to elucidate seeing-in. Each of these proposals can be, and have also been, put forward as freestanding accounts of depiction. So we should ask two questions about them: Do they complete the seeing-in account by elucidating either the basis for or the nature of seeing-in? Are they superior accounts of depiction in their own right?

Make-Believe

Let us begin with the last of these proposals since we are already familiar with the idea of make-believe on which it is based. The make-believe view claims that, like fictional representations, depictions are props in make-believe, but props of a distinctive kind. If one is looking at a picture of a mill, then, on the make-believe view, one is imagining seeing a mill. The viewer is imagining her actual visual experience to be of a mill. An experience that is both visual and imaginative is thus claimed to be the constant feature of grasping pictorial content by looking at a picture. That is the make-believe view's freestanding account of depiction. As an elucidation of seeing-in, it adds that this imaginative visual experience is what seeing-in consists in.

If the make-believe view is going to successfully elucidate seeing-in, it must be successful in its own terms as an account of depiction. As such an account, it has met a lot of resistance. One criticism is that it makes all depictions fictional representations. This criticism is similar to the complaint that the view makes some history, some biography, and some pieces of journalism works of fiction. Among depictions, the objects that are said not to be fictional are portraits, technical and scientific drawings, and photographs intended to record bits of reality, among other items. However, we can completely sidestep this objection if we adopt the definition of fiction proposed previously. On that definition, not all rule-guided use of props for authorized make-believe creates fiction, so we will not be forced to call the pictorial items just mentioned fictions.

What the make-believe view has to insist on is that all visual experience of depictions has an imaginative aspect. We are always imagining something when we are visually grasping depictive content. This strikes many people

as counterintuitive. Much imaginative activity is voluntary and active. That is, we are consciously doing something that we can refrain from doing in much of our imaginative experience, whereas if you look at many a pictorial representation, one can't help seeing a mill, a woman, or some other item in it, and one is quite passive in having this experience beyond the fact that it requires directing one's eyes at the picture. Suppose you are looking at a poster illustrating the game fish that inhabit the Great Lakes or an anatomical drawing of the muscles in the human arm. Does one imagine seeing fish or muscles? One need not do so in the active, voluntary way one imagines, while looking at the poster, fishing on a Great Lake for one of the illustrated species. But there are, it could be claimed, passive, rather minimal, imaginings, and that is what is happening in the visual experience of depictions (Walton 2002, 31).

I think that the intuition (not shared by the critics of the make-believe view) that we are always engaged in some sort of imagining with depictions derives from the nonexistence condition on seeing-in. For any picture, even a photograph, there is no entailment from the fact that we see something that is F in it to the conclusion that there is something that is F we are seeing or that the picture refers to. (There may be other properties of photographs that secure such reference.) One way of putting this fact is to say that there is always an imaginative element to seeing a depiction. However, if I am right in pinpointing the source of the intuition that there is this imaginative element, the make-believe view does not elucidate seeing-in but derives whatever plausibility it has from what I have claimed to be a central condition of seeing-in: nonexistence. The conclusion to be drawn is that the seeing-in view is not made more comprehensible by the make-believe view. This does not mean that we have to reject the make-believe view outright. It also may be that there are features of depictive visual experience that are easier to elucidate with the make-believe view.[5] The two accounts might be satisfactory parallel explications of important features of depiction. But the main motivation for speaking of imaginative seeing is better explained by the seeing-in account properly understood rather than vice versa.

Resemblance

The idea that pictures resemble what they represent is perhaps the first to come to mind when one contrasts depiction and description. Many people think that we can define depiction by appealing to resemblance and thereby clarify the seeing-in intuition. To pursue this strategy, two things, both well known, have to be realized right at the start. First, resemblance consists in two things sharing some properties, and since any given thing shares *some* properties with everything else that exists, everything resembles everything in some way or other. For this reason, any attempt to explain depiction in terms of resemblance has to specify the *relevant* resemblance in

question. Second, resemblance is a symmetrical relation. If A resembles B, B resembles A in the same way. Depiction or representation is nonsymmetrical. If A depicts B, B need not and typically does not depict A. This means that if one wishes to define depiction in terms of resemblance, one has to appeal to some one or several additional conditions as well.

The most obvious thought concerning relevant resemblance is that depictions look like what they represent or resemble what they represent in visual appearance. However, this thought is still too undeveloped to be useful because it is consistent with a number of incompatible accounts. First, there are a number of different aspects to visual appearance—color, shape, relative size, and so on—and one might think that not all these are equally important. Second, one can develop the basic idea of similarity in visual appearance in two fundamentally different ways. One could claim that there are objective similarities between (the appearance of) objects and the figures that depict them. Alternatively, one could claim that there are similarities between the visual experience of depictions and the visual experience of the objects or scenes they depict.

One feature or, rather, a family of related features has attracted a number of theorists. These are either certain shape properties of the depictions and their objects or the visual experiences of these shapes. The sort of shape that is often put forward is one that would be identified by tracing the outline of the objects one sees through a window on that glass. This is sometimes called outline shape. Some claim that pictures resemble what they depict by sharing outline shape or something quite like this (Hopkins 1998; Hyman 1989). Others claim that one's visual experience of a depiction's outline shape resembles one's visual experience of the outline shape of objects represented (Peacocke 1987). There is no doubt that some depictions bear some such similarity to their subjects. In the case of fictional pictures, we would have to say something a bit more convoluted: that the depiction would bear the similarity if there were a scene it was really depicting. Even if we grant all that, there are many styles of depiction that don't capture this sort of resemblance. Just think of stick figures, various sorts of stylization, and so on. Second, the reproduction of outline shape from certain viewing positions, such as seeing a knife blade straight on so that one sees just a line of some small thickness, would not produce recognition of a depicted object by itself. Even that most recognizable of objects, the human face, might have an unrecognizable outline shape from some viewing positions. In these cases, it is other features that allow us to recognize a figure as representing a kind of object. Finally, there are objects that have amorphous, constantly changing shapes or no shape, such as the sky, which cannot be depicted by means of an outline shape. (A defender of the view might reply that even items like the area occupied by the sky could be outlined on a window looking out on a scene. But then there are other ways of representing the sky that would not have this characteristic.)

If these criticisms are correct, there is not one salient type of resemblance in shape that always is in play when we have a depiction. If this is so, a likely further inference is that such a single salient resembling feature of some other kind or combination of such features will not be found either. What is left for the resemblance theorist to do is appeal to overall visual resemblance or to visual experiences of depictions bearing an overall resemblance, or a resemblance in some respect or other, to visual experiences of objects or scenes. However, the explanatory or analytic value of this far more vague appeal to resemblance is suspect. It's not clear that it is really more informative than the direct appeal to seeing-in.

Recognitional Ability

On a picture-by-picture basis, it may often be true that recognition of what is depicted is underwritten by some resemblance or other between depiction and object, though we may not be aware of that fact. Another way to put this point is that seeing an object in a picture is made possible by the resemblance because it is the basis in a given case for our recognitional ability. This leaves open that in other cases the basis of our ability to recognize what a depiction depicts (to see the object in the picture) is something other than a resemblance. This suggests that the best way to account for seeing-in is to give an explanation in terms of recognitional ability rather than resemblance. This is precisely what the final proposal to be considered does.

One version of the proposal suggests that a representation of a given object is pictorial if it triggers the same recognitional abilities as would be triggered by visually perceiving actual objects (Schier 1986). One problem with this version of the proposal is that we should have equally easy access to all kinds of depictions because they would all trigger the same sort of recognitional abilities—those used in ordinary perception. But this is not so. Some styles of depiction, such as the cubist style, require a period of familiarization before we see with ease the objects represented in them. Another objection is that this proposal implies that we can't know whether something is a depiction without doing psychological research into the basis for recognizing what is represented. It is highly counterintuitive that such research is needed before we can tell that something is a depiction. The proponents of the recognitional ability view do have a reply to this last objection. There is a ready test whether perceptual recognitional abilities are in play. It is a fact that once we are familiar with a pictorial style, we readily see what is represented in any picture in that style as long we can recognize the objects represented in their own right. This property, sometimes called natural generativity, is the mark of the operation of perceptual recognitional abilities. This mark can be noticed without engaging in psychological experiments. However, this reply to the second objection sug-

gests a third. Pictures are not the only representations that rely on perceptual recognitional abilities. Diagrams, maps, charts, and graphs also do. Thus, such reliance is not sufficient to identify depictions.

An improvement over the initial recognitional ability account of depiction appeals to our ability to recognize a variety of aspects of objects. According to this view, different styles of picturing selectively carry information about different aspects of perceptual objects and for that reason call on somewhat different recognitional abilities. A picture depicts a kind of object F if it embodies aspectual information derived from Fs on the basis of which a suitable spectator can recognize that it is an F (Lopes 1996, 152). This view is equipped to answer the first objection to the first recognitional account. Whether it can answer the third objection mentioned previously is less clear.

Because of these doubts, I am inclined to think that the seeing-in account of depiction is still the best basic account. Appeal to recognitional abilities may well be the best explanation of the seeing-in phenomena. It also may provide or suggest ways of accounting for certain features of depiction that the seeing-in account is silent about. For example, the second version of the recognitional ability account seems especially well equipped to identify what is distinctive about different styles of depiction. So it may not only explain the fact that seeing-in occurs but also supplement the seeing-in account by providing a more fine-grained analysis of its varieties.

Photographs

On the view defended here, seeing-in is a crucial feature of depictions, and a crucial property of seeing-in is nonexistence. Photographs are depictions that might be thought to provide a counterexample to this view because, it could be claimed, when we see an object that is F in a photograph, there always is an object that is F that we are seeing. If so, it could be argued either that not all depiction is characterized by seeing-in or that seeing-in is not rightly understood to have the property of nonexistence.

This argument raises a complex set of issues. One issue is whether both ordinary seeing and seeing-in are in play when we look at photographs. Do we see objects *in* photographs as we do in painting or drawing, or do we just see objects when we look at photographs as we see objects when we look at a garden? If we do see-in photographs, does this seeing-in have the nonexistence property? A related issue is whether we literally see the actual objects photographed when we look at photographs or merely substitutes or depictions of those objects. If we do see the objects, do we also see depictions (representations) of them, or is representation absent from photography?

Seeing-in does occur when we look at photographs, and photographic seeing-in has the property of nonexistence. It is simply not necessarily true that if one can see an object that is F in a photograph, there is an object

that is F that one is seeing. It is not even true that if such seeing-in occurs, there is (or was) an object that is F that was photographed. This is so for several reasons. First, if seeing-in occurs at all in photographs, we can see-in them kinds of things *not* represented, just as we can with paintings. In that case, there will certainly be no such thing to be seen. Second, we can photograph actors or models representing fictional beings and see those fictional being in the photographs. Third, photographs can misrepresent their subjects, so that we see something that is F in the photo (something with huge hands and a tiny head, for example) but the subject photographed was not F. Hence, from that fact that we see-in a photograph something that is F, it doesn't follow that there is something that is F that we are seeing. To establish that there is something that is F that was photographed and that we are perhaps seeing, more needs to be established than that we are seeing-in the photograph something that is F.

The previous examples show that seeing-in can occur in photographs and that it has the nonexistence property. What we have not shown is that we see-in photographs those actual things that are photographed. If we have a photograph of a woman (say, Betty), do we see Betty in the photograph, or do we just literally see Betty by looking at the photograph? One piece of evidence that we see Betty in the photo comes from the fact that such seeing can have the property of twofoldness. That is, we can at one and the same time see a photograph of a woman and see the photo's physical surface and design properties. Photographic depictions can also have the property of nonexistence (as we have already seen). After looking at the photo of Betty, we may see Betty in the next snapshot as well, but the photograph actually portrays Hetty, Betty's twin sister. Some claim, however, that photography is not a representational medium at all (Scruton 1983), and if this is so, that might be a reason to deny that we see its subjects in the photograph. On this view, photographs simply and mechanically record how its subject would be seen at a given moment in time. In doing this, it shows us either the subject itself or a substitute for the subject but not a representation of the subject. But this conception seems to misconstrue both what photographs are capable of doing and our interest in photographs, which the conception reduces to an interest in their subjects. Photographs can present their subjects in ways that they never could be seen, and we can be interested in the artistic point of showing a subject in a certain way in virtue of what it says about the subject (King 1992). All this suggests that photographs are pictorial representations of their subjects, and that would support the idea that we see the subjects in the photographs.

These considerations suffice to show that photographs are not a counterexample to the claim that depiction can be understood in terms of seeing-in or that a defining property of seeing-in is nonexistence. We have also claimed that photographs are pictorial representations of their subjects. One issue that we have not addressed is whether we literally see the subjects of

photographs—not *just* a picture of Betty but Betty herself. This is an issue, however, that we do not need to deal with here, so we will pass over it on this occasion.[6]

Summary

Many works of art are representational in the broad sense sketched at the beginning of this chapter. We have a representation in this sense when a symbolic vehicle "stands for" something. In this chapter, we have tried to get a better understanding not of representation in this broad sense but rather of two kinds of representation commonly found in art: fictions and depictions.

Regarding the nature of fiction, we have argued for a modified version of the make-believe view. Not every work that has the proper function of authorizing us to imagine certain things is a work of fiction, roughly only those that authorize imagining for its own sake. On this view, many depictions are fictional, but many are not. What is more a possibility is that every depiction engages our imagination. Depictions are to be understood as works that are intended or properly function so that we see-in them certain things. Seeing-in is characterized by two properties: nonexistence and the potential for twofoldness. Whether we should agree that all depictions engage our imagination depends on whether we agree that the nonexistence property of seeing-in implies that a passive, minimal degree of imagining always occurs when we see-in a work what it depicts.

If we deny that even such minimal imagining is implied by seeing-in, one might also wonder whether all fictional pictures really involve make-believe. Perhaps we can define a fictional picture as one that depicts nothing that actually exists. However, like an earlier suggestion about fiction in general, this won't do. One can have fictional pictures of actual historical events that refer to those events just as one can have historical novels that do this. Perhaps one can have pictures that refer to nothing real that are not fictions. Pictures created to help perpetrate a hoax might be examples. So it is still best to define fictional pictures, like all fiction, in terms of make-believe.

Further Reading

Currie, Gregory. 1990. *The Nature of Fiction*. Cambridge: Cambridge University Press. A make-believe account of fiction different from Walton's.

Dilworth, John. 2004. "Internal versus External Representation." *Journal of Aesthetics and Art Criticism* 62: 23–36. A defense of fictional reference.

Feagin, Susan. 1998. "Presentation and Representation." *Journal of Aesthetics and Art Criticism* 56: 234–40. A defense of the strong twofoldness condition on seeing-in against the objection based on trompe l'oeil.

Goldman, Alan. 2003. "Representation in Art." In *The Oxford Handbook of Aesthetics*, edited by Jerrold Levinson. Oxford: Oxford University Press, 192–210. A defense of the resemblance account of depiction.

Goodman, Nelson. 1976. *Languages of Art*. Indianapolis: Hackett. A highly influential critique of the resemblance view and development of the idea that depictions belong to a special type of symbol system.

Hopkins, Robert. 1998. *Picture, Image, and Experience*. Cambridge: Cambridge University Press. A highly sophisticated presentation of the resemblance view of depiction.

Levinson, Jerrold. 1998. "Wollheim on Pictorial Representation." *Journal of Aesthetics and Art Criticism* 56: 227–33. A defense and modification of the seeing-in view of depiction.

Lopes, Dominic. 1996. *Understanding Pictures*. Oxford: Oxford University Press. A thorough critical overview of the literature on depiction and a defense of the recognitional ability view.

Searle, John. 1975. "The Logical Status of Fictional Discourse." *New Literary History* 6: 319–32. An influential presentation of the pretense view of fiction.

Walton, Kendall. 1990. *Mimesis as Make-Believe*. Cambridge, Mass.: Harvard University Press. The best source of the make-believe view of fiction and depiction.

Wollheim, Richard. 1980. *Art and Its Objects*. 2nd ed. Cambridge: Cambridge University Press. The original source of the seeing-in view of depiction.

Zemach, Eddy. 1997. *Real Beauty*. University Park: Pennsylvania State University Press. The most detailed defense of fictional reference.

Notes

1. "Accidentally" true narratives are fictions on this view. A narrative is accidentally true if by chance, unbeknownst to the artist, there is a sequence of events that correspond event by event to the narrative. Even if something like this occurred, most fictional narratives would be true only in a loose sense. Suppose I write the following fictional narrative, "The Story of Frank": "Frank lived in a house. The house burned down. Frank moved." Suppose that unbeknownst to the author there is a Frank who lived in a house that burned down, after which he moved. Since I am unaware of this Frank, my sentences don't refer to him and are not made true by the events of his life.

2. It is hard to state this condition with precision. Usually, creators of fiction have a variety of purposes in mind in presenting events we are to imagine. A novelist may want to further the plot along, to create a parallel with an earlier part of the story, as well as get a reader to imagine the events of the story. But this imagining must be central to the writer's project if it results in a work of fiction. It is central if it is to be engaged in for its own sake, even if it also has other instrumental functions. We don't have a fiction if the only point of getting us to imagine a set of events is to convey a truth claim more effectively.

3. Symbolic or structural theories of depiction will be bypassed in the discussion that follows, but let me in this note point the reader to the most important such theories. The best-known theory is that of Nelson Goodman (1976), who thinks of pictures as belonging to symbol systems analogous to languages. The chief

analogy is that symbols in pictures have the same function of reference and predication as symbols in a language. What distinguishes pictorial symbols from others, according to Goodman, is that they are syntactically and semantically dense and relatively replete. Syntactic density means that between any two symbols there is potentially a third. Hence, there are an indefinite number of symbols in such a system. Semantic density means that there is an indefinite number of objects that its symbols can denote. Repleteness, finally, means that virtually every design property of a picture can have a distinct pictorial significance. Unfortunately, it's possible to think of counterexamples to this approach to identifying what is distinctive to pictures (Goldman 2003, 200–203; Lopes 1996, 55–76). A more recent structural account, one that avoids these problems, has been proposed by Kulvicki (2003). It is too recent to have received much assessment as yet and too complex to summarize here, but it is the most promising such account currently available.

4. The seeing-in account was first introduced and developed by Wollheim (1980, 1987, 1998). Wollheim emphasizes twofoldness above everything else in his explication of seeing-in. It is not entirely clear whether he would accept the claim that seeing-in possesses the nonexistence property. I believe he would, but this depends on how to interpret some of his claims. For a different interpretation, see Walton (2002). What Wollheim would not do is modify the twofoldness condition in the way proposed later in this chapter. For a view of twofoldness similar to (and pre-dating) mine, see Levinson (1998b).

5. Walton (2002) suggests that the make-believe view is better placed than the seeing-in view to account for the point of view from which we see pictures. It is the point of view from which we imagine seeing the objects represented in them. It is not clear to me that this explains much. Shouldn't the explanation of point of view tell us why we imagine seeing those objects from that point of view, why we see-in the picture objects arrayed in the pictorial space in a certain way? This explanation perhaps comes down to identifying the perspective (for example, linear, orthogonal, oblique) in which the picture is made and the viewer's tacit grasping of this.

6. For a discussion of this issue, see Lopes (2003), Martin (1986), Walton (1984), and Warburton (1996).

9

Expressiveness in Music and Poetry

A rt is expression. Many people would assent to this claim. But it is puzzling in two respects. First, if it can be taken as a truth at all, it is not easy to precisely identify it. We saw in chapter 5 that we cannot *define* art as expression. The best that can be said is that many artworks are expressive in some sense, and this is a feature of these works that intrigues us. Second, it is far from easy to say exactly what the expressiveness of a work consists in. Consider an exuberant piece of music such as Duke Ellington's version of Billy Strayhorn's *Take the A Train*. What does its exuberance consist in? What are we saying when we assert it is exuberant? It turns out that these are difficult questions that have stirred up a lot of controversy. This controversy is the subject of this chapter.

What can be expressed is limited to psychological states, real or fictional. These include beliefs, intentions, desires, attitudes, emotions, and moods. People can and do express any of these things through what they do, say, write, or make. Artists can use artworks as such a vehicle of expression. However, the topic of expression in art is typically even more narrowly defined in two respects. First, the focus is on what works express or are expressive of, and it is now widely understood that this need not be a psychological state that the artist actually was in. A work can be sad or express a belief in God without it expressing the artist's sadness or religious belief. Second, the focus of most discussions of expression has been on attitudes, moods, and emotions rather than beliefs, intentions, and desires. We will follow this practice in our discussion of expression here.

Expression across the Arts

Let us begin by making two preliminary observations about expressive phenomena across the arts: a lyric poem being expressive of a certain sort

of grief, a passage of music being expressive of gloom and despair, a painting being expressive of anxiety-induced terror.

The first observation is about the diversity of terms used to refer to expressive phenomena in the arts. We say that works *are* sad, that we *hear* or see sadness in them, that they are *expressive* of sadness, that they are *expressions* of sadness, or simply that they *express* sadness. In the preceding remarks, I have already used "expressive" and "expression" without distinguishing between them. In ordinary discourse about art (and beyond art), I doubt that there are sharp distinctions in meaning segregating these locutions, but they are not always interchangeable. They can be used to say different things. I shall distinguish among these different things by using the previous locutions in the following way. To say one hears or sees sadness in something does not imply it is sad, is expressive of sadness, or is an expression of sadness. Hearing sadness in something is a (quasi-)perceptual state, which has the same nonexistence property as seeing-in. Sometimes it can involve misperception ("I know you heard sadness in her voice, but that is because you read something into what she said that simply wasn't there."). It can also involve what might be called an idiosyncratic perceptual state ("I know you see rivers and mountains in the cracks of that old wall, but the wall doesn't represent rivers and mountains." "I don't deny that you heard sadness in the passage, but it is implausible to take the passage as expressing sadness."). To say a work *is* sad is to attribute some property to it but not one that implies that the work is an expression of sadness. A work is an expression of sadness only if it in some way conveys, communicates, or makes manifest (an actual or fictional) someone's sadness, and a work can *be* sad without doing this. Most difficult is marking off "expressive of." I shall not try to settle in advance how to do this because much of the controversy in the musical case is over this. With respect to music, some take a passage's being expressive of sadness as equivalent to its being sad. Others take the passage's expressiveness as equivalent to its being an expression of sadness. Finally, there are others who take it as neither.[1] To say a work *expresses* an emotion can mean either that it is expressive of or that it is an expression of the emotion.

Second, we should note that different art forms are expressive in different ways. Thus, the expressiveness of lyric poetry tends to consist, in large part, in the "articulation" of the propositional content of an emotional state—the beliefs, desires, perceptions, and so on—whereas expressiveness in music must necessarily be located, for the most part, elsewhere. At a minimum, this means that one finds quite different expressive phenomena in different arts. More significantly, the conditions on a work expressing an emotional state probably differ in different art forms. In literary forms, it suffices that we can *infer* the emotional state from the expressive phenomena. Music is expressive only if we can *perceive* (that is, hear) emotion in the music. Hence, it may be that what we mean by "expression" or "expressive of" is not univocal across art forms.

A Theoretical Challenge

We can define the challenge of giving a theory of expressiveness in the arts as that of finding some way of unifying these diverse phenomena. One approach to this is the evocation view, which claims that the expressiveness of a work or passage consists in its tendency to evoke emotion in its audience. There are two main problems with this approach. First, people's emotional reactions to expressive works are highly variable. One person may react to a deeply sad musical passage with sadness, another with joy at its beauty, and a third with no feeling at all. It's not clear that the tendencies presupposed by a simple evocation theory are sufficiently widely shared to track expressiveness. Second, even if they were widely shared, the evocation of emotion in an audience is more a reaction to expressiveness than the expressiveness itself. Hence, it is the wrong item to use to analyze expressiveness.[2]

An alternative to the evocation theory focuses on a different aspect of the audience's experience, one that is more recognitional than emotional (though emotional reactions may play a role in bringing about the recognition). When one experiences an expressive artwork, it is *as if* one encounters something bearing an emotional state while one really is not since the object of cognition—the artwork—is incapable of being in such a state. Thus, one *sees* anxiety *in* a painting, hears the music *as sad*, and reasons about what is said in a poem *as if* one is confronted with someone's psychological state. Generalizing, I will call these experiences "*apprehension as of*" an emotional state or quality to bring out the idea that we are having an experience as of confronting something in an emotional state without literally doing so. The assumption underlying the recognitional view is that, while it is wrong to simply identify a work or passage being expressive of an emotion E with our *hearing, seeing, or inferring E in it*, understanding the latter is crucial for understanding the former because such *apprehension as* will enter into a correct account of expressiveness.[3]

The recognitional view would be no better than the evocation view if the object of recognition is the expressiveness itself. It would then presuppose what it was trying to explain. However, this is not the case. As noted previously, one can, for example, hear sadness in a musical work that is not expressive of sadness. Hence, to complete an account of expressiveness, one needs to identify a relation between apprehending as and artworks that holds only when works are expressive of an emotion, mood, or attitude. The conditions under which this relation holds are the truth conditions for work being expressive of an emotion, mood, or attitude.

Let us now turn to some proposals about musical expressiveness and see what conditions they offer.

Musical Expressiveness

There are several approaches to clarifying what it is to hear emotion in music. First, there are views that take it to be the perception of a phenomenal quality of the music, "an emotion characteristic in appearance," as Stephen Davies calls it.[4] Call this the phenomenal appearance view. Just as hearing *motion* or dynamic qualities in music is hearing a phenomenal quality or presented appearance of music, so is hearing *emotion* on this view. Further, the hearing of the former is intimately related to the hearing of the latter. To a considerable extent, we hear emotion in music because we hear motion and dynamic qualities in it. The "because" here is most often cashed out in terms of a perceptible likeness between the movement and dynamic quality of the music and the pace and posture of a person in a certain emotional state, such as a sad, happy, or angry one (Davies 1994, 229–39). Some, however, suggest the relevant likeness is with the felt inner quality of emotions such as those just mentioned (Budd 1995, 133–55; Langer 1953).

This view has notable advantages. First, its proponents point out that the perception of an emotion characteristic in appearance is by no means restricted to music but is a variant of a familiar phenomenon: certain faces both human and nonhuman (such as those of some dogs) present a sad appearance independently of whether their possessors are actually sad, as do weeping willows, whereas twisted, dead apple trees have a tormented appearance, and there is something joyful about the open arms of a bright blue cloudless sky. Hence, the phenomenon of hearing emotion in music is by no means an isolated one. Second, the view does not require that music express or represent cognitive content of emotions, something many believe music to be incapable of doing. Third, the view also does not require that anyone—either composer or listener—actually be in an emotional state, something many believe *not* to be requisite for music to be expressive. Fourth, there seems to be a straightforward way of supplementing the account of hearing emotion in music to provide an account of expressiveness per se. We hear emotion in music when the music presents an emotion characteristic in appearance to us, as when we hear the music as possessing a "cross-categorial likeness" (Budd 1995, 136) to either the human expression of emotion or the experience of an emotion. The music actually is expressive of the emotion when it is correct to so hear the music, because the music actually possesses the likeness in question.

The phenomenal appearance view, however, has some notable disadvantages as well. First, given this account, it becomes a nice question whether it is proper to say that music expresses emotion at all when this is taken to mean not merely the possession of an appearance but also the being expressive of a psychological state. It might be thought that we can escape this

problem by severing music's being sad from its expressing the psychologi-
cal state of sadness and claiming that the account explains how music is the
former but not the latter. The problem here is that we were initially look-
ing (or believed ourselves to be looking) for an account of the latter. A sec-
ond problem is that the present account will be unable to explain the value
we attach to expressiveness in music unless it can forge a link between the
possession of emotion characteristics and the world of human feeling. The
account is incomplete until it does this. This problem is intimately related
to the first one because an explanation that refers to the realm of human
psychological states could be regarded as a more full-blown account of ex-
pressiveness in music.[5]

Third, the proposal for supplementing the account to provide a treat-
ment of expressiveness in terms of *correctly* hearing emotion in it is prob-
lematic. It is clearly not sufficient for a work to express an emotion or that
it in any old way resemble expressive behavior or emotional experience.
This much can be happily admitted by proponents of the account under
examination because they do require more than any old resemblance; they
require a perceptible one. However, this still does not do the trick since not
any old perceptible resemblance will suffice either. One can attempt to give
examples of sufficient resemblance, but beyond that I frankly have no idea
how to specify them and distinguish them from an insufficient likeness. As
Levinson (in press) has put it, "The only way to anchor 'sad musical ap-
pearance' . . . is in terms of our disposition to hear music as sad." If this is
correct, then an attempt to explicate correctly hearing emotion in music in
terms of possession of emotion characteristics in appearance is doomed to
failure because it is doomed to circularity. On the other hand, perhaps the
way to explicate the true attribution of an emotion characteristic in ap-
pearance is through a disposition among nearly all qualified listeners to hear
emotion in music.

Aaron Ridley builds an evocation theory of *expressiveness* on the back of
the fact that music presents emotion characteristics in appearance. Ridley,
like Davies, points out that the presentation of such characteristics does not
justify the assertion that music is expressive of emotions (understood as psy-
chological states). The presentation of such a characteristic (which Ridley
dubs "musical melisma") "is not expressive. It only resembles something ex-
pressive" (Ridley 1995, 120). We experience music not merely as resem-
bling something expressive but as itself expressive when "the melismatic
gestures are heard as expressive of those states which, sympathetically, we
experience" (138). To undergo a sympathetic emotional response to per-
ceived "melismatic gestures" is to experience music as expressive, to appre-
hend the expressiveness of a work or passage.

Ridley's claims about musical expressiveness run parallel to a view he ac-
cepts about what it is to apprehend expressiveness in human behavior. One
can "robotically" employ generalizations that certain features of face, voice,

posture, or movement are associated with some emotions or moods. But we experience behavior as expressive only when we know what it is like to experience an emotion or mood, and this requires something different from applying generalizations. According to Ridley, it requires a sympathetic emotional response. Ridley (1995) concludes that a full understanding of "expressive vocabulary" (132) requires such a sympathetic (empathetic) emotional response and an ascription of these predicates is only fully warranted when the "affective responses are engaged" (132). As with human behavior, so with melismatic gesture in music, according to Ridley.

Ridley's view is insightful in noting that full-blown expressiveness in music requires something additional to the occurrence of emotion characteristics in appearance. Looking for the needed supplement in an evoked emotional response is not implausible if only because many have been drawn in this direction, as the persistence of less plausible versions of evocation theory demonstrates. However, there are a number of flaws in Ridley's view that render it unsatisfactory. Let us begin by noting those that pertain to the apprehension of emotion in persons and then move on to musical expressiveness.

Ridley claims that to fully understand emotions, moods, and their expressions in human behavior, we have to be able to do something more than form true beliefs about when people are in those states. We must know what it is like to experience them. Let us grant that this is so. Let us also grant that a sympathetic (empathetic) emotional response—actually *feeling* what another feels—plays a role here. The point that needs to be made is that this is not the only way to gain this understanding: one can do so by bringing past experience to bear in the present situation and also by exercising the imagination in ways that may or may not be empathetic but in any case fall short of undergoing an emotion or mood. One can be very insightful about the feelings of others but very unsympathetic (or unempathetic). So the role of sympathetic arousal in understanding others is not as pervasive as Ridley suggests, and the alternatives of robotic belief formation and sympathetic understanding are not as exhaustive.

Turning now to musical expressiveness, let us begin by noting an equivocation regarding the notion Ridley is attempting to illuminate. Officially, Ridley is offering an account of musical expressiveness, but (as the previous exposition indicates), he often speaks of accounting for the *experience* of musical expressiveness. These are two different things: one can experience (hear) music as expressive when it is not, and one can experience (hear) music as expressive of one state when it is expressive of another. Hence, an account of the experience of music as expressive falls short of an account of expressiveness.

Is Ridley's account satisfactory at least as an account of what it is to experience (hear) music as expressive? No. It certainly does not provide a

necessary condition for such hearing, for there are those who do hear music as expressive but lack the affective response. This is not surprising given the points noted previously about understanding human expression. Affective response is no more the only means to this in music than it is with regard to human behavior.

A third account is the persona view. The basic idea is that artworks are *expressive* in virtue of being the fictional *expression* of someone's emotion, mood, or attitude. This is someone who fictionally utters the work, and this someone is called the work's persona.[6] The easiest way to get a handle on the idea of such a persona is to first think of the case of lyric poetry. Consider the line "A slumber did my spirit seal." When we read this, we hear someone speaking these words to us. Perhaps it is the poet William Wordsworth. But it needn't be. Wordsworth may be imagining someone who utters the poem, including the line just quoted. Whoever utters it is the poem's persona, and if an emotion is expressed through the uttering, it belongs to the persona. This idea works well for lots of poetry. The claim of the persona theorist is that it can be extended to other art forms, in particular, to music.

So applied, the view can take two different forms. Bruce Vermazen (1986) suggests that a work expresses a mental property if and only if the work is *evidence* that the imagined utterer of the work has that mental property. This view proposes that apprehension as if something is in an emotional state is identical to an inference that an imagined producer of an object (for example, an imagined utterer of a poem) is in that state. It is not obvious that this works in the case of music, where we hear an emotion in the work. When we hear sadness in a passage of music (or hear the music as sad), this does not seem to be an inference from the music based on evidence that an imagined utterer of it is sad. It is better to say that hearing an emotion in a passage of music consists in the music being *perceived* by a listener as the expression of the emotion by an indefinite agent—the music's persona (Levinson 1996). This is the second form a persona view can take. It differs from the first in claiming that, rather than inferring the presence of an emotion in the fictional persona, in the case of music, one directly perceives this.

The advantage of the persona view is that it offers a way of making intelligible puzzling phenomena such as hearing an emotion in music (for example, hearing sadness in the music or hearing the music as sad) so that one is able to construe "emotion" as referring to a type of psychological state (not merely a phenomenal appearance). One might be inclined to think that when someone claims to hear such and such in a passage, she is claiming that the passage *sounds like* such and such. (So, if one hears bells in a passage, this is because the passage has a bell-like sound.) However, it is *not* intelligible to say (literally) that a passage sounds like sadness. What it is intelligible to say is that the music sounds like someone's

expression of sadness or that it might furnish evidence that someone is sad.

There is, however, a disadvantage to this attempt at making hearing emotion in music intelligible. This is that, while the explanation is more intelligible than the phenomena, it is far less readily acknowledged than the phenomena. That is, many who are willing to say that they hear emotion in music are not willing to say that they hear (abstract) music as having a persona or utterer. The idea that musical pieces are to be heard as uttered does not have the inevitability it has in the case of poetry.[7]

So far, I have been noting pros and cons of the idea that we hear emotion in music in virtue of hearing the music as an expressive utterance. To settle what expressiveness in an artwork is, we still need to go on to decide when a work is expressive of emotions (and other psychological states) that we perceive or infer in them, that is, when it is correct to attribute the state to the work.

The proposal we will focus on (Levinson 1996) claims that a musical passage expresses an emotional state if it is *readily* and *spontaneously* heard as someone's expression of that state by a *properly backgrounded* listener who hears the passage *in the context* of the whole work and its historical setting. This, though a pretty elaborate condition, still is not enough. Nothing in the properties of such hearing rules it out as a case of misperception. For me, at least, it is easier to see this by shifting to another art form: lyric poetry.

Expressiveness in Poetry

Unlike pure, instrumental music, as we noted previously, it is virtually impossible to read a lyric poem without taking it to be uttered by someone. This someone is most standardly understood as a fictional utterer, though perhaps it should not be assumed a priori that it is never the actual poet. It is also virtually impossible to read a lyric poem without taking it to express an attitude or emotion toward (a possibly fictional) someone or some (possibly fictional) state of affairs. The attitude or emotion expressed is often that of the utterer, though it is not always. It is *not* the utterer's attitude or emotion that is expressed when the poem somehow suggests we should not take this attitude or emotion at face value or when the poem manages to express another attitude toward the utterer's expressed psychological state. It is important to distinguish, by the way, an utterer expressing an ironic attitude and a poem expressing irony toward its utterer's attitude or emotion. In Herrick's short poem, "Fain would I kiss my Julia's dainty leg, / Which is as white and hair-less as an egge," the utterer expresses an ironic attitude toward Julia and parodies the conventional poetic means of praising a woman's appearance. The poem also parodies this *through* the utterer. The

utterer's attitude and that expressed by the poem converge, and it is the former that conveys the latter. In Blake's *Songs of Innocence and Experience*, one cannot take the attitude expressed by the utterer of one of these poems quite at face value because it is clear from the overall context that the utterer views the world from a particular perspective (that of innocence or experience), but it is not clear what these perspectives involve, how accurate a view of the world one gets from them, or even if there is such a thing as an accurate view specifiable independently of these perspectives.

Thus, both the utterers of lyric poems and the poems themselves express attitudes and emotions, that is, psychological states, albeit often imaginary ones. This is another way poetry differs from music where it is *not* clear that the emotion we hear in music can be cashed out in terms of the *expression* of psychological states.

These features of lyric poetry pointed out in the discussion so far make it a clearer testing ground of the persona conception of expressiveness than the musical case. For with poetry, there is no controversy whether there is an utterer (persona) or that there is the expression of psychological states. So we have better hope of a determinate answer to the question whether a poetic passage expresses an emotion if it is readily read as someone's expression of that state (either the utterer's or the implied or actual author's) by a properly backgrounded reader who understands the passage in the context of the whole work and its historical setting. Elaborate as this condition is, I will argue that, taken in one way (the most natural or literal way), it is insufficient to guarantee poetic expression, while taken in another way, it provides a sufficient condition for expression, but it is more clearly put in other terms.

To bring this out, we will briefly consider a well-known debate, originally between the critics Cleanth Brooks (1994) and F. W. Bateson (1966), over the interpretation of Wordsworth's poem "A Slumber Did My Spirit Seal." The poem is short enough to reproduce:

> A slumber did my spirit seal;
> I had no human fears;
> She seemed a thing that could not feel the touch of earthly years.
>
> No motion has she now, no force;
> She neither hears nor sees;
> Rolled round in earth's diurnal course,
> With rocks, and stones, and trees.

The debate is easily seen as one about the emotional state expressed by the poem. Bateson construes the state as one that is accepting of a loved one's death, while Brooks's interpretation regards the poem as despairing. Both critics are properly backgrounded and are looking at the poem in its historical context, and both interpretations are apt and unforced. It is possible

that the poem is ambiguous or indeterminate on the matter being debated by these critics, but it is also possible that one (or both) of these critics is mistaken in the interpretation offered despite the fact that all of Levinson's conditions are met.

Whether this criticism is ultimately to be accepted depends on how one construes the force of "readily," "properly backgrounded," and "contextually situated." Bateson's interpretation of "A slumber" is to me apt and unforced. If one approaches the poem with Wordsworth's pantheism chiefly in mind, one can *readily* read the poem in Bateson's terms, making the interpretation unforced and plausible, and in doing so provide a way of appreciating the poem as a whole. Bateson contextually situates his interpretation with respect to the work as a whole because he uses it to explain many aspects of the poem. He is clearly "historically backgrounded" and uses this in emphasizing Wordsworth's pantheism.

However, despite (to my mind) meeting the relevant criteria, I think Bateson's interpretation is mistaken in the emotion it infers to be in the poem. I believe this because there are at least two features of "A Slumber" that Bateson's interpretation does not adequately account for. In the first stanza, the speaker takes himself to task for some failure in himself toward Lucy (the "she" in poem) when alive. ("A slumber did my spirit seal; . . ." "She seemed a thing that could not feel / The touch of earthly years"). For what is the speaker taking himself to task? However we finally wish to express it, it has something to do with a blindness to Lucy's mortality, a blindness that a pantheistic conception of the world might *promote* but could hardly justify in the context of the speaker's self-reproach. Second, the choice of such hard, lifeless, and impenetrable things as rocks and stones to accompany Lucy's diurnal course hardly seems the right choice if one wishes to convey an emotion based on a reassuring pantheistic conception of the world.[8]

It might now be replied that, if I am right in my assessment of Bateson's interpretation, it turns out that it was not apt and unforced or not adequately contextually situated. If one says this, one is packing more requirements into these terms than I did in the preceding paragraph. One is requiring that one's inference adequately take into account everything relevant to identifying the poem's expressive properties, whether it be in the text or part of the historical background. What is involved in taking into account everything relevant to such an identification? A simple way of putting the matter would be to say that it takes into account all the features of a poem. Bateson's interpretation fails to take into account two such features (according to me). Though simple, this is not a very clear way of putting the matter. Bateson offers a close reading of the poem in which he has something to say about every line, almost every word. What has he failed to do? What he does not offer, if my criticism is correct, is an account that is as justified as possible alternatives of what Wordsworth could have

meant in arranging his speaker to utter those lines. For example, if I am right, we are most justified in believing that Wordsworth intended his speaker to express regret over a past failing with regard to Lucy, and Bateson's interpretation does not give us this belief.

It is interesting that Levinson has offered a theory about the meaning of literary works that fits this account to a tee. It is called hypothetical intentionalism, and it asserts that the meaning or core content of a work is the intention that an ideal audience would be most justified in attributing to the author of a work (Levinson 1996, 175–213; for a discussion of this view as a theory of interpretation, see chapter 7). Levinson never suggests that in offering his account of expression in music he is extending hypothetical intentionalism to that domain, and hence there is no reason to think he intended to pack hypothetical intentionalism into his account of expression. Nevertheless, when we push Levinson's account of expression (at least in the domain of poetry), it avoids counterexamples only when understood as hypothetical intentionalism.

It follows that we should say that readily inferring an emotional state in a poem, even when this occurs when the work is received in its proper context by a properly backgrounded individual, does not *entail* that the work expresses that emotional state *unless* what one is asserting is that an ideal audience member would hypothesize that the creator of the work intended such inferring.

Expressiveness in Music Again

Applied to music, the view now being proposed is that a musical passage is expressive of an emotion if the best hypothesis of an ideal listener is that the composer intended the emotion to be heard in the music. Before defending the view, let's first review how we arrived here.

The discussion of musical expressiveness in part II reached the following conclusions. First, we hear emotion characteristics in appearance in music, understood as heard resemblances, but an account that stops with noting that music with such characteristics fails to give us a satisfactory conception of musical expressiveness. Second, appeal to music's undoubted ability to evoke feelings in us does not satisfactorily provide the further element needed to get an account of expressiveness. We are now in a position to ask whether our revision of Levinson's proposal, understood as a version of hypothetical intentionalism, does better than these other views and should be carried over from literature to music.

The first point to note is that understood in terms of hypothetical intentionalism, it is a very different account from the one originally proposed. The original proposal combines two different claims. One claim is that we hear music as the expression of a (fictional) someone: a musical per-

sona. The second claim is that music is expressive of an emotion when this is the hearing of someone properly backgrounded and the hearing spontaneous. My main criticism of the first claim is that, for it to be a plausible basis on which to account for musical expressiveness, the hearing of music in this way needs to be as widely shared among listeners who perceive emotion in music as the hearing of an utterer of a poem is for readers of lyric poetry. That is simply not the case. I argued against the second claim by pointing out that, unless this is a covert way of formulating hypothetical intentionalism, the view fails to provide a condition sufficient for expression. To reinforce this point, imagine Levinson's condition is met for a properly backgrounded listener who readily and spontaneously hears emotion E in a passage of music. It remains possible for another equally qualified listener listening in an equally ideal way to hear no emotion or a different one in the same passage. However, if this were to happen, it would at be an open question whether the passage is really expressive of E.

Is hypothetical intentionalism adequate for identifying what musical expressiveness is (when detached from the idea that we always hear emotion in music in virtue of hearing the expression of a musical persona)? Let us proceed by considering objections to the viability of hypothetical intentionalism in the musical case.

The first objection is that hypothetical intentionalism fails to meet the requirement that, in music, expressiveness is typically heard rather than inferred. The proposal requires us to infer that an ideal audience would be most justified in hypothesizing an intention that listeners hear an emotion in a work. However, the objection is based on a misunderstanding. The perceptual requirement operates on the level of hearing emotion in music, and there is nothing about hypothetical intentionalism that precludes such hearing. The determination that a passage is expressive of an emotion is not a perception but a judgment about the music, commonly in part based on what one hears in it.[9]

To this it might be replied that there is still an important difference between the original persona view and the hypothetical intentionalist alternative. For the qualified listener, the mere hearing of the music can bring a well-justified conviction (if not knowledge) that the music expresses E. This is sufficient to count as this listener's perception of the music's being expressive of E. On the other hand, arriving at the best hypothesis about a composer's intentions is essentially a more inferential affair. Hence, the persona view better accommodates the thought that, for music, expression is something more heard than inferred.

However, these claims exaggerate at both ends, as it were. On the one hand, they exaggerate the perceptibility of expression on the persona view. To see this, recall that the fact that one qualified listener hears E in a passage is no guarantee that the passage expresses E if other qualified listeners hear something different. Hence, there is an essentially inferential aspect to

expression on the persona view regarding what qualified listeners will *generally* hear. On the other hand, the well-justified conviction that one is hearing the expression of E in a certain passage is just as available on the hypothetical intentionalist view. Sometimes, intentions are relatively transparent. When this is so, and when a listener hears E with the conviction that this is intended, she also has the well-justified conviction that she hears the expression of E.

To summarize, the two views share in common that there is such a thing as hearing E in the music. They both share a reading of such hearing according to which it can be nonveridical, that is, according which one can hear E in the music but the music does not express E. However, they both claim that sometimes musical passages really are expressive of E, and when they are and when a listener hears E in the passage, both views can claim that the expressiveness of E is perceived (though not necessarily known to be). Hence, both views are capable of explaining how the musical expression of emotion is something that can be heard. On the other hand, both hypothetical intentionalism and the persona view include truth conditions that only an inference, not perception, can establish to hold in a given case.

A second objection is to the analogy with poetic expression we used to reach the hypothetical intentionalist analysis of musical expression. The objection claims that the analogy is not apt because the two kinds of artistic expression are so different. Musical expression is accomplished through gesture (musical movement), while expression in poetry is a much more propositional affair in which we cognize the intentional content (the beliefs, desires, perceptions, and so on) of someone in a particular emotional state. (In "A Slumber," the speaker's self-reproach over his failure to appreciate Lucy's mortality is an example of intentional content.) We shouldn't expect that expression achieved by such different means to be open to the same analysis.

There is a simple response to this objection. To adequately account for expression in music and poetry, the difference just mentioned cannot be ignored. However, this difference does not settle whether both sorts of artistic expression have aspects that can be only inferred rather than perceived. We have just argued that both do have such features, and if this is correct, both are amenable to hypothetical intentionalist treatment despite their differences.

A third objection is that it is quite possible that very often music lacks the means of communicating fairly specific emotion types in anything like a determinate way. Hence, very often there will be a great deal of indeterminacy over which emotion, if any, we are most justified in supposing that a composer intended us to hear. If the indeterminacy is sufficiently great, it may be better to say not that the music ambiguously expresses a perhaps open-ended range of emotions but that it expresses not a particularized emotion, such as brash exuberance or despair-

induced gloom, but only a generalized downcast or happy mood. In such cases, it may be more proper to speak of the expression of more particularized states as something a listener *may* permissibly hear rather than as something that is in the work as such.

This is a good point, but it is not an objection to anything claimed here. I imagine that musical works and passages will vary concerning whether we can say they express such and such an emotion or whether they merely permit us the option of hearing in them that emotion. Levinson (1990) has argued that Mendelssohn's *Hebrides Overture* expresses hope, and Robinson and Karl (1997) have argued that Shostakovitch's Tenth Symphony expresses false hope. If these ambitious claims are sustainable, it is reasonable to require that they satisfy hypothetical intentionalism. If this is true, then where music expresses emotion in a fairly determinate manner, we should expect hypothetical intentionalism to be a good theory of what such expression comes to. Where what music expresses is indeterminate, where we can at best say that the music permits us to hear a certain emotion in it, we don't have a case of a musical passage expressing E. Hence, we are outside the range of expressive phenomena that hypothetical intentionalism is supposed to cover.

There is another problem that should be mentioned here. There are some, I am sure, who think of expressiveness not only as something that is *not* intended but not even as something that is perceived as intended. They are certainly right about some expressions of emotion in ordinary behavior. A wailing cry drawn out of you by your grief is not the result of an intention to communicate grief. So it may be thought implausible that musical expressiveness can be understood in terms of an intention. In reply, recall that such an understanding was not implausible for poetry. Even if one reads a poem as the utterer's unintentional expression of an emotion or attitude (as some poems can surely be read), one will still take the poem as intending us to take the utterance as such an expression. If hypothetical intentionalism is correct, the poem is such an expression if this is the best hypothesis about the poet's intention. Similarly, one may hear a musical passage as a wailing cry, an unintentional expression of grief, but one will think the passage is such an expression only if one thinks it is *supposed* to be heard that way. According to hypothetical intentionalism, it is supposed to be heard that way if this is the best hypothesis about the composer's intention.

Another objection claims that there are many cases where music has a perceptible emotional quality but that it's clear that it is not intended because the quality performs no important functional role in the music. A possible example here is Bach's *The Art of the Fugue*, which one commentator takes to be "melancholy and somber almost throughout. "But," the commentator goes on, "Bach had absolutely no intention of making it melancholy and somber. These . . . qualities have nothing to do with

what makes the work tick." I would reserve judgment about the accuracy of this assessment of the emotional quality of this vast piece of music and whether that quality is anything other than epiphenomenal. However, for the sake of example, let us suppose the commentator is correct. Is this a counterexample to the present proposal? By no means, and this is so whether we take the intention in question as actual or hypothetical. Rather, it fits right into the view I am proposing. For one of the motivations of the account on offer is to be able to distinguish cases of music that sounds sad (or melancholy and somber) and that is adequately captured by the phenomenal appearance account and cases of musical expressiveness where something more is required. A good way of stating what is required is that the quality is an intrinsic part of what makes the work "tick." When that is so, it will also be reasonable to hypothesize that the quality is intended.

A related objection might go as follows: suppose a composer explicitly disavows any intention to make works expressive of emotion, yet a passage from one of this individual's compositions is regularly heard as expressing a certain emotion by properly backgrounded listeners hearing the music in its proper context. Is it not then true that the work expresses that emotion, but the best hypothesis of an ideal audience is that the composer did not intend to express it? There are a number of ways of escaping this dilemma. One is to discount the composer's disavowal. We should distinguish intentions from expressions of intentions and not assume that the latter is always the best, even if it is relevant, evidence of the former. Alternatively, one can restrict appropriate evidence to be used by an ideal audience to simply exclude direct expressions of intention. Despite these counters, we should admit that this case most vividly suggests an alternative to hypothetical intentionalism (or any other intention-based account). The alternative is that what one is *supposed to hear* in a work is what an ideal audience does hear. This alternative is viable, however, only if reactions of ideal audience members tend to converge. However, what one hears depends on what one is listening for. I see no reason to expect convergence when listening is not guided by the intention to form the hypotheses required by hypothetical intentionalism.

At this point, the reader may be thinking back to the discussion of hypothetical intentionalism in chapter 7, which argued that there are convincing counterexamples to this view as a theory of work meaning. If this argument is correct, doesn't it follow that hypothetical intentionalism would face similar counterexamples regarding expression and so must be unsatisfactory here too?

In answering this objection, I want to remain somewhat noncommittal. Perhaps hypothetical intentionalism can work in the domain of expression even if it can't work as a general theory of meaning. Alternatively, perhaps the objections to it can be answered (though at present I don't see how).

However, even if this view does succumb to objections, there is a replacement waiting in the wings, namely, the moderate actual intentionalism defended in chapter 7. According to this view, actual intentions, not hypothetical ones, are determiners of meaning, but they are only one of several contextual features that play a role in doing this. Hence, as with hypothetical intentionalism, expression can occur in an artwork that is not actually intended to be expressive if there are conventions and background conditions capable of determining its presence. To be completely forthright, it is this moderate actual intentionalism that would be my own most favored view of artistic expression. However, I want to leave the hypothetical intentionalist version on the table because the point to emphasize is that an account of expression can be assimilated to a more general account of work meaning, whichever account proves to be the best.

A last objection is that the account of musical expressiveness in terms of hypothetical intentionalism (or moderate actual intentionalism) tells us what is expressiveness without telling us what hearing emotion in music is. However, if the account of the former is to be based on the latter, as was proposed at the start of this chapter, the account is empty, or at least contains a large hole, without an account of hearing emotion in music.

This is a serious objection, and it deserves a longer answer than can be given here. The gist of the answer I would give consists of two claims. First, I don't think that the explanation of hearing emotion in music needs to be pinned down to one thing. For example, if one hears in the music the expression of an emotion by an imaginary persona, that counts as hearing the emotion in the music, even if this is not entirely typical of hearing emotion in music generally. Second, I assume that the basic case or the most standard way of hearing emotion is to be built on the apparent perception of an emotional quality—an emotion characteristic in appearance. What one has to build into such hearing is a reference to the world of human feeling, that is, the psychological states such emotion characteristics resemble. This is achieved with the recognition that the characteristics are intentionally placed to make such connections.

Finally, even if we can ward off objections to hypothetical intentionalism's account of musical expression, we need to ask whether the proposal has advantages that make it deserving of acceptance or at least further consideration. Like the persona view, it allows music to be expressive of psychological states without supposing there is an actual someone (composer or audience) who undergoes these states. It has the negative advantage of not tying this expressiveness exclusively to the hearing of musical personae (if I am right that this is a relatively uncommon way of hearing music). At the same time, it allows that both the hearing of musical personae and the arousing of emotion in listeners are relevant to *a determination of* musical expressiveness (a separate issue from what such expressiveness consists in). Of course, the emotion characteristics in appearance possessed by a passage

would provide the most fundamental evidence of expressiveness. So the present proposal is at least able to recognize the insights of other views discussed previously as well as avoid their drawbacks.

Summary

We have examined several accounts of expressiveness in two art forms: music and poetry. For poetry, hypothetical or moderate actual intentionalism works just fine because which emotions are expressed in a poem is a function of the meaning or meanings possessed by the poem. Such a view has not been considered as an option in giving an account of expressiveness in music. However, having considered several of the more usual proposals—the evocation view, the phenomenal appearance view, and the persona view—we have argued that the same account that works for poetry is the best analysis of expressiveness in music. We have also given a role to the more standard views in providing an understanding of the phenomena of hearing emotion in music and in correctly doing so. The fact that it is sometimes right to hear one emotion rather than another in a musical passage is not sufficient by itself to account for the passage being expressive of a particular emotion, but there would be no musical expressiveness at all unless there is such hearing.

Further Reading

Davies, Stephen. 1994. *Musical Meaning and Expression*. Ithaca, N.Y.: Cornell University Press. An exhaustive overview of views about expression and a defense of expression as phenomenal appearance.

———. 1997. "Contra Hypothetical Persona in Music." In *Emotion and the Arts*, edited by Mette Hjort and Sue Laver. Oxford: Oxford University Press, 95–109. A critique of the persona view.

Kivy, Peter. 1980. *The Corded Shell*. Princeton, N.J.: Princeton University Press. A well-known defense of expressiveness as phenomenal appearance.

Levinson, Jerrold. 1996. *The Pleasures of Aesthetics*. Ithaca, N.Y.: Cornell University Press, 90–125. An overview of the debate about musical expression and a defense of the persona view.

Ridley, Aaron. 1995. *Music, Value and the Passions*. Ithaca, N.Y.: Cornell University Press. A sophisticated defense of the evocation view.

Robinson, Jenefer, and Gregory Karl. 1995. "Shostakovitch's Tenth Symphony and the Musical Expression of Cognitively Complex Emotions." *Journal of Aesthetics and Art Criticism* 53: 401–15. An attempt to show that music can express complex emotion when conceived as the expression of a musical persona.

Vermazen, Bruce. 1986. "Expression as Expression." *Pacific Philosophical Quarterly* 67: 196–224. A defense of the persona view.

Notes

1. Proponents of "the musical persona view" (see note 6 for references) identify expressiveness with the expression of a fictional persona. Classical expression theorists such as Collingwood (1938) and Tolstoy (1996) would identify expressiveness with the expression of an artist. Those who understand expressiveness in terms of the possession of "emotion characteristics in appearance" identify being expressive of sadness with being sad. Aaron Ridley (1995, 120–45) is one theorist who identifies expressiveness neither with expression nor with possession.

2. The evocation view has many proponents. Among these are Matravers (1998), Mew (1985), Nolt (1981), and Ridley (1995). For a thorough exposition and critique of attempts to solve the problem of identifying the right way music tends to evoke emotion, see Davies (1994, 184–99).

3. Malcom Budd (1995) seems to be expressing a similar point when he says, "The most basic way in which we experience music when we hear it as being expressive of an emotion is that we hear the emotion the music is expressive of as characterizing the music itself . . . we hear the emotion in the music" (136). For Budd, music *is* expressive of emotions so heard if it is *correct* to so hear it. Jerrold Levinson (1996) also seems to be expressing a similar point when he says, "Passages of music in which we perceive expressiveness are understood to be a designed sequence of sound that invite hearing-as of various kinds" (108).

4. Davies (1994, 228). The most important proponents of this view are Davies (1994) and Kivy (1980). The view seems to me to have affinities to more general theories of expressiveness in art proposed by Beardsley (1958) and Bowsma (1950).

5. Davies (1994, 267–77) is aware of this problem and does the most among proponents of this view to solve it.

6. The musical persona view is defended by Cone (1974), Levinson (1996), Mauss (1988), Newcombe (1984), Robinson and Karl (1995), and Vermazen (1986).

7. For another critique of the persona view, see Davies (1997a).

8. It might be objected that I am confusing two separate issues in trying to bring this critique of Bateson's interpretation to bear on Levinson's account of expression. Levinson is giving us an account of what expression of emotion in a work *is*. The critique of Bateson's interpretation, it might be claimed, relies on an account of when an interpretation is correct or what evidence shows that an interpretation is correct. The objection is that the correctness of either account is independent of the other. However, this objection misses the point. In interpreting the poem as he does, Bateson is inferring that its utterer expresses a certain emotion, and if Bateson is properly backgrounded, if his inference is apt and unforced, and, finally, if the attitude of the utterer can be identified with the attitude of the poem, then that is all that is required, on Levinson's account, applied to poetry, for a poem to express an emotion. So applied, Levinson's account says that a poem or a passage of a poem expresses an emotion just in case *a* properly backgrounded reader makes such an apt and unforced inference. The problem is that other equally well-backgrounded readers make inferences that are also apt and unforced but are inferences to quite different emotions. If it is implausible that the poem expresses these very different emotions, this poses a problem for Levinson's account.

9. Though the point is ad hominem, let me mention that Levinson would need to appeal to the same distinction. No matter how immediately convincing is one's hearing of a persona's expression in a passage of music, this in itself would not establish that the passage is expressive of the emotion heard. In order to know this claim is true, one would need to *infer* it from the fact that one is so hearing the music and at least one additional premise, namely, that one is an appropriately backgrounded listener hearing the music in context.

10

Artistic Value

Essentialism/Antiessentialism

Willem de Kooning's abstract work *Untitled III* (1977) consists of numerous irregular patches of paint—whites, blood reds, dark browns, bilious greens, and flesh tones—seemingly smeared on the canvas, one patch often overlaying and mixing with another. One can gaze for a long time simply at these patches in relation to each other as one would at the groups of figures and their interrelations in paintings from earlier periods. But the painting also gives a distinct impression of (without literally representing) human skin overlaid with all sorts of bodily fluids and excretions. As one might imagine, the experience of looking at this painting is not a pleasant, but it is a very powerful one, evoking, as Richard Wollheim (1987, 348) notes, infantile experiences that (I believe) we no longer count as pleasures. The experience of dwelling on this complex of colored patches and all that they evoke is an example of aesthetic experience: object oriented, sensuous, valued for its own sake, though not pleasant and perhaps elusive in the aesthetic properties it contains. I have mentioned only a few (powerful, evocative) of the latter in describing the experience.

It is fair to say of this painting that it has aesthetic value as we defined it in chapter 4, namely, the capacity to provide such valuable experience to those who understand the painting. We can also assert that possessing this value makes it valuable as art. However, is this capacity to provide valuable experience the *only* feature of the painting that makes it valuable as art? Suppose this painting gives us some *insight* into infantile states of mind or allows us to simulate infantile pleasures that ordinarily are no longer pleasures for us (or a related primitive exploration of the body). Would that also give this work artistic value? No doubt, this insight or the ability to simulate in some way depends on the experience of the painting, but this should be distinguished from the experience. We have the experience only when

viewing the painting, but the insight or the ability to simulate is something we can take away with us when the experience is over.

By artistic value, I mean the sort of valuable properties it is appropriate to bring forward and weigh up when we are evaluating an item as an artwork. This chapter compares two conceptions of the value of works of art—the essentialist conception and the nonessentialist conception—and argues in favor of the latter over the former.

First consider the essentialist conception. In its strongest form, the conception makes four claims. It insists that artistic value is 1) a unitary kind of value. It is the one thing we value when we value something "as art." 2) It is unique to art. Nothing else provides this value. 3) It is shared by all artworks valuable as art across all art forms. 4) It is intrinsically valuable and renders art intrinsically valuable.[1] However, there can be weaker versions of this conception that drop or qualify some of these claims. Proponents of this conception of artistic value tend to accept it a priori on the grounds that an understanding of what art is involves knowing that art has a distinctive sort of value *as art*.[2]

The nonessentialist conception denies all four claims made by the essentialist. The nonessentialist claims that artistic value consists in those valuable properties that artists commonly try to imbue in their works and that critics and appreciators commonly look for or seek out in works. These properties may sometimes be, but needn't be, the same across the arts. Hence, there can be some artistic values that are never found in some art forms. The properties may be, but needn't be, unique to art. Hence, items other than art can be providers of these valuable properties. They may be intrinsically or extrinsically valuable. Hence, it is conceivable, on this conception, that art has only instrumental value. There is absolutely no reason to suppose, on this conception, that there is one valuable property or one sort of value that artworks possess "as art," although the conception does not strictly rule out this possibility.[3]

It is this second view that will be supported here. In fact, this chapter will argue for something stronger, namely, that some artistically valuable properties are found only in some art forms but not in others, that *none* of these values are unique to art, that art is *always* extrinsically or instrumentally valuable, and that there is no one kind of value that a work has as art.

This conception is empirical or a posteriori in the sense that, according to it, no amount of reflecting on the concept of art will identify which values are artistic and whether they are intrinsic or instrumental, singular or plural, unique to art or not, always shared across art forms or not. One can find these things out only by examining the relevant aims of artists and appreciators and the artworks about which they have these aims. However, this does not completely preclude a place for conceptual investigation of artistic value. If the historical functionalist view about the concept of *art*, endorsed in chapter 5, is correct, then it at least suggests that since what

counts as art evolves historically in virtue of evolving functions of art, artistic value also is likely to evolve and hence change over time. Furthermore, this view implies that there is no one value or valuable property that must be possessed or even intended for an item to be art. Hence, essentialism about value could not be established via a definition of art. On the other hand, there are certain ways in which artworks are valuable that we know in advance form no part of *artistic* value. The monetary value of artworks or the fame they give to some artists is no part of the artistic value of the works in question. There must be something about the concept of art that excludes these "external values."

A Unitary Kind of Value

Evaluative Perspectives

We begin by exploring the essentialist conception of artistic value and, in particular, the first claim made by this conception that it is a unitary or single kind of value that is appreciated when we value something as art. One might think that the very idea of artistic value implies this claim. As noted previously, artworks can be valued in any number of ways that have nothing to do with their being art or are only extrinsically related to their having that status. In the first category would be valuing an artwork for some temporary or ad hoc purpose it happens to be serving: a sculpture serving to keep a door open or a painting serving to hide a crack in a wall. In the second category are items such as the economic value of a work. This is related to its being an artwork but is no part of its artistic value. Economic value can fluctuate while artistic value remains constant. The same can be said about other sorts of value: the sentimental value a work might have for an audience member or the instrumental value of a work in promoting the career, fame, or fortune of the artist. Malcom Budd (1995) extends this point in the following passage:

> A work of art can have many different kinds of value—a cognitive value, a social value, an educational value, a historical value, a sentimental value, a religious value, an economic value, a therapeutic value; it can possess as many kinds of value as there are *points of view* from which it can be evaluated. What an artist tries to do is to create a product with a distinctive kind of value. He attempts to make something valuable *as art*. (1; emphasis added)

The initial point was that some ways of valuing art have no bearing on a work's value *as art*. This is not controversial in the case of economic value. The passage extends this initial point in two ways. First, it partitions artistic value from a number of others the exclusion of which is less obvious. The second way the passage extends the initial point is by providing a rationale

for excluding a type of value from a work's value as art. The argument claims that whatever can be evaluated can be evaluated from different points of view or perspectives and that each point of view defines a distinct kind of value. To evaluate something as art is to evaluate it from one such perspective (which is distinct from the various other perspectives listed in the passage). Hence, artistic value is a distinct, unitary kind of value.[4]

To a proponent of a nonessentialist conception of artistic value, this argument is troubling because it appears to make an assumption that virtually begs the whole question between her and the essentialist. It assumes that "artistic" designates a particular perspective or point of view, one defined by a kind of value. However, there are other ways of thinking of the designation of "artistic," as many, at least, as there are definitions (conceptions) of art. For example, one can think of art as a practice that embraces a number of different aims and hence more than one value (for an elaboration of this idea, see the section "Art as a Practice Rather Than a Perspective" later in this chapter). Of course, an essentialist does not deny that art or artworks can possess as many values as one likes, but the claim being made here that Budd and others would deny is that no single value is definitive of the artistic evaluative perspective. None of this shows that the essentialist is wrong in making the opposite assumption. It shows only that the ability to distinguish among various evaluative perspectives does not show that artistic value should be identified with exactly one such perspective.

It is controversial that many of the evaluative perspectives that Budd's argument excludes are really irrelevant to the value of a work of art. For example, suppose I listen to a piece of music in an initially anxious and despairing state of mind and as a result of appreciatively following the music feel calmer and have more fortitude when the listening is over. This would mean that the music had therapeutic value for me. Is the capacity of the work to accomplish this no part of its artistic value? Suppose the work I have just been listening to is an example of the classical style at its best, has been enormously influential on the composition of later music, and is a highly original work. Exemplifying the best in a style, being influential, and being original are all historically (in particular, art-historically) valuable properties. They all refer to this work's relation to others in the historical development of music and put those relations in a positive light. Is this no part of the work's artistic value?

To further illustrate this point, consider a claim that Peter Lamarque (1995) makes about tragedy. He claims that to properly appreciate the value of tragedy, one has to recognize several "dimensions" of a literary work: a fictive dimension, a literary dimension, and a moral dimension. The fictive dimension invites "imaginative involvement." The literary dimension "invites a related but distinct . . . response, the attempt to define a unifying aesthetic purpose in the work through thematic interpretation." The moral di-

mension facilitates an "appropriation of the work's content, either as a contribution to moral philosophy or as an illustrative support for some broader metaphysical picture or just for clarifying one's own moral precepts" (245–46). A nonessentialist will claim that if authors of tragedies commonly and successfully aim at facilitating the "appropriation" definitive of the moral dimension of these works (as Lamarque conceives it) or if audiences commonly and without misunderstanding the works seek them out because they value this dimension, then this is an artistic value of tragedy. The same could be true for some of the values derived from its fictional dimension if they too are commonly aimed at or sought after by author or audience.[5]

At this point, then, we are faced with starkly contrasting views about the value that works possess as art. The examples we have just been considering suggest that we have to adopt a variety of evaluative perspectives to take in this value. In other words, artistic values are plural. The alternative is the claim that the relevance to grasping artistic value of all but one of these perspectives is illusory. If we are going to make further progress in deciding between these views, we need a candidate for the uniquely relevant perspective.

Artistic Value as Aesthetic Value

The first place to look for this is in a conception of aesthetic value because the tradition of thinking about art in terms of the aesthetic provides the most plausible unitary perspective.

In part I, we claimed that the aesthetic value of an artwork is a function of the experience of attending to various features of a work, an experience valued for its own sake. This precisely matches Budd's idea of the relevant evaluative perspective to assess the artistic value of a work (though he doesn't use the word "aesthetic" in describing this perspective). The value of a work of art as art "is (determined by) the intrinsic value of the experience the work offers" (Budd 1995, 4). Such an experience is one in which the work is "understood." The experience in question does not refer to actual experiences but to a type or types that actual experiences can instantiate or approximate. The relevant types of experience are not narrowly conceived. They are not confined to those derived from attending to formal aesthetic features but happily include the experience of representational ones as well. The experience can have an ethical or cognitive dimension, as when one finds oneself in sympathy with the work's point of view or when one has a sense of dawning insight.

If the valuable experience of a work can have a cognitive or ethical dimension, does that mean that the cognitive or ethical value of a work is part of its artistic value, thereby blurring the lines between different evaluative perspectives? Not obviously. The experiences mentioned previously—feeling sympathy for a work's point of view and having a sense of dawning

insight—can occur independently of whether the work's point of view is worthy of sympathy and whether it actually is insightful. Only these latter properties would be indicative of genuine ethical or cognitive value, and the experience of the work alone does not reveal whether the work has these properties. Hence, even this broadened conception of the valuable experience of the work can be construed as maintaining the line between different evaluative perspectives. But this just raises again the question whether one such perspective is adequate to fully comprehending artistic value.

Instrumental versus Noninstrumental Value

Aesthetic Value versus Instrumental Value

In contrast with the aesthetic value of an artwork as art (the "intrinsic" value of the work in Budd's terminology), there is the instrumental value of a work of art. These are actual effects, good or bad, of a work on those who experience it or effects that would be produced if people were to experience it. To maintain that aesthetic value adequately captures artistic value, it has to be shown that instrumental value is no part of the artistic value of a work. In this section, we consider two reasons for thinking this is so.

First, there is purportedly a conspicuous, generally acknowledged mismatch between our beliefs about a work's artistic value and our beliefs about its instrumental value. We are apt to be much more unsure about the latter than the former since instrumental value is "many headed and ill-defined" (Budd 1995, 6). However, what knowledge we do have of the effects of art beyond the experience it offers is that it is extremely variable. The point here is that this distinction between artistic value per se and valuable effects of artworks is suggested by and, perhaps, would help explain these facts.

Second, one may attempt to account for, as part of a work's intrinsic artistic value, some features that, at first appearance, seem properly classified as merely instrumentally valuable. On the one hand, "the invigoration of one's consciousness, or a refined awareness of human psychology . . . or moral insight" (Budd 1995, 7) are purportedly part of the experience of the work rather than mere benefits of that experience. On the other hand, an experience can be *such as* to be conducive to a beneficial effect, as when good poetry is such as to "increase the intelligence and strengthen the moral temper" (Budd 1995, 8) of people. To say of an experience that it is such as to be conducive to a beneficial effect is, apparently, to mark an intrinsically valuable property of it for Budd.[6]

Of these two reasons, the second is both harder to understand and, to the extent that we can understand it, harder to accept. This is made even harder by the fact that it itself has two parts. First, is it true that it is part of

the experience of a work that one attains moral insight or a refined aware-
ness of human psychology? Such *achievements* are likely to come to us
through an experience and, furthermore, not after but during the experi-
ence. But unless one takes something away from the experience, possesses
something useful when the experience is over, one has not attained moral
insight or a refined awareness of human psychology from the experience of
a work. Hence, the experience is one thing, and the benefits (moral insight,
refined awareness, and so on) are another no matter how intricately bound
up they are.

Second, is it true that there is a difference between saying that an expe-
rience *is* beneficial (thereby straightforwardly asserting it is instrumentally
valuable) and saying that it is *such as* to be conducive to a beneficial effect?
The difference is between saying that the work has actually effected a
change (namely, benefited someone) and saying that it has the capacity to
effect such changes. This distinction, however, is not one that is serviceable
to the present argument because having such a capacity is just as much an
instrumentally valuable property of artworks as the property of producing
benefits. Drinking milk provides nutrition to the body. Milk is such as to
be conducive to providing this nutrition when drunk. That is, milk happens
to be so constituted to have this effect. Does this imply that drinking milk
is instrumentally valuable but that milk is intrinsically valuable? Such a
claim is absurd. Artworks are often so constituted as to provide certain ben-
efits when properly appreciated (experienced). Does this mean that they are
intrinsically valuable? Such a claim is equally absurd. Providing a benefit
makes something instrumentally valuable, and that it is such as to be con-
ducive to doing this just means it will reliably do so under certain condi-
tions. Thus, when Yvor Winters says that poetry "should offer a *means* of en-
riching one's awareness of human nature; . . . a *means* of inducing certain
more or less constant habits of feeling, . . . [and] these *effects* should naturally
be carried over into action" (quoted in Budd 1995, 8; emphasis added), he
is surely claiming that poetry should be instrumentally valuable in being
such a means and inducing the said effect, not willy-nilly but by being re-
liably so constituted to do so.

All this suggests that the complex second reason for excluding instru-
mental value from artistic value is unconvincing. However, if it is, this
will serve to weaken his first reason because what has emerged is that,
while the actual effects of artworks on individuals vary, there are bene-
ficial effects works are such as to have (that is, capable of producing suit-
able appreciators).

There is another, more accommodating way to express the conclusions
we have just reached. Proponents of the previously mentioned reasons, such
as Budd, it turns out have an extremely broad conception of the experi-
ence of the work that even includes things that he himself refers to as ben-
efits of the experience. Given this broad conception, there may be little real

difference between their views about artistic value and the nonessentialist's view that artistic value is plural. If the invigoration of consciousness is part of the value of the experience of a work, therapeutic value is not excluded from artistic value. If moral insight is part of the value of the experience of a work, then ethical and cognitive value is not excluded from artistic value. What does seem to go by the boards is the idea that aesthetic value any longer provides a unique perspective by which to judge artistic value or that there is any such unique perspective.

Aesthetic Value as Instrumental

In the previous section, we distinguished the valuable experience of a work from other benefits it provides, such as insight or increased intelligence, that one takes away from artworks after one ceases to experience them. The type of value that works have in virtue of providing these benefits (or having the capacity to do so) is clearly instrumental value. Is there a different type of value that works have in virtue of providing aesthetic experience? Recall that Budd labels this the intrinsic value of the work. But there is something misleading about this. The experience itself may be intrinsically valuable when this is understood to mean valuable for its own sake. It may also be attainable only from the work. This is just to say that the work is the unique *means* to the experience. While all this is true, the fact remains that the experience is one thing, the work is another, and the former is caused by an involvement with the latter. We have still identified an instrumental value of art, something we value art for giving us.[7]

Unique Value

There is another source that motivates essentialism about artistic value, namely, fear, in particular, that the valuable properties that artworks offer could be offered by other things. If so, it is conceivable that these other things might do a better job at offering these valuable properties, and thus art could be replaced, superseded by these other things. At best, art would have to compete with these other things.[8]

When one thinks, in a general way, about what we find valuable in artworks, this fear may seem to be well founded. Certainly art hardly has a monopoly on the ability to provide moral insight or a refined awareness of human psychology, to increase intelligence or induce admirable habits of feeling. (Further, there are many artworks and perhaps some art forms that are incapable of doing these things.) Artworks are not the only things that represent the world in fascinating or unusual ways or with verisimilitude. They are not the only things we find expressive or evocative of human emotions or of religious or political sentiments. They are obviously not the

only sources of escape from everyday life and not the only providers of "worlds" in which we can lose ourselves. They are certainly not the only things that are beautiful or give us aesthetic experiences. Aesthetic value can be found in nature and almost every domain of human endeavor.

There is another related worry. Suppose we value a work for containing a moral or psychological insight. Not only is the work replaceable by something else that provides the same insight, but even if the source of the insight is the work, once we have it, we don't have to return to that source. Once we have absorbed the insight, it seems that we can now dispense with the work. A theory of artistic value that implies this dispensability is thought to be just as unacceptable as a theory that implies replaceability. The value of artworks is sometimes said to be inexhaustible, but even if this is exaggeration, they can be revisited on many occasions and yield up new value each time. So it may be thought that a condition on a good theory of artistic value is that it implies that artworks have a kind of value that makes them neither replaceable nor dispensable.

Irreplaceability would seem to be guaranteed if at least part of the value of an artwork is unique to that work. If there is one aspect of the value of an artwork that is unique to it, it is the valuable experience it offers to those who understand it.

Perhaps one can cleverly think of cases where a pair of artworks or a pair consisting of an artwork and a nonartwork offer identical experiences. Since such cases would trade on the exceptional, the coincidental, or the bizarre, let us not pursue them, and grant that usually an artwork uniquely offers the valuable experiences to be had from it. How significant is this fact in understanding the value of art? It is significant but not as significant as one might think.

To see why it is not as significant as one might think, consider first a parallel case from a realm outside the art world. (There are countless examples along these lines.) I enjoy fishing not just because it sometimes results in catching fish but also because, among other things, of the enjoyable experiences I have casting lures, retrieving them, and playing fish with my fishing rod. These pleasurable experiences are unique to the particular rod I use; had I used a different rod, I would have somewhat different experiences. This does not keep my fishing rod from being replaceable. It is not just that I could buy another rod of the same type (model)—that would just involve getting another token of the same rod. No, I could buy a different model that offered similar (perhaps better) experiences. The fact that something offers a unique experience is no bar to its replaceability if there are other things that offer equally desirable experiences and there is no real loss in exchanging one experience for the other. Notice one more thing: if you want to know what makes a fishing rod a good one, it won't be very illuminating to be told that people have valuable experiences with it. You need to know what functions fishing rods serve. Only then will you

understand how some might be better and provide better experiences than others.

Fishing rods are instruments; works of art are not. However, one can run similar examples with noninstruments, such as fine cigars or wines. A particular fine cigar, such as the Julieta no. 3, offers a unique experience. It would nevertheless not be unreasonable to substitute for this experience an equally good one offered by another cigar. The moral of such examples is twofold: first, if you are worried about the replaceability of one artwork by another or of artworks by nonartworks, then merely discovering that artworks provide a uniquely valuable experience shouldn't allay your fears. Second, if you want to understand the value of art, it certainly won't suffice to know that artworks offer uniquely valuable experiences. You will need to understand the sort of value such experiences provide, and to do that you will have to make reference to items such as the functions or purposes (not unique to art) listed at the beginning of this section and the instrumental value of those functions. If this is so, then discovering that artworks provide uniquely valuable experiences is no reason to accept an essentialist view of artistic value. The experiences may be unique to the works that offer them, and this may make the experiences uniquely valuable, but the type of value involved in these experiences is not unique to art.

I said earlier that the fact that artworks offer unique experiences does have some significance in an argument for the irreplaceability of the value we receive from individual works. What we have seen so far is that just citing this fact does not cinch the argument. What needs to be added is that there is a real loss in exchanging one valuable experience for another. The experience uniquely provided by a great (or perhaps even a good) artwork is irreplaceable because, even though there are other equally good experiences out there, the world would clearly be poorer for the loss of this one. The same is much less likely to be true for a certain fishing rod model, but it is also not true for many lesser works. In both cases, these sorts of things are constantly going out of existence or becoming unavailable without a great loss of value in the world.

The idea of dispensability is distinct from replaceability. The latter idea involves the thought that something else can substitute for the original item by providing an equivalent value. The former idea involves the thought that the original item is no longer needed once its service in a valuable role is over. Toothpaste tubes are no longer valuable when they no longer hold toothpaste. They are then dispensable and are dispensed into the wastebasket. If one focuses on one specific instrumental value of artworks, these works can also seem dispensable. This can lead someone to deny that the artistic value of a work is any such instrumental value. "The value of a poem as a poem does not consist in the significance of the thoughts it expresses; for if it did, the poem could be put aside once the thoughts it expresses are grasped" (Budd 1995, 83). I believe this passage is correct if we

interpret it as saying that the significance of the thoughts does not account for the whole value of a poem (though it would be incorrect if it meant to exclude this significance as even a part of a poem's artistic value). We can grant, for example, that the imaginative experience derived from reading the poem also forms part of its value, both with respect to the experience in its own right and for benefits it delivers. However, since it is dispensability we are worried about, let us ask whether locating the value of a poem in the significance of its thoughts really makes the work dispensable while locating it in experiences intimately tied to the poem avoids dispensability. Neither claim is as obvious as it might seem at first sight. If a poem's job is to deliver an experience, why shouldn't we say that we could dispense with it once the delivery is made? There could be two reasons for denying this. One would be that we want to repeat the experience. Whether we do or not seems to be contingent on individual preferences. The other reason for not dispensing with the poem would be based on the belief that we have not exhausted the poem of experiences it could make available. Then we could return to it with the expectation of new experience. I think this is the more common reason for rereading a poem. Now what about the poem's significant thoughts? There are three reasons why we might reread a poem out of interest in its significant thoughts. First, we may want to remind ourselves of what these thoughts are or reencounter them (just as we may want to reencounter an experience of a poem). Second, we may be unsure whether we interpreted the poem correctly with respect to its thoughts. So we may read it again to see if we really got it right the first time. Third, we may read it with the expectation that it will yield up new thoughts. We may believe it will be open to new interpretations that will deliver new thoughts. Hence, valuing a poem primarily for its significant thoughts (and I am not saying that we do) would not make it more dispensable than finding its value in experiences it delivers.

There are many reasons why we want to return to works of art. We just mentioned two such reasons: to reencounter some aspect of the work and to encounter something new in or through it based on a new interpretation of the work. A third reason is supplied by pluralism about artistic value. If artworks are valuable as art in multiple ways, we may return to a work to derive from it a different kind of value than we found in an earlier encounter. A first reading of a poem might concentrate on what it says. Next we may want to analyze how it says this through its formal structure and imagery, for example. On another occasion, we may simply enjoy the story it tells and so on. Since a work offers multiple pleasures and benefits, there is good reason to believe that we haven't exhausted all of them in a first encounter.

We began this section with the fear of the replaceability and dispensability of art as a motivation for locating artistic value in an experience uniquely provided by a work. We have found that the mere fact that a work

offers such an experience fails by itself to dispel these fears. Artworks are not "emptied" like toothpaste tubes primarily for three reasons: the importance of the functions they can fulfill by providing their unique experiences, their multiple interpretability, and the plurality of valuable properties that they possess.

A Common Value

Essentialism about artistic value, in its strongest form, consists of four claims, and so far we have denied three of them. We have denied that *artistic value is a single kind of value*, such as aesthetic value. We have asserted instead that the label "artistic value" covers a diverse plurality of values. We have denied that *artworks are intrinsically valuable or valuable for their own sakes*. We have asserted instead that artistic value consists in a plurality of instrumental values. We have denied that *these values are uniquely possessed by artworks*, even though the valuable experiences offered by artworks may well be unique to them. Instead, we explain irreplaceability and indispensability (the ideas that the experience of one work is not replaceable by the experience of another and that works repay repeated encounters) in the alternative ways just mentioned in the previous paragraph. In this section, we turn to the fourth and last essentialist claim that *there is one value that all (valuable) artworks share in common*. This claim could be true even if there are a plurality of other artistically valuable properties, even if nonartworks share in the possession of these properties, and even if all these valuable properties can be understood in instrumentalist terms. But is it true? We will attempt to find out by examining this claim in terms of its most plausible instantiations: first, that the one value all artworks have in common is aesthetic value, and, second, that it is some sort of cognitive value.

Do All Valuable Artworks Possess Aesthetic Value?

The claim that all valuable artworks possess aesthetic value is the hardest essentialist claim to defeat. There are several reasons why this is so. One reason was explored extensively in chapters 3 and 4. The notion of the aesthetic is both ambiguous and vague. That is, there are multiple notions of the aesthetic, and there is a degree of play concerning which properties are aesthetic properties. So for any work, it is possible to find a property that can be ascribed to it that gives it value and that might be considered an aesthetic property. Second, on the minimal conception of the aesthetic endorsed in part I, the capacity for producing aesthetic experience, even if it is a very meager one, is shared by a wide variety of objects, and, consequently, so is the possession of real aesthetic properties if there are aesthetic properties at all. Artworks are hardly likely to be an exception. Nearly all

should be able to afford some sort of aesthetic experience, possess aesthetic properties in virtue of this fact and in virtue of the same fact be subject to aesthetic evaluation. What remains to be seen is whether an item's value as art always depends on its ability to provide aesthetic experience.

As one example of the difficulty in answering this question, consider Sherrie Levine's photographs of photographs. The originals that have been rephotographed (including those of important American photographers Edward Weston and Walker Evans) had aesthetic qualities intrinsic to their value as art that Levine's works inherit, at least in the sense that one can look at these works and see the same qualities appreciated in the original. (This is a corollary of the fact that one can look at most photographs and see some of its subject's aesthetic properties.) But in evaluating Levine's work, does its value lie in a new set of aesthetic properties it possesses that is not possessed by its subject? I doubt it, though I admit to being unsure. The value of these works seem to me to be based on the fact that they have an unexpected subject matter (other photographs). The realization of this refocuses our attention to properties, including aesthetic properties but also social and art-historical ones, that the subjects have as photographs. This seems to me primarily a kind of cognitive rather than aesthetic value, though ironically one that, if successful, gives us a new way to experience the original photographs aesthetically.

Those who wish to defend the claim that aesthetic value is the one common value shared by all valuable artworks adopt one of two strategies. The more modest strategy (Anderson 2000; Zangwill 2002) proposes a highly qualified version of this claim, namely, that most valuable artworks possess aesthetic value as such and that the remaining valuable artworks possess value that is parasitic on the aesthetic properties of the majority of artworks. The Levine photographs, as I have interpreted them, would be a good example of a work the value of which is not aesthetic but is parasitic on the aesthetic value of other works. A different type of example would be antiaesthetic art (sometimes simply called "anti-art"). This includes some of the much-discussed Dadaist works of Duchamp, such as his ready-mades and L.H.O.O.Q. The former are ordinary objects (a urinal, a bottle rack, a snow shovel, a bicycle wheel) the artist simply selected and displayed as art with little or no adjustment by the artist. They were purportedly selected for the lack of aesthetic interest. L.H.O.O.Q. is a postcard reproduction of the *Mona Lisa* on which the artist drew a graffiti-like mustache and goatee. The modest strategy claims not that these works have aesthetic value but simply that whatever value they do have can be understood only in relation to and in contrast with the aesthetic value possessed by most works.

The modest strategy contains an insight. It is correct in claiming that much artistic value that is of a nonaesthetic variety often if not always in some way depends on aesthetic value. The works discussed so far are good examples of this. I'm not sure, however, that the thesis universally holds.

Perhaps there are conceptual artworks that simply try to present a thought or idea. Perhaps there are political works that simply have a political message. However, one wonders if these works have any positive value as art. If not, they would not be counterexamples to the modest strategy.

The chief problem with the modest strategy is that it is too modest. It does not sustain the claim that all valuable artworks possess a single value in common, namely, aesthetic value. In fact, it is premised on the belief that all do *not*. Hence, for the purposes of this chapter, we do not have to decide whether the modest strategy is based on a truth. It is enough to point out that it doesn't save the common value thesis.

A proponent of the modest strategy might reply that if it can be established that artworks *necessarily* typically possess aesthetic value, the spirit, if not the letter, of essentialism has been maintained. The correct response to this reply is to point out that this is not what has been established. Nonaesthetic art, far from being atypical, is now common. What is at best true, is that it is typical of nonaesthetic art that there is an implicit reference to one of following: other artworks that are aesthetic (Levine case) or the absence of the aesthetic (anti-art case). This is what gives some credence to the claim that nonaesthetic art is parasitic on aesthetic art, but this claim falls well short of the stronger one made in the reply.

The ambitious strategy (Lind 1992; Shelley 2003) claims that all valuable artworks, including those mentioned previously, do have aesthetic value that is intrinsic to their value as art. This needs to be distinguished from extrinsic aesthetic value that some of these objects possess. If my interpretation of Levine is correct, her photographs have lots of extrinsic aesthetic value inherited from her subjects. *Bottle-rack* has a complex form, while the mounted *Bicycle Wheel* has as an elegant one. Both sustain contemplation that could be aesthetically gratifying. However, finding this sort of aesthetic value in these ready-mades has nothing to do with appreciating them as the artworks they are. One could find the same aesthetic value in any similar bottle rack or bicycle wheel (mounted for the purpose of repair).

The interesting claim of the ambitious strategy is that these works possess aesthetic properties intrinsic to them as artworks. For example, *Fountain* (Duchamp's urinal ready-made) possesses daring, wit, cleverness, impudence, and irreverence (Shelley 2003, 370). These are aesthetic properties, it is claimed, and appreciating the works for possessing them is intrinsic to appreciating them as art. Is this claim true? Let us grant that *Fountain* has these properties and that they are relevant to its appreciation. The important question is whether they are aesthetic properties. My view is that (with the exception of wit, which requires a different treatment) there is no clear answer to this question. "Daring," "cleverness," "impudence," and "irreverence," let us assume, can sometimes be names of aesthetic properties (though this isn't completely obvious), but these terms

certainly can and do sometimes name nonaesthetic properties. Impudent behavior, a daring strategy, irreverent remarks about religion, and clever philosophical arguments are cases of items having nonaesthetic attributes denoted by the previously mentioned expressions. They name aesthetic properties when the application of the term is grounded in aesthetic experience. The trouble is that it is admitted by all that *Fountain* sustains little aesthetic experience. Hence, it is not clear that the ambitious strategy can make good its claim to find aesthetic properties in what is commonly thought of as nonaesthetic art.

If one is to argue that works such as the ready-mades have aesthetic value, one needs to argue that they are capable of providing a significant aesthetic experience when understood as the artworks they are. In the case of *Fountain*, this may just be a viable option. Selecting a urinal and mounting it upside down gives this ready-made a shock value not equaled by all the others. For this reason, one is not simply intellectually aware of the irreverent questions Duchamp is asking about the contribution of the artist, the creative process, and the role of craft in making art. One experiences the force of the questions through seeing this work. This is surely why *Fountain* is the most famous of the ready-mades, the one that always shows up in art-historical surveys, and the one that has by now been discussed ad nauseum. Still, this experience is a very limited one, pretty well exhausted in a single viewing and probably provided as well by a photograph of the work as by the work itself. (So the claim that *Fountain* sustains *little* aesthetic experience is not inaccurate.) The chief value of the work lies elsewhere, namely, in the cognitive value of the reconceptualization it proposes and symbolizes. That other such works have aesthetic value as the works they are is even less plausible.

So we should conclude that neither the modest nor the ambitious strategy succeeds in showing that all valuable artworks are aesthetically valuable.

Cognitive Value

There are a number of conceptions of art that are built on the assumption that art has some sort of cognitive value. For example, although Collingwood's (1938) theory of art is usually classified as an expression of emotion theory, his understanding of expression makes it look like cognition. Expression is a process by which we become aware of the emotion we are feeling in all its particularity. It isn't far-fetched to say that by expressing an emotion we come to know that this particular state is identical to the emotion I am feeling. According to Collingwood, art is expression in this sense, and the value of art is the value of such expression.

In a not altogether different vein, Arthur Danto (1981) claims that for something to be a work of art, it is necessary both for it to be about something and for some attitude or point of view to be expressed toward what

it is about. It is not far-fetched to rephrase this by saying that each work of art offers a conception of its subject. Since Danto is not explicit about endorsing a particular theory of artistic value, we should be cautious about attributing a purely cognitive view to him. But it would be possible for someone to take from Danto's theory of art the view that art's value lies chiefly in the value of the conceptions (attitudes, points of view) it offers. Further, this is arguably a kind of cognitive value, not in the sense of art's being a significant source of new knowledge but in the sense of making us newly aware of or alive to ways of thinking, imagining, and perceiving.

Nelson Goodman (1976, 1978) is far more explicit than either Collingwood or Danto in claiming that the value of art lies in being "a way of worldmaking," which is Goodman's provocative reconception of the pursuit of knowledge. For Goodman, art is just as much a cognitive inquiry as science, even if it uses different means involving different kinds of symbols.

The idea behind all these views, as well as other, not necessarily essentialist accounts of art's cognitive value (Carroll 2001a; Gaut 1998; Graham 1997; Jacobson 1996; Kieran 2004, Kivy 1997; Levinson 1996; Stecker 1997), is that there are intellectual benefits in offering to the imagination vivid and detailed conceptions that are obviously tied up with but that go beyond the experience of the work. As Collingwood suggests, not only may one imaginatively experience an emotion in reading a poem, but one might take away from that ways of identifying one's own emotions that break stereotypes and lead to new self-knowledge. One may not only imaginatively experience a visual world represented in painting but also, through that, come to see the actual world presented in vision in new ways. Not only may one imaginatively experience a fictional world of human beings, living under psychological, social, and economic conditions in which certain values hold, but one can also then try out such conceptions in the real world. In doing so, one can, perhaps, come to see that they are apt or, if they exaggerate or simplify, what features of reality or what states of mind would lead people to accept them.

If art broadens one's conceptual repertoire in ways that can lead to new ways of thinking or perceiving and sometimes to new knowledge, engaging with works can also make us better thinkers and perceivers in other ways. When works of fiction regularly lead us to grasp in the imagination the psychological states of characters, we enhance our ability to do something similar with real people. If such works lead us to imagine fictional situations from points of view other than our own (namely, those of the narrator or characters of the work) and empathize with those points of view, again we become better able to do this for real situations. Similarly, if viewing pictures requires us to become fine observers, carefully tracking the visual properties of a represented scene, this is also an ability that we can carry over to real scenes. In short, there are all sorts of cognitive abilities or virtues that are promoted by the experience of artworks.

This understanding of art's cognitive value is not the only one on offer, and some would like to extend it to make more ambitious claims, such as that art is capable of giving us knowledge that some conception is true or false in actuality (Nussbaum 1990). However, the conception of cognitive value sketched here is the one that has achieved the widest consensus and most easily resists the more common objections to the idea that art has such value.

One objection is that art can't really give us knowledge since it can't give us evidence that its conceptions are true. However, this is beside the point if the cognitive value of art lies in providing new ways of thinking or perceiving or bringing home to us the significance of already familiar ways (Graham 1997). We should expect these to be a mixed bag when assessed for truth just as would be various hypotheses tested in a laboratory. A second objection is that when the conceptions offered by a work are distilled into straightforward statements, these typically turn out to be either familiar truths or obvious falsehoods (Hyman 1984). However, this again mislocates where the value lies. Not only is it wrong to place too much emphasis on the ultimate truth or falsehood of the conceptions, but it is also wrong to suppose they boil down to such simple distillations or morals. Part of their virtue lies in their detail, which is as rich as the "world" of the work. This reply brings up another problem. The conceptions found in artworks are often richly "particularized," as was just suggested. But to be useful in the pursuit of knowledge or understanding, they must have sufficient generality to apply beyond the work, to recurring features of the world. The resolution of this problem consists in realizing that we always must extrapolate from what we encounter in experience, whether aesthetic experience of a work or ordinary experience of the world. When one reads *Anna Karenina*, one may feel as if one has met people very like Anna, Vronsky, Levin, and other characters but, of course, not like them in every detail. (For a detailed extrapolation of conceptions one finds in *Anna* and in other novels that respects their richness, see Jones 1975.) The last objection concerns the by now familiar issue of replaceability. Couldn't we arrive at the conceptions given to us in works in other ways, and, if so, doesn't art become replaceable? The answer is that, while art cannot be completely guarded against replaceability, given that what we appreciate in the conceptions found in works is so closely tied to the experience of the work, and the means by which they are expressed (Levinson 1996), the value here is as irreplaceable as the work's aesthetic value.

The idea that many artworks have cognitive value is thus plausible. Further, it is plausible that the achievement of this value is an essential part of the artist's project when some works are created and an important part of what is appreciated by the audiences of those works. For this reason, it is arbitrary to deny that such value is part of a work's value as art. On the other hand, it is not plausible to suppose that artistic value can simply be

identified with a work's cognitive value. For one thing, it is far from clear that all valuable works have cognitive value or that, among works that have it, this is always where their chief value is to be found. For example, if works of pure music have any cognitive value at all, as Graham (1997) and Levinson (1997) claim, this could hardly be their chief value. Recall that a mark of an artistic value is that artists try to imbue their works with it and that audiences seek out works for the sake of it. It is very plausible that there are many works that are neither made nor sought out for any of the cognitive advantages discussed previously. Many works don't attempt to expand our conceptual repertoire. For many of these, this is not even a possibility. A delicate piece of ceramic art may be a wonderful aesthetic object but offer nothing by way of a new conceptualization of the world.

If someone were to argue that all artworks possess some cognitive value, the most plausible ground for this claim would lie in the potential of almost any artwork to refine someone's intellectual, perceptual, or imaginative powers. Taking in the properties of the ceramic work just mentioned may tend to make one a more discriminating perceiver of visual properties. There is a large literature on the cognitive benefits of some music. These benefits, however, are largely unintended and unsought. Worse, if and when they actually occur is largely still unknown. Finally, if one worries about the replaceability issue discussed previously, conceiving of such benefits as the chief artistic value would likely make art replaceable with a vengeance by various regimens psychologists and educators might someday devise.

Second, there is even less reason to think that cognitive value is the exclusive artistic value. We have no ground to dismiss aesthetic value as part of artistic value, and, indeed, very often this is the more important value. Nor is it possible to simply combine aesthetic and cognitive value into a more complex essentialist conception of artistic value. First, as just noted, not all valuable works have both kinds of value, and, second, there is reason to suppose that we have not yet exhausted artistic value. Many emphasize the value of the emotional response to a work (Feagin 1996; Walton 1990) that might constitute a further kind of artistic value. Others speak of art-historical value—the value of a work's contribution to the development of art, an art form, a genre, or an oeuvre (Goldman 1995). A nonessentialist and pluralistic conception of artistic value looks more and more plausible.

Two Problems for the Nonessentialist Conception

I now turn to some problems for the nonessentialist about artistic value. First, a solution is needed to the problem of distinguishing artistic from the nonartistic value since even someone who is a nonessentialist and a pluralist should admit that some valuable properties possessed by artworks are ir-

relevant to their value as art. Fortunately, there is a solution available. One can say that a valuable feature of a work is part of the work's artistic value only if the work's possession of the value can properly be grasped by understanding the work.[9] Normally, such understanding requires experiencing the work, but there may be exceptions, such as some of the examples mentioned previously of nonaesthetic art. The sort of items mentioned at the beginning of this chapter as examples of nonartistic value possessed by works of art all share in common the fact that we can completely understand how the work possesses such a value without either understanding, appreciating, or experiencing the work. We can understand the financial value of a work simply in terms of economic variables such as market forces. We can understand the value of a sculpture for holding a door open simply in terms of certain physical properties it possesses, such as its weight and height. The proposal is that something similar can be said for any nonartistically valuable property of an artwork.

It may be objected that this proposal will not be adequate to all cases of nonartistic value. Consider the sentimental value of a song for a certain couple. Part of the explanation of why the song has this value follows the previously mentioned pattern. It was first heard on a significant occasion, and the significance has been transferred to the song. However, it may be that this song, rather than others also heard on that special day, came to have sentimental value because it expressed a mood particularly fitting to the occasion. In that case, understanding the song is necessary for understanding why it has sentimental value for the individual. But sentimental value is usually regarded as nonartistic.

However, it is not clear that this example constitutes a genuine counterexample to the previously mentioned proposal. We might say that when sentimental value involves the accurate perception of the mood expressed by a song and the aptness of the expression to a significant occasion, this value is a positive artistic one after all. It is only when sentimentality distorts one perception of the expressive aptness of the song and thereby involves misunderstanding or operates independently of an understanding of that aptness that sentimental and artistic value come apart.

The second problem is that the nonessentialist view seems to imply that many nonartworks have artistic value, that is, some properties it would be appropriate to tally up and weigh in evaluating an artwork. This is so because the nonessentialist claims that these properties are not unique to art. Yet it might seem odd to say that a nonartwork has artistic value, and it may even seem that to say that something has artistic value is tantamount to saying that it is art.

I think one can accept that there is some oddity of speech here, sufficient even to say that it would be a bit misleading to say of a newly purchased appliance that it has artistic value. It would not, however, be odd to say that it has aesthetic appeal, that it has a graceful shape or a sturdy look,

or that its form expresses its function. In artworks, these could be artistically valuable properties.

So artworks and nonartworks can share valuable properties. We are inclined to call such properties "artistically" valuable only when we are speaking of artworks. Is there a rationale for the restriction on the way we talk? There certainly is. There are two contexts where the expression "artistic value" has a home. The first is the context of identifying the properties that make artworks considered as such valuable. The question we are asking here can be formulated as, What is artistic value? That the very same properties make some nonartworks valuable is not immediately relevant to answering this question. The second context is one in which we are evaluating an artwork. Here we want to know what its artistic value consists in, the degree of value it has, and so on. The restriction on our way of talking is made reasonable by the fact that both contexts in which "artistic value" has a home are contexts in which we are talking about art. This is not true of related expressions such as "aesthetic value."

We could give up this restriction on our way of talking and start speaking of the artistic value of nonartworks just as we talk of their aesthetic value now without a sense of oddity. However, if we choose not to give it up, we should recognize the decision for what it is: a reasonable restriction on our way of talking, not on what things can have the valuable properties that make artworks artistically valuable.

Art as a Practice Rather Than a Perspective

Earlier in this chapter, we discussed the idea that to identify artistic value, one has to adopt a special perspective. In this section, I will suggest that this idea is based on a misunderstanding. Art is a practice, and complex practices typically are valuable in multiple and evolving ways.[10]

To begin with a different practice, suppose one was trying to understand religious value. What would that consist in? If anything seems to set this apart from other things, it is the pursuit of something transcendent that is supposed to be supremely valuable. However, notice two things. First, this pursuit can be found outside the framework of religious institutions and practices, in philosophy, in some nonreligious art, in some ways of appreciating nature, and even in some perspectives on science and mathematics. Second, this is not the only way religion and religious practices are valuable. Religion typically provides a moral outlook. It provides fellowship, rituals, comforts, and an understanding of life, death, and nature. One could say that these are valuable things religion can provide believers but that these are not religious values. That, however, seems wrong. All are interrelated, not least by their being un-

derstood in the light of the paradigmatically (if not exclusively) religious pursuit of the transcendent.

Similarly with art. It too is a practice or a complex set of practices. It would be equally wrong to suppose that there is just one type of distinctively artistic value. However, there is something about art (just as there is something about religion) that can mislead someone into thinking there is a single distinctively artistic value. Just as a religious value is typically connected in some way to the pursuit of the transcendent, artistic value is typically connected to the understanding of a work via the experience of it. Notice this does not preclude various instrumental values from being artistic values (as long as they come by way of experiencing, understanding, or appreciating artworks). It does, however, typically preclude, as we just saw, value in no way tied to the experience and the understanding of the work, such as investment or monetary value, from being artistic value. This is the reason such values are external to art. Finally, it should be noted that typical connections can conceivably be broken. Perhaps there can be a religion that does not pursue the transcendent. Perhaps there can be art that is not made to be experienced. Indeed, we have seen that there very likely is such art.[11]

If art is an evolving practice, the valuable properties of which also evolve, how do we recognize when we have an art practice rather than another practice? One answer to this question is that we can identify an art practice in complete independence of its valuable properties. But one does not have to completely divorce one's understanding of an art practice from all considerations of artistic value or function. The proposal might be that we can identify a practice as an art practice by looking at its origins.[12] Whether art has an original nature is one of the most difficult questions for a historical conception of art such as the one presupposed here. As with art in all ages, I would expect a certain amount of indeterminacy and borderline cases. However, there is a cluster of features that are marks of an artistic practice at an early stage. One would be the existence of traditional artistic forms, such as painting, carved or molded forms, music and dance, and poetry and stories. Second, one would expect to find items with striking aesthetic, expressive, or representational qualities that are either essential to the proper functioning of the items or that at least fulfill the artistic functions just mentioned with excellence. Third, unlike some more recent art, one would expect to find the practice integrated with other important practices of the society or culture in question, such as religious practices, agricultural or food-gathering practices, or political practices.

If art is a complex and evolving set of practices not least because of the complex and evolving aims of artists and appreciators, then we do well to recognize this if we wish to understand art as well as we can. A nonessentialist conception of artistic value will be most serviceable in the attempt to understand art.

Summary

In this chapter, we compared two broad conceptions of artistic value: the essentialist and the nonessentialist conceptions. According to the strongest version of essentialism, artistic value is one, unitary kind of value, shared by all valuable artworks, unique to art, and rendering art intrinsically valuable. According to the essentialist, it can be known a priori that art has these features, based on reflection on the nature of art or on the nature of our interaction with it. Aesthetic value is the most common candidate to fulfill these essentialist conditions on artistic value.

The nonessentialist conception denies that each of these essentialist claims *need be* true of artistic value. We have gone one step further here and denied that each of these claims *is* true. Hence, we have argued that a plurality of different valuable properties contribute to artistic value, that not all artworks are valuable as art for the same reasons, that nonartworks can possess the same valuable properties as artworks, and that art is instrumentally rather than intrinsically valuable. Finally, determining which properties of artworks contribute to artistic value is an empirical matter based on the aims of artists and the expectations of audiences.

Further Reading

Beardsley, Monroe. 1958. *Aesthetics: Problems in the Philosophy of Criticism*. New York: Harcourt, Brace. A classic defense of an aesthetic conception of artistic value.

Budd, Malcom. 1995. *Values of Art: Pictures, Poetry, and Music*. London: Penguin. A sophisticated argument for an essentialist conception of artistic value.

Carroll, Noël. 2001. *Beyond Aesthetics*. Cambridge: Cambridge University Press, 5–62. A reprint of several articles arguing against an aesthetic conception of artistic value and for a pluralistic conception.

Dickie, George. 1988. *Evaluating Art*. Philadelphia: Temple University Press. An overview of the debate about artistic value and an argument for a pluralist conception.

Goldman, Alan. 1995. *Aesthetic Value*. Boulder, Colo.: Westview Press. Offers a moderate aesthetic conception of artistic value.

Lamarque, Peter, and S. H. Olsen. 1994. *Truth, Fiction and Literature: A Philosophical Perspective*. Oxford: Oxford University Press. An aesthetic conception of the value of literature.

Zangwill, Nick. 1995. "The Beautiful, the Dainty and the Dumpy." *British Journal of Philosophy* 35: 317–29. Argues for the diversity of artistic value.

Notes

1. "Intrinsically valuable" is used here as equivalent to valuable for its own sake and stands in contrast to instrumentally valuable or valuable for the sake of some-

thing else. This usage is common, but some philosophers argue that there are two different distinctions that the usage conflates: 1) intrinsic/extrinsic value and 2) valuable for its own sake/valuable for the sake of something else (Korsgaard 1996, 249–74).

2. The version of this conception that I will be chiefly discussing is presented in Budd (1995). Goldman (1995) argues for a conception of artistic value that in many ways is similar to Budd's though is at best a less pure version of essentialism. An argument for a version of essentialism applied strictly to literature is presented in Lamarque and Olsen (1994). These references are obviously only a sampling of works espousing essentialism.

3. This conception of artistic value is endorsed by Zangwill (1995). "The overall artistic value of a work is the composite of all the types of value—including aesthetic value—which it attains. There is no such thing as artistic value *per se*, and no such thing as the value of a work of art considered as a work of art" (318). This also is the conception of artistic value as expressed in Dickie (1988) and is at least implicit in a number of papers by Noël Carroll collected in Carroll (2001a, 5–62).

4. This argument, presented at the beginning of Budd's (1995) book, bears a striking resemblance to the attempt by Urmson (1957) to mark off aesthetic satisfaction from moral, economic, personal, and intellectual satisfaction.

5. The reader should not suppose that Lamarque would necessarily endorse the claim made here. Lamarque might confine the *artistic* (literary) value of tragedy to the value of its literary dimension. This latter view is explicitly endorsed in Lamarque and Olsen (1994, 449–56).

6. Christine Korsgaard (1996, 249–74) makes a somewhat similar claim. She suggests that instead of saying artworks are valued instrumentally as a means to pleasure, aesthetic experience, or insight, we should say that we value an artwork for its own sake but under the condition that people get these other good things from it. One reason for this preference is a resistance to the idea that the only things we value for their own sake are experiences or states of consciousness. (Notice that in this respect her motivation is very different from Budd's.) However, it should be pointed out that there are many positions not committed to the claim that only experiences are valued for their own sake that still say that all artifacts including artworks are only instrumentally valuable. The resistance in turn is motivated by the thought that there are many things we value as long-term and relatively ultimate goals that are not states of consciousness. "A mink coat can be valued in the way we value things for their own sakes . . . [it can be put] on a list of things he always wanted right along side adventure, travel and peace of mind" (263). Notice, however, that a mink coat, adventure, and travel do not look to be on a par with peace of mind. In the unlikely event that one is asked why one values peace of mind, it's enough to say it's for its own sake, while one always has further reasons for valuing the other items on the list. For example, travel might be valued because it provides a novel experience, exposure to the interesting and the beautiful, and a sense of freedom. Are these the conditions under which travel is valued for its own sake, or is travel simply a means to these goods? Without further argument, the formulation in terms of means and ends looks to be adequate and easier to understand.

7. I take intrinsic value to be possessed only by those items we value for their own sake rather than for their effects. Budd defines intrinsic value somewhat differently.

Budd seems to think that artworks *inherit* intrinsic value from the intrinsic value of the experiences they have the capacity to offer to those who understand them. These effects we value for their own sake (although not necessarily only in that way). Others call this inherited value "inherent" value and distinguish it from intrinsic value.

8. This replaceability argument is one that is frequently appealed to by essentialists. It is found in Goldman (1995, 4–5) as well as in Budd (1985, 29–30), where he says, "If music is of value as a means to an independently specifiable end . . . , then it must be possible that there should be other, and perhaps better, means for achieving what music aims at; so that music could be dispensed with and replaced."

9. This is only a necessary condition for a valuable feature being part of a work's artistic value. We get a sufficient condition when we add the additional condition that the valuable feature is one artists intend or audiences expect to be in works of the relevant kind.

10. For a fleshing out of the conception of art as a practice relied on here, see Carroll (1994). It should be noted that thinking of art as a practice does not automatically settle the issue of whether an essentialist or a nonessentialist conception of artistic value is to be preferred. For an essentialist account of literary value based on a very different conception of literature as a practice, see Lamarque and Olsen (1994).

11. Timothy Binkley (1977) has also claimed that some avant-garde works are not made to be experienced.

12. When I speak of looking at origins, I don't mean trying to identify what is sometimes called first art but merely the early art of a given tradition. For a more ambitious attempt to identify first art along somewhat similar lines, see Davies (1997b, 2000).

11

Interaction: Ethical, Aesthetic, and Artistic Value

In chapter 10, we argued for a nonessentialist and pluralist view of artistic value, but we were especially concerned with the debate between essentialists and their opponents. In this chapter, we focus on pluralism and some of the controversies that attend it. We will pursue this project with respect to two sorts of values artworks possess: ethical and aesthetic, ignoring the other sorts of properties a pluralist may recognize as aspects of artistic value, such as art-historical value and cognitive value, when this has nothing to do with ethical value. However, when a work offers insight into an ethical issue, we will regard that insight as contributing to its ethical value.

We shall be concerned with two questions that arise from the thesis that the ethical value of an artwork can be a proper part of its artistic value and one that is distinct from the work's aesthetic value. First, how should we understand this sort of ethical-artistic value (as I will call the ethical value of a work that is an aspect of its value as art)? Second, do aesthetic and ethical-artistic values interact in such a way that the presence of one has a bearing on the degree of the other in a given work?

The Ethical Value of an Artwork

There are many ways that an artwork can be ethically evaluated. A given work can have broad social consequences, sometimes intended or sometimes not, sometimes foreseeable or sometimes not. I will call these macroconsequences. A work can also have consequences specifically on individual members of the audience in virtue of experiencing the work. I will call these microconsequences. The consequences of a work on its audience and beyond can be good or bad (or both good and bad), and works can be ethically evaluated for having such consequences or for having the potential (the capacity) to produce them. This is not to say that all consequences are

equally relevant to an ethical evaluation of the work. Which, if any, needs to be investigated.

A work can also express an ethical judgment or point of view, such as condoning or condemning behavior or practices, endorsing or rejecting a set of values, or putting forward a type of character as admirable, flawed, or contemptible. Clearly, we can evaluate such attitudes ascribable to a work from an ethical point of view. Is this also an evaluation of an aspect of a work's artistic value? It may seem that when an ethical attitude belongs to a work, it is more intrinsic to that work than its consequences, that is, its effects on its audience and beyond. But can these two things—attitudes and consequences—be cleanly separated for the purposes of evaluation?

Consequences and attitudes (judgments, points of view, and so on actually endorsed by a work) are the items I will take to be the best candidates of ethical-artistic value. There are other ways that works can be subject to moral evaluation. Sometimes works are condemned (though rarely praised) simply for having a certain subject matter: sex, violence, or controversial religious themes. However, such condemnations are a corruption of more legitimate concerns that arise when a work endorses a morally reprehensible attitude regarding one of these (but also many other) topics (see Giovanelli 2004 for a similar view about the kinds of ethical value artworks possess.)

There are various issues concerning the means of production of a work that are more compelling. The vast material resources lavished on artistic productions appalled Tolstoy. One might be equally appalled by certain production materials or methods. One artist produced paintings by dipping goldfish in paint and letting them flop around on a canvas until they expired. Others have produced work by means of self-mutilation or self-inflicted injury. What might be called mortuary art has been on the rise of late: using corpses as art objects. However, Tolstoy's criticism would be best seen as directed toward society at large rather than toward any particular work. In the case of goldfish art, it is the artist rather than the work that deserves criticism (if criticism is deserved). The other cases are trickier. When the work is a photographic recording of a self-mutilation, it is hard to separate content and production means. If one thinks that there is something morally amiss with making human remains the object of aesthetic satisfaction or artistic contemplation, this evaluation necessarily extends to the work. It is a further step to determine the bearing, if any, of these sort of ethical evaluations on the artistic value of such works, evaluations made independently of the attitudes the works express toward their subject matter and possibly even independently of their consequences for audiences or society. Though these are interesting issues, they won't be pursued further here.

Attitudes and Explorations

Some works express pro or con attitudes toward institutions, practices, systems of values, characters, or actions. Thus, *The Jungle* condemns the

practices of the American meat industry, *Uncle Tom's Cabin* condemns the practice of slavery, and *Germinal* condemns the treatment of coal miners in nineteenth-century France. In *Women in Love*, D. H. Lawrence praises one kind of relationship between men and women based on physical attraction, mutual sexual satisfaction, and reciprocal respect for each partner's autonomy and blames another kind of relationship based on the idea of romantic love for ensuring the subservience of one of its members to the other. It is easy to think of similar examples in literary genres other than the novel, such as the poetry of William Blake or the dramas of Ibsen or Shaw. Such attitudes are not confined to literature. For example, Raphael's painting *The School of Athens* presents the pursuit of knowledge as a noble activity and thereby expresses the high value the Renaissance placed on classical learning.

All the previously mentioned works are fictional. Even *The School of Athens* depicts an imaginary scene, though one inhabited by thinkers who really lived in ancient Greece. Literary works and other fictions pose a problem for identifying attitudes that can be unambiguously attributed to the work itself. In such works, characters express their own attitudes, and among these characters is the work's narrator or narrators. A work may not endorse the views of any character, including a seemingly authoritative narrator.[1] However, sometimes a narrator or even a character embedded in a work will convey an attitude, point of view, or message the artist intends the work to express. When there is this convergence of intention to express and the actual conveyance of what is intended, the relevant attitude, point of view, or message is attributable to the work. Interpretation is normally required to identify when this happens, but the examples mentioned previously are clear cases of its occurrence.

Works can also express attitudes that are not intended. One example of this (mentioned in chapter 7) is the residual racism in Jules Verne's portrait of the former slave Neb coexisting with an intentionally expressed abolitionist point of view. Normally, when we find an attitude such as residual racism expressed in a work, we attribute that attitude to the artist as well, just as we did in the case of an attitude intentionally expressed and successfully conveyed. This is because the most likely explanation for this attitude "seeping into" the work is that the author is inadvertently or unknowingly expressing something deeply ingrained in his psyche. I believe we assume we find something similar when we encounter works from alien cultures, such as the ancient Greek *Iliad* or the medieval Japanese *Tale of Heike*. In each of these works, we find a system of values not so much endorsed as taken for granted. In the two works just mentioned, these values are based on warrior-like virtues and the demands of a system of communal honor as it is locally conceived in each culture. Perhaps there can be cases where an ethically evaluable attitude is expressed in a work but is neither expressed nor possessed by the artist. One such case would be one where an artist intentionally gives a work a point of view foreign to her

own perhaps for the sake of exploring how things look from that point of view but without passing judgment on it. Another case would be one where an attitude is unintentionally expressed in a work more through ineptitude or carelessness than a deep though subconscious commitment. I have no ready examples where these possibilities are realized, but possibilities they are. I won't attempt to give a unified account of attitude expression in art that covers all these cases.[2]

Leaving to one side artistic and aesthetic value, when does the expression of an ethical attitude in an artwork have positive or negative *moral* value? It might seem as if there is an obvious answer. If the attitude is morally praiseworthy, it has some positive moral value; if it is morally blameworthy, it has negative moral value. This seemingly obvious answer is mistaken. Unlike morally praiseworthy behavior, which always has some positive moral value, the expression of a morally praiseworthy attitude may neither be particularly admirable in itself nor do any good and so have no moral value whatsoever. There is an analogy here with the cognitive value of uttering truths. If I say, "I see you still have ears," I utter a truth because I do see that you still have ears. However, this has no cognitive value because (unless the continued possession of your ears is in some doubt) it does nothing to promote the growth of knowledge or understanding. Similarly, when the expression of a morally praiseworthy attitude does nothing to promote virtue, ethically acceptable behavior, or the growth of moral understanding but, for example, pedantically states the obvious, we should not assign to such an expression any positive moral value. On the other hand, the expression in a work of attitudes ranging from the morally uncertain to the reprehensible may do some good. For example, the latter may inadvertently harden us against behavior based on such an attitude or make us aware of the great range of attitudes that may gain adherence and guide behavior, while the former may help us explore some of the morally perplexing areas of life. While these are good consequences, a work is not necessarily deserving of praise for producing them. A work that intentionally helps us explore morally difficult matters is deserving of praise, while one that inadvertently hardens us against a reprehensible attitude it endorses is not.

In addition to the outright expression of moral attitudes, works of art can explore important ethical issues. How should one live? To what values should one be loyal? These central ethical questions are explored by the great philosophers of ancient Greece. They are also explored in many of the great novels of the nineteenth and twentieth centuries: *Anna Karenina*, *The Brothers Karamazov*, *Pride and Prejudice*, *Middlemarch*, *Howard's End*, and *Women in Love*, to mention a few.

Another writer who also investigates these questions is a nineteenth-century German-speaking Swiss author, Gottfried Keller. (He happens to be one of Wittgenstein's favorite authors as well.) His best work is *Grüne Heinrich* (*Green Henry* in the English translation, through which I know the

novel). The work belongs to the genre called bildungsroman, which literally means a novel about the education and development of a central character. It often concerns the moral education and moral development of the character. It typically traces the life of this character from childhood or youth well into maturity or beyond. Green Henry is born in a small Swiss village at a time when it is ruled by age-old traditional values. These are given and are unquestioned rather than the reward of an autonomous journey of discovery. Yet Henry does set off on such a journey because his goal in life is to become a landscape painter, and he knows that to pursue this he must leave the village and find a teacher in a center for such art. So he moves to a German city (Munich, if I remember correctly) that has already entered the modern world of the nineteenth century. Here he absorbs a fascinatingly different way of life. However, Henry's journey in this new world does not look like a success. He fails in love, and he also gives up the idea that he has enough talent to become a painter. He returns to his village, where he becomes a civil servant.

Big, ambitious, novels such as *Green Henry* are never about just one thing. However, one of its themes is the clash between the traditional values found in the village in the first part of the story and the values more autonomously chosen from a menu offered up by the modern world. This work is especially successful at portraying the strong pull of both ways of life, what is immensely attractive as well as what is deplorable in each. Henry embodies the struggle to sort this out and also to come to terms with the slow but sure disappearance of the old ways both in his own person and in society. Even the village he returns to is not the one he left, though it sits on the very same spot in the Swiss countryside. At least on my interpretation, Henry manages to pull off this coming to terms with modernity. He recognizes what is good in the inevitable changes in himself and the world, though he never feels completely part of it, and as an exemplary civil servant makes a difference in that new world. Though he fails as a painter and a lover, he is a success in perhaps the most important task life gives him.

Whatever you want to call Henry's problem—displacement, loss of identity, alienation—it still ripples around the world. There are many who are torn between two worlds—traditional and modern, old country and new country, religious and secular—who can no longer enjoy the comforts of one, if it still exists as one knew it, or completely identify with the other. Or they may be simply at a loss how to reconcile them. There are also people who don't face this problem and who would find it incomprehensible, unless they can empathetically understand it through works such as this novel. Through it, one then can see why one would fiercely desire to hold on to traditions despite their stifling flaws and injustices.

It is not very important whether one ultimately agrees with the novel's resolution of the ethical issues it raises. One might well think it puts

Henry's compromise in a rosier light than it deserves. However, if it makes the presentation of its moral issues compelling and convinces us that it sensitively explores them, we will take seriously the attitude it expresses and find the exploration worthwhile. There is more moral value in such an exploration than in the endorsement of more obvious ethical truths.

Microconsequences

The microconsequences of a work are those that arise from imaginative engagement with it. Some people worry that such engagement with some works will lead to the corruption of its audience, such as that violent works will tend to make their audience more prone to violent behavior. The same people might hope that other works will have an edifying effect and thereby make their audience better people. Knowing whether these hopes and fears are grounded in true beliefs seems to be doomed to sociological indeterminacy, as one inconclusive study after another seems to demonstrate. However, if works do have such consequences, they beg for moral evaluation.

While the behavioral consequences just mentioned of engagement with art are wrapped in uncertainty, the discussion of attitudes in the previous section demonstrates that other sorts of consequences are inevitable concomitants of those expressions. For example, if a work condemns an institution or a kind of behavior, it asks its audience to respond in a certain way: to feel the condemnation it expresses. The audience will then deliver the response or withhold it, but either way, the work will elicit something from the audience of ethical import. Further, when we evaluate the attitudes expressed in works, we are concerned less with whether they are (by our lights) morally correct than with what they can do for their audience: advance moral understanding, comprehend points of views previously unavailable to us, or empathize with those who find value in a certain practice. This is a concern with the potential microconsequences of the expression of attitude. A morally insightful or sensitive work has the capacity to deliver moral insight to or enhance the moral sensitivity of at least some of its audience. In these cases, the moral attributes of the work and its capacity to produce microconsequences are virtually inseparable.

Macroconsequences

Artworks can sometimes have a broad impact on society and culture. After Goethe published *The Sorrows of Young Werther*, there was a wave of suicides committed by young men emulating the romanticized fate of Goethe's protagonist. This was a bad though unintended and hard-to-foresee consequence of the novel. After Upton Sinclair published *The Jun-*

gle, reforms of the meat industry were undertaken in the United States in part as an intended but still hard-to-foresee consequence of the exposé of its practices in the novel. Are large-scale consequences like these, intended or not, relevant to the ethical value of the novel? I doubt that the unintended ones are relevant to an ethical assessment of Goethe's work, but surely Sinclair's novel deserves praise for helping to set in motion an important social reform. Furthermore, such reforms brought about by making the public vividly aware of the social reality and its effect on people are a goal of the naturalistic, muckraking fiction of the type Sinclair was writing. Hence, on the nonessentialist conception of artistic value, it is an artistic goal of the work, and it is not only morally praiseworthy but also artistically better for fulfilling it. At least this is so if we acknowledge that this sort of fiction is literature (art).

Many would dissent from this conclusion. One reason for doing so is that the social consequences of publishing a novel are so highly contingent. They depend on many things beyond the work, such as social climate and political power structure. In addition, the social consequences of a work are at best only loosely related to its aesthetic value. The work has to tell a story well enough to reach a large audience, we may suppose, but it may also have to carefully limit the aesthetic demands it places on that audience. As a result, aesthetic value probably is no predictor of social impact. Further, judged simply on the basis of its social impact, works become both replaceable and dispensable. They are the former because another work might achieve the desired impact as well or better, and they may be the latter because there may be no reason to return to the work once the social issue is resolved or understood to be a hopeless cause. (However, most works will offer rewards beyond the social good they achieve, so that it would be absurd to judge them simply on the basis of such impact.)

Despite these reasonable qualms, I stick with my original assessment. Muckraking fiction is a form of literature that aims to achieve social impact via artistic affect—stirring up moral emotions such as indignation, presenting a vivid picture of a social problem that readers can not only understand but feel. So the work is artistically better for achieving its social goal. This doesn't mean it is artistically great or even good, all things considered. It also doesn't mean that achieving social impact is a central or core consideration in assessing artistic value. But it is a consideration at least when it is intrinsic to the aims of a genre. What has been said about the relevant class of macroconsequence applies even more straightforwardly to the ethical value of artworks based on the moral attitudes they express, the way they explore ethically significant issues, and the microconsequences they can have on their audience. As long as the achievement of such ethical value is intrinsic to the aims of these works, ethical value contributes to artistic value.

Ethical, Artistic, and Aesthetic Value

In the previous section, we focused on various ways that artworks possess ethical value through the attitudes they express, the issues they explore, and the effects they are capable of having on their audience. We also noted that when artists aim to give their works this sort of ethical value and audiences expect to find it there, that is, when the pursuit of this value is part of the artistic project underlying the work, this ethical value is an artistic value, according to the nonessentialist conception of such value. The aim of this section is to explore in more detail the interaction of ethical, artistic, and aesthetic value. We will first briefly explore sources of resistance to the idea that the ethical value of a work can contribute to its artistic value. We will then turn to the harder problem of whether the ethical value of a work bears on its aesthetic value.

Resistance to Ethical–Artistic Value

One source of resistance to the recognition of ethical–artistic value is the twofold idea that 1) artistic value is to be identified with aesthetic value and that 2) aesthetic value is distinct from ethical value. If this idea is true, there is no room for saying that the ethical value of an artwork is part of its artistic value. Most, though not quite all, parties to the debate would accept the second part of the idea, which I would also endorse.[3] The first part of the idea, though, is simply an expression of aesthetic essentialism. It is hoped that chapter 10 discredited this view. There we argued against the claim that for the idea of artistic value to be coherent, there must be a value unique to art or shared by all artworks, aesthetic value being the most plausible candidate. We argued further that not all works valuable as art are aesthetically valuable and that others that possess some aesthetic value are not primarily valuable as art in virtue of this aesthetic value.

Despite the fact that there is good reason to reject the first part of the previously mentioned idea, it is easy for it to creep back into our thinking and even easier for our verbal formulations to conflate aesthetic and artistic value. This is in part because there is a sense of "aesthetic" where it is a synonym of "artistic." That sense makes no commitments about the nature of artistic value, but it is easily confused with a sense of "aesthetic" that stands for a distinctive kind of value. It is equally true of the debate about the interaction of ethical and aesthetic value that it tends to conflate the aesthetic and the artistic.[4] So we should both reject the first part of the idea and also take care not to talk as if it is true.

A second source of resistance to ethical–artistic value has a very different character. Even if one rejects essentialism and is a pluralist about artistic value, one might be leery of the ethical evaluation of art because one associates it with a simplistic moralism and with its tendency to censor in

order to keep others from being corrupted by immoral works. Of course, there are people who find nothing wrong with such moralism. A little thought, however, makes it clear that the issues of whether art should be censored and whether it has positive or negative ethical value are separate. This is demonstrated by the fact that some hold that immoral art has something valuable to offer and should be protected, while others hold that it should be protected even if it has nothing valuable to offer as a matter of free speech. Classifying it as immoral in the first place implies an ethical evaluation.

I won't pursue other ways of denying that the ethical value of a work may contribute to its artistic value. Many of these, such as the claims that it makes artistic value instrumental or that it makes artworks dispensable or replaceable, were discussed in a more general way in chapter 10. The issues have also been well covered by others (Carroll 2000b, 2002b, Kieran 1996). Instead, let us turn to the main issue of this section.

The Interaction of Ethical and Aesthetic Value

The ethical and the aesthetic are two different kinds of value. The exact nature of each is controversial. I suggest that ethical value lies roughly in the promotion of the good for human beings and honoring of obligations or constraints against certain forms of behavior. There are obviously many competing conceptions of the good for human beings, and that is why we value sensitive explorations of these different conceptions that make them vivid or allow us to feel what is attractive about them. On the other hand, there are certain things that almost all of us agree are bad, such as pain, bodily injury, the taking of life, cruelty, mental anguish, boredom, and so on. That is why we recognize moral obligations that we must honor or constraints that our actions must fall within. We have already noted various parameters along which we can ethically evaluate artworks.

As we have noted several times, there is no one conception of the aesthetic that all theorists adhere to. The operative conception here is based on the "minimal view" of aesthetic experience expressed in chapters 3 and 4: experience valued for its own sake in virtue of being directed to forms, qualities, and meaning properties of an object. The aesthetic value of an artwork is a function of its capacity to deliver aesthetic experience. In the discussion that follows, this is the conception of aesthetic value that will be assumed. However, we will try to note when a different conception seems to be at work in the views of others.

In many, though by no means all, artworks, both aesthetic and ethical values are present, and both, as we have just claimed, can contribute to the overall artistic value of a work. The question now is, Does the presence of one kind of value affect the degree of the other? For example, does a work that expresses (rather than merely contains an expression of) a morally reprehensible

attitude diminish the aesthetic value of a work? If it ever does so, does it always, or does it do so only under special circumstances? Let "interaction" name the view that the presence of one kind of value affects the degree of the other. Ethical-aesthetic (or e-a) interaction is the view that ethical defects in work diminish aesthetic value and that ethical merits enhance aesthetic value. Aesthetic-ethical (or a-e) interaction holds the corresponding thesis for the bearing of the aesthetic value of a work on its ethical value. Total interaction combines these two views. We will be concerned primarily with e-a interaction since that is the view that has been the focus of much of the recent literature on this topic, but we will briefly look at the plausibility of a-e interaction as well.

Let us begin by looking at one type of argument in favor of e-a interaction that has been popular but hardly unchallenged in the recent literature on this subject and that we will call the affective response argument.[5] The basic idea behind this type of argument consists of three claims. The first claim is that certain features of a work either will or ought to prevent a response that the work "requires" of or prescribes for its audience. This claim can be illustrated by many examples. Consider a thriller that fails to make the bad characters very menacing. Then the audience won't (or ought not) fear for the vulnerability of the protagonists, and the piece will fail *as a thriller* in virtue of failing to elicit fear for the protagonists or, at least, being unworthy of such a response. The second claim is that sometimes a moral defect will be the feature that prevents (or ought to prevent) the required response. The final claim is that when a work has a feature that prevents (or ought to prevent) a response that a work requires from its audience, this feature is an aesthetic defect of the work. In the case of the thriller, the lack of menace in the bad characters is an aesthetic defect. The conclusion of the argument is that an ethical defect is or entails an aesthetic one, from which it follows that the ethical defect diminishes the aesthetic value of the work. This basic style of argument can take either a factual ("prevents") or a normative ("ought to prevent") form. It also has a stronger or weaker form depending on whether it claims that the said feature is always or only sometimes an aesthetic defect in virtue of always or only sometimes preventing the required response or making the work unworthy of it.

This type of argument is vulnerable to a criticism the target of which is the third premise of the argument: that we have an aesthetic defect every time we have a required (prescribed) response that is or ought to be blocked by a feature of the work. First consider the nonnormative case, where the prescribed response simply is blocked by some feature of a work. One has to ask, Is the response blocked for all audience members or only for a subclass of them? The only safe answer is a subclass because there could always be some members who, perversely or not, respond as prescribed. For example, there could be undiscriminating lovers of thrillers

who respond as prescribed to the lamest instances of the genre. So if a pre-scribed response is blocked for some audience members but not for others and we want to criticize the work's aesthetic character on the basis of this blockage, we would have to argue that those who fail to respond in the pre-scribed way do this because the work does not deserve the response. The lame thriller does not deserve the response it seeks from its audience, and in this case at least this is an aesthetic defect.

The example of the lame thriller suggests that the affective response ar-gument is best cast in some sort of normative terms. There also appear to be counterexamples to the idea that we have an aesthetic defect whenever a work is unworthy of a prescribed affective response. Sometimes works of fiction attempt to do more than create an imaginary world for our con-templation and enjoyment. Some works want us to see this fictional world in relation to an aspect or historical period of the real one. This can create aims for a work that go beyond creating something that aesthetically en-gages. Some works aim to present a wealth of factual detail about the rele-vant aspect of the real world. Others present theories or reflections that propose explanations of the aspect. A work that has both aims is Tolstoy's novel *War and Peace*. Now the factual information and the theories of his-tory may serve an aesthetic purpose of representing the fictional world in greater detail or from a particular angle. However, they may have another purpose of providing credible information or a plausible theory. My own view is that the detailed descriptions and the theoretical chapters of *War and Peace* accomplish their aesthetic goals (though not everyone agrees), but some of the information may not be credible, and the theory of history may be ultimately implausible. The work would not be worthy of belief regard-ing all the purported information it seeks to provide about nineteenth-century Russia or in the plausibility of its theory of history. These may be artistic defects on the antiessentialist view of artistic value but not aesthetic defects.

The examples so far show that we don't necessarily have an aesthetic de-fect whenever a work is unworthy of a prescribed response, but the re-sponses mentioned so far are cognitive rather than affective ones. Hence, they are not yet counterexamples to a normative version of the affective re-sponse argument.[6] But such examples can also be provided. In fact, the counterexamples are especially prevalent in the case of our moral affective responses to works. Consider a work such as the epic poem the *Iliad* or any number of other works from ancient Greek literature. The *Iliad* is an ac-count of the Trojan War. The cause of the war is the abduction of Helen, the wife of a Greek ruler, by Paris, a prince of Troy. The point of the war is to bring Helen home and to restore the honor sullied by her abduction. To accomplish this, Troy must be destroyed, its men killed, its women and chil-dren enslaved, and its fields made barren. To restore honor, the Greeks too must be willing to undergo no end of sacrifices: its best warriors killed and

Iphigenia, the daughter of Agamemnon, leader of the military expedition, sacrificed so that the winds will blow. The poem does not hold back in describing the brutality of war. Over and over again, it describes the path a spear or arrow takes through the body it impales. But it presents these as the events that occur as part of an essentially noble enterprise. The poem describes these events beautifully and powerfully. It by no means represents the Greeks as good and the Trojans as bad. But it does take a different attitude to the values that drive this war than we would. It sees honor as a powerful moral force that can justify, or at least provide a very strong reason for, the sacrifice of a daughter and the destruction of a city-state. Most of us (I assume) regard this as a seriously flawed weighting of moral values that leads to unnecessary and often disastrous sacrifices in lost lives and in suffering. We do sometimes react with horrified disapproval when we encounter this outlook in the work, but I doubt that it makes us think one iota less of the *Iliad* or interferes with our aesthetic engagement with the work. Nor does it make us think the work is less worthy of such engagement. In this case, the explanation may be the huge distance in time and culture that separates us from the world of the poem. We are simply grateful to be allowed entry into the world in so effective a fashion. Finally, we would not say the work would be even better if it displayed a set of values we would approve of. There is no counterfactual situation where this work could do that, and if, per impossible, it did, we would lose one of the things we most value about the poem: access to a world dominated by a very different outlook than ours.

We disapprove of but respond as prescribed to the pursuit of honor and other warlike "virtues" in the *Iliad*. Further, the work is worthy of the response in making so real to us something that would normally be so foreign. Hence, it is not always true that a perceived moral defect entails that a work is unworthy of a response it requires for full aesthetic engagement. Hence, a moral defect does not necessarily entail an aesthetic defect. In the case of the *Iliad*, we hypothesized that it is cultural distance that permits moral disapproval of its outlook to have little bearing on that engagement. As the late Bernard Williams would have put it, the ethical viewpoint of archaic Greece is not a moral option for us, and this makes curiosity about it a far greater force than disapproval. (However, it is not so clear that in military circles and in the context of war, the conception of "virtue" has changed all that much, though what will rationalize going to war certainly has. If so, the *Iliad* may have more moral relevance to the present day than this paragraph suggests, and a different hypothesis would need to be put forward.) Cultural distance is just one of many factors that can secure the unyoking of our moral reaction and the aesthetic response a work merits. Certain genres, where moral seriousness is simply suspended, would be another example.

The only way to save the affective response argument is to show that a moral defect *sometimes* is or entails an aesthetic defect in virtue of making

a work unworthy of a prescribed response and to provide a principled way of picking out the occasions when this is so. The modern "art" novel (from the eighteenth century to the present) is perhaps one type of work where a version of the affective response argument works. (This claim would probably have to be further narrowed down to pertain only to a subclass of these novels.) The reason is that it is a standard feature of such works that they investigate ethical aspects of societies, cultures, traditions, and individuals in ways that explore real options for us. Consequently, whether a work is worthy of full aesthetic (including affective) engagement in its world is contingent on its persuading us that the work possesses a degree of moral seriousness or competence. Notice the standard here is not correctness. We can believe that the work has gotten it wrong on some question of ethical value without regarding the work as unworthy of a prescribed response as long as it convinces us that its outlook represents an option that merits consideration. Drama and cinematic fiction, when they have similar thematic content, would fall into the same boat. Documentary film would also, but for a somewhat different reason; namely, its literal claim to represent reality carries with it a demand to get moral reality more or less right.

To briefly illustrate this point, imagine that *Green Henry* failed to represent traditional values as possessing anything or having any consequences that we can regard as good. Instead, suppose they were simply represented as a repressive set of prohibitions. While for some novelistic purposes that would be fine, it would ruin *Green Henry* in just the way a lame thriller is ruined by unconvincing villains. The clash of values at the heart of the fictional world of Keller's novel would be equally unconvincing because of a failure to imagine one set of those values in an ethically positive light. It might be objected that the problem here is purely aesthetic: a failure to create a conflict that the story requires. That is not quite right. The novel is premised on there being a genuine conflict that many people face, which the novel is to explore. It then has to treat this issue insightfully. The imaginary *Green Henry* has both an ethical defect and an aesthetic defect. The ethical defect is its lack of insight into the positive aspects of traditional systems of value. Its aesthetic defect is its failing to represent a convincing clash of values. The two defects are not identical, but the ethical defect is responsible for the aesthetic defect.

In the example just discussed, the ethical defect is of a cognitive nature: lack of insight. This is an important type of example because novels of the type under discussion here are often evaluated on such grounds. However, it is not the typical example envisioned by those who put forward a version of the affective response argument. They are more commonly concerned with such things as the expression of a morally egregious attitude, where these are endorsed by the work itself. Contempt for a particular race or pleasure in the suffering of others are examples of such attitudes. An interesting case of this occurs in the Nathaniel Hawthorne's novel or, rather, romance

The House of Seven Gables. Chapter 18 is devoted entirely to a reflection on the recently deceased Judge Pyncheon. It is true that this character is the "villain" of the piece, who is the contemporary representative of all that is corrupt in the ancient Pyncheon family. It would not be surprising for this chapter to bring home the evil and the vanity such a life embodies. What is surprising is that the narrator positively gloats over Judge Pyncheon's death, taking no end of pleasure in mocking his newly immobile state. Further, there seems to be no distance at all between this flawed attitude of the narrator and the attitude of the work. The flaw here is perhaps not a gross moral defect, but vindictive pleasure even at the death of a villain is not admirable and is worse for its seeming gratuitousness in this context. It would be one thing for the judge's victims to feel this way, but one is entirely taken by surprise by the new tone in the heretofore objective voice of the narrator. This is where the aesthetic problem arises. It is very hard to respond as prescribed by the chapter's tone of voice, and it is harder to believe one ought to so respond. Once again, the aesthetic defect is not the same as the ethical one, but the latter is responsible for the former.

Having achieved this very qualified vindication of a version of the affective response argument, we can note that ethical defects can aesthetically mar works independently of blocking a prescribed affective response. The previous examples illustrate this claim as well. Thus, the chief aesthetic flaw in the imaginary *Green Henry* is its failure to represent a convincing clash of values. The failure to merit a prescribed response simply follows on this more basic failure. To take one last example, Evelyn Waugh's *Brideshead Revisited* embraces a (purportedly Roman Catholic) moral outlook that requires sacrifices from its characters that many readers would find ethically (and religiously) unjustified. This work might also be thought to have an aesthetic flaw underwritten by a flawed moral (religious) attitude. To imaginatively engage with the fictional world of this work, one has to buy in to the idea that the characters face real moral dilemmas and that the recommended choices can be regarded as noble. If purchase of that idea is unmerited, the reader aware of this is in an aesthetically intractable position. Notice that in some respects we are in a similar position with this work as with the *Iliad*, but the differences in context and genre make an important difference to our reception of the work.[7]

We have just argued that an ethical flaw can, in the right circumstances for the right type of work, diminish the aesthetic value of a work. Before leaving this topic, let us briefly consider whether aesthetic flaws can diminish the ethical–artistic value of a work. To evaluate this claim, one has to ask, What might the ethical goals of an artwork be? It will not be simply to express a morally meritorious attitude. It is also unlikely that there is just one such goal. Works might explore a conflict of values or a moral dilemma. It may display an ideal type, satirize a questionable aspect of society, or, as we saw in the case of *The Jungle*, push for large-scale political reform. There is almost no end to the possibilities, but any such goal will

require creating a fictional world or presenting the real world in a way that secures more than an intellectual response from the audience of the work. They must be able to feel by way of vividly imagining the conflicting pull of the values, the inadequacy of all solutions to the dilemma, the folly of satirized aspects of society, or the bad consequences of the practice in need of reform. This is a requirement that the audience's aesthetic experience of the work have a certain character. Hence, to accomplish an ethical goal, a work of art must be able to deliver such experiences. One might call this the reverse affective response argument. It suggests that an aesthetic flaw can be responsible for failure to achieve such an ethical goal. Such failure is compatible with the work expressing a commendable moral attitude. An example of such a work is Brett Easton Ellis's novel *American Psycho*. This work seeks to embody the excessive greed of the 1980s in the United States by making a serial killer a symbol of that vice. Unfortunately, the serial killings represented in the novel are so gruesomely described that the work does not merit the amusement needed to take it as a parody of the cut-throat pursuit of wealth. The novel's primary ethical attitude is perfectly commendable: the condemnation of greed as a vicious character trait. The problem is that the work chooses the wrong aesthetic means to get the reader to feel the viciousness of greed.[8]

Summary

In this chapter, we examined some implications of the pluralist and antiessentialist view of artistic value defended in chapter 10. We argued that many works of art have ethical aspects—that is, aspects that can be evaluated from a moral point of view—and these include certain artistic aims of an ethical nature. Further, we claimed that the ethical value of a work can sometimes be part of its overall artistic value. A work can acquire ethical value in virtue of the attitudes it endorses, the manner in which it explores ethical issues, and its consequences for its audience and even beyond its audience. The ethical features of a work can not only contribute to its artistic value but also interact with a work's specifically aesthetic value. The presence of ethical value in a work can affect the degree of the work's aesthetic value and vice versa. However, this is not invariably the case. It is typically the case only for works that belong to certain genres and that stand in the right relation to their audience.

Further Reading

Anderson, John, and Jeffrey Dean. 1998. "Moderate Autonomism." *British Journal of Aesthetics* 38: 150–66. A critique of the affective response argument and a defense of the independence of aesthetic and ethical value in art.

Carroll, Noël. 1996. "Moderate Moralism." *British Journal of Aesthetics* 36: 223–37. One of the first versions of the affective response argument for the interaction of aesthetic and ethical value in art.

———. 2000. "Art and Ethical Criticism: An Overview of Recent Research." *Ethics* 110: 350–87. Just what it says: an overview of the debate on interaction.

Gaut, Berys. 1998. "The Ethical Criticism of Art." In *Aesthetics and Ethics*, edited by Jerrold Levinson. Cambridge: Cambridge University Press, 182–203. An influential version of the affective response argument.

Jacobson, Daniel. 1997. "In Praise of Immoral Art." *Philosophical Topics* 25: 155–99. An argument for the independence of the aesthetic and the ethical.

Kieran, Matthew. 2001. "In Defense of the Ethical Evaluation of Narrative Art." *British Journal of Aesthetics* 41: 26–38. Combines a critique of Carroll and Gaut with a defense of his own version of the affective response argument.

———. 2003. "Art and Morality." In *The Oxford Handbook of Aesthetics*, edited by Jerrold Levinson. Oxford: Oxford University Press, 451–68. Another good overview of the debate on interaction.

Levinson, Jerrold, ed. 1998. *Aesthetics and Ethics*. Cambridge: Cambridge University Press. An important collection on the interaction of art, ethics, and the aesthetic.

Nussbaum, Martha. 1990. *Love's Knowledge*. Oxford: Oxford University Press. A collection of essays on the ethical importance of literature.

Notes

1. On the issue of ascribing attitudes to a literary work, it has become fairly common to speak of the implied author as the object of attitude ascription. The implied author is not the narrator and not the real author but a construct. There are many different conceptions of the implied author. One conception suggests that from the way the work is written, it may appear to us or we may infer that the author has certain characteristics. The set of such characteristics constructs the implied author (Robinson 1985; Walton 1979). I argue against the necessity of appealing to an implied author in Stecker (1987a).

2. For a unified account, see Levinson (1996, 224–41). His views are not completely congruent with those expressed here.

3. One exception is Gaut (1998), who includes ethical and cognitive values of art within the idea of aesthetic value. This is because he understands an aesthetic property as any property that is relevant to the artistic evaluation of works. Hence, for him, but not for many other writers, aesthetic value and artistic value come to virtually the same thing.

4. This conflation occurs in Anderson and Dean (1998), Carroll (1996), and Gaut (1998), though in the latter case at least it is intentional.

5. This argument intentionally combines a number of distinct lines of thought. One such line is developed by Carroll (1996, 1998, 2000b). A somewhat different line is developed by Gaut (1998). Both lines of thought are criticized by Anderson and Dean (1998), Jacobson (1997), and Kieran (2001, 2003). The latter has defended (2001) yet another version of the argument but is less sympathetic to it in (2003). My discussion attempts to identify something all these lines of thought share in common.

6. The same could be said about a similar criticism made by Anderson and Dean (1998, 159) using the whaling information supplied in Herman Melville's *Moby Dick*.

7. One implication of the view defended here is that there is at least a degree of relativity regarding the circumstances in which an ethical defect will be responsible for an aesthetic defect. Consider the *Iliad* one last time. We argued earlier that although many of the values implicitly endorsed or presupposed by this poem are ones we might find highly questionable, this does not diminish the aesthetic value of the work for us. This is in part because these values are not real options for us and in part because of the not unrelated cultural distance between the work and us. On the other hand, the situation is quite different if we consider the same work in the context of Plato's Athens. Here the *Iliad* presents character traits as purported virtues that were taken very seriously as options. If in fact such traits are not virtues but are destructive of social stability and the pursuit of the good life, as Plato believed, then the *Iliad* would possess an ethical flaw that could diminish its aesthetic value. The case of the *Iliad* in Plato's day would be no different from the case of certain novels in our own. However, the same is not so for the *Iliad* in our own time.

8. This work is more commonly portrayed as an example of e-a interaction than a-e interaction. However, it seems better conceived in the latter way. Carroll (1996), where the example was first introduced, considers the novel an example of both kinds of interaction.

12

The Value of Architecture

We begin this chapter by considering the aims of architecture and the aesthetic appreciation of buildings. This part of the chapter returns to the discussion of environmental aesthetics that began our examination of the aesthetic since the works of architecture should be considered artificial environments within larger, partly artificial, partly natural ones. However, because buildings are designed by human beings, the intentions with which they are made, the aims that architects or builders attempt to realize, and the achievements audiences look for define the objects of appreciation more sharply than occurs in nature appreciation. In this way, the appreciation of these artificial environments is more like that of art than nature. Often it *is* the appreciation of art, as many buildings are artworks. However, many others, the majority of such structures in fact, are not. This raises several interesting questions: Is what we appreciate in architectural art significantly different than what we appreciate in buildings that are not artworks? What distinguishes the two classes of buildings? If so many buildings, even among those designed by architects, are not artworks is architecture an art form? By pursuing these questions, we can apply many of the results reached in earlier chapters. We will see that the historical functionalist view about the nature of art does a good job in distinguishing architectural artworks from nonartworks. We will also see the way we appreciate architecture further illustrates claims we have made about the plurality of artistic value. Finally, we will see that uncertainty about the objectivity of our evaluations persists in this arena, though more so within some parameters of value than others.

Buildings as Environments

Among the overarching aims of architecture, one is to create a building, which is a good artificial environment serving some particular practical

purpose, and a second is to integrate this building with a larger environment, artificial or natural, which includes the grounds belonging to the building but typically extends beyond that. Let me begin with two examples that vividly illustrate this point. The first example is the new Getty Museum (Center) in Los Angeles, a brilliant complex of buildings, courtyards, and gardens. The exterior of the buildings are made from rough stone and smooth marble in a way that immediately engages the eye as well as suiting the California hills atop of one of which it sits. This effect is enhanced by the fact that the materials are assembled into complex round and cornered shapes that are echoed in the pools, courtyards, gardens, and even benches and tables. The interiors of the buildings do two things wonderfully well. First, the buildings are designed to be maximally lit by natural light. Second, the same design creates a dialogue between buildings and site by providing layers of views: of building sections, grounds, the surrounding neighborhoods, and downtown Los Angeles. One is keenly aware of the complex as an (artificial) environment within a larger environment and of the aesthetic qualities of the interaction of these. The Center is completely successful as what one might call an architectural park. Is it also successful as a museum? Some could raise doubts mainly, I suspect, based on two practical considerations. (Others might just disagree with the aesthetic assessment stated previously.) The first consideration is accessibility. The location in the hills makes the museum difficult or expensive to access except by car, but then cars face the problem of limited parking. Further, the art is harder to find in this sprawling complex. Second, someone might consider the interest of the Center as an architecturally created environment as competing with and as a distraction from the art. The first consideration expresses a reasonable complaint but one that merely points to an acceptable cost of what the Getty has achieved. The complex of buildings at the hilltop location is essential for the achievement, and it is also responsible for the costs. The second consideration is wrongheaded. Placing art in an aesthetically fine environment does not distract one from the art. It heightens one's awareness of the place of art among the aesthetically good things, the place of painting and sculpture among the visual arts; it offers refreshment when one begins to feel one has seen too many paintings; and, in general, in addition to offering an experience of individual artworks, it helps one to deepen one's experience of art in relations to other things.

The second example is of a house at the end of an upscale subdivision built in a large, grassy field, bordering on a nature reserve. I encountered the house on a walk in the nature reserve. As one ascends a small rise on a wooded trail (a trail that seems to hold out the prospect only of more woods), tall white slender columns, then the whole rear of the house, jump out at the walker. The columns support a portico, under which is a swimming pool surrounded by a garden. As one goes down the trail, one goes right by this house. The front does not have the roughly classical trappings

of the rear but preserves the imposing air, which strikes one from the moment the house is seen. Only then can one see that there are other houses. At first, one sees two more but eventually realizes that there is a whole subdivision of new, individually designed homes.

The house left a lasting, if not too pleasant, impression on me. Its eclectic exterior features do not blend particularly well together. Indeed, if one abstracts from the setting, one might be a little unsure whether this is a house or a municipal building of uncertain purpose. But it is the mismatch between house and setting, a mismatch that to a lesser degree applies to the whole subdivision, that is most striking. There is something odd about all these homes, ranging from large to grand, sitting in a rough field.[1] But some did so more comfortably than others, and the house in question was the most out of place. It was clearly built—or at least gave this impression—to dominate its neighborhood, and the field beside the nature reserve is not an appropriate object of this ambition.

Having offered this brief critique, I should temper it by pointing out some of the oddities and limitations of the example. First, as is probably obvious, my approach and viewing of the house from the nature trail was peculiar. Mine was not the intended approach: it was back to front, it was from a public path rather than a public street or road, and it was limited to three sides of the exterior and no view of or from the interior. Second, my discussion might be thought to illustrate the aims of architecture considered as art, and it is far from clear that the present example is of an architectural artwork or of a building that has any pretensions of being so considered. In connection with this, it might be said that my dissatisfactions are those appropriate to thinking of the house as an artwork, whereas it may be completely satisfactory given the nonartistic aims with which it was (hypothetically) made.

I shall leave it an open question whether my unusual approach to the house made perspicuous real faults (if faults they be) or simply skewed my perception. The aesthetic question raised by this is whether normal viewing conditions of a building include a first sighting from a particular vantage. (My answer would be: sometimes.) The second issue is of greater concern. It seems obvious that any building can be evaluated aesthetically, as if it were a work of art, and even that this is always relevant to its evaluation as a building. However, if this is so, this raises a question about the viability of the distinction between architectural works that are and those that are not artworks. If there is such a distinction, shouldn't it imply differences in criteria of evaluation? I return to this in later sections. For now, let me draw some conclusions about the aims of architecture based on the two examples discussed.

One thing that both my examples make plain, though I am hardly the first to point this out, is that buildings are part of and help create an environment. Except in cases where the building and its surroundings are protected by walls of privacy, they intrude into the lives not only of those who use the

buildings but also of anyone who passes through or in sight of the environments of which they are part. Much of what we are concerned with when we evaluate buildings aesthetically is their contribution to an environment and the way they function as a part of one. Of course, as is typical of aesthetic concern in general, much of this has to do with the look of the environment: the look of a material and the way they relate to other materials, the look of exterior shapes and the ways they relate to other shapes and materials, the look of all these things in relation to a site when viewed from the outside of the building, and the look of the site from the inside of the building. What has been said about the outside carries over to the inside. The inside of a building is also an environment, albeit one experienced only by those who use or visit it. Many of the same considerations apply concerning the looks of materials and shapes and the looks created by relations among these. However, there are many other aspects of the interior of a building. There is the literal, tactual feel of many parts of the interior, such as floors, counters, fixtures, rails, and so on. One cannot inhabit a building without constantly touching parts of it, and its feel to the touch is part of its overall character. The most important interior unit of a building is the room, and the character of a room is a result of many variables beside shape and materials, including its intended and actual function, natural and artificial lighting, furnishings and decoration, and interplay with exterior and site and with other rooms and passageways.

Unlike natural environments, one conceives of a building under many intentional categories. The looks themselves are either conceived as intentionally created or as happy or unhappy accidents, resulting from what was intentionally created. If the accident is unhappy, one might think of it as created by negligence. The parts of a building, both interior and exterior, are not thought of merely as shapes with certain looks but are intended as functional parts and as arising from within certain historically situated architectural styles. Thus, the facade of a Georgian row house presents "a complete vertical element" consisting of plinth, cornice, entablature, column, capital and molding" (Scruton 1994, 18). Furthermore, one thinks of all these intentions as subsidiary to an intention to create a certain type of building that will fulfill the practical functions of that type and possibly additional functions to suit special needs or desires of or to create special opportunities for the users of that building. Because of these layers of intentions, the looks become expressive of these intentions, whether real or hypothetical. This is at least one way a building can be expressive and project a character. One also thinks of at least some of these looks as expressive (suggestive) of functions fulfilled by the building (not merely the intention to fulfill the function). Thus, the exterior of a house may be suggestive of spaciousness within or of the existence of various nooks or special rooms. When this happens, it's important that the impression of the exterior be actually maintained within, or else the passage from outside to inside will be a disappointment.

This discussion indicates some of the aesthetic considerations relevant to deciding the extent to which the environmental aims of architecture are achieved. Let me conclude this section by making two further points. First, aesthetic considerations are not the only ones relevant to deciding how well these aims are achieved. They play little role in the design of some buildings in the broader medium of architecture, though there is a separate question (to be returned to later) whether such buildings can be good buildings in the absence of aesthetic goodness. Second, both the good and the bad will exhibit all the qualities and relations I have discussed. For example, bad works of architecture can be highly expressive (just of qualities we deplore). I have given categories rather than criteria of evaluation. I have also said nothing as yet about the degree of objectivity, if any, of evaluative judgments of architecture. Let us now turn to that issue.

Evaluative Judgments of Architecture

When we make an overall aesthetic judgment of a building, we are judging it as an environment that is part of a larger environment. How objective can such judgments be? For example, suppose, as is not unlikely, that the owner-occupants of the house discussed in the previous section took issue with my critique. They claim that the eclectic exterior provides visual interest, that the large size of the house is suggestive of roominess and comfort within, and that its apparent dissonance with its larger environment (field and woods) is something that passes as one enjoys the surroundings from within and without the house. They really enjoy the environment that the house and surroundings provide, and part of their enjoyment is aesthetic. Using roughly the same criteria, they and I come to different evaluations. Is there anything to settle the difference?

As we have seen previously, there are various levels of intentional considerations applicable to architecture but not to natural environments. These considerations broaden the issues about which we can dispute and what we can bring forward to settle them. As Roger Scruton (1979, 1994) emphasizes, some of these may be ethical issues about how we should live and the attitudes we project in the buildings we make, which is not to say that they are no longer issues about the artistic value of buildings (when artistic value is in question). Perhaps this additional range of considerations helps make evaluative disputes about architecture more settleable. For example, perhaps the uneasy relation between the house and its surroundings, which suggested to me an aesthetic imbalance, also suggests certain ethical concerns. A house this large is bound to use large amounts of energy no matter how energy efficient the appliances within. This apparent fact might create a further dissonance with its pretty country setting, this time with ethical overtones, at least if one thinks that unnecessarily large expenditures of energy indicate an indifference to legitimate environmental concerns.

Could one go even further and say that this house in particular and the subdivision in general are expressive of a wasteful, high-consumption lifestyle and the contemporary American society that encourages such a way of life?[2] Perhaps these suggestions are not completely far fetched, but couldn't one also see the house as expressive of more acceptable ethical ideals: a commitment to family, the rewards of hard work, and the honest pursuit of happiness or the good life? So it is not clear that the plausible alternate assessments illustrated previously are not duplicated here. In more straightforward ethical disputes, such as disagreements over the right thing to do on a particular occasion, while we may disagree over which considerations are relevant, and we certainly may disagree about how to weigh competing considerations, we agree about the resolution toward which a consideration points. That an act causes injury or is promise breaking points toward its not being right. In the case of the house, that it has an eclectic design does not clearly point to a deficit rather than an asset. That it is conspicuously large does not clearly point to an ethical flaw. So it seems quite possible that there can be different evaluations of intentional features just as commonly as there can be different evaluations of the same looks. I am not saying that resolution of disputes can never occur but that it is not clear when it is forced.

There is also another wrinkle in the evaluation of buildings as expressions of ways of life or social, political, or religious ideals. Whether or not we place positive value on the way of life or ideal expressed, we value the achievement of expressing it. An individual may reject the Christian worldview expressed in gothic cathedrals but be full of admiration for the cathedrals themselves, in part because of their expressive qualities associated with this very worldview. Indeed, this is more likely an avenue toward significant interpretive and evaluative consensus than the ethical evaluation of architectural works, with the exception, perhaps, of ideals widely agreed to be odious. A building that expressed well the totalitarian ideal of intimidating state domination would plausibly be the worse for being successful in this regard. However, instances of this sort are the exception rather than the rule.

Whether the argument just given is persuasive or defective, there is one constraint on evaluations of which we can be certain. This is the context dependence of any reasonable evaluation. Relevant contexts are multiple. We have already discussed the context provided by a site, consideration of which is essential to all (singular) buildings.[3] In addition, the period during which the building was constructed is essential for properly identifying style. There is also something we might call social context, which is another important source of properties relevant to evaluation, emphasized in the previous discussion. All these contextual considerations need to be recognized to properly understand a building and hence to properly evaluate it.

The Aesthetic Evaluation of Architectural
Artworks and Nonartworks

When we inhabit or merely pass through an environment, whether it is natural or artificial or a mixture of both, we can't help appreciating (in the sense where this can be positive or negative) and evaluating it. Some of the categories we use may be purely nonaesthetic, but only when our evaluative purpose is highly specialized will such categories be used exclusively. Otherwise, aesthetic considerations will invariably enter into the equation and very often dominate it. This is as true for buildings as for any other feature of the environment, and this is as true for buildings that are made, apparently, with no artistic or aesthetic intent, such as the factoryscape east of Chicago, the warehouses on the west side of Queens in New York, and the innumerable strips off highways. One knows that few, if any, aesthetic considerations went into their making. (The story is more complex for the strip, but leave that aside.) One certainly knows one is not dealing with artworks, but one sees what is to be seen and passes judgment all the same. For a building to have features that can be subject to aesthetic appraisal, those features needn't be intentionally designed for the sake of this purpose. All buildings will have such features, so they will be subject to aesthetic appreciation and evaluation. Most buildings will have some intended aesthetic features, and this is as true for those that are not artworks, such as the house discussed in the previous section, as for those that are.

It seems plausible that the distinction between architectural art and nonart is to be made in terms of the aims intended and achieved by architects. We can try to ascertain these aims, indirectly, by thinking about the consideration that would be relevant to the aesthetic evaluation of buildings on the assumption that the artistic aims of architects would be concerned with these considerations. However, the considerations turn out to apply to all buildings, and intentions regarding these considerations are likely to be extremely common among architects. Thus, it turns out that we take a similar evaluative stance to buildings that purportedly are artworks as to those that purportedly are not. It also turns out that many of the buildings that purportedly are not artworks are made with aesthetic intentions. These two facts seem to place in doubt the distinction between architectural artworks and nonartworks. So should we abandon the distinction or revise it? What is the bearing of this on the artistic and aesthetic appreciation and evaluation of architecture?

Regarding the second question, I'm inclined to say that for the aesthetic appreciation of architecture, not much hangs on whether we can we can maintain the distinction between architectural art and nonart. For, as we have seen, the considerations relevant for such appreciation would apply across these categories, even if the distinction between them can be sustained. When we bring these considerations to bear, those buildings we

would tend to think of as art might be richer in detail or more original in form. That, however, is a (mere?) difference in degree that results from applying the same criteria to different objects.

I have so far equated aesthetic and artistic appreciation of architecture, assuming that when we engage in the former, we are, in effect, treating a building as if it were an artwork, whether or not it is. However, that assumption is simply incorrect, as we should have known from the earlier chapters of this book. Almost any product is made with some regard to making its appearance appealing, and that is an aesthetic concern. It would be astonishing if buildings, which are among the most expensive and most public of products, were not so made. (There are special circumstances or locales where these considerations are suspended, such as, among others, some factory or warehouse districts and, more unfortunately, some housing.) Nowhere can the artistic be distinguished simply by the fact that its products are made with aesthetic intentions or are capable of aesthetic appreciation.

How, then, are architectural artworks to be distinguished from other buildings? I can think of many conditions that may be sufficient but few, if any, that are necessary. It is sufficient that a building achieve aesthetic excellence as an architectural work. It is perhaps also sufficient that it is a unique and original building at least where this originality is in the service of considerations like those mentioned in the previous section. Similarly, a building that is a creative response to past architecture is probably an artwork. It might be sufficient that a building be made with an ambition to aesthetic excellence, originality, or creative wrestling with earlier architecture, even if it does not achieve success. These may be some sufficient conditions, but I do not claim that they are the only ones.

Is Architecture an Art Form?

On this question, different considerations about art push us in different directions. One line of thought reaches a negative answer as follows. In asking whether architecture is an art form, one is not asking whether there are buildings, works of architecture, that are artworks. That is not in doubt, as we just argued. However, it is arguable that not everything that is an artwork belongs to an established art form. There are many crafts, such as the making of pottery, carpets, and furniture, that sometimes produce artworks but in general do not. Similarly, there are forms of writing, including history, biography, the essay, philosophical writing, nature writing and so on, about which the same could be said. It seems plausible that the crafts and forms of writing just mentioned are not art forms even though some of their instances are artworks because artworks are not the typical product of the practice of those crafts and forms of writing. Stephen Davies (1995)

argues that the same can be said of architecture, and so it too is not an art form. The great majority of buildings designed by architects not only have little artistic value but also make no pretense to it. Think of shopping malls, average office buildings, and rubber-stamp suburban housing. Here the functional is not merely blended with the aesthetic (or artistic), which is true of all architecture, but the former has clear priority over the latter. Hence, not being a practice whose typical product is a work of art, architecture is not an art form. (However, as we have argued extensively by now, it should not be thought that such buildings are made with no thought to their aesthetic features or that they are incapable of aesthetic appreciation. The former is rarely, the latter is never, true.)

There are other considerations that suggest architecture is indeed an art form. One important reason to think this is historical. The idea of an art form currently of interest to philosophers of art derives from the idea of the fine arts that first fully emerged in the eighteenth century. Architecture was one of the five central, undisputed fine arts at the time of the emergence of that concept. Since the eighteenth century, many new art forms have been added to the original list, and many other changes have taken place in the way we think of the arts with regard to their media, their production, and their aims. One thing that has remained fairly constant is that almost all practices counted among the fine arts two hundred and fifty years ago remain central within the arts today. Unless the practice of architecture has significantly changed, so we are not really talking about the same thing as eighteenth-century theorists, architecture is an art form now if it was then.

Perhaps architecture has significantly changed, however. Now architects design all sorts of largely functional buildings. The suburban shopping mall, which commonly sprawls in a way that makes it impossible to take it in as a building, is one of the best examples. Between the Renaissance and the Enlightenment—the period in which architecture achieved its status as a fine art—perhaps the works of architects were pretty much confined to such buildings as churches, palaces, important government buildings, and great houses. What is certainly true is that it is such architectural works that writers from the Renaissance through the nineteenth century focused on. Such buildings, while capable of being perfectly pedestrian, offer great scope to blending a high degree of the aesthetic with the functional and were made with the expectation that this would be accomplished. Is there a rationale for this focus that might help to decide whether architecture is (still) an art form?

There is. Consider another comparison. The vast majority of films and photographs are, plausibly, not artworks. Most snapshots and even most professional photographs make no claims to arthood. The status of mass-media cinematic entertainments is less clear, but again many would deny them art status. Nevertheless, cinema and photography give every appearance of be-

ing recognized art forms. There is a significant subclass of films and photographs that are made with artistic intentions, achieve important artistic aims, receive the attention of art critics and audiences interested in the visual arts, and are prominently screened or displayed in art museums and other art world venues.

Or consider such undisputed art forms as music and literature. Isn't there plenty of music—the majority of music, from much mass-media popular music to advertising jingles—that has no artistic pretensions? Isn't the same true of Harlequin romances and potboilers, though in form they are novels, and many great works of literature are novels?

How do we reconcile these findings with our original consideration, borrowed from Davies, that we have an art form when a typical product of that form is a work of art? We could, of course, reject this claim, but I think there is a better way of dealing with it that preserves the intuition in its favor. What is needed is a distinction, and unfortunately there are no words that standardly make it. I will make it by distinguishing between a *medium* and an *art form*. Words such as "photography," "music," and "painting" can be used to refer either to a medium or to an art form, and according to my distinction, they are being used to refer to different things depending on which is meant. The medium encompasses all music (photography, painting), whether it is a piece with artistic pretensions (status) or not. The art form typically encompasses a subclass of items in the medium, items made with certain intentions or that achieve certain aims, that are capable (and possibly worthy) of receiving attention of art critics and audiences and being placed in certain institutional settings. Crucial to making something an *artwork* are the intentions with which it is made and the aims achieved. Crucial to the creation of an *art form* is the existence of institutional settings to organize the availability of such works to interested audiences, to interpret and evaluate them, and so on.[4]

It may be objected that we can use this distinction between media and art forms to indiscriminately claim to discover art forms where none exist, for example, to claim, counterintuitively one might think, that we can also distinguish between the media of pottery, furniture, carpets, and the cognate art forms and even more implausibly distinguish the media of historical, philosophical, or nature writing from cognate art forms. With the latter group, we are surely right to reject the deployment of the distinction. The reason is twofold. First, it is questionable whether the terms of the distinction apply. Philosophical, historical, and nature writing are not obviously three distinct media since media are usually not distinguished by subject matter. Second, whatever medium the previous mentioned types of writing belong to, there is little in the way of institutional arrangements for placing those (relatively rare) items that are made with artistic intentions or achieve artistic aims (to a significant degree) in settings that make them readily available for artistic appreciation. In contrast, the novel is an art form

(or subform) not only because novels (that is, writings in that medium) are frequently artworks but also because there are such institutional arrangements for making these works available for the right kind of criticism and reception. Whether the distinction between medium and art form applies with regard to the items first mentioned (pottery, furniture, carpets) is less clear; we are at the very least in the area of borderline cases. Many works of pottery are artworks, and there are institutional arrangements (display in museums and galleries) for picking these out and making them available to audiences. One might think of the Bauhaus as, among other things, attempting to provide an institutional framework that did something similar for furniture.

The distinction fits the practice of architecture well. We can distinguish between architecture as a medium and as an art form. Many architects work in the medium without intending to produce and, indeed, without producing artworks. However, the historical placing of architecture within the fine arts and the sheer number of great architectural artworks have (I suspect) conspired to create the institutional arrangements for the appreciation of those artworks, that is, have created the art form: architecture. Davies, though right to note that some building design has nothing to do with art, is wrong to claim that one cannot identify a subclass of architectural works that belong to the art form.

If the claim that there is an art form of architecture within the broader medium is to be made good and avoid triviality, there must be characteristic artistic aims or functions that architects working within the art form are attempting to achieve as well as the institutional arrangements mentioned previously. About the institutions, I simply want to say a few words to point to their rather obvious existence. There are canonical works of great architectural art and of important writings about architecture. There are artistic movements, distinctive styles, and critical controversies. There are histories of architecture that in every way look like art histories. There is an architectural avant-garde. One could go on and on, but I don't see great philosophical interest in tracking down further the evidence for the existence of institutions of the art of architecture. Others with more specialized interests will do a better job than I could here. The important thing is to recognize how clear it is that the institutions exist.

The aims of architecture have been the topic of much of this chapter. Since all buildings have aesthetic features and can be aesthetically appreciated, the aims characteristic of architectural art require a more complex formulation. Some of these were mentioned at the end of the preceding section: aiming for aesthetic excellence, originality, a wrestling with earlier architecture. Architectural artworks are designed under a concept of what a building or a building of a certain type or function should be and aim to realize the ideal expressed by the concept. Finally, whether intentionally aimed at or not, any building that excellently fulfills the function of

creating an artificial environment connected with a larger surrounding environment is an artwork.

Summary

I have argued that "architecture" names both an art form and a medium. All buildings that belong to the art form belong to the medium but not vice versa. If this purported doubleness in meaning is unique to the concept of architecture, we would have reason to be suspicious of it. However, the ambiguity seems to hold in many other cases where we speak of art forms.

Whether a building is an artwork depends on the aims with which it is made and the functions it actually fulfills, as the historical functionalist definition of art would predict. However, whether there is an art form of architecture depends not only on the existence of architectural artworks but also on the existence of practices or institutional arrangements for presenting, classifying, explaining (interpreting), and evaluating architectural works for artistically minded audiences. There are indeed such practices and institutions.

When it comes to the appreciation and evaluation of architecture, these activities are by no means confined to buildings that are indisputably artworks. One can aesthetically appreciate (where this can be a positive or negative experience) or evaluate any building, and there is nothing unusual in doing so. The considerations relevant to such appreciation or evaluation are not strikingly different with buildings that are and are not artworks. However, when it comes to architectural artworks, a more plural range of values comes into play. For example, we evaluate such works for their arthistorical as well as aesthetic value. However, it shouldn't be supposed that this complexity in evaluative considerations is completely confined to those works of architecture that are artworks. To some extent, it could come up for any building, as our discussion of the ethical evaluation of buildings illustrated.

Finally, I raised questions about the objectivity of our evaluations of architecture. While expressing doubts whether there is a high degree of objectivity here, I do suggest that there are constraints on reasonable evaluations of architectural works. Attention to context is one such constraint. Let me add here that the distinction between architectural artworks and nonartworks may bring to the fore considerations that might help provide other constraints. For example, the distinction between original and derivative can be probably applied with a good deal of consensus. Which buildings are the best examples of a style may also garner a decent amount of agreement. When we compare vernacular buildings with unquestioned artworks of high quality, distinctions in the degree of aesthetic or other kinds of artistic value may become plainly visible. So despite the doubts expressed

here, I mean to leave the question of the objectivity of these evaluations an open one, hoping that others can give better and more decisive answers.

Further Reading

Davies, Stephen. 1995. "Is Architecture an Art?" In *Philosophy and Architecture*, edited by Michael Mitias. Amsterdam: Editions Rodopi. Argues that architecture is not an art form.

Graham, Gordon. 1997. *Philosophy of the Arts*. London: Routledge. Chapter 7 provides an interesting discussion of the artistic value of architecture.

Scruton, Roger. 1979. *The Aesthetics of Architecture*. Princeton, N.J.: Princeton University Press. One of the few extensive philosophical works on this topic.

———. 1994. *The Classical Vernacular: Architectural Principles in an Age of Nihilism*. New York: St. Martin's Press. A collection of essays arguing for the superiority of traditional architecture over modern and postmodern styles.

Notes

1. Since my initial encounter, I have returned many times to the same trail and hence to the house and subdivision in question. The field has gradually become a huge lawn, and fences have been erected separating the subdivision from the nature area. These changes have softened some of the dissonant features noted in the text but not radically changed the overall aesthetic evaluation of the house and its situation.

2. Gordon Graham (1997, 131–48) suggests that architecture at its best can express human ideals. If so, it can express ways of life that are less than ideal but rather open to ethical criticism.

3. Davies (1995) points out that architectural works can be singular, that is, allowing of only one instance for a given architectural design, or multiple, that is, allowing of more than one instance for a design, but that most such works belong to the former category because they are designed for a single site. He also points out that buildings are located not only at physical sites but also at "sociohistoric" ones, which is to say that cultural and historic contexts give buildings artistically important properties.

4. I argue for and spell out in much more detail this conception of artwork and art form in Stecker (1997).

Conclusion

Let us take stock.

Part I was about the aesthetic. Our goal was to get a handle on a certain kind of value—aesthetic value. However, to do this, one has to pin down the appropriate conception of the aesthetic that would fix the value. We argued that there is no uniquely correct conception of the aesthetic, and this implies that there is not a unique aesthetic value on which to get a handle. Nevertheless, we also argued that one conception did a pretty good job in capturing the extension of experiences considered aesthetic while preserving some widely accepted constraints on what should count as such an experience. This is the minimal view, which says that aesthetic experience is the experience derived from attending in a discriminating manner to forms, qualities, or meaningful features of things, attending to these for their own sake or the sake of a payoff intrinsic to this very experience. We adopted the minimal view as our working conception of aesthetic experience. With this conception in hand, we could identify two kinds of aesthetic value. First, there is the intrinsic value of such experiences. Second, objects can possess the instrumental value of possessing forms, qualities, or meaningful features that, when attended to in a discriminating manner, produce this experience. This conception of aesthetic experience allowed us to remain agnostic about the existence of aesthetic properties. We don't have to identify a special subset of forms, qualities, or meaningful features as aesthetic properties to talk about aesthetic experience and aesthetic value. At the same time, the conception does provide a way of picking out aesthetic properties if certain further conditions, regarding the objectivity of aesthetic judgments, are met.

The minimal view gains further support from our discussion of the aesthetic appreciation of nature (chapter 2) and architecture (chapter 12). Nature presents a vast array of possible objects of appreciation from fleeting appearances to large-scale relationships that are embodied in an environment.

Different models of nature appreciation seem to be built on a preference for certain types of objects of appreciation. However, there is no need to choose. As long as nature really offers up the object, then one is attending to properties it really has, and this attention results in an experience valuable in itself, and one is aesthetically appreciating nature in a perfectly appropriate way. With architecture, something similar is true. Some buildings are artworks, while others are not, but both types of buildings can be objects of aesthetic appreciation, and the appreciation could be based on similar sorts of properties and relations.

When we turn to the philosophy of art, we are faced with a much wider array of issues. Each of the eight chapters of part II took up one or more such issues. What is art? What kinds of objects are artworks? Do artworks have meanings, and are these determined by artists' intentions? And so on. I won't review each issue that we took up and the resolution to it proposed here. The reader can readily find these in the summaries at the end of the chapters. Rather, let me make explicit some more general claims that emerge from the whole discussion. These general claims concern the way to approach these issues. On the negative side, we argued against two approaches: essentialism (discussed mainly in chapters 5, 6, and 10) and constructivism (in chapter 6). The main essentialist approach we considered is the aesthetic conception of art. It tells us that art is to be defined in terms of the aesthetic, roughly as an artifact intended to provide significant aesthetic value. It sometimes claims that artworks are one type of entity: aesthetic objects. It claims that the interpretation of art has one dominant aim: to enable, or maximize, aesthetic appreciation. It asserts that artistic value just is aesthetic value. We have argued against all the claims and argued as well that there is no alternative essentialism that would work better.

The constructivist approach tells us that artworks are intentional objects— objects without essential natures. That is, they are constituted by our (individual or collective) conceptions of them, and as these conceptions change, so do the works. This implies that interpretations of works cannot coherently aim to discover meanings in them because there are no fixed meanings to be discovered. Rather interpretations contribute to the changing "identity" of the work. This in turn implies that what a work represents or expresses and the value to be found in it are equally open to change. Chapter 6 contains a critique of this approach.

We have argued instead that more promising solutions to all these issues can be found by combining two ideas: contextualism and pluralism. Contextualism is the view that the central issues of the philosophy of art can be satisfactorily resolved only by appealing to the context in which a work comes into existence: the context of origin or creation. This has proved fruitful in our discussions of definition, ontology, interpretation, and value. The concept of art is to be defined historically, where this history provides the contextually relevant functions, intentions, and forms to identify art-

works at any given stage in the development of an art practice. Context of creation is crucial to individuating particular artworks, and this is the one constant that holds true across other variations in ontological type. Musical and literary works (among others) are abstract structures, but identity in structure is not sufficient to guarantee identity of work. This is because identical structures can be used by artists to say or do very different things just as identical sentences can be used to make very different utterances. Such artworks are indicated structures or structures-in-use. Paintings and some sculptures are physical objects, not abstract structures. However, once again we have to appeal to contextual properties to pick out the particular physical object in question and distinguish it from others present at the same time in the same location. Work meaning and consequently artistic value equally depend on features of context, and for the same sorts of reasons. The message that a sequence of sentences conveys, what can be seen in a particular pattern of paint, and what can be heard in a series of notes will all depend on contextual facts about the work in which those sentences, paint patterns, or notes appear.

Pluralism is, in part, the idea that one needs to appeal to a set of disjoint concepts to adequately account for something. It cropped up in our discussion of the definition of art when we claimed that art needs to be defined disjunctively in terms of two or more sufficient conditions, none of which are necessary. It also cropped up there when we argued that art *cannot* be defined in terms of a single function or intention. It showed up when we argued that there is no single ontology that applies to all artworks. We (briefly) argued for a plurality of acceptable interpretations of artworks resulting from a plurality of aims with which we interpret. Finally, we argued that artistic value is essentially plural, being constituted by many different kinds of valuable properties.

Within this contextualist and pluralist framework for thinking about art, aesthetic value no longer has an essential role to play, but it still has an important one. Artworks have many artistic functions beyond being providers of aesthetic experience or value. Correlatively, aesthetic value is one among several values—which also include ethical, cognitive, emotion-oriented, and art-historical values—that can contribute to the overall artistic value of an artwork. However, we saw in chapter 11 that these values are not always isolated from each other but can interact—meaning that the presence of one can add or detract from the degree of another. In that chapter, we focused most on the issue of whether ethical value can diminish or enhance aesthetic value. However, at the end we mentioned that the interaction works the other way as well. Let us conclude by noting that this kind of interaction is by far the most pervasive. The heightening of perceptual or imaginative engagement that is the mark of aesthetic experience is typically the enabler of not just ethical but other kinds of artistic value as well. So the aesthetic still has a crucial, if not a defining, role to play in art and its philosophy.

References

Allison, Henry. 2001. *Kant's Theory of Taste*. Cambridge: Cambridge University Press.

Anderson, John. 2000. "Aesthetic Concepts of Art." In *Theories of Art Today*, edited by Noël Carroll. Madison: University of Wisconsin Press, 65–92.

Anderson, John, and Jeffrey Dean. 1998. "Moderate Autonomism." *British Journal of Aesthetics* 38: 150–66.

Barnes, Annette. 1988. *On Interpretation*. Oxford: Blackwell.

Bateson, F. W. 1966. *English Poetry: a Critical Introduction*. 2nd ed. London: Longmans Green.

Beardsley, Monroe. 1958. *Aesthetics: Problems in the Philosophy of Criticism*. New York: Harcourt Brace and World.

———. 1969. "Aesthetic Experience Regained." *Journal of Aesthetics and Art Criticism* 28: 2–11.

———. 1970. *The Possibility of Criticism*. Detroit: Wayne State University Press.

———. 1982. *The Aesthetic Point of View*. Ithaca, N.Y.: Cornell University Press.

———. 1983. "An Aesthetic Definition of Art." In *What Is Art?* edited by Hugh Curtler. New York: Haven Publications, 15–29.

Bell, Clive. 1914. *Art*. London: Chatto and Windus.

Bender, John. 1996. "Realism, Supervenience, and Irresolvable Aesthetic Disputes." *Journal of Aesthetics and Art Criticism* 54: 371–81.

———. 2001. "Sensibility, Sensitivity and Aesthetic Realism." *Journal of Aesthetics and Art Criticism* 59: 73–83.

Berleant, Arnold. 1992. *Aesthetics of the Environment*. Philadelphia: Temple University Press.

Binkley, Timothy. 1977. "Piece: Contra Aesthetics." *Journal of Aesthetics and Art Criticism* 35: 265–77.

Bowsma, O. K. 1950. "The Expression Theory of Art." In *Philosophical Analysis*, edited by Max Black. Englewood Cliffs, N.J.: Prentice Hall, 71–96.

Brooks, Cleanth. 1994. "Irony as a Principle of Structure." In *Context for Criticism*, edited by Donald Keesey. Mountainview, CA: Mayfield, 74–81.

Budd, Malcom. 1985. *Music and the Emotions: The Philosophical Theories*. London: Routledge.

——. 1995. *Values of Art: Pictures, Poetry, and Music*. London: Penguin.

——. 1996. "The Aesthetic Appreciation of Nature." *British Journal of Aesthetics* 36: 207–22.

——. 2002. *The Aesthetic Appreciation of Nature*. Oxford: Oxford University Press.

Carlson, Allen. 1979. "Appreciation and the Natural Environment." *Journal of Aesthetics and Art Criticism* 37: 267–75.

——. 1981. "Nature, Aesthetic Judgment, and Objectivity." *Journal of Aesthetics and Art Criticism* 40: 15–27.

——. 1993. "Appreciating Art and Appreciating Nature." In *Landscape, Natural Beauty and the Arts*, edited by S. Kemal and I. Gaskell. Cambridge: Cambridge University Press, 244–66.

——. 1995. "Nature, Aesthetic Appreciation, and Knowledge." *Journal of Aesthetics and Art Criticism* 53: 393–400.

——. 2000. *Aesthetics and the Environment*. London: Routledge.

——. 2001. "Environmental Aesthetics." In *The Routledge Companion to Aesthetics*, edited by Berys Gaut and Dominic Lopes. London: Routledge, 423–36.

Carney, James. 1991. "The Style Theory of Art." *Pacific Philosophical Quarterly* 72: 273–89.

——. 1994. "Defining Art Externally." *British Journal of Aesthetics* 34: 114–23.

Carroll, Noël. 1993. "Essence, Expression, and History: Arthur Danto's Philosophy of Art." In *Danto and his Critics*, edited by Mark Rollins. Oxford: Basil Blackwell, 79–106.

——. 1994. "Identifying Art." In *Institutions of Art: Reconsiderations of George Dickie's Philosophy*, edited by Robert Yanal. University Park: Pennsylvania State University Press, 3–38.

——. 1996. "Moderate Moralism." *British Journal of Aesthetics* 36: 223–37.

——. 1998. "Moderate Moralism versus Moderate Autonomism." *British Journal of Aesthetics* 38: 419–24.

——. 1999. *The Philosophy of Art: A Contemporary Introduction*. London: Routledge.

——. 2000a. "Art and the Domain of the Aesthetic." *British Journal of Aesthetics* 40: 191–208.

——. 2000b. "Art and Ethical Criticism: An Overview of Recent Research." *Ethics* 110: 350–87.

——, ed. 2000c. *Theories of Art Today*. Madison: University of Wisconsin Press.

——. 2001a. *Beyond Aesthetics: Philosophical Essays*. Cambridge: Cambridge University Press.

——. 2001b. "Enjoyment, Indifference and Aesthetic Experience: Comments for Robert Stecker." *British Journal of Aesthetics* 41: 81–83.

——. 2002a. "Aesthetic Experience Revisited." *British Journal of Aesthetics* 42: 145–68.

——. 2002b. "The Wheel of Virtue: Art, Literature, and Moral Knowledge." *Journal of Aesthetics and Art Criticism* 60: 3–26.

Collingwood, R. G. 1938. *Principles of Art*. Oxford: Oxford University Press.

Cone, Edward T. 1974. *The Composer's Voice*. Berkeley: University of California Press.

Crawford, D. W. 1974. *Kant's Aesthetic Theory*. Madison: University of Wisconsin Press.

Currie, Gregory. 1989. *An Ontology of Art*. London: Macmillan.

———. 1990. *The Nature of Fiction*. Cambridge: Cambridge University Press.

Danto, Arthur. 1964. "The Artworld." *Journal of Philosophy* 61: 571–84.

———. 1973. "Artworks and Real Things." *Theoria* 39: 1–17.

———. 1981. *The Transfiguration of the Commonplace*. Cambridge, Mass.: Harvard University Press.

Davidson, Donald. 1986. "A Nice Derangement of Epitaphs." In *Actions and Events: Essays on the Philosophy of Donald Davidson*, edited by E. Lepore and B. McLaughlin. Oxford: Basil Blackwell, 433–46.

Davies, Stephen. 1991. *Definitions of Art*. Ithaca, N.Y.: Cornell University Press.

———. 1994. *Musical Meaning and Expression*. Ithaca, N.Y.: Cornell University Press.

———. 1995. "Is Architecture an Art?" In *Philosophy and Architecture*, edited by Michael Mitias. Amsterdam: Editions Rodopi.

———. 1997a. "Contra Hypothetical Persona in Music." In *Emotion and the Arts*, edited by Mette Hjort and Sue Laver. Oxford: Oxford University Press, 95–109.

———. 1997b. "First Art and Art's Definition." *Southern Journal of Philosophy* 35: 19–34.

———. 2000. "Non-Western Art and Art's Definition." In *Theories of Art Today*, edited by Noël Carroll. Madison: University of Wisconsin Press, 199–216.

———. 2001. *Musical Works and Performances*. Oxford: Oxford University Press.

Dean, Jeffrey. 2003. "The Nature of Concepts and the Definition of Art." *Journal of Aesthetics and Art Criticism* 61: 29–35.

Dickie, George. 1974. *Art and the Aesthetic: an Institutional Analysis*. Ithaca, N.Y.: Cornell University Press.

———. 1984. *The Art Circle*. New York: Haven Publications.

———. 1988. *Evaluating Art*. Philadelphia: Temple University Press.

———. 1989. "Reply to Stecker." In *Aesthetics: A Critical Anthology*, 2nd ed., edited by G. Dickie, R. Sclafani, and R. Roblin. New York: St. Martin's Press.

Dilworth, John. 2004. "Internal versus External Representation." *Journal of Aesthetics and Art Criticism* 62: 23–36.

Dodd, Julian. 2000. "Musical Works as Eternal Types." *British Journal of Aesthetics* 40: 424–40.

———. 2002. "Defending Musical Platonism." *British Journal of Aesthetics* 42: 380–402.

Dworkin, Ronald. 1986. *Law's Empire*. Cambridge, Mass.: Harvard University Press.

Eaton, Marcia. 2001. *Merit, Aesthetic and Ethical*. Oxford: Oxford University Press.

Feagin, Susan. 1996. *Reading with Feeling: The Aesthetics of Appreciation*. Ithaca, N.Y.: Cornell University Press.

———. 1998. "Presentation and Representation." *Journal of Aesthetics and Art Criticism* 56: 234–40.

Fish, Stanley. 1980. *Is There a Text in This Class?* Cambridge, Mass.: Harvard University Press.

Fodor, Jerry. 1998. *Concepts: Where Cognitive Science Went Wrong*. Oxford: Oxford University Press.

Fry, Roger. 1956. *Vision and Design*. Cleveland: World Publishing.

Gaut, Berys. 1998. "The Ethical Criticism of Art." In *Aesthetics and Ethics*, edited by Jerrold Levinson. Cambridge: Cambridge University Press.

———. 2000. "'Art' as a Cluster Concept." In *Theories of Art Today*, edited by Noël Carroll. Madison: University of Wisconsin Press, 25–44.

————. In press. *Art, Emotion, and Ethics*. Oxford: Oxford University Press.

Giovanelli, Alessandro. 2004. *Artistic and Ethical Value in the Experience of Narratives*. Ph.D. Dissertation, University of Maryland, College Park.

Goehr, Lydia. 1992. *The Imaginary Museum of Musical Works*. Oxford: Oxford University Press.

Goldman, Alan. 1990. "Interpreting Art and Literature." *Journal of Aesthetics and Art Criticism* 48: 205–14.

————. 1995. *Aesthetic Value*. Boulder, Colo.: Westview Press.

————. 2003. "Representation in Art." In *The Oxford Handbook of Aesthetics*, edited by Jerrold Levinson. Oxford: Oxford University Press, 192–210.

Goodman, Nelson. 1976. *Languages of Art*. Indianapolis: Hackett.

————. 1978. *Ways of Worldmaking*. Indianapolis: Hackett.

Goodman, Nelson, and Catherine Elgin. 1988. *Reconceptions in Philosophy and Other Arts and Sciences*. Indianapolis: Hackett.

Gould, Carroll. 1994. "Clive Bell on Aesthetic Experience and Aesthetic Truth." *British Journal of Aesthetics* 34: 124–33.

Gracyk, Ted. 1996. *Rhythm and Noise: An Aesthetics of Rock Music*. Durham, N.C.: Duke University Press.

Graham, Gordon. 1997. *Philosophy of the Arts: an Introduction to Aesthetics*. London: Routledge.

Graves, L. 1998. "Transgressive Traditions and Art Definitions." *Journal of Aesthetics and Art Criticism* 56: 39–48.

Guyer, Paul. 1997. *Kant and the Claims of Taste*. 2nd ed. Cambridge: Cambridge University Press.

Hepburn, Ronald. 1996. "Landscape and the Metaphysical Imagination." *Environmental Values* 5: 191–204.

Hirsch, E. D. 1967. *Validity in Interpretation*. New Haven, Conn.: Yale University Press.

Hopkins, Robert. 1998. *Picture, Image, and Experience*. Cambridge: Cambridge University Press.

Howell, Robert. 1979. "Fictional Objects: How They Are and How They Aren't." *Poetics* 8: 129–77.

————. 2002a. "Ontology and the Nature of the Literary Work." *Journal of Aesthetics and Art Criticism* 60: 67–79.

————. 2002b. "Types, Indicated and Initiated." *British Journal of Aesthetics* 42: 105–27.

Hume, David. 1993. "Of the Standard of Taste." In *Hume: Selected Essays*, edited by L. A. Selby-Bigge. Oxford: Oxford University Press, 133–54.

Hyman, John. 1984. "Morality and Literature: The Necessary Conflict." *British Journal of Aesthetics* 24: 149–55.

————. 1989. *The Imitation of Nature*. Oxford: Blackwell.

Iseminger, Gary. 1992. "An Intentional Demonstration?" In *Intention and Interpretation*. Philadelphia: Temple University Press, 76–96.

Jacobson, Daniel. 1996. "Sir Philip Sidney's Dilemma: On the Ethical Function of Narrative." *Journal of Aesthetics and Art Criticism* 54: 327–36.

————. 1997. "In Praise of Immoral Art." *Philosophical Topics* 25: 155–99.

Jones, Peter. 1975. *Philosophy and the Novel*. Oxford: Oxford University Press.

Kant, Immanuel. 1902. *Gesammelte Schriften*. Berlin: German Academy of Sciences

————. 1952. *The Critique of Judgement*, translated by James Creed Meredith. Oxford: Oxford University Press.

Kieran, Matthew. 1996. "Art, Imagination, and the Cultivation of Morals." *Journal of Aesthetics and Art Criticism* 54: 337–51.

———. 2001. "In Defense of the Ethical Evaluation of Narrative Art." *British Journal of Aesthetics* 41: 26–38.

———. 2003. "Art and Morality." In *The Oxford Handbook of Aesthetics*, edited by Jerrold Levinson. Oxford: Oxford University Press, 451–68.

———. 2004. *Revealing Art*. London: Routledge.

King, William. 1992. "Scruton and the Reasons for Looking at Photographs." *British Journal of Aesthetics* 32: 258–65.

Kivy, Peter. 1980. *The Corded Shell*. Princeton, N.J.: Princeton University Press.

———. 1993. *The Fine Art of Repetition*. Cambridge: Cambridge University Press.

———. 1997. *Philosophies of Arts*. Cambridge: Cambridge University Press.

Knapp, S., and W. B. Michaels. 1985. "Against Theory." In *Against Theory*, edited by W. J. T. Mitchell. Chicago: University of Chicago Press, 222–32.

Korsgaard, Christine. 1996. "Two Distinctions in Goodness." In *Creating the Kingdom of Ends*. Cambridge: Cambridge University Press, 249–74.

Krausz, Michael. 1993. *Rightness and Reasons*. Ithaca, N.Y.: Cornell University Press.

Kulvicki, John. 2003. "Image Structure." *Journal of Aesthetics and Art Criticism* 61: 323–40.

Lamarque, Peter. 1995. "Tragedy and Moral Value." *Australasian Journal of Philosophy* 73: 239–49.

———. 2002. "Appreciation and Literary Interpretation." In *Is There a Single Right Interpretation?* edited by Michael Krausz. University Park: Pennsylvania State University Press, 285–306.

Lamarque, Peter, and S. H. Olsen. 1994. *Truth, Fiction and Literature: A Philosophical Perspective*. Oxford: Oxford University Press.

Langer, S. 1953. *Feeling and Form*. London: Routledge.

Levinson, Jerrold. 1979. "Defining Art Historically." *British Journal of Aesthetics* 19: 232–50.

———. 1987. "Review of *The Art Circle*." *Philosophical Review* 96: 141–46.

———. 1989. "Refining Art Historically." *Journal of Aesthetics and Art Criticism* 47: 21–33.

———. 1990. *Music, Art, and Metaphysics*. Ithaca, N.Y.: Cornell University Press.

———. 1993. "Extending Art Historically." *Journal of Aesthetics and Art Criticism* 51: 411–24.

———. 1994. "Being Realistic about Aesthetic Properties." *Journal of Aesthetics and Art Criticism* 52: 351–54.

———. 1996. *The Pleasures of Aesthetics*. Ithaca, N.Y.: Cornell University Press.

———. 1997. "Evaluating Music." In *Musical Worlds*, edited by Philip Alperson. University Park: Pennsylvania State University Press.

———, ed. 1998a. *Aesthetics and Ethics*. Cambridge: Cambridge University Press.

———. 1998b. "Wollheim on Pictorial Representation." *Journal of Aesthetics and Art Criticism* 56: 227–33.

———. 2001. "Aesthetic Properties, Evaluative Forces, and Differences in Sensibility." In *Aesthetic Concepts: Essays after Sibley*, edited by Emily Brady and Jerrold Levinson. Oxford: Oxford University Press, 61–80.

———. 2002. "The Irreducible Historicality of the Concept of Art." *British Journal of Aesthetics* 42: 367–79.

———. In press. "Musical Expressiveness as Hearability-as-Expression." In *Contemporary Debates in Aesthetics*, edited by Matthew Kieran. Oxford: Blackwell.

Lind, Richard. 1992. "The Aesthetic Essence of Art." *Journal of Aesthetics and Art Criticism* 50: 117–29.

Livingston, Paisley. 1998. "Intentionalism in Aesthetics." *New Literary History* 50: 615–33.

Lopes, Dominic. 1996. *Understanding Pictures*. Oxford: Oxford University Press.

———. 2003. "The Aesthetics of Photographic Transparency." *Mind* 112: 433–48.

Mandelbaum, Maurice. 1965. "Family Resemblances and Generalization concerning the Arts." *American Philosophical Quarterly* 2: 219–28.

Margolis, Joseph. 1980. *Art and Philosophy*. Atlantic Highlands, N.J.: Humanities Press.

———. 1995. *Interpretation Radical but Not Unruly*. Berkeley: University of California Press.

———. 1999. *What, After All, Is a Work of Art?* University Park: Pennsylvania State University Press.

Martin, E. 1986. "On Seeing Walton's Great-Grandfather." *Critical Inquiry* 12: 796–800.

Matravers, Derek. 1998. *Art and Emotion*. Oxford: Oxford University Press.

———. 2000. "The Institutional Theory: A Protean Creature." *British Journal of Aesthetics* 40: 242–50.

Matthews, Patricia. 2002. "Scientific Knowledge and the Aesthetic Appreciation of Nature." *Journal of Aesthetics and Art Criticism* 60: 37–48.

Mauss, Fred. 1988. "Music as Drama." *Music Theory Spectrum* 10: 232–50.

McFee, Graham. 1992. "The Historical Character of Art: A Reappraisal." *British Journal of Aesthetics* 32: 307–19.

Mew, Peter. 1985. "The Expression of Emotion in Music." *British Journal of Aesthetics* 25: 33–42.

Nathan, Daniel. 1992. "Irony, Metaphor and the Problem of Intention." In *Intention and Interpretation*, edited by Gary Iseminger. Philadelphia: Temple University Press, 183–202.

Nehamas, Alexander. 1981. "The Postulated Author: Critical Monism as a Regulative Ideal." *Critical Inquiry* 8: 133–49.

Newcombe, Anthony. 1984. "Sound and Feeling." *Critical Inquiry* 10: 614–43.

Nolt, John. 1981. "Expression of Emotion." *British Journal of Aesthetics* 21: 139–50.

Norris, M. 1994. "Not the Girl She Was at All: Women in 'The Dead.'" In *The Dead*, edited by D. R. Schwarz. New York: St. Martin's Press, 190–205.

Novitz, David. 1996. "Disputes about Art." *Journal of Aesthetics and Art Criticism* 54: 153–63.

Nussbaum, Martha. 1990. *Love's Knowledge*. Oxford: Oxford University Press.

Peacocke, Christopher. 1987. "Depiction." *Philosophical Review* 96: 383–410.

Predelli, Stefano. 2001. "Musical Ontology and the Argument from Creation." *British Journal of Aesthetics* 41: 279–92.

Ridley, Aaron. 1995. *Music, Value and the Passions*. Ithaca, N.Y.: Cornell University Press.

Robinson, Jenefer. 1985. "Style and Personality in the Individual Work." *Philosophical Review* 94: 227–47.

Robinson, Jenefer, and Gregory Karl. 1995. "Shostakovitch's Tenth Symphony and the Musical Expression of Cognitively Complex Emotions." *Journal of Aesthetics and Art Criticism* 53: 401–15.

Sartwell, Crispin. 1990. "A Counter-Example to Levinson's Historical Theory of Art." *Journal of Aesthetics and Art Criticism* 48: 157–58.

Schier, F. 1986. *Deeper into Pictures*. Cambridge: Cambridge University Press.

Schlesinger, George. 1979. "Aesthetic Experience and the Definition of Art." *British Journal of Aesthetics* 19: 167–76.

Schopenhauer, Arthur. 1966. *World as Will and Representation*, 2 vols., translated by E. F. Payne. New York: Dover.

Schwarz, D. R. 1994. *The Dead*. New York: St. Martin's Press.

Scruton, Roger. 1974. *Art and Imagination*. London: Methuen.

———. 1979. *The Aesthetics of Architecture*. Princeton, N.J.: Princeton University Press.

———. 1983. "Photography and Representation. In *The Aesthetic Understanding*. London: Methuen, 102–26.

———. 1994. *The Classical Vernacular: Architectural Principles in an Age of Nihilism*. New York: St. Martin's Press.

Searle, John. 1975. "The Logical Status of Fictional Discourse." *New Literary History* 6: 319–32.

Shelley, James. 2003. "The Problem of Non-Perceptual Art." *British Journal of Aesthetics* 43: 363–78.

Shusterman, Richard. 1988. "Interpretation, Intention, Truth." *Journal of Aesthetics and Art Criticism* 45: 399–411.

Sibley, Frank. 1959. "Aesthetic Concepts." *Philosophical Review* 68: 421–50.

Stecker, Robert. 1986. "The End of an Institutional Definition of Art." *British Journal of Aesthetics* 26: 124–32.

———. 1987a. "Apparent, Implied, and Postulated Authors." *Philosophy and Literature* 11: 258–71.

———. 1987b. "Free Beauty, Dependent Beauty, and Art." *Journal of Aesthetic Education* 21: 89–99.

———. 1997. *Artworks: Definition, Meaning, Value*. University Park: Pennsylvania State University Press.

———. 2000. "Is It Reasonable to Attempt to Define Art?" In *Theories of Art Today*, edited by Noël Carroll. Madison: University of Wisconsin Press, 45–64.

———. 2001. "Only Jerome: A Reply to Noël Carroll." *British Journal of Aesthetics* 41: 76–80.

———. 2003. *Interpretation and Construction: Art, Speech and the Law*. Oxford: Blackwell.

Stock, Kathleen. 2000. "Some Objections to Stecker's Historical Functionalism." *British Journal of Aesthetics* 40:479–91.

Tilghman, B. R. 1984. 1984. *But Is It Art?* Oxford: Blackwell.

Thom, Paul. *Making Sense*. Lanham, Md.: Rowman & Littlefield, 2000.

Thomasson, Amie. 1999. *Fiction and Metaphysics*. Cambridge: Cambridge University Press.

Tolhurst, William. 1979. "What a Text Is and How It Means." *British Journal of Aesthetics* 19: 3–14.

Tolstoy, Leo. 1996. *What Is Art?* Translated by A. Maude. Indianapolis: Hackett.

Trivedi, Saam. 2001. "An Epistemic Dilemma for Actual Intentionalism." *British Journal of Aesthetics* 41: 192–206.

Urmson, J. 1957. "What Makes a Situation Aesthetic?" *Proceedings of the Aristotelian Society* 31 (suppl.): 75–92.

Van Inwagen, Peter. 1977. "Creatures of Fiction." *American Philosophical Quarterly* 14: 299–308.

Vermazen, Bruce. 1986. "Expression as Expression." *Pacific Philosophical Quarterly* 67: 196–224.

Walton, Kendall. 1970. "Categories of Art." *Philosophical Review* 79: 334–67.

———. 1977. "Review of *Art and the Aesthetic: An institutional Analysis.*" *Philosophical Review* 86: 97–101.

———. 1979. "Style and the Products and Processes of Art." In *The Concept of Style*, edited by Beryl Lang. Ithaca, N.Y.: Cornell University Press.

———. 1984. "Transparent Pictures." *Critical Inquiry* 11: 246–77.

———. 1990. *Mimesis as Make-Believe*. Cambridge, Mass.: Harvard University Press.

———. 2002. "Depiction, Perception, and Imagination: A Response to Richard Wollheim." *Journal of Aesthetics and Art Criticism* 60: 27–35.

Warburton, Nigel. 1996. "Individual Style in Photographic Art." *British Journal of Aesthetics* 36: 389–97.

Weitz, Morris. 1956. "The Role of Theory in Aesthetics." *Journal of Aesthetics and Art Criticism* 15: 27–35.

Wiggins, David. 1980. *Sameness and Substance*. Oxford: Blackwell.

Wollheim, Richard. 1980. *Art and Its Objects*. 2nd ed. Cambridge: Cambridge University Press.

———. 1987. *Painting as an Art*. Princeton, N.J.: Princeton University Press.

———. 1998. "On Pictorial Representation." *Journal of Aesthetics and Art Criticism* 56: 217–26.

Wolterstorff, Nicholas. 1980. *Works and Worlds of Art*. Oxford: Oxford University Press.

Zangwill, Nick. 1995. "The Beautiful, the Dainty and the Dumpy." *British Journal of Philosophy* 35: 317–29.

———. 2000. "Aesthetic Functionalism." In *Aesthetic Concepts: Essays after Sibley*, edited by E. Brady and J. Levinson. Oxford: Oxford University Press.

———. 2001. *The Metaphysics of Beauty*. Ithaca, N.Y.: Cornell University Press.

Zemach, Eddy. 1997. *Real Beauty*. University Park: Pennsylvania State University Press.

Ziff, Paul. 1953. "The Task of Defining a Work of Art." *Philosophical Review* 62: 466–80.

Index

About the Author

Robert Stecker is professor of philosophy at Central Michigan University. He is the author of two previous books on the philosophy of art: *Artworks: Definition, Meaning, Value* (1997) and *Interpretation and Construction: Art, Speech and the Law* (2003).